LIVING WITH ANTIQUES

A treasury of private homes in America

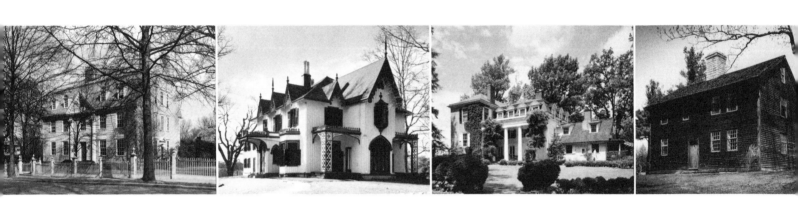

LIVING
WITH
ANTIQUES

EDITED BY ALICE WINCHESTER

AND THE STAFF OF

ANTIQUES MAGAZINE

E. P. DUTTON AND COMPANY, INC.

NEW YORK, 1963

Contents

Contents

Contents

Color plates

facing page

For the use of color plates we are grateful to the Viking Press, J. A. Lloyd Hyde,
Mrs. Lowe Fallass, Mr. and Mrs. Hiram D. Rickert, and Mr. and Mrs. Herbert A. May.

Living with antiques

By Alice Winchester

EDITOR OF ANTIQUES MAGAZINE

IN THIS BOOK we have brought together treasures from the past and a wealth of ideas for their use and enjoyment in the present. Like *The ANTIQUES Treasury of Furniture and Other Decorative Arts* published in 1959, to which it is a companion, this volume is full of information about antiques, but while the previous volume concerned itself with the collections of seven great American museums, this is devoted to American private homes. It makes no recommendations as to what should be done, but it shows what has actually been done by some of America's most discriminating collectors to bring beauty and also a sense of stability and continuity into their homes. For to these collectors living with antiques does not mean living in the past: it means preserving and enjoying the best of the past in order to add an extra dimension to the present.

As early as the 1920's the magazine ANTIQUES occasionally pictured the home of a collector who treated his antiques less as specimens than as furnishings to live with. At that time, strange as it now seems, such an attitude was relatively novel. To be sure, designers had been creating interiors as a whole since the eighteenth century, when many of our antiques were new, but they were concerned primarily with new things — the latest style of 1780, or 1840, or 1920, say — not with those of the past. It was only about a generation ago that American collectors, influenced on the one hand by the period rooms which were beginning to appear in museums, and on the other by the integrated interiors advocated by interior decorators, developed a concern for what went with what, for attractive arrangement of major pieces and decorative accents, for suitability of background in terms of colors, fabrics, wall and floor coverings, lighting.

It was the beginning of a trend. In the years since then, ANTIQUES has published literally hundreds of collectors'

homes in its continuing series "Living with antiques." From those that have appeared in the past decade we have selected forty which we present, with additional black-and-white pictures and color plates, in this book.

Scattered over the United States, these houses and apartments are as varied as antiques themselves. Naturally enough, the emphasis in most of them is on American things, but English and Continental are also well represented. Some show the influence of the museum or historic house in their conscientious regard for "period" correctness; others exemplify the more recent taste for freely mixing antiques of different ages and sources. Several are furnished almost entirely with antiques indigenous to their own part of the country, reflecting the collector's interest in the regional characteristics of American antiques. A surprisingly large number are what may be called heirloom houses, where most of the antiques were not really collected but have descended by inheritance to their present fortunate owners. But in every case the antiques in their settings represent the individuality and personal taste of those who live with them.

We are grateful to all these collectors for the opportunity to include their homes in this book. We wish to express our appreciation also to the authors of several articles for permission to reprint them here: Edward Deming Andrews (page 24), Maxine Bartlett (page 222), Joseph T. Butler (page 126), J. A. Lloyd Hyde (page 44), James A. Nonemaker (page 144), Celia Jackson Otto (page 160), and Phelps Warren (page 174). The other articles were written by members of the editorial staff of ANTIQUES: Helen Comstock, Ruth Davidson, Edith Gaines, Barbara Snow, and myself; Dorothy Baltar, Ann Sigmund, and Elizabeth Stillinger also participated in the production of this volume. The book was designed by Milton H. Glover.

Eighteenth-century comfort and charm

Mr. and Mrs. Sifford Pearre, Baltimore, Maryland

A HEPPLEWHITE DINING TABLE inherited by Mrs. Sifford Pearre from her ancestor and namesake Angelica Kauffmann Peale first aroused her interest in Baltimore furniture, and soon after its acquisition she and her husband began their search for more examples of this school of cabinetmaking. Their careful study of woods, design, and decoration has enabled them to assemble an outstanding group of furniture. In variety and sophistication their Baltimore furniture reveals ever new aspects — a pier table of extraordinary elegance, a pembroke games table, an early Hepplewhite window seat, and a gadroon-based tripod tea table.

The meteoric rise of the Baltimore school of cabinetmaking in the late 1700's was without parallel in other centers. Mercantile trade and shipbuilding, the Chesapeake schooner and trade with the West Indies, sales of wheat, flour, and tobacco in a world market, all made Baltimore a prosperous center of industry which attracted many craftsmen emigrating from Europe after the Revolution. A small town with a population of about thirteen thousand in 1790 passed the thirty-one-thousand mark in 1800 to become a fine city. In the background were the manorial families of Maryland living on their great estates, and in the city a new merchant class grew up which soon imitated the country aristocrats and acquired estates of its own. Both were in a position to indulge in the purchase of fine furniture. The combination of a cultivated taste on the part of the patrons and an influx of trained artisans resulted, in a remarkably short time, in a distinctive classical style which places Baltimore work with that of Boston, Salem, Newport, New York, Philadelphia, and Charleston.

Although Baltimore and Maryland work is the Pearres' favorite, they also have fine examples of New England and Philadelphia craftsmanship ranging in style from Queen Anne to Federal.

All their antiques have been selected and arranged with care in a twentieth-century house of traditional design. Muted colors and appropriate architectural elements — the Wellford stucco mantel in the living room, for example, the paneling in the music room, and the Maryland mantel in the dining room — provide a sympathetic background for their choice furniture, paintings, prints, and China Trade porcelain. Since the Pearres insist on the everyday use of even their finest antiques, their house is warm and attractive as well as distinguished.

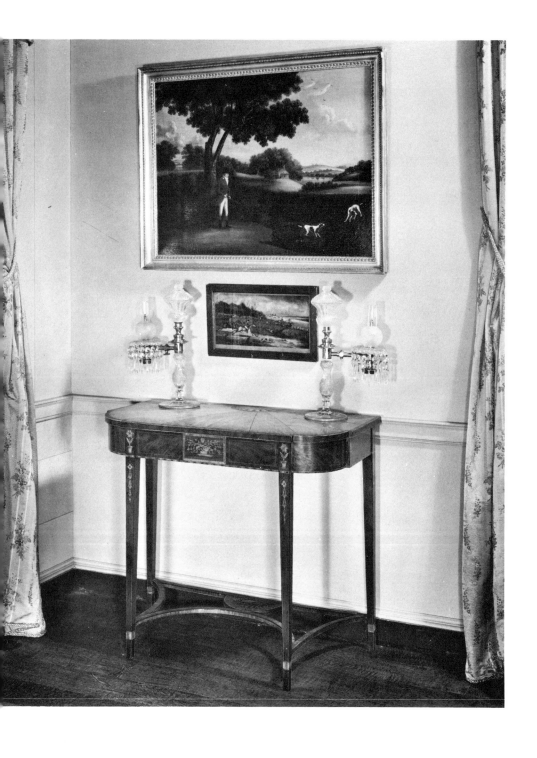

The richest of Baltimore mahogany and satinwood pier tables to come to light dominates this corner of the living room; it is left bare except for a pair of beautifully cut Argand lamps of Anglo-Irish glass. Spreading outward from a semicircular medallion in the table top is a sunburst of radiating lines of mahogany in satinwood. A forerunner of a popular Regency form, the stretcher shelf is inlaid with the conch shell which was to be a favorite Regency decoration. The inlaid bowl of flowers on the frieze is the same (in reverse) as that on the table which belonged to William Paca the Signer (No. 15, *Baltimore Furniture 1760-1810*, Baltimore Museum of Art), and there is the same bellflower dependent from a four-petaled rosette on a card table in the Garvan collection (No. 16 of the same catalogue). *Photographs by Holmes I. Mettee Studio.*

At the other end of the living room are choice examples of Philadelphia craftsmanship. A masterpiece of bold line and architectural strength is the chest-on-chest (c. 1760) with its large fluted quarter columns, heavily molded broken-arch pediment, and strong molding between the upper and lower sections. All three "rungs" of the ladder-back chairs are molded like the top rail, instead of being left flat as was usual. The low-backed open-arm chairs, of maple, are believed to have been made in New England although they have the covered arms usually associated with Philadelphia. The Chippendale tripod tea table (c. 1760) is a rare Baltimore piece; the gadrooning at the base of the tripod is a unique detail.

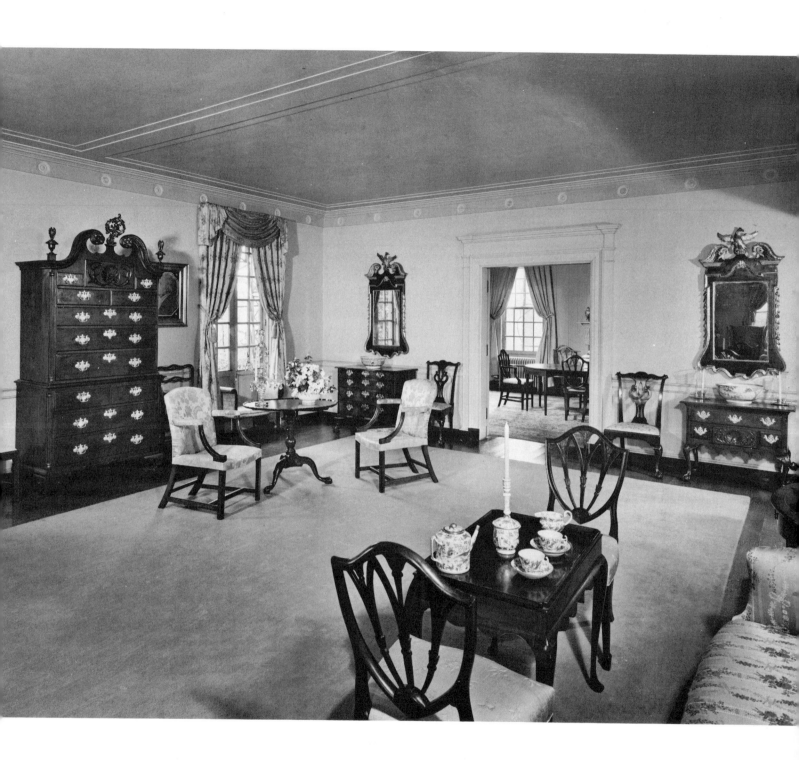

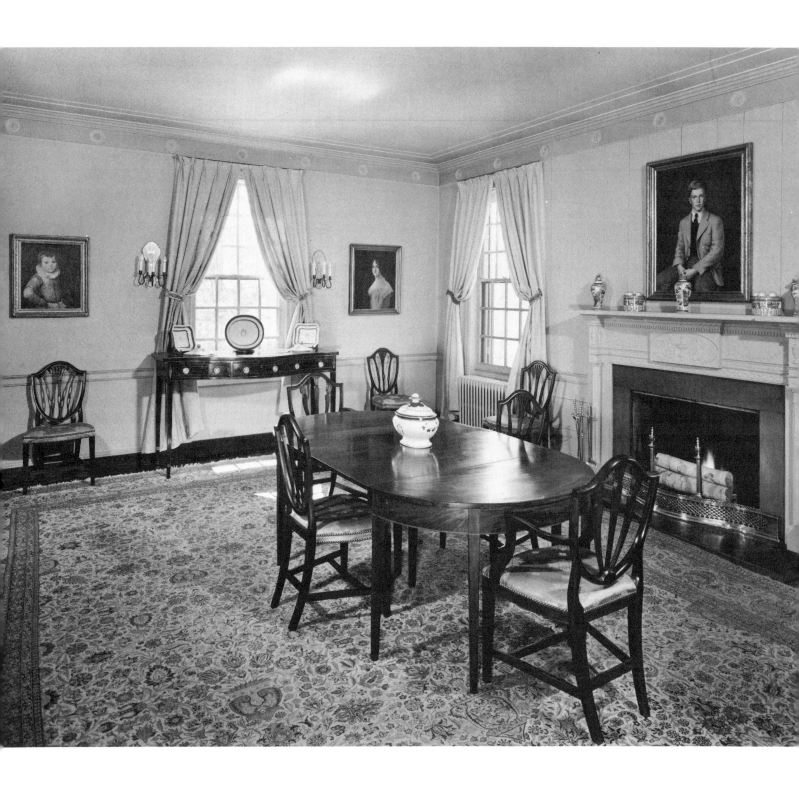

The Hepplewhite dining table was the Pearres' introduction to Baltimore furniture so it is especially appropriate that all the furniture in this room is of Baltimore origin. Six carved and inlaid Hepplewhite shield-back chairs which family tradition associates with Governor Bradford of Maryland are characteristic of Baltimore in the back design of three pierced splats (similar examples are shown on Plates 52, 54, 60, *Baltimore Furniture*). The serpentine-front inlaid huntboard is a fine example of the elaborate Baltimore interpretation of this distinctively Southern form of tall-legged serving table.

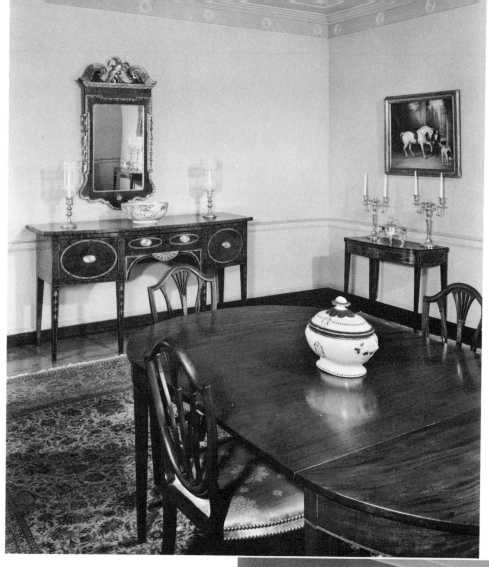

A swell-front mahogany sideboard represents Baltimore's restrained magnificence in use of inlay. The shaded inlaid medallion which depends from the center of the front and the form of bellflower appear only in Baltimore. Typical also are the emphasis on ovals and the use of cross-banding on the sideboard and on the mahogany and satinwood card table, one of a pair.

Charmingly small and beautifully proportioned is this mahogany blockfront in the upstairs hall. The boldly shaped and projecting top suggests a Connecticut maker. The carving of the pair of Salem side chairs (c. 1790) is attributed to Samuel McIntire.

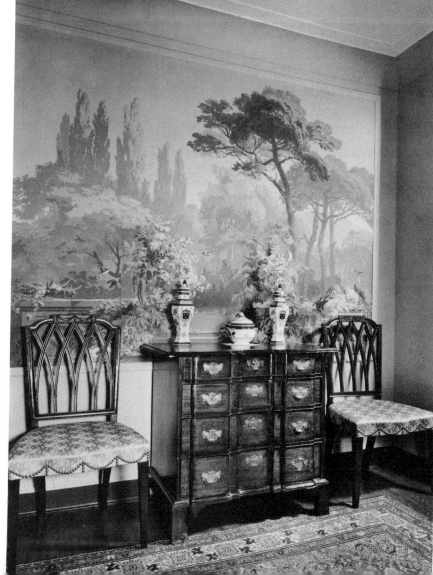

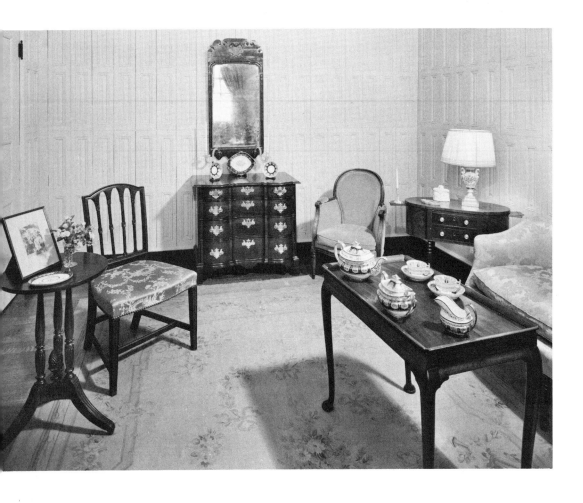

In the music room is another of the Baltimore heirlooms inherited from Angelica Peale — the oval sewing table with tiny candle slides. Perhaps the most prized piece in this room is the walnut-veneered mirror, believed to have been made by John Elliott of Philadelphia because of structural details of the back; it is extraordinary in having glass candle arms, almost unknown in American work. The Philadelphia candlestand (c. 1800), which has a finely carved pineapple finial in the center of the three reeded columns and fluting on the supporting block and the legs, is attributed to the Connelly-Haines school.

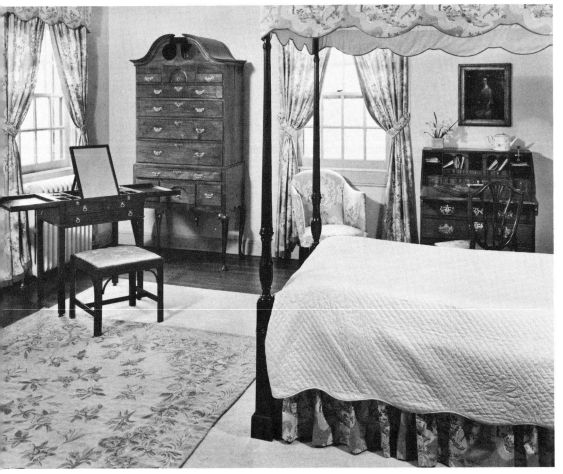

In Mrs. Pearre's bedroom are seen two unusually small pieces of New England origin. The maple desk has a gracefully stepped and shaped interior. Equally graceful in its simplicity is the bonnet-top Queen Anne highboy, also of maple.

Color plate, facing page.

Soft blue-gray walls in the living room provide a sympathetic background for gleaming mahogany, blue and gold brocade, and the flower tones of the China Trade porcelain. The Hepplewhite sofa is upholstered in the same Lyons brocade as is used for the draperies. The charming small oval table of the Connelly-Haines school beside the wing chair has acanthus carving and reeding typical of this school. Above the Philadelphia mantel by Robert Wellford, which depicts the battle of Lake Erie, hangs a mid-eighteenth-century portrait in its original carved and gilded frame.

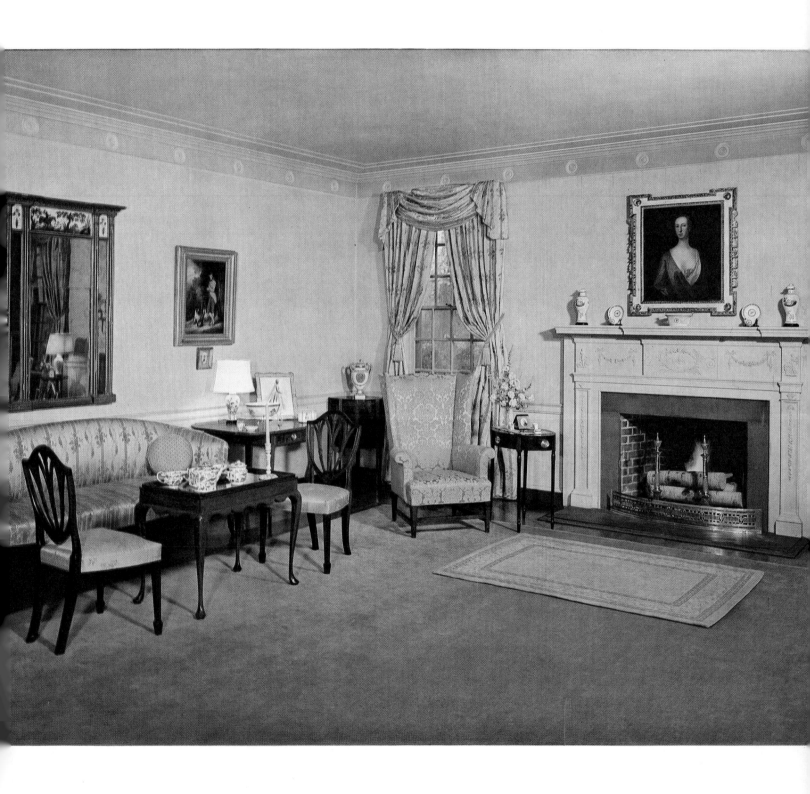

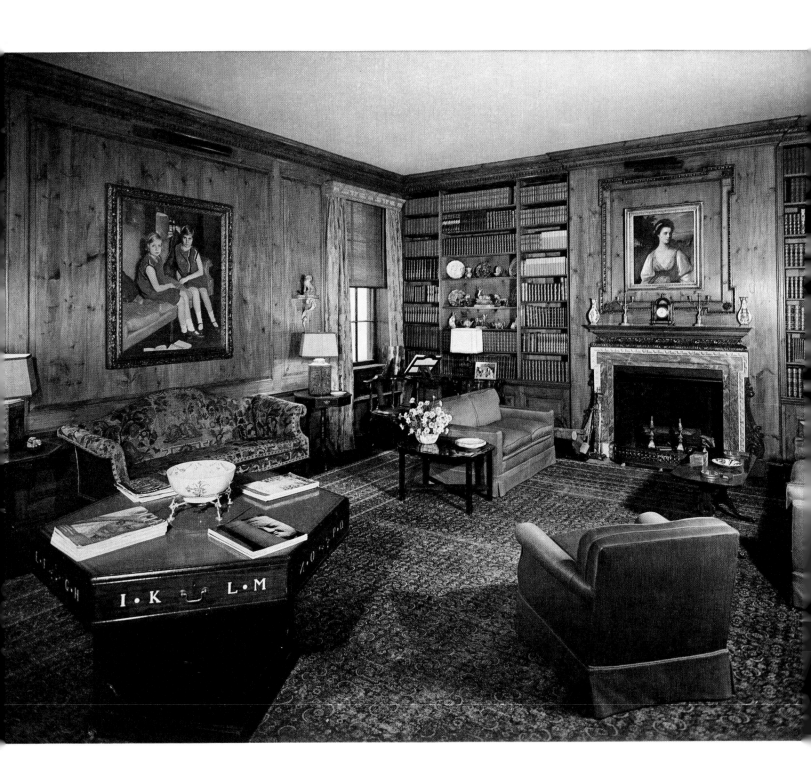

Town house in New York

Mr. and Mrs. Charles C. Paterson, New York City

The pine-paneled library with its fine English furnishings serves also as a most inviting family living room. Rare volumes share the shelves with pottery of Astbury-Whieldon type; the horses are especially fine examples. A founding member of the Royal Academy, Dublin-born Nathaniel Hone (1717-1784), painted the portrait of Miss Nicholson which hangs on the chimney breast; the portrait of Mrs. Paterson's daughters above the needlepoint sofa is by Harrington Mann. Of particular interest here are the leather-topped rent table with letters of ivory inlaid in the drawer fronts, and the walnut dual-purpose chair in the corner. The rug is an antique Khorassan. *Photographs by Taylor and Dull.*

Mirrors are used to advantage throughout the house. In two niches in the entrance hall they reflect, with an effect of *trompe l'oeil*, a pair of bronzes from the Speyer collection on original Louis XVI carved, painted, and gilded wood bases. The Canaletto above the fireplace shows one of his many views of the Grand Canal, and on the mantel is a Louis XVI marble clock between English Regency bronze and ormolu candelabra. The steel fender and grate are English. Beige and deep rose are the upholstery colors of the crown-crested chairs (three of a set of eight) and the sofa, which is covered in seventeenth-century *grospoint*; the pale gold of the carpet, made in India for the European market, is an effective background. Almost an exact match for the Swansea dessert service in the painted and gilded cabinet (Portuguese, early 1700's) are the *porcelaine de Paris* urns on its top.

TOWN HOUSES are a fast-disappearing type, and nowhere is the type or the pleasant way of life it represents vanishing more rapidly than in New York City; a distinguished survivor is the home of Mr. and Mrs. Charles C. Paterson.

Located on a quiet street in Manhattan's east eighties, it comprises a spacious four-story dwelling with a small garden in the rear and at the second-floor level an interior court, secluded and ivy-lined. Its furnishings have been selected without pedantic consistency in source or period; most of them come from France or England, but other countries are represented as well, and they range in date from the sixteenth to the nineteenth centuries. They share, however, a high degree of sophistication — they are carved and lacquered, painted and gilded — and often they are unusual examples of their genre. The Patersons have made wise and effective use of unpatterned walls and fabrics, subdued background colors, and expanses of mirror in their generously proportioned rooms. The result is a house that has character; perhaps its outstanding quality is elegance, with comfort and without ostentation.

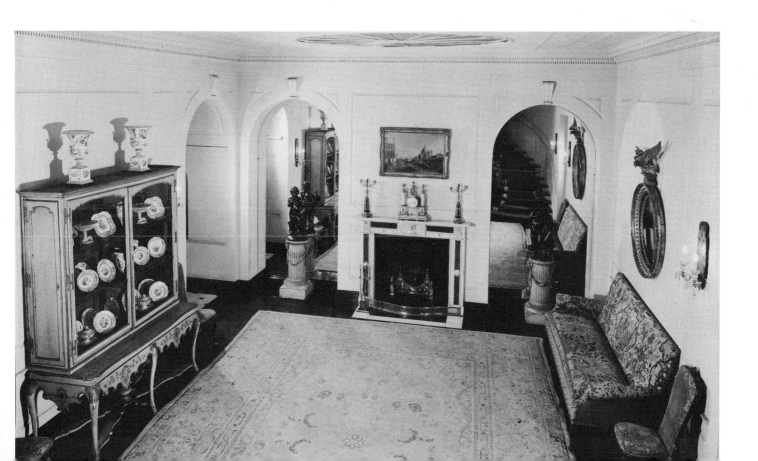

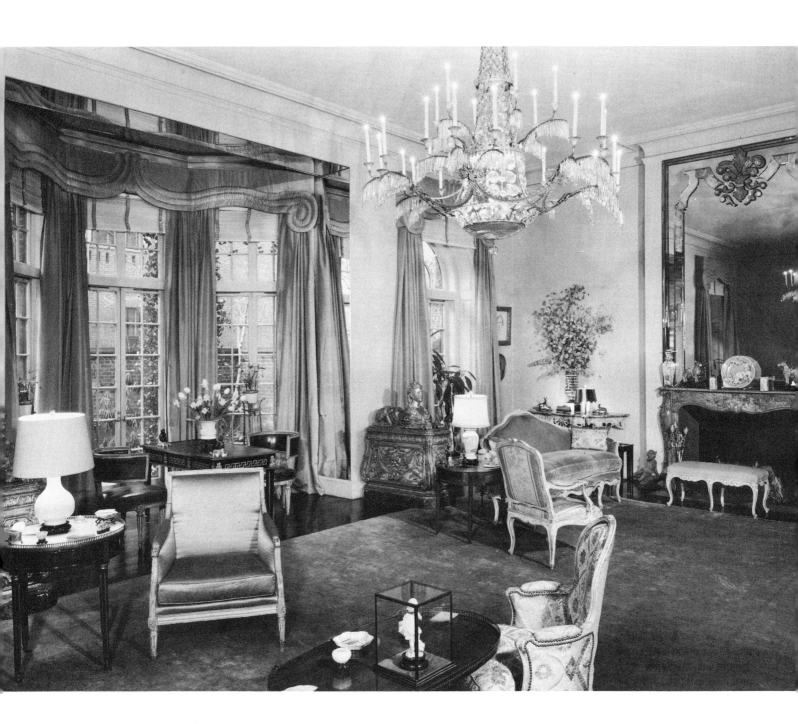

In the drawing room, walls, draperies, and carpeting in slightly varying tones of celadon green provide a tranquil background for furniture and decorations mainly of the Louis XV and Louis XVI periods; painted chair and canapé frames and upholstery fabrics add accents of rose, beige, rust, and gray. In the window embrasure — the small formal garden lies beyond — a Louis XVI ebony and *bronze-doré* writing table signed IDUBOIS (the mark used by Jacques du Bois, 1693-1763, and his son René, 1737-1799) is flanked by rare "tub" chairs of the same period in oyster-white painted wood and brown leather. The two Régence carved and gilded wood sphinxes on gilded and marbleized wood plinths were apparently done as portraits: the faces are quite different from each other. Examples from the Patersons' extensive collections of Chinese porcelains and Chinese and French bibelots appear on mantel and tables. The lamps are all Chinese porcelain, mostly *famille verte*, and there are additional pieces on the fine French carved gray marble mantel. The striking gilt and crystal chandelier is English; it may have been intended for the Russian market.

Other English pieces in the drawing room share the chandelier's un-English air. The small table at the left, for instance, is very much in the French taste, though it was made in England; its brass gallery and oval shape relate it closely to the *bouillotte* table (one of a pair) on the right. The gilt and crystal sconces, which appear to be almost *en suite* with the chandelier, were made in England, early nineteenth century. Painted polychrome decoration, a rare survival, lightens the carving in the frieze of the long (sixteen-foot) English oak table and gives it a gaiety quite unexpected in a sixteenth-century piece. The porcelain on it is K'ang Hsi *famille verte*. The fine Brussels tapestry with its luxuriantly detailed border is one of three in this room from a set of six depicting the Biblical story of Jacob; they are dated 1575 and signed with the monogram CT for the master weaver Corneille Tseraerts.

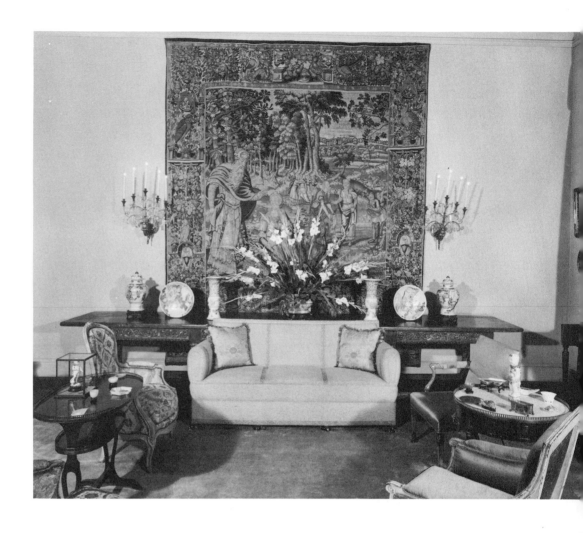

French furniture of the periods represented in the drawing room is notable for its adaptability to congenial arrangements. This group includes one of the most important pieces in the collection, an elaborately carved and painted Louis XV marble-topped console; it is one of a pair (the other is at the left of the mantel) believed to be from the atelier of Nicolas Pineau (1684-1754). Other important items are the Regency bronze and crystal vases on these consoles and the *bronze-doré* tables with marble tops on either side of the sofa. The needlework pictures represent in silk and gold scenes from the story of the Prodigal Son, and are part of a set of four (French, eighteenth century). The bronze plaque is one of a pair by Clodion (or Claude Michel, 1748-1814).

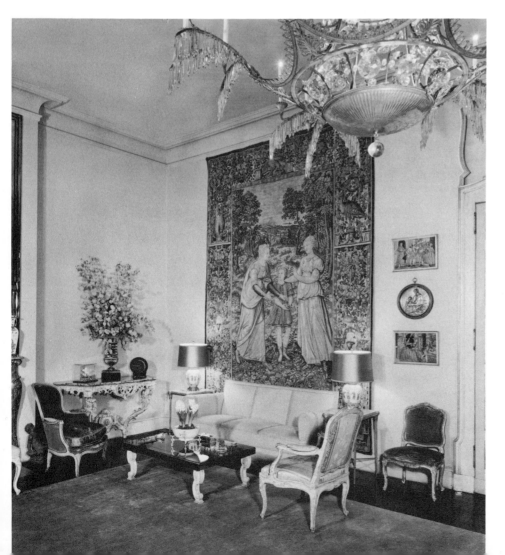

19

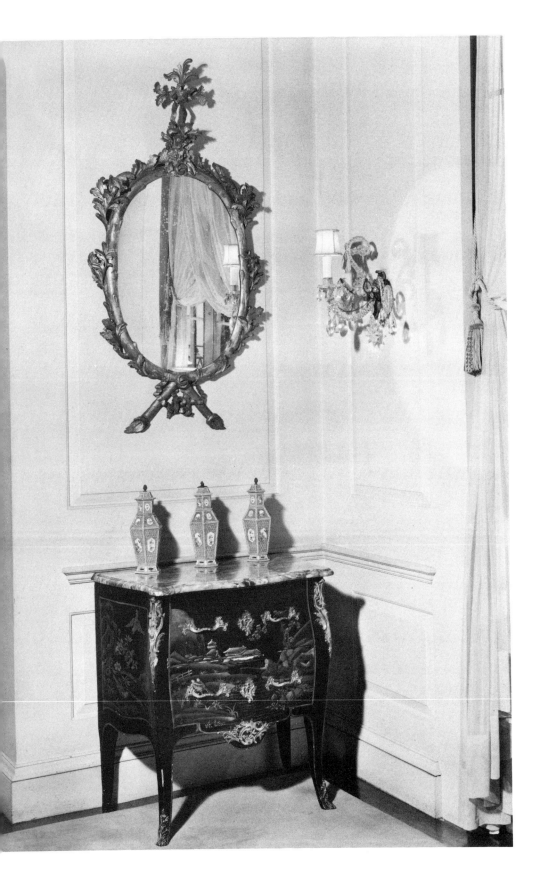

A group in pleasantly small scale in the upper hall is composed of an English gilt looking glass (one of a pair) of the early eighteenth century, with exceptionally deep carving in the leaf-and-branch frame; a Louis XV *bombé* commode of black and gold lacquer with marble top and *bronze-doré* mounts; and one of a pair of English eighteenth-century crystal single-arm sconces. Louis XVI *bronze-doré* pineapple finials top the *famille rose* jars on the commode.

Facing page.

An English Chippendale secretary-bookcase of finely carved mahogany in the library has its date (1761) incised in the center panel below the glass doors. The ceramic pieces here were selected to suit a catholic taste and include Spanish pottery, a pair of early Staffordshire lions, Meissen figures, China Trade casters, a Longton Hall teapot, and Worcester plates. Most unusual is the covering of the early Georgian desk chair — leather dyed to simulate tortoise shell.

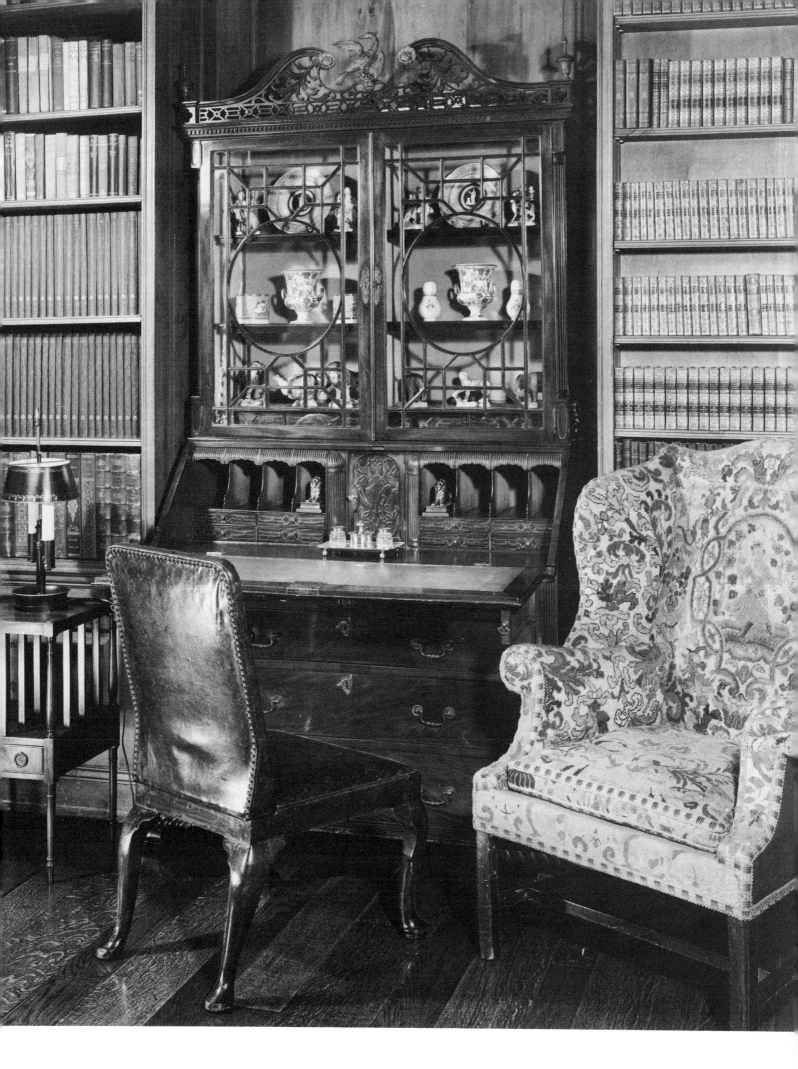

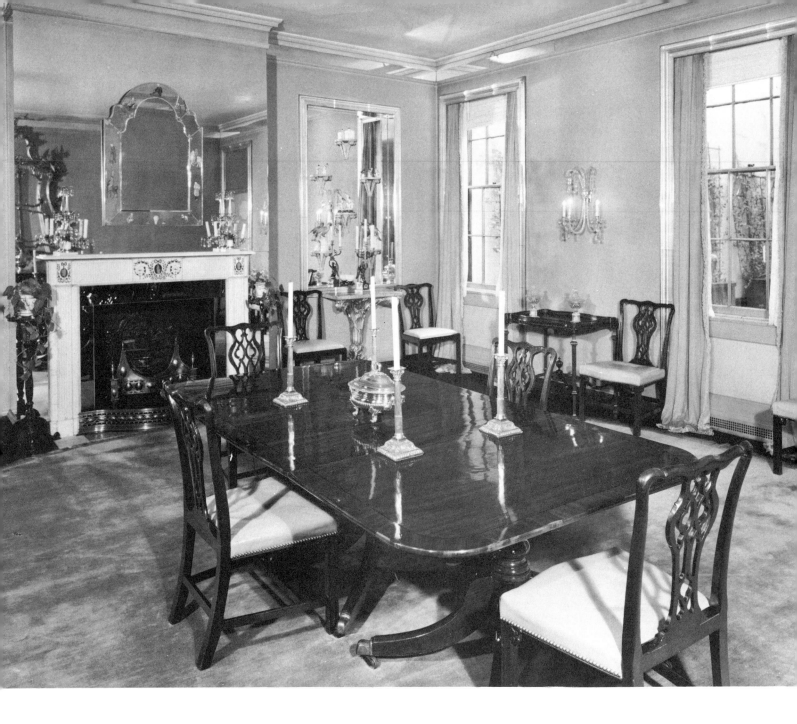

In the dining room subtly blending shades of gray and yellow are an effective foil for the dark glow of mahogany; through the windows may be glimpsed the green of growing things in the patio. In this room, too, mirrors are used in unusual ways: in the moldings framing windows and wall mirror, and as a background for the arch-top looking glass with polychrome chinoiserie figures over the mantel. The mantel itself is of the Bossi type, white marble with polychrome inlay. The candelabra are of marble, gilt, crystal, and Bristol rose glass, made in England but perhaps, like the drawing-room chandelier, designed for the Russian market. On the Sheraton three-pedestal table with cross-banded edge are an eighteenth-century Irish silver tureen and English silver candlesticks of the same period. Of the sixteen matching English Chippendale chairs ten have saddle seats, six slip seats.

In this surprisingly happy juxtaposition of delicate contours and exuberant carving, both the Sheraton sideboard and the gilt Chinese Chippendale looking glass are English, though the latter has all the extravagance of the French rococo. Its carving is amusingly — and typically — out of scale: a hound on the left is larger than the deer on the right, and the birds at the top are bigger than either. The sideboard has patera and line inlay and lion-mask-and-ring handles. The China Trade bowl rests on a Georgian silver dish cross, and the English candlesticks are of silver gilt.

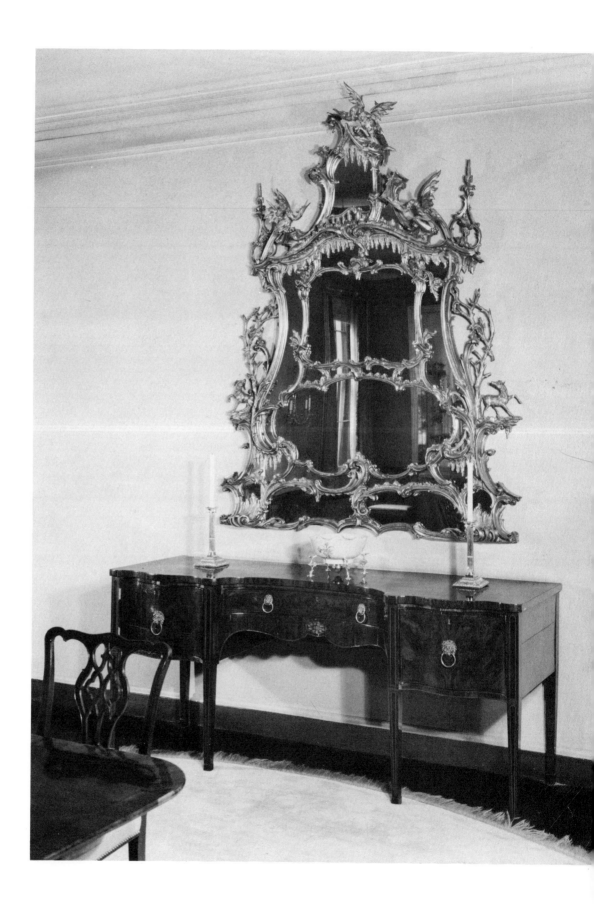

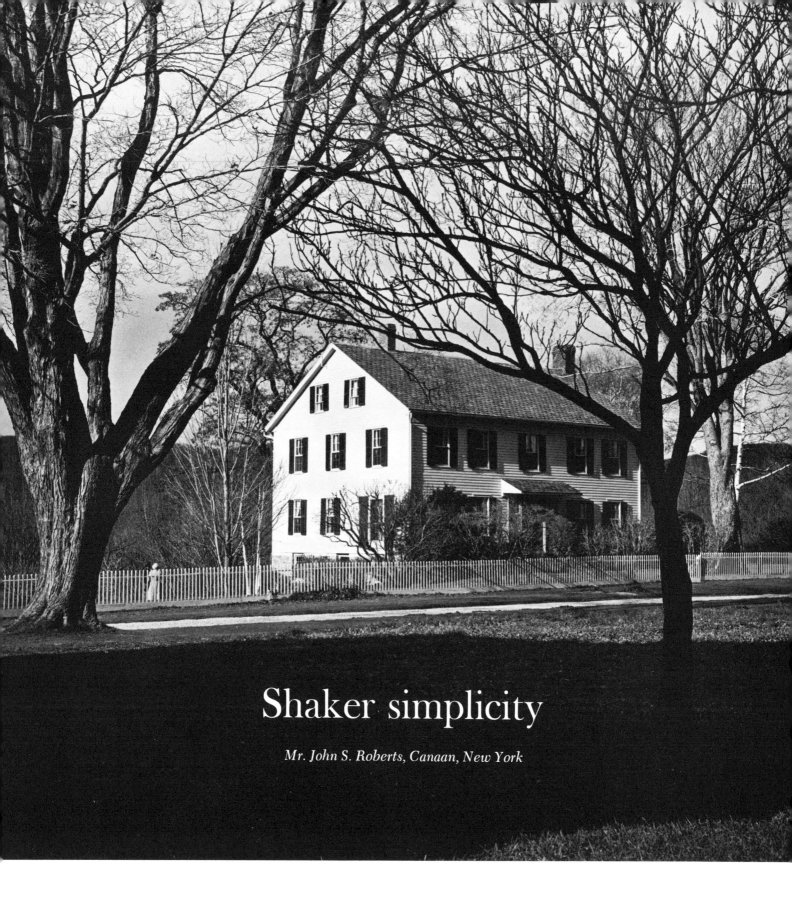

Shaker simplicity

Mr. John S. Roberts, Canaan, New York

The house was originally the sisters' shop of the Canaan (New York) Upper family of Shakers. The hooded doorway is a distinguishing feature of Shaker architecture. Sliding doors, painted a warm yellow-brown, close off the entry to provide protection in inclement weather. To the north are a flagstone terrace and a sunken garden whose walls and brick arches once formed the foundation of the family dwelling, and beyond this a young apple orchard. To the east are open fields reaching up to mountain woodland. *Photographs by William H. Tague.*

In December 1813 eleven Shakers gathered at Canaan, in eastern New York State, on what was called the Patterson farm, situated about two miles from the North or Novitiate family of the central Shaker community in New Lebanon. The year following they moved to the Mill House, near a gristmill a half mile from that family; then seven years later, on May 9, 1821, they moved again to another farm, the so-called Peabody place, where the colony, now numbering thirteen brethren and fourteen sisters, formed what came to be known as the Canaan Upper family. Here, in a clearing in a fold of the Taconic Mountains, they developed a largely self-sufficient religious order, chiefly agricultural but with a number of shops for industries based on the soil.

After this secluded little community of believers disbanded in 1897, the buildings stood unoccupied for a number of years. The property was eventually purchased by Laura Langford, well-known feminist, author, and one of the editors of the *Brooklyn Eagle*, whose interest in Shaker principles had been stimulated by an intimate correspondence with Eldress Anna White of the New Lebanon North family. In 1931, after Mrs. Langford's death, the property was bought by Mr. and Mrs. John Roberts, also of Brooklyn, who made it their summer home. Though some of the buildings, including the family dwelling, were by that time in bad condition, two of them — the sisters' shop, built in 1854, and another frame structure — were restored for the use of the owners and a caretaker. An 1842 barn and wagon shed were also preserved, and the foundations of the razed buildings converted into flower, herb, and vegetable gardens.

Restoration of the sisters' shop was carried out, over a number of years, by Mr. Roberts and the late Mrs. Roberts. Being near the New Lebanon community, they found guidance, as well as furnishings, in the still existent families there, not only the North (of which the Canaan Shakers had once been a branch) but also the Church, Second, and South families. Eldress Sarah Collins of the South family took a particular interest in the project, and from her Mr. and Mrs. Roberts obtained rugs and many fine pieces of furniture.

Restoration was carried out with restraint and exquisite taste. Shaker furnishings were selected with discrimination. The pine floors, door and window frames, pegboards, built-in drawers and cupboards, and other woodwork were carefully cleaned down and waxed to a soft brown sheen. Most important of all, the true Shaker spirit — the gift of order and simplicity — imbues the rooms with a quiet grace. Since there is nothing superfluous or useless in them, the warm-toned furniture, the rugs and runners, the draperies, the paneling above the fireplace, the books — all show to best advantage. Spacious and bathed in light, the rooms are colorful yet serene, a happy abiding place nestling in the hills.

A bell in an inner entry
is rung by pulling a cord
in the outer entry.

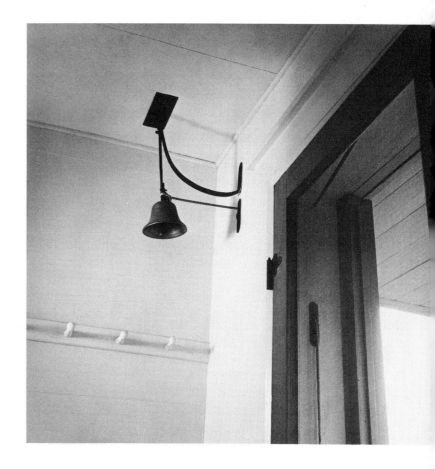

25

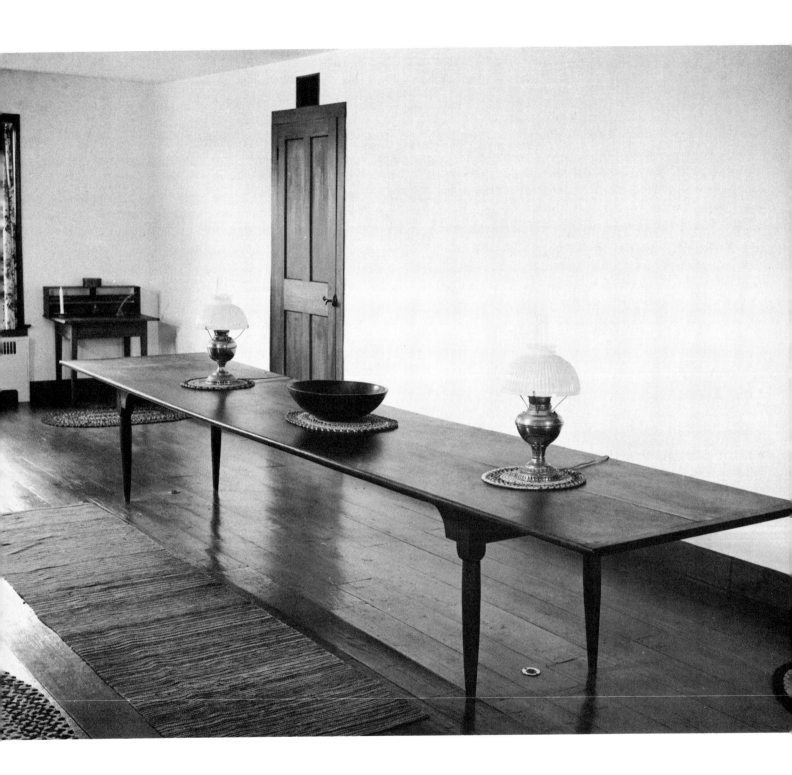

A partition was removed to give length to the living room, which is 17 feet wide and 34 feet long. The pine and maple table (14 feet long, 34 inches wide, and 27 inches high) came from a shop of the South family, New Lebanon. The carpet is home woven. No pictures were ever hung on Shaker walls.

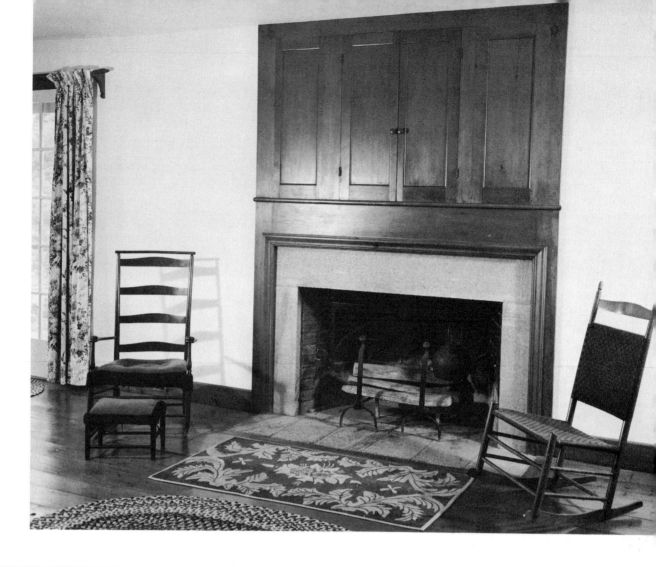

Besides the removal of a partition, the only other structural change was the installation of a 7½-foot-wide fireplace to replace the small box stoves of Shaker usage. Paneled cupboards, built into the wall above it, harmonize with the rest of the woodwork. The rocking chairs are "cushioned" with tape seats, and one has a tape back.

A favorite armchair, with the colorful tape seat characteristic of Shaker manufacture. The simple, clean lines of the candlestand are also typically Shaker. Both pieces came from New Lebanon. To insure a free circulation of air in Shaker houses, holes (in the form of pyramids) were often bored into the baseboards. In the Roberts house, delicately shaped swinging panels set into apertures above the interior doors serve the same function.

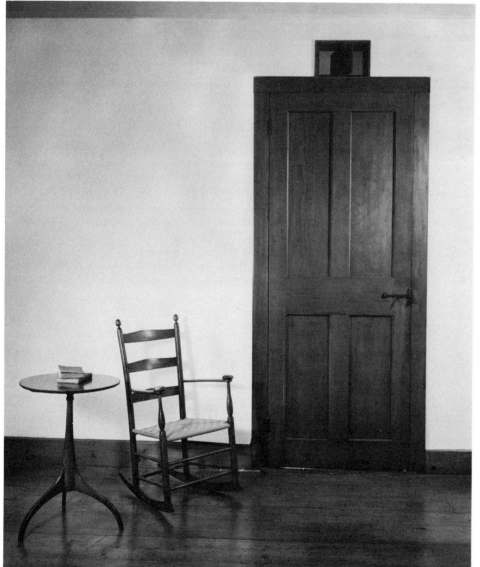

27

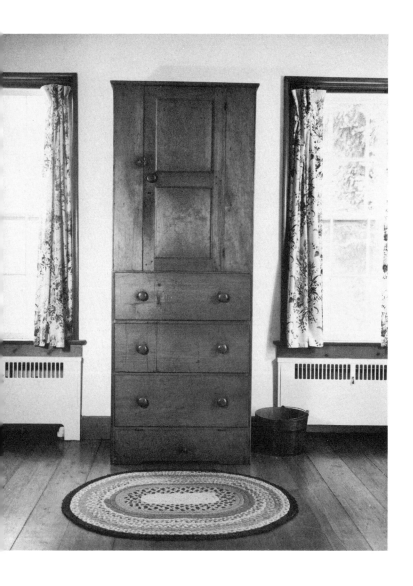

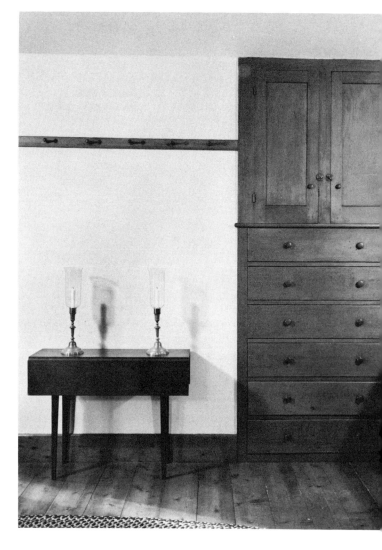

At one end of the living room is an early pine cupboard-case from New Lebanon, particularly interesting for the hinged dust board at the base. It is 79 inches high, 30 inches wide, and 18 inches deep. Floral draperies were not used by the Shakers but braided rugs were.

In the earliest Shaker houses and shops, drawers and cupboards were built into the walls as a means of saving space and promoting order and convenience. This pine unit, in the dining room, is 43 inches wide and a little over 8 feet high, the height of the room. Pegboards high on the wall served a similar purpose. The drop-leaf table is an early New Lebanon piece.

Striped rag carpeting covers the stairs that rise in a straight flight from floor to floor. The newel post is tapered and chamfered like the "pencil" posts of an early New England bed.

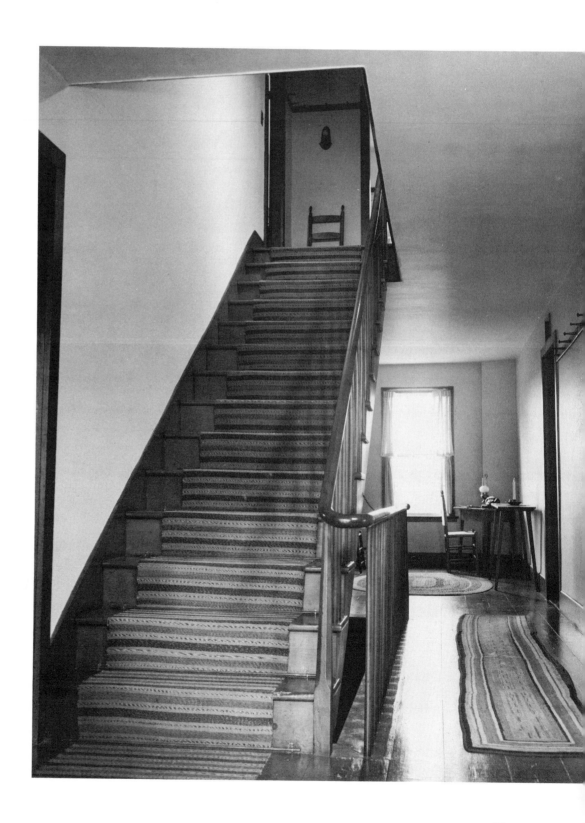

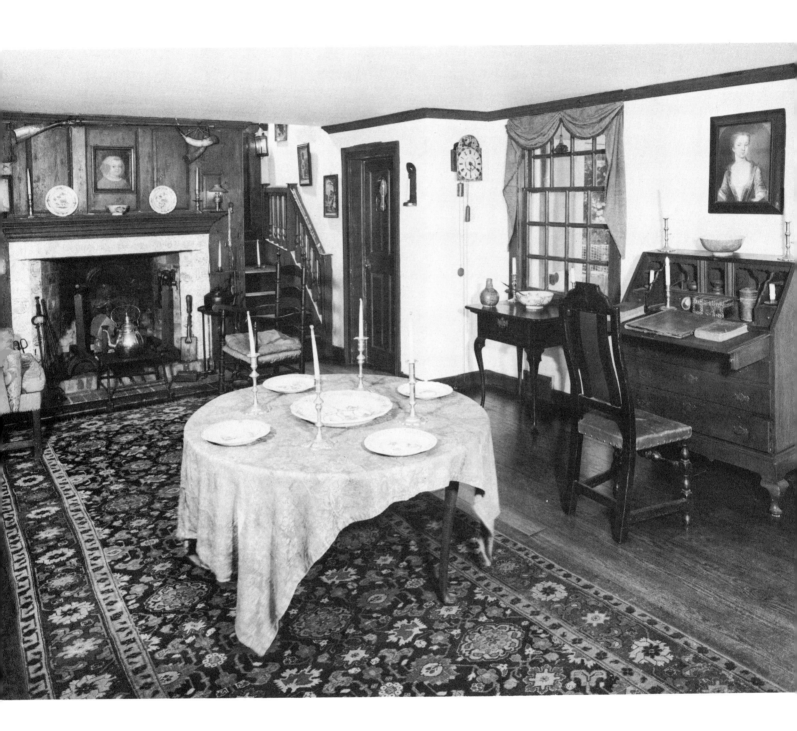

The front door opens on a broad hall furnished in the manner of the early eighteenth century, with furniture of American origin and varied decorations from this and many other parts of the world. Dutch tiles with Biblical scenes in purple frame the fireplace, and the pine-sheathed chimney breast and other woodwork are painted a dull brick red. Matching the curtains, which are skillfully draped with fringe and red tassel, old green silk damask covers the Queen Anne drop-leaf table in the center of the room; on it are contemporary brass candlesticks and a group of that rare English creamware decorated in Holland with portraits of members of the house of Orange (late 1700's). All sorts of small objects of the period add to the warmth and character of this room, from fireplace paraphernalia to skates hanging on the door; from the wag-on-the-wall clock to the varied candlesticks, lanterns, sconces, and lamps; from the writing equipment on the desk to the pastel portrait above it. *Photographs by Taylor and Dull.*

Heirlooms on Long Island's North Shore

Mr. and Mrs. Reginald P. Rose, Oyster Bay, New York

COLLECTING RUNS IN THE FAMILY of Mr. and Mrs. Reginald P. Rose of Oyster Bay, New York. They themselves are both enthusiastic collectors, and their sons, brought up among antiques, have shown collecting propensities since boyhood. Mrs. Rose's mother, Mrs. Harry Horton Benkard, was one of the distinguished group of American collectors who became active in the 1920's. And long before that Mrs. Rose's grandmother and great-grandmother had acquired American antiques, adding them to heirloom pieces that had been in the family since they were new. These several generations of collectors have contributed to the antiques that furnish the house illustrated here.

The major contribution was made by Mrs. Benkard, who acquired the pre-Revolutionary farmhouse in 1929, embellished and added to it, and lived in it until her death in 1945. She filled it with American antiques that reflected her sure knowledge and her discerning taste. After her death two rooms were removed from the house and installed, one in the Metropolitan Museum, the other in the Museum of the City of New York, as permanent memorials to a great collector. The other rooms remain substantially as she furnished them, with such changes and additions as Mr. and Mrs. Rose have made in the course of their own collecting, to suit their personal taste and pattern of living.

This room as it was during Mrs. Benkard's lifetime is now in the Metropolitan Museum's American Wing. Its woodwork, from Newburyport, Massachusetts, and the furnishings collected by Mrs. Benkard are of the Federal period; in replacing them Mr. and Mrs. Rose moved back a generation or two. The mid-century fireplace is painted dark gray and marbleized. Outstanding among the furniture, which is mostly of the Chippendale period, are the card table and the chairs drawn up to it; the Philadelphia armchair at the right of the fireplace; and the desk and corner chair, both of which originated on Long Island. Black and white ceramics give accent here and there — transfer-printed fireplace tiles, Worcester and China Trade porcelain, English creamware. Notable objects in brass are the andirons and pierced fender, the chandelier, sconces, and candlesticks, and a double snuffer holder on the desk.

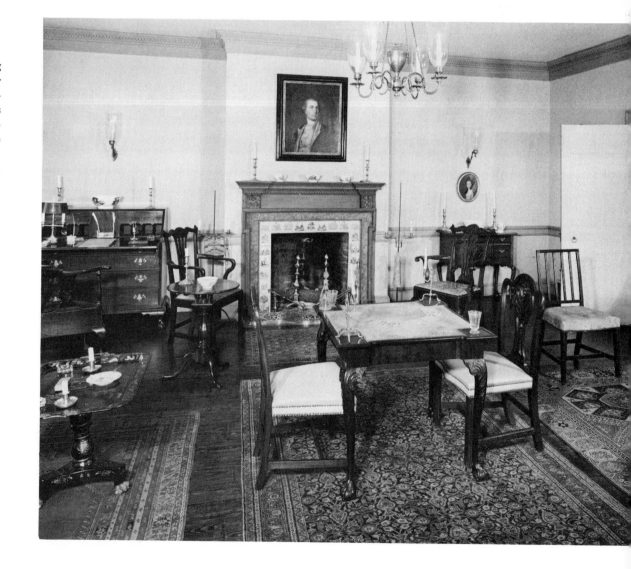

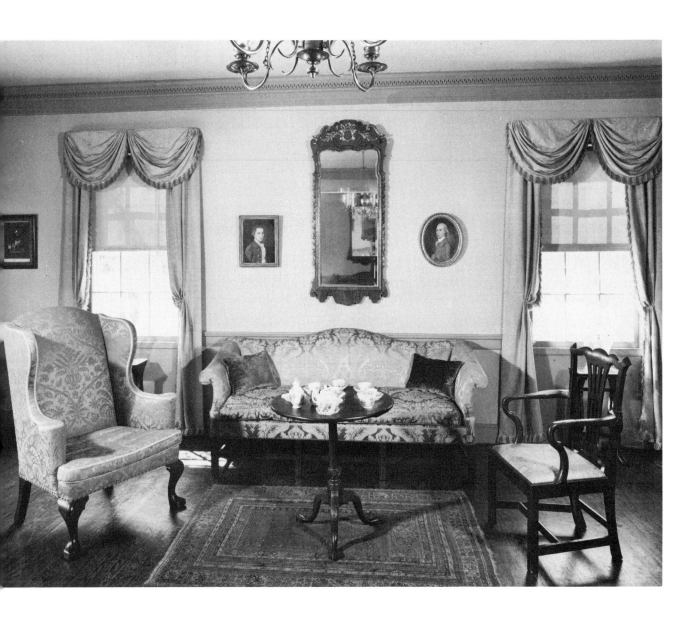

Another view in the drawing room emphasizes a New England tea table of elegant proportions and exceptional quality. The Worcester tea set is decorated in black with tea-drinking and similar scenes. The Queen Anne wing chair is a rare example with the thick pointed foot — a successful combination of club and slipper — which is a New York characteristic; it was found nearby on Long Island. Upholstery and curtains of yellow damask contrast with gray walls and woodwork.

This fine mahogany card table has lobed corners on the folding top, carved shell and husk on the knee, and the thick pointed New York foot. It was found on Long Island and dates about 1740-1750. Quite at home with this table are some of those "American" antiques from abroad: black-printed Worcester porcelain mugs, brass candlesticks from England or Holland, a Dutch brass tobacco box, a hurricane shade — one of a rare pair in frosted glass — from England or Ireland, and a tea box covered with painted paper from China.

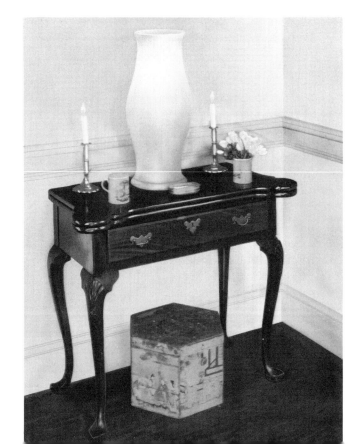

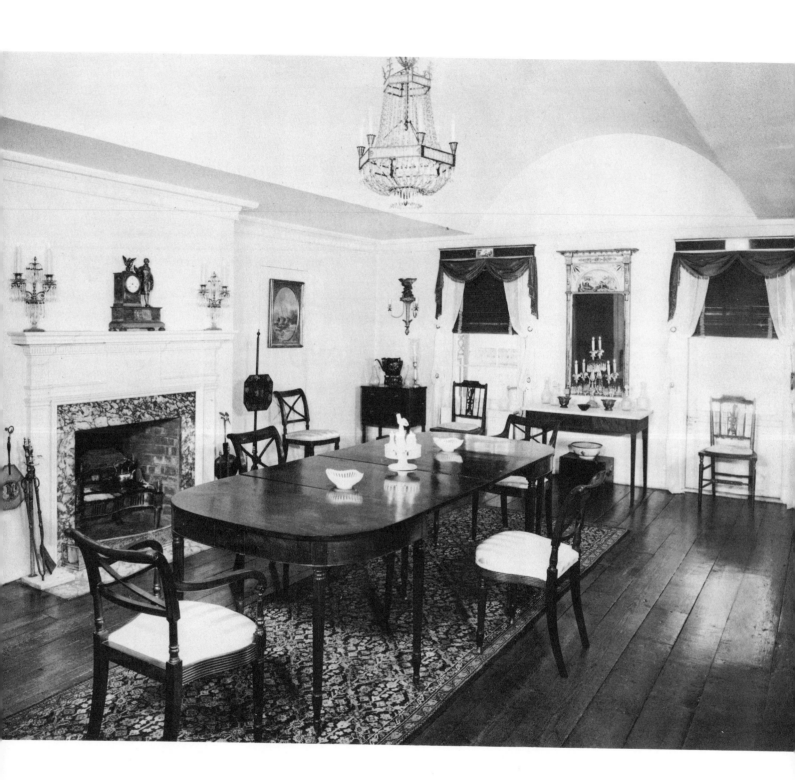

The Duncan Phyfe chairs in the dining room came down in Mrs. Benkard's family, and it was they that first kindled her interest in collecting American antiques. This room is as she furnished it, and recalls her love of Phyfe furniture — she was one of its first collectors and gave many important pieces to museums; her fine color sense — the room is mauve and white, with green curtains and accents of purple and gold; her knowledge of early window treatments — the stylish draperies here are based on historic precedent; and her originality — the vaulted ceiling was raised to give a sense of space to the long low room and accommodate the handsome French chandelier.

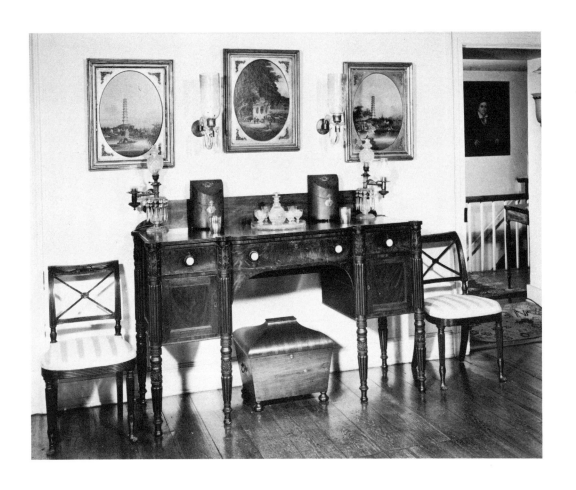

A sideboard in the dining room has the label of Duncan Phyfe affixed to the back of the center drawer, and was acquired by Mrs. Benkard as a Phyfe piece. Other students of furniture have, however, noted the similarity of the leaf carving with punchwork ground to the carving of Samuel McIntire, and of the leg turnings and pronounced reeding to Salem rather than New York work.

In the library is an unusual and graceful curved sofa made in Baltimore. The shelves of the New England secretary are filled with colorful China Trade porcelain. The lacquered serving stand is of about 1830; beside it is a whalebone swift for winding yarn. Here, as elsewhere in the house, are decorative objects varied in source yet fitting happily together.

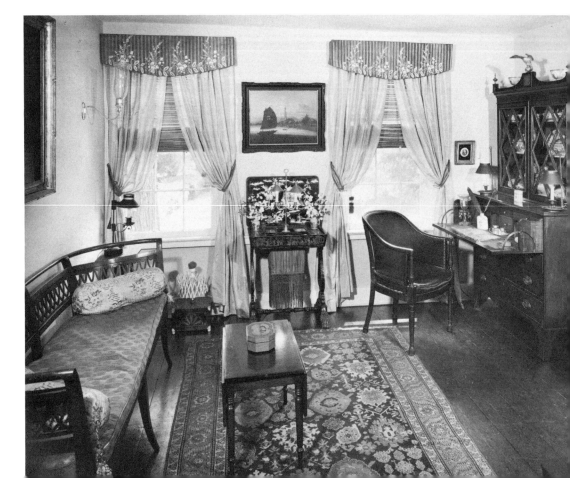

A long upper hall, painted cream with a wallpaper border, provides a gallery for colorful furniture, paintings, glass, ceramics, and wood carvings. Sheraton fancy chairs are painted red, gray, and white. Black and gold lacquer tables support unusual hurricane shades painted in colors. Hanging lanterns and candle-bracket shades are rarities in brilliant green. The portraits of two sisters are by the Albany painter Ezra Ames; that on the right is of Mrs. Rose's great-great-grandmother, Mrs. James King.

The unusual architectural features of this bedroom, with its plain white plaster and dark green woodwork, make it an unusually pleasing setting for early furniture. One chair is of walnut, caned and elaborately carved; the others are stiff banister-backs, painted brown or black. The day bed with its block-and-turned legs and straight stretchers dates close to 1700. The Sadler tiles at the fireplace are printed in green with scenes from Aesop's fables. A little copper tea kettle rests on the steel fender. Early engravings and delftware relieve the severity of the room.

Boldly patterned blue resist curtains the windows and the pencil-post bed in a room whose walls and woodwork are painted in sunny shades of yellow. The coverlet is white on one side and blue on the other, double-woven in an unusual technique to simulate elaborate quilting. The yoke-back turned chair to the left of the Connecticut wardrobe is a Long Island piece. Mr. Rose is particularly proud of the Lambeth delft plate on the mantel decorated with his own initials and the date 1725.

New England farmhouse on the Ohio

Mr. and Mrs. Richard W. Barrett, Cincinnati, Ohio

ONE OF THE OLDEST houses in Ohio came, like many of the early settlers of the Northwest Territory, from Connecticut. Built in Watertown some time before Cincinnati was founded in 1788, this venerable New Englander was moved there in 1953 by Mr. and Mrs. Richard W. Barrett.

The greatest care has been taken to retain the character of the old house. Over two hundred photographs recorded the dismantling process, and every piece was carefully numbered for reassembly; only the stairway was shipped in one piece. Stone steps, hearths, and brick for the fireplaces were all carefully preserved, and all eight fireplaces were rebuilt. Every room has its original paneling or wainscoting, and all the paint colors used,

which are strong ones, were found on the woodwork. The frame of the house is oak, pegged together, and the paneling, flooring, and trim are pine. The original siding was used, painted ocher with white trim as it had been in the eighteenth century. A new wing, built to conform to the old house, incorporates a room end from another eighteenth-century New England house.

The Barretts' early New England furniture is completely at home in the paneled rooms. A great deal of attention has been given to decorative detail throughout the house; appropriate lighting fixtures of the seventeenth and eighteenth century are used, as well as silver, brass, and pewter, English and American ceramics of the same period, and Oriental rugs of suitable age and type.

The library has paneled wainscoting similar to the paneled fireplace wall, which embodies original cupboards. It is painted a strong mustard yellow, with a dark mulberry baseboard. The curly maple desk, with its delicate pad feet, is mid-eighteenth century. Also of curly maple is the small table under the window which has a shaped apron and tapering splayed legs ending in pad feet. An early maple windsor provides greater comfort than the cane-seated chair by the desk (c. 1730), in which the banisters of the back present their turnings instead of flat surfaces to the back of the sitter. On the desk are two bell-metal candlesticks and a Bristol delft crocus brick. The plaster plaques on the wall above are of Princess Charlotte and George III, cast and painted at the time of their marriage in 1761. *Photographs by Kazik Pazovski.*

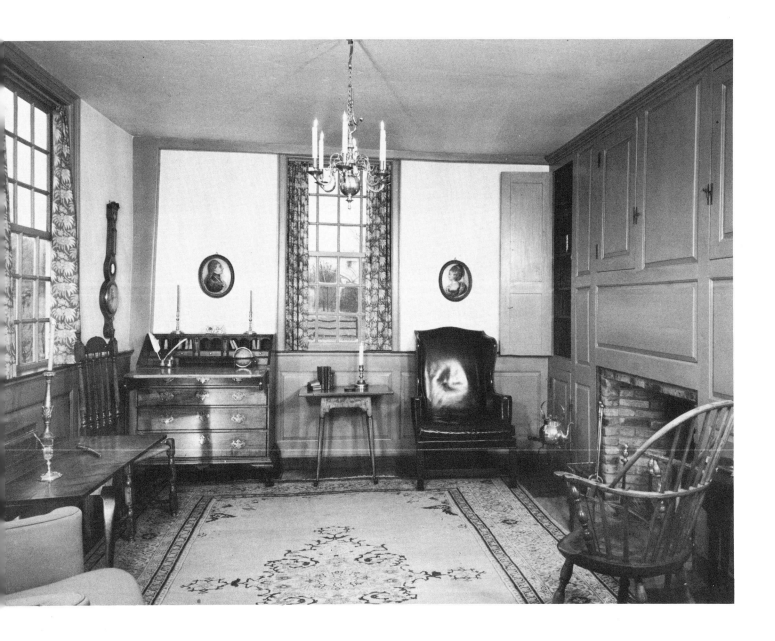

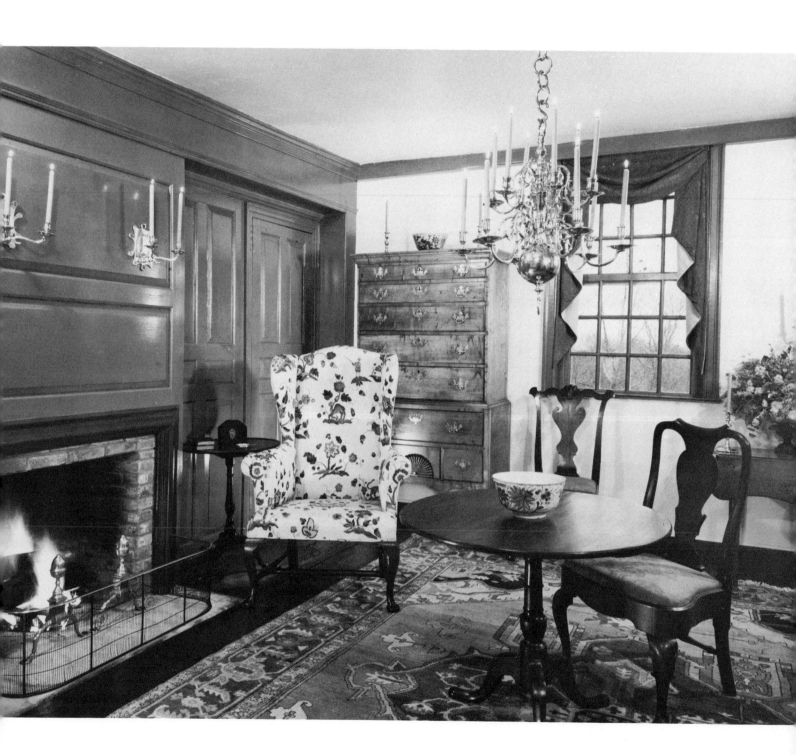

The parlor, which contains some of the more elegant furnishings, is painted olive green, and the mulberry color of the baseboard is carried around the bolection molding that frames the fireplace. The walnut and maple Queen Anne wing chair is a fine Rhode Island piece; of the same period is the small walnut dish-top table beside it. Against the wall stands a New Hampshire flat-top highboy with carved sunburst on the center bottom drawer. A walnut Philadelphia Chippendale chair with shell cresting and drake feet stands under the window beside a pembroke table with scalloped leaves. The mahogany tilt-top table in the center of the room and the Queen Anne compass-seat chair are English. The matching Lambeth delft bowls (c. 1710) on the table and on the are an unusual early pair. Sconces, chandelier, and 1760) are of brass.

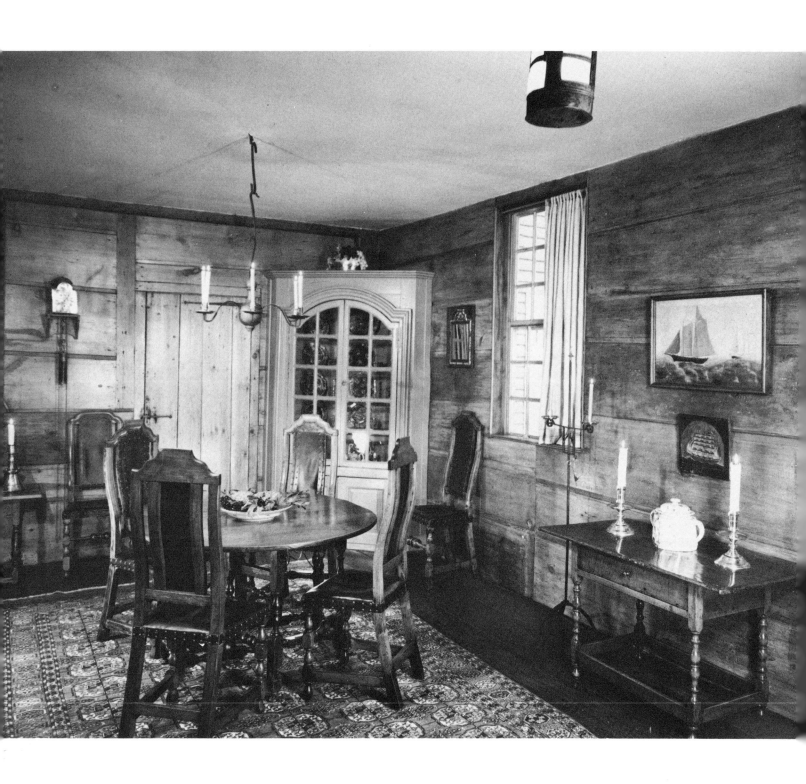

Facing page.

Some of the Barretts' earliest pieces are in the dining room, where the feather-edge pine sheathing has its original beeswax finish. A maple gate-leg table has vase-and-ring turnings on legs and stretchers. Drawn up around it are leather-upholstered maple chairs whose bold turnings and crests are reminiscent of the William and Mary style while Queen Anne influence is apparent in the curve of the backs. Two early tavern tables with plain box stretchers and turned legs are also of maple. A Bristol delft polychrome posset pot and a pair of brass mid-drip-pan candlesticks adorn the larger of these, and a collection of tortoise-shell Whieldon and agateware fills an eighteenth-century corner cupboard which comes from another Connecticut house; on the wall beside it a so-called courting mirror hangs in its box. The seventeenth-century brass lantern clock is English. Soft shades of red predominate in the Bukhara rug.

On the opposite wall of the dining room early pine hanging shelves are bright with marked American pewter and three colorful delft plates. The small butterfly table is of curly maple; the well-turned slat-back chair (c. 1710) beside it retains its original blue paint. The bedroom seen through the doorway has marbleized paneling. A walnut and gesso mirror of Connecticut origin (1720-1740) hangs on the far wall above a prim country wing chair; the early candlestand is of wrought iron.

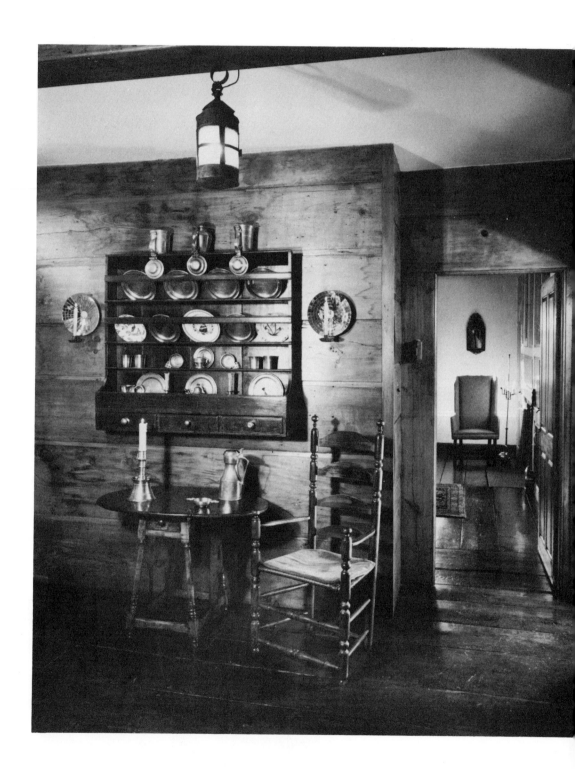

41

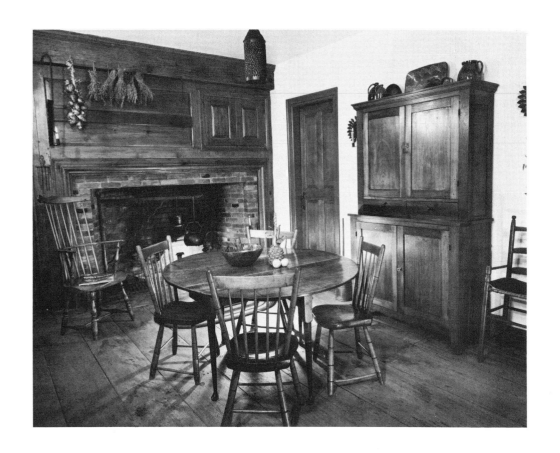

The kitchen, which is in the new wing, has an old room end from Danvers, Massachusetts; this paneling is unpainted, while the door trim is brick red. The wide fireplace is fitted with iron crane and kettles and scroll-top andirons, and simple country pieces from New England and Virginia furnish the room. The round drop-leaf table with tapering legs and pad feet is of maple, as is the eighteenth-century comb-back windsor arm-chair beside the fireplace. The other windsors, stiffer and heavier, are of the nineteenth century. On top of the walnut cupboard, early Connecticut pottery and Pennsylvania redware add a note of color. Sunflower sconces and pierced lantern are of tin.

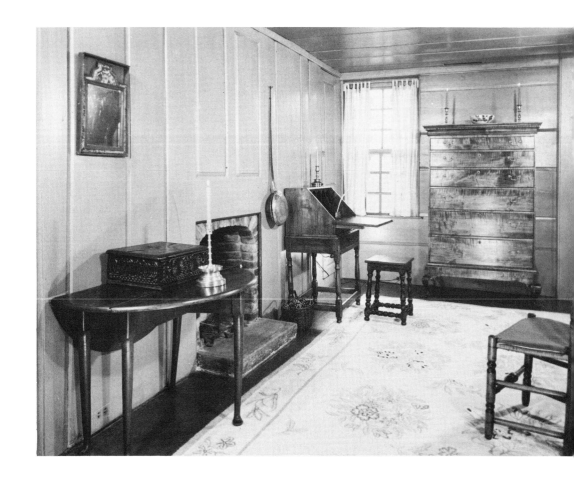

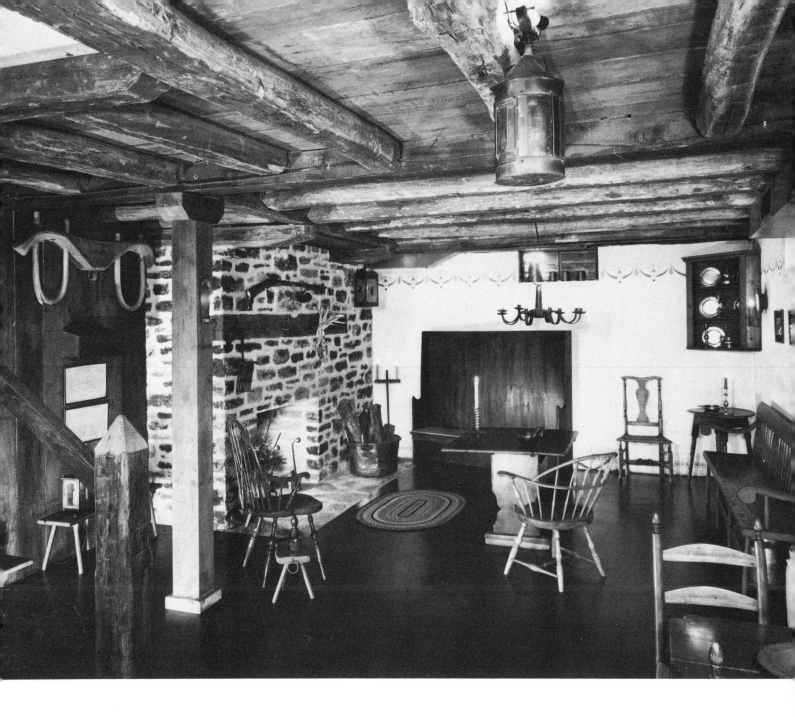

A hospitable tavern room has been created in the basement by means of stenciled walls, stone fireplace, and heavy beamed ceiling. The high-back pine settle has its original red paint; so does the Rhode Island windsor armchair by the fireplace. Also from New England are the trestle-foot hutch table, the oval splay-leg table in the corner, and the "Dutch-type" transitional chair beside it. Old lanterns, ox yoke, fire bucket, and Kentucky rifle contribute to the informal atmosphere.

Facing page.

A bedroom has pine sheathing, painted gray-green, on all walls and also on the ceiling. Against the paneled fireplace wall is an early maple desk-on-frame and a Queen Anne drop-leaf table which holds a carved Bible box and a seventeenth-century brass candlestick. The tiger-maple chest-on-frame with dentil molding in the cornice and the banister-back chair are New England pieces, as is the turned cherry joint stool.

Cosmopolitan collection in Connecticut

Mr. J. A. Lloyd Hyde, Old Lyme, Connecticut

DUCK CREEK, the country house of J. A. Lloyd Hyde at Old Lyme, Connecticut, is a very improbable but very practical house. Designed, built, and furnished over twenty years ago by a young Norwegian with no special training, the late Arvid O. Knudsen, it brings under one New England roof elements from all over the world. The entrance front suggests Tidewater Virginia. The terrace front with its long windows resembles a French pavilion, overlooking the clipped cypress bushes and classic white marble urns of a green and white formal garden leading to a swimming pool. The brick of the walls and the slate of the roof came from an old post office in nearby New London, torn down in 1939; most of the woodwork too had been used before.

Inside, the house is a highly successful potpourri of antique French paneling and parquet floors, Italian marble, Chinese and French wallpapers, Thai and Chinese silks, Chinese and French porcelains, and French and English furniture. Throughout the house the lighting simulates the old as closely as possible, through the use of antique chandeliers, sconces, and candlesticks equipped with candle-like bulbs, and in each room all fixtures are turned on by one switch. Today, when so much building is standardized and so much furnishing unimaginative, a house like Duck Creek is very refreshing.

The entrance hall gives the visitor a bright and colorful greeting. Its early nineteenth-century French wallpaper is block-printed in a series of sporting scenes, and a *cor de chasse* and coaching horn of brass hanging over the doorway introduce a motif that is repeated elsewhere in the house. The handsome ormolu lantern is typical of its Louis XVI period. The only furniture is a French marble console with boldly carved supports, of the same era, and a pair of Louis Philippe square upholstered stools with matching long bench which came from the promenade of a theater in France. *Photographs by Taylor and Dull.*

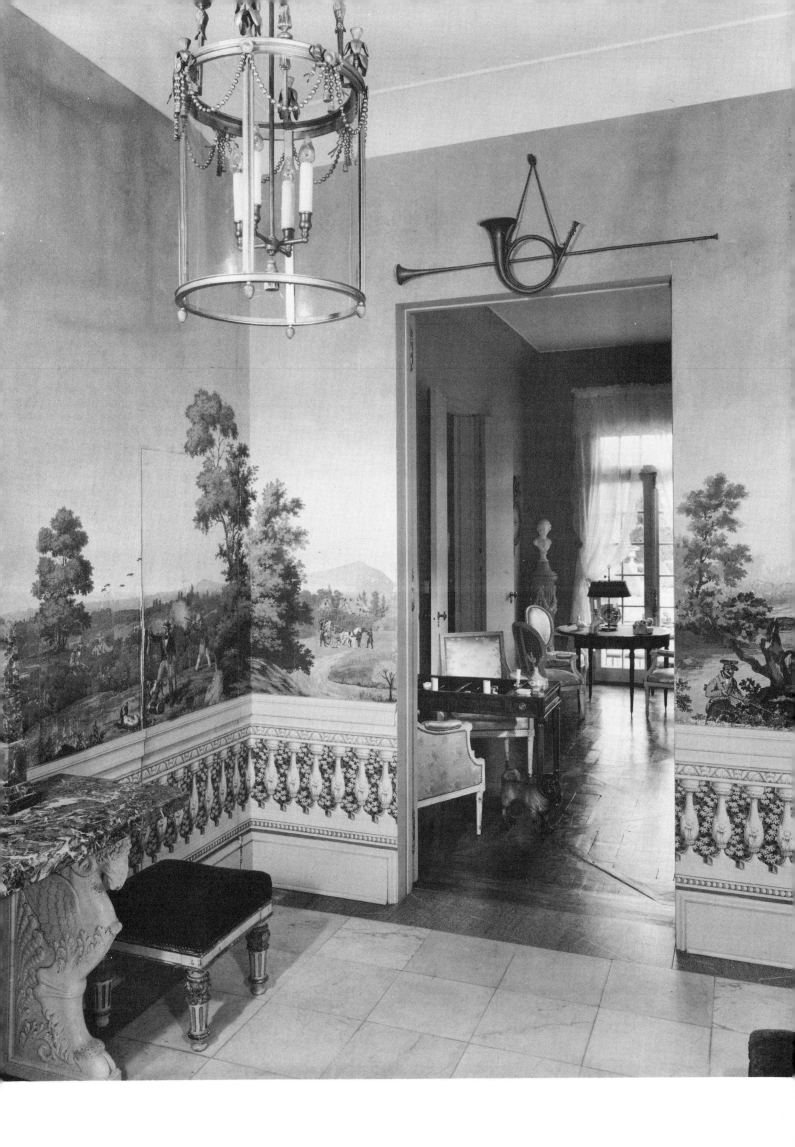

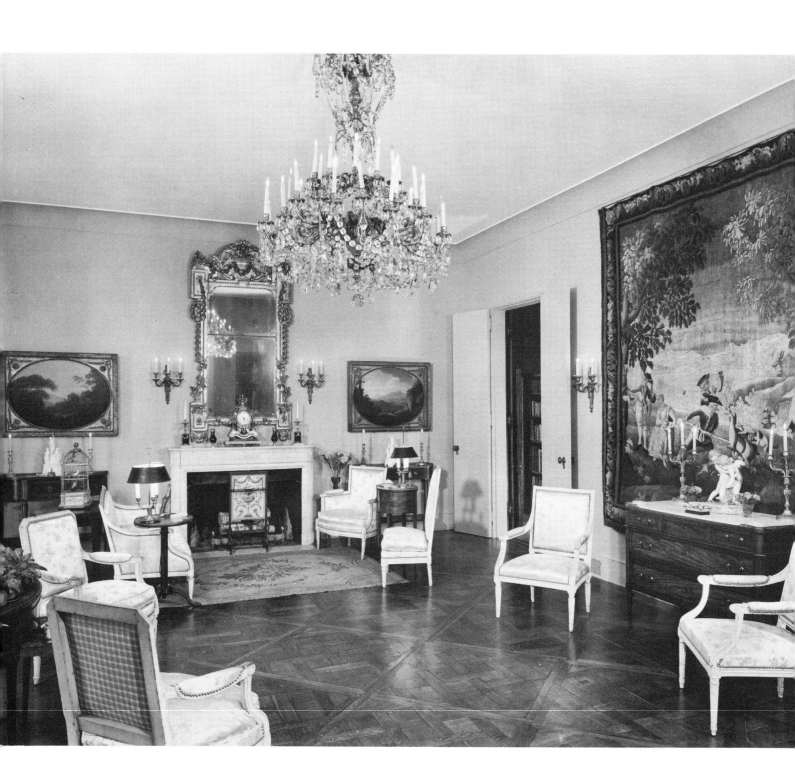

Facing page.

The living room has pale gray-blue walls, and the color is repeated in the brocade upholstery. The room is of generous proportions, thirty by twenty feet, with a twelve-foot ceiling, a handsome background for neoclassic furnishings. Over the white marble mantel is a Louis XVI mirror believed to have come from the Palace of Versailles, and the early eighteenth-century oak parquet floor was found in Fontainebleau. The Louis XVI chairs and sofa are painted white in what is known as the *Gustaviansk* manner, a fashion much favored by Scandinavians, and their backs are covered with a checked linen in accordance with French eighteenth-century custom. Flanking the mantel are two landscapes painted by Richard Wilson in his Italian period and in their original Adam gilt frames. The Aubusson tapestry is *La Chasse de Louis XV*. All the lighting fixtures and door hardware here are gilded.

An arrangement in one corner of the living room is a reminder of the eighteenth-century fondness for gaming. The Louis XVI table for *trictrac*, or backgammon, has the pattern of the board inlaid in ebony and ivory, and adjustable silver candle holders for late hours. Above it hangs the portrait of a little Iberian boy, painted probably by a pupil of Goya. The never-aging pug dog (English or German porcelain) was found in Copenhagen.

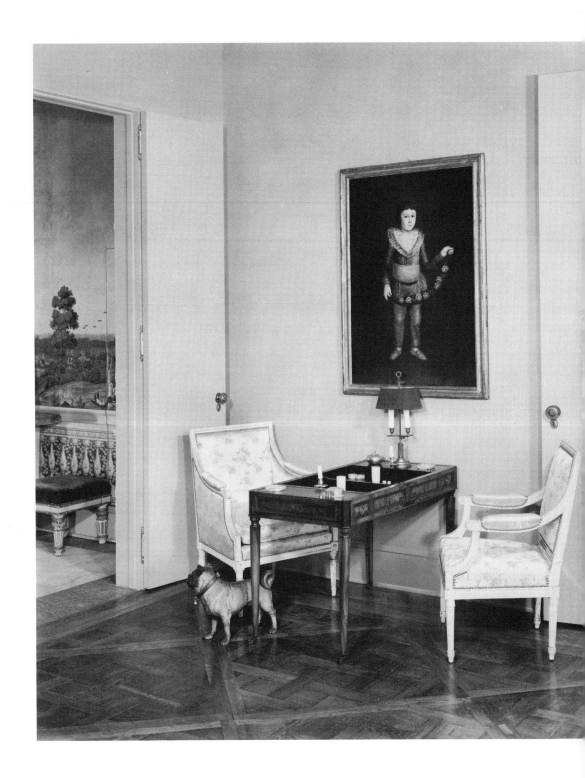

47

This corner of the *salon*, in its summer dress, shows one of the French windows hung with *rideaux à tambour* (embroidered muslin curtains) of the first quarter of the nineteenth century. The plain mahogany desk and table, relying on brass strips for ornament, and the practical, well-designed chairs are good examples of the simple late Louis XVI style. On the card table, which is permanently in place for handy use, are grouped animal figures and a plate from the owner's collection of China Trade porcelain; and in the center is a *lampe à bouillotte*, a shaded candelabrum which takes its name from the game played by its light in eighteenth-century France.

Color plate, facing page.

In the library the provincial chestnut paneling (c. 1770) from the region of Bordeaux is set off by red Thai silk curtains. Books, faïence, provincial Louis XV furniture, flowers, and a much-used fireplace make this a sympathetic and livable room. Above the wood mantel, which is painted to simulate marble, is a severe Louis XVI looking glass that belonged to the first French consul in New York. More sophisticated is the marquetry *secrétaire à abattant,* a transitional Louis XV-Louis XVI piece. The two large paintings above it are Portuguese (c. 1770), from a series of six in the room illustrating the parable of the Prodigal Son. The Louis XVI chandelier and sconces are of carved and gilded wood. Also of wood, carved and painted, are the shepherd and shepherdess on the mantel, once models for Chelsea porcelain figures.

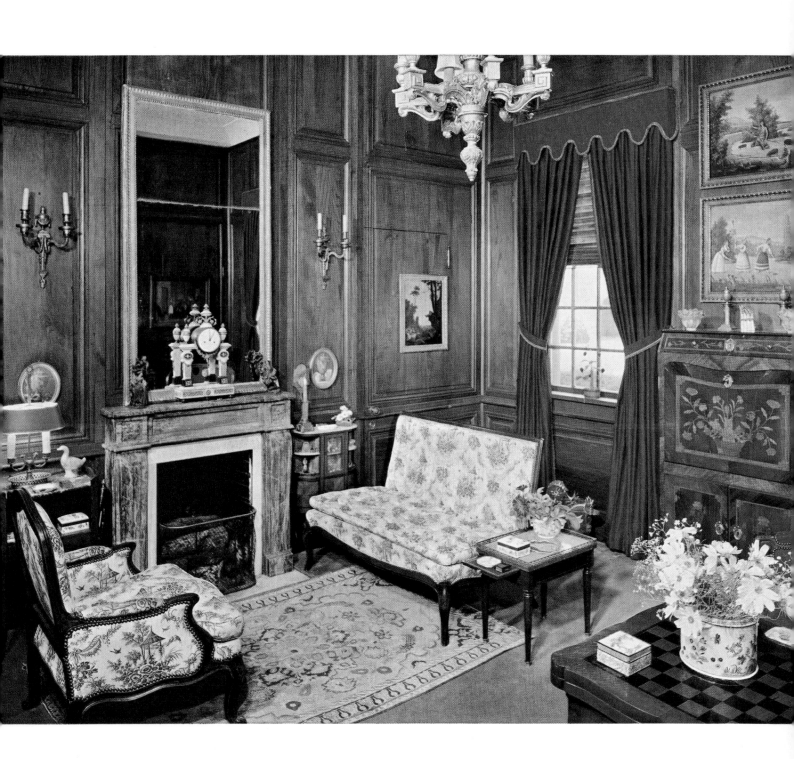

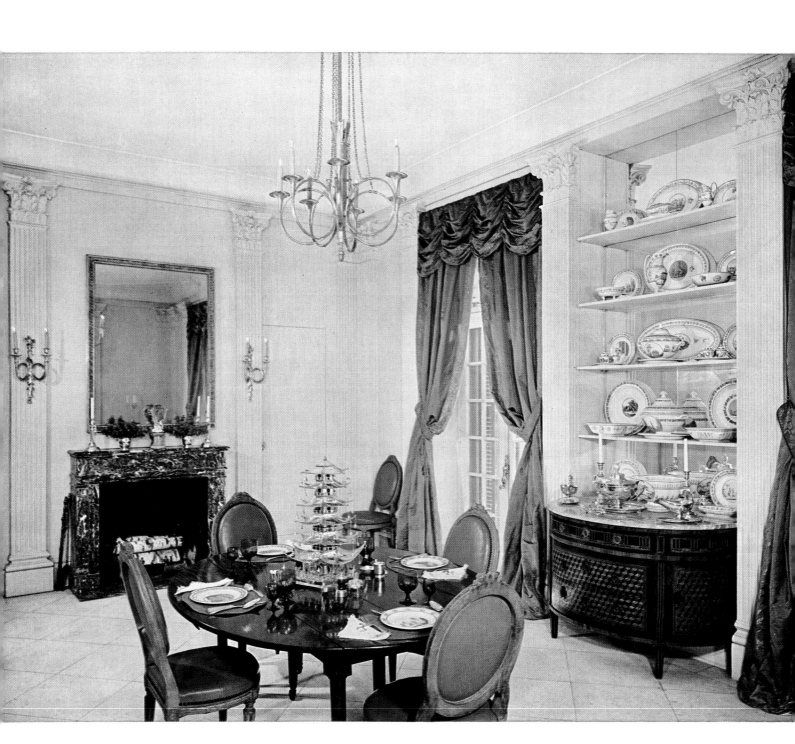

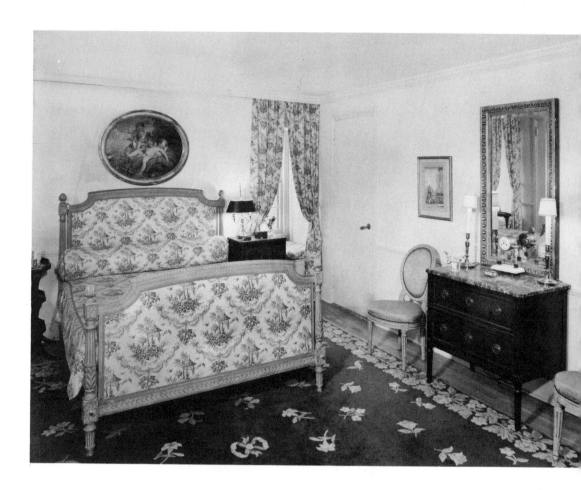

The dining room is an example of pure Louis XVI classicism, the antithesis of earlier, rococo styles. Measuring twenty-three by eighteen feet, the room is a French gray with a red marble mantel and a matching sideboard-console (not shown). The white Carrara marble floor came from an old house on Fifth Avenue in New York, and the carved Corinthian pilasters from Winterthur in Delaware. The hunting-horn motif of the front hall reappears here in the chandelier and wall lights, which, with all the door hardware of this room, are silvered. The antique green satin curtains once belonged to the Misses Hewitt, known for their benefactions to the Cooper Union Museum in New York; and the overmantel mirror in silver leaf was part of the furniture of the Duchesse d'Angoulême, daughter of Louis XVI. Creil earthenware transfer-printed in black, a well-known French product of the early 1800's, fills the shelves and is used for table service. The silver is French Directoire, with the exception of the elaborately fanciful pagoda centerpiece on the table. This is of Sheffield plate, made about 1800.

The French believe in comfort as well as style; this wide Louis XVI bed in the guest room has both. The shrimp-pink walls and the brown Savonnerie rug with its pink and blue flowers and ribands make a happy combination with the dark red of the *toile de jouy* after a Pillement design. The plain marble-topped Louis XVI commode is a practical dressing table, and simple pieces of comparable period serve as bedside tables. The print by Louis Carmontelle shows the young Mozart at the harpsichord.

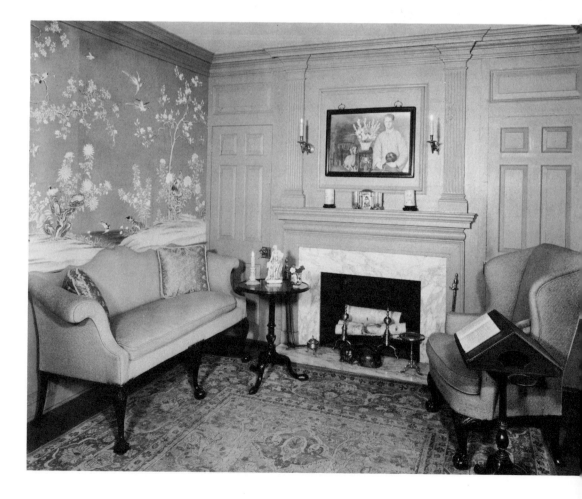

The fireplace end of the master bedroom, painted an eighteenth-century blue, dates from 1780 and comes from a house in New London. Chinese painted wallpapers were much used in similar rooms; the one here is of appropriately small scale with a blue background. The portrait on mirror of the designer and builder of the house, done from life in Canton, is a modern example of an old technique. The heavy Chippendale wing chair is Georgian, as are the table and reading stand; the sofa is a copy of a Philadelphia example. A Chelsea figure of John Wilkes ornaments the table.

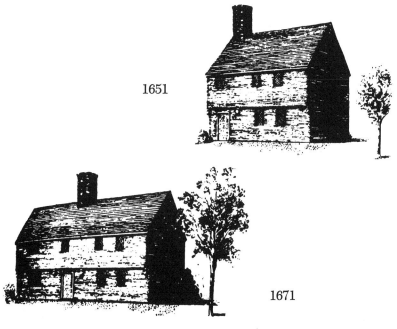

1651

1671

1722

1963 The Pickering house

Ten generations in Salem

Mr. and Mrs. John Pickering, Salem, Massachusetts

IN THIS RESTLESS NATION of ours where the population has been constantly shifting about and moving on since the days of the earliest settlers, a family that still lives in the home of its grandparents is the exception rather than the rule. And a house that has been occupied for over three hundred years by successive generations of the same family is very rare if not unique. That is true of the Pickering house in Salem, Massachusetts.

Today the house, sitting comfortably behind a wooden fence and blackthorn hedge, presents a gray-painted façade so generously ornamented in the Victorian Gothic taste that at first glance one might mistake it for a creation of the 1840's. But between the peaked gables one can see the great clustered chimney of the seventeenth century, and within the house exposed beams, wide floor boards, and other structural elements bear witness to its genuine antiquity.

The architectural history of the house which can be read in its own fabric is substantiated by family records. The oldest part was built in 1651 by John Pickering, and it must have been a typical dwelling of the time, with end chimney, steep roof, second-story overhang, and leaded casement windows. Twenty years later the house was doubled in size by the addition of rooms beyond the chimney end, and in 1722 changes were made in the roof and lean-to. The next major alterations did not come until 1840, when the house was converted from a farmhouse to a mansion by certain structural changes, as well as new woodwork within and the Gothic ornament without. In 1904 an ell was added in the rear. In 1948 the present generation of Pickerings made some interior alterations, primarily in the nature of restoration, under the guidance of the Boston architect Gordon Robb.

Since 1651 the house has been lived in by ten generations of Pickerings, father to son in all but two generations when the heir was a nephew. In its furnishings, as in its architecture, it has grown with its occupants. There are in it today heirlooms from all the past generations, serenely mingled with twentieth-century additions. Many of the heirlooms would be welcome in museum collections, and they have particular significance in this family home. Besides furniture, portraits, needlework, china, silver, there are documents: the 1642 deed for the land on which the house stands; letters from George Washington to Colonel Timothy Pickering, who held several important posts in the Revolution and the early Republic; the colonel's commissions, and his Cincinnati badge; letters from Thomas Jefferson to John Pickering "the linguist"; sermons and writings by various members of the family.

Mr. and Mrs. John Pickering, who now occupy the house, have a full appreciation of their rich inheritance. They have made no attempt to restore the house to 1651, or to 1722, or to return themselves to the manner of living of their forebears. But they have cherished, with respect and affection, the material things that have been passed on to them and, following the family tradition, have made them a part of their life. So that this home may be preserved for future generations of the family, and also be enjoyed by others, they have established it as a foundation and it is open to visitors by appointment.

The large library with its low ceiling and great beams in the 1651 part of the house was originally two rooms. Here are gathered some of the earliest family heirlooms. Dominating the room are three portraits painted by Joseph Badger about 1755: one of Mary Pickering Leavitt, daughter of Deacon Timothy Pickering, shown in a blue dress, with her daughter Sarah; one of her husband, Reverend Dudley Leavitt; and on the opposite wall, one of their daughter Mary, with a bird perched on her finger. The oak table below this portrait is of exceptional interest, with its great bulbous legs and angled stretcher. It probably antedates the house itself, and is believed to have been brought from England by the first Pickering who came to America, in 1636. Colorful embroideries also hang on the walls. The large "chimney piece" by the fireplace, one of that rare group of mid-eighteenth-century New England examples, was worked by the same Mary Leavitt portrayed in Badger's painting, and her own silver thimble rests on top of the frame. The smaller needlework picture here was made by her sister, Eunice Pickering. The curious piece of pine furniture below these — a combination reading desk and gateleg table — was made about 1725 by Theophilus Pickering, a minister who was also a craftsman. He likewise made the bellows that hang by the fireplace. *Photographs by Samuel Chamberlain.*

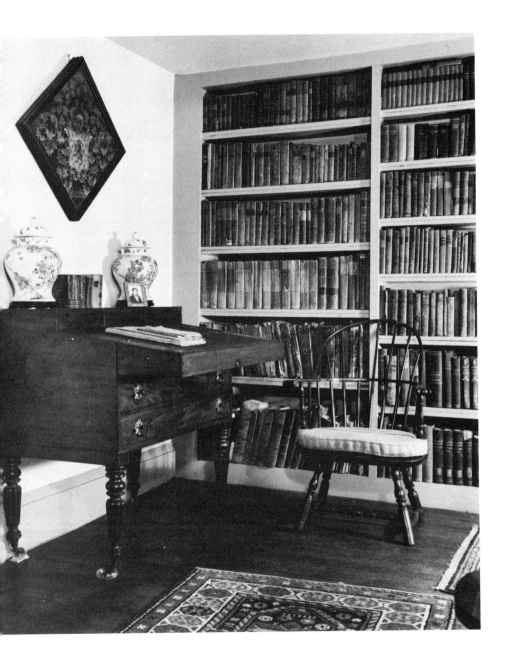

On another wall is one of those up-ended-square embroideries of a coat of arms called hatchments, in which is worked the name *Sarah Pickering* with the date *1753*. The mahogany desk below it, a late Sheraton piece, was owned by Colonel Timothy Pickering, and the bookshelves are filled with the eighteenth- and early nineteenth-century books which made up the working library of John Pickering, linguist and lexicographer.

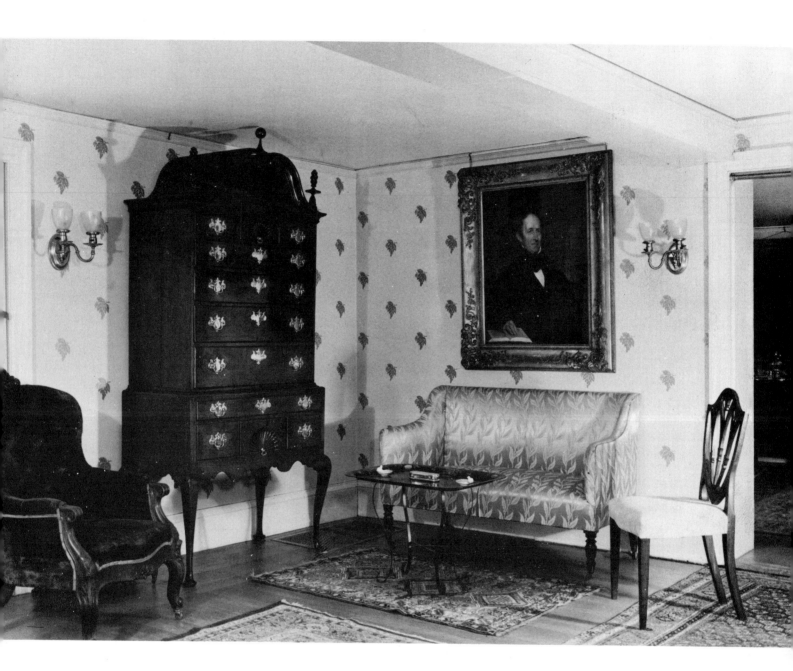

The parlor, in the 1671 addition to the house, was refur-
bished in 1840 when the ceiling was raised and new wood-
work put in. The furniture, too, covers a long span of years
and changing styles. It includes a bonnet-top highboy of
the mid-1700's, some shield-back Hepplewhite chairs and
a pair of Sheraton sofas of the Federal period, and rococo
revival pieces in the "French" style of the mid-1800's. The
portrait of John Pickering the linguist is by Chester Hard-
ing; other family portraits in the room include the work of
Sharples and Waldo.

In an alcove off the dining room are chairs from a set used in the room, ten side and one arm, made about 1725 by Theophilus Pickering. On the Sheraton drop-leaf table are pieces from a large and remarkably complete set of China Trade porcelain with eagle design in gold and sepia, originally owned in the late 1700's by Benjamin and Elizabeth Cox, great-grandparents of the present John Pickering. On the sideboard, which probably dates from the 1840 refurbishing of the house, is a handsome French silver wine cooler presented and inscribed to Timothy Pickering by George Washington in 1792.

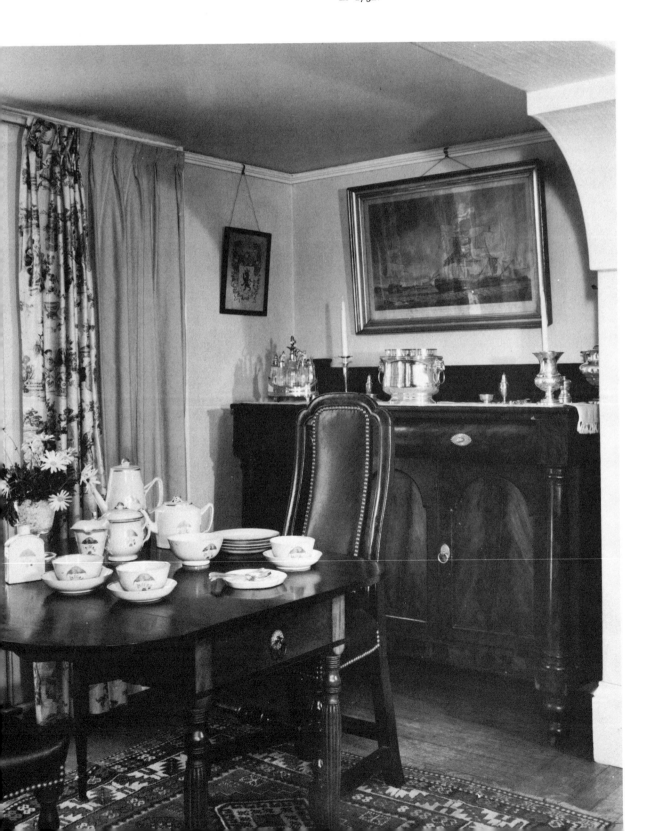

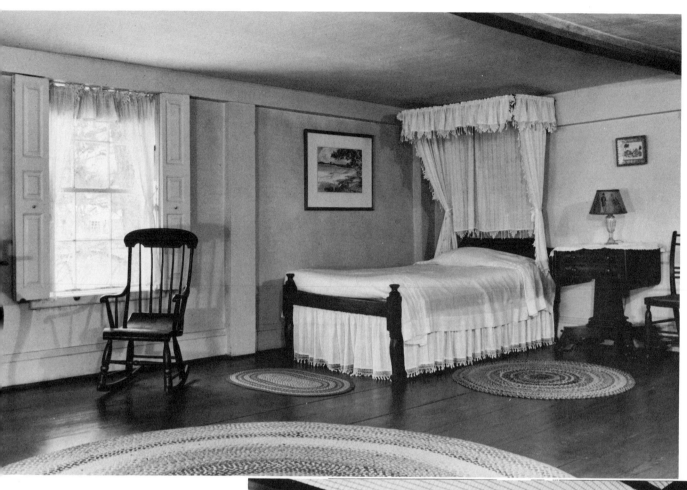

In the bedroom over the parlor the floor was raised when the ceiling below was heightened, and the big summer beam was pared down. Here an amiable Boston rocker and an Empire stand are used with an early eighteenth-century low-post bed. Another bedroom, equipped with an 1840 mantel, has a Sheraton field bed and Queen Anne highboy. Braided and hooked rugs on the wide floor boards lend color and informality.

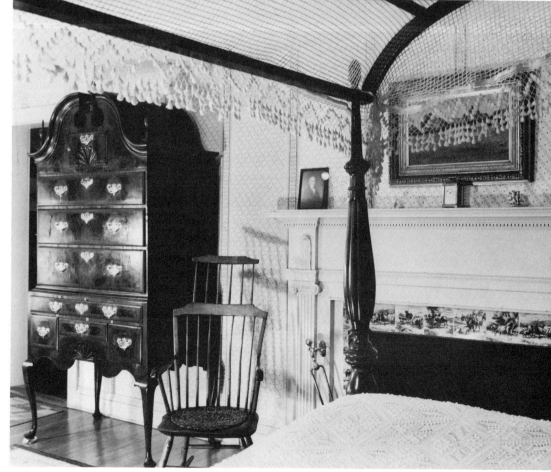

Historic house in Germantown

TIME AND AGAIN in this country our handsome early houses have passed into alien hands and fallen into disrepair, eventually to be demolished completely or perhaps to be rescued belatedly at the cost of extensive restoration. One of the happy exceptions to this rule is Cliveden, the seat of the Chew family in Philadelphia's Germantown. Since 1761 when it was built the house has remained continuously in the family, except for an eighteen-year interval at the close of the eighteenth century, and it is now occupied by the sixth generation of direct descendants of the original owner, Benjamin Chew.

Benjamin Chew (1722-1810), trained for the bar in Philadelphia and London and holder of various public offices in Delaware and Pennsylvania, is known to history as an eminent jurist. From 1774 until the outbreak of the Revolution he was chief justice of the supreme court of Pennsylvania, and from 1791 to 1808, judge and president of the high court of errors and appeals of Pennsylvania. In 1777, with his friend Governor John Penn, he was temporarily "enlarged upon parole" in the "back country" of New Jersey because his patriotism was questioned; in fact, however, his sympathies were with the American cause, and less than a year later he was permitted to return to Philadelphia. He is one of the significant figures of our late colonial and early Federal period.

Benjamin Chew was married twice, first to his cousin Mary Galloway, who died in 1755, then two years later to Elizabeth Oswald, who became the mother of his first son, Benjamin Jr. One of his daughters was Peggy, a celebrated beauty, who was courted by Major André and later married Colonel John Eager Howard of Maryland. A portrait of the latter hangs at Cliveden, and poems written by the ill-fated major to Peggy Chew are preserved there.

For much of his life, Chew maintained a residence in Philadelphia. Cliveden was built as his summer home, on a site north of old Germantown which was added to gradually until it comprised sixty acres. The handsome house was set well back from the road, sheltered by trees and shrubbery and accented by marble statuary placed on the lawn. Chew named his estate for the famous English country seat of Frederick Louis, Prince of Wales, where the latter had died and where his son, George III, grew up.

The American Cliveden was known then, as it is still, as one of the finest houses near Philadelphia. The Chew family spent much of each year there, and it was visited by many of the great of the day. But it met with disaster during the Revolution. In the battle of Germantown on October 4, 1777, it was the scene of heavy fighting; the house was riddled with bullets, woodwork and stonework were shattered, one cannon ball went straight through the house from front to back. The place was wrecked though not ruined, and Chew, who could not obtain materials for repairing it, sold it in 1779 to Blair McClenachan, a prosperous merchant who four years later acquired Mount Pleasant, the greatest of the houses in Philadelphia's Fairmount Park. In 1797 Benjamin Chew bought Cliveden back, and his family has owned it ever since.

The successive generations that have lived at Cliveden have preserved not only the house but also its contents. Many pieces of eighteenth-century furniture which must have been acquired by Chief Justice Chew are still in place, some of them outstanding examples of Philadelphia craftsmanship. There is also much in the neoclassic style of the Federal period, apparently added in the early 1800's: quite probably the house was refurbished by Benjamin Chew Jr. after his father's death in 1810. And, as in any house that is continuously lived in, later things too were added through the nineteenth century — pictures, china, furniture, ornaments of various kinds.

But nothing, apparently, was ever thrown away. When the present owner moved into the house in 1959 it was full of the accretions of the years, lovingly cherished by the last occupant, his nonagenarian aunt, Miss Elizabeth B. Chew, who had spent her life at Cliveden. Family papers and memorabilia of all sorts crammed attic, cellar, and outbuildings, while furnishings spanning nearly two hundred years were mingled throughout the house. Sifting through these precious possessions, Mr. and Mrs. Samuel Chew have eliminated from the major rooms the pieces least appropriate to their setting. Now, its interior freshly painted and rearranged to suit today's pattern of living, its exterior little changed and carefully tended, Cliveden has taken a new lease on life.

Mr. and Mrs. Samuel Chew, Philadelphia, Pennsylvania

Cliveden, built in 1761, is a dignified interpretation of English styles, combining classical details of Georgian character with the general proportions of the Queen Anne manor house. The façade is of ashlar in gray Germantown stone, the sides and back are stuccoed. The columned doorway has a handsome pediment whose classic motifs are repeated in the cornice, and tall chimney stacks rise above the roof. Behind are two outbuildings, miniatures of the house itself; the one seen here, originally the kitchen, is connected to the house by a curved covered passage. *Photographs by Charles P. Mills & Son.*

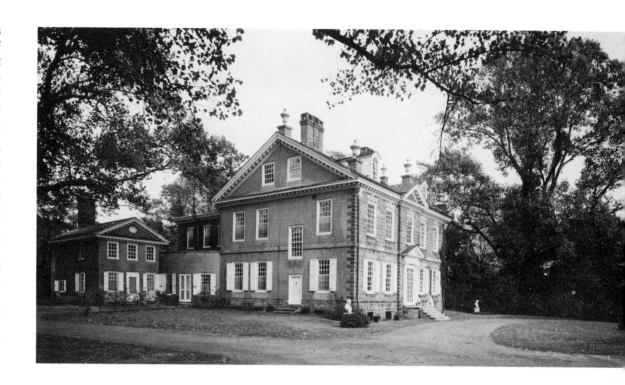

The artist E. L. Henry (1841-1919), painter of genre, landscape, and portraits, reconstructed the 1777 battle of Germantown in this painting which hangs at Cliveden. While it is hardly a document, since it was painted long after the event, it is probably reasonably accurate and at any rate is a graphic storytelling picture. The statues spaced about the lawn, as well as the lions couchant flanking the door and the urns on the roof, are uncommonly elegant features.

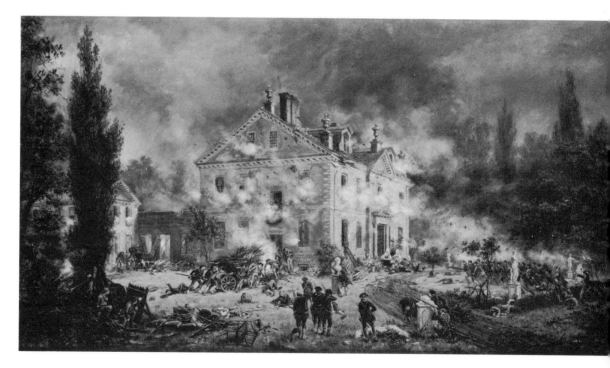

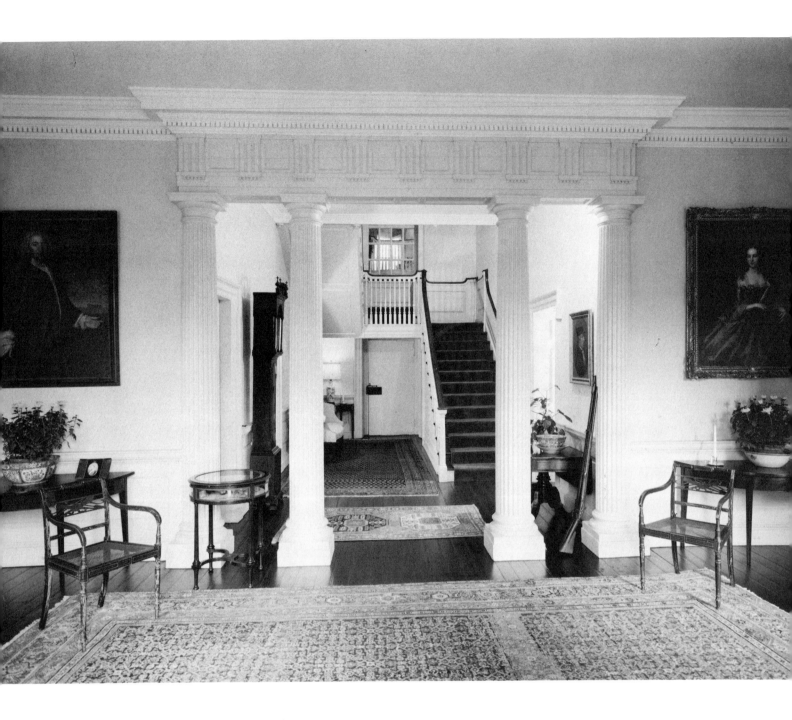

In design and detail, the hall at Cliveden is unusual in American domestic architecture. The entrance door, from which one views it here, faces four columns which separate the broad expanse in front from the stair hall. The columns and their entablature repeat the classic details of the front door. The two Sheraton fancy chairs in the foreground are from a set of six in the house, painted dark green and red with gilding. The portrait at the right is of Benjamin Chew's sister-in-law, Peggy Oswald; that at the left, attributed to John Smibert, is his second wife's uncle and Chew's friend, Captain Joseph Turner. Memorabilia displayed in the vitrine below include Chew's seal and watch, a chatelaine he gave his wife, and bullets found at Cliveden after the battle of Germantown. Other reminders of the battle are the muskets leaning against a column, and round scars made in the floor beside them by the smoking barrels of firearms.

When the Marquis de Lafayette visited America in 1824 and 1825 he was entertained at Cliveden. Years later E. L. Henry depicted the scene as it must have appeared — the aging Frenchman shaking hands with everyone, the other guests bedecked in their best finery, an old veteran toward the right reminiscing, a lady at the left resting (and bored) after all the excitement, and in the rear hall uplifted hands bearing a laden tray of refreshments from the dining room. Apparently most of the furniture has been moved out of the hall for this reception, but the portraits of Turner and Peggy Oswald hang where they are today.

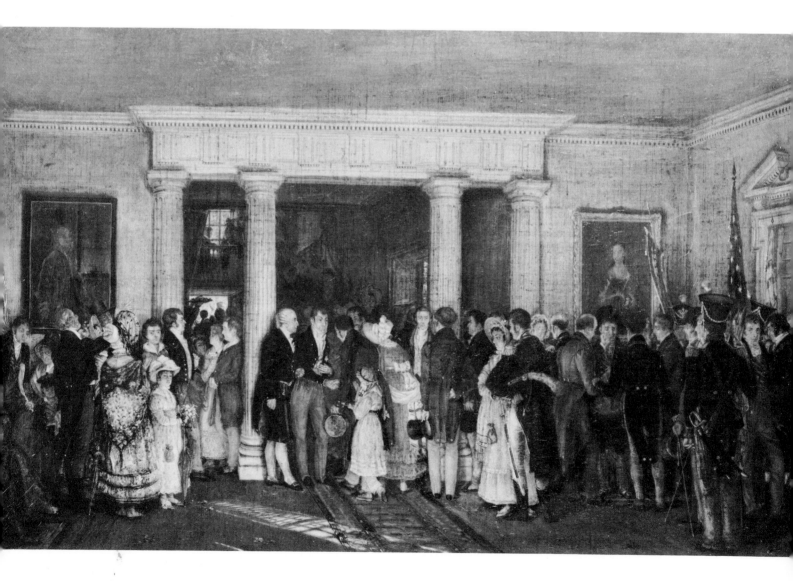

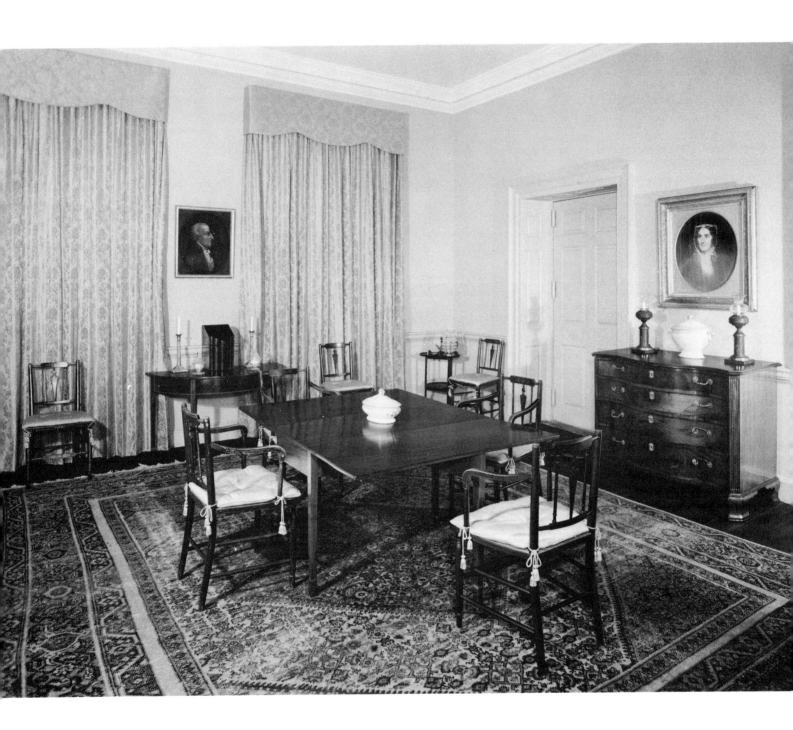

The dining-room walls, curtains, and seat cushions are a subtle hue between rose and gold that matches the border of a large set of French porcelain displayed in a cabinet in the room. Sheraton fancy chairs painted brown and bronze with gilding are used with the three-part Hepplewhite mahogany table. The imposing Chippendale chest of drawers with heavy chamfered bracket feet is the work of Jonathan Gostelowe of Philadelphia and bears his label in the top drawer. The portrait above it is of Anne Sophia Penn Chew (c. 1860). The portrait of Benjamin Chew between the windows was painted by James R. Lambdin about 1872, after a silhouette done from life.

At either side of the broad front hall is a handsome doorway; perhaps the small pedestal within the broken pediment originally supported a carving or piece of statuary. In each generation the room at the right of the hall has been Mrs. Chew's sitting room, and that at the left (seen here), Mr. Chew's library. Today one wall of this room is lined with eighteenth-century leather-bound books that belonged to Chief Justice Chew. The Pennsylvania walnut desk has a handsome interior with tiered, shaped drawers. Above it hangs an attractive nineteenth-century primitive portrait of Cliveden.

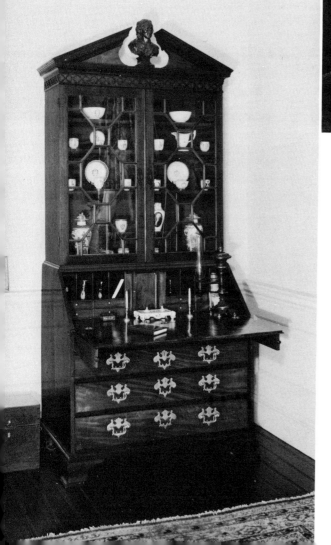

In Mrs. Chew's sitting room off the entrance hall stands a fine Philadelphia mahogany secretary which is distinguished by the carved bust in its pediment; efforts to identify the subject have thus far been unavailing.

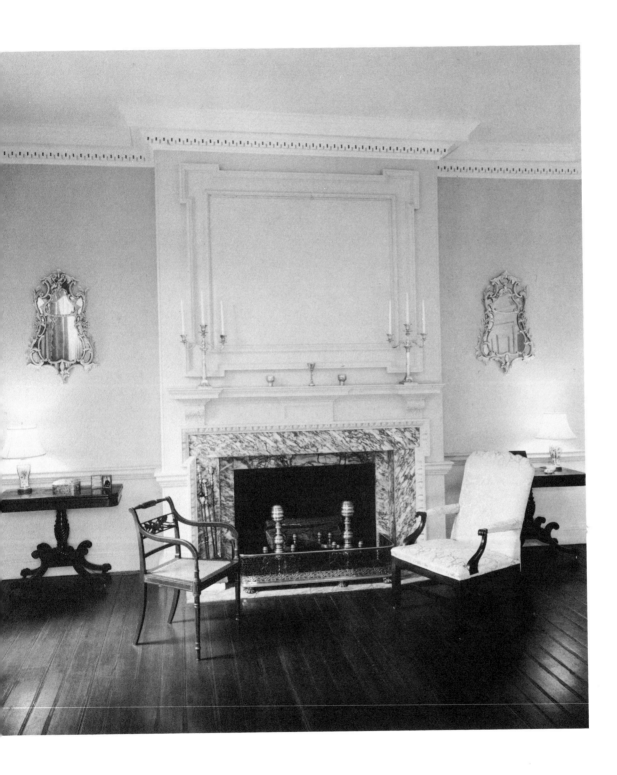

The drawing room is large and well proportioned, with high ceiling, dentiled cornice, molded chair rail, and an imposing fireplace, mantel, and chimney breast. The two elegant, and very rare, Philadelphia Chippendale mirrors are *en suite* with two large rectangular looking glasses in the room, all elaborately carved and painted white, to contrast with the blue of the walls. The matching card tables below and the fireplace equipment are part of a considerable group of nineteenth-century neoclassic furnishings in the house, probably acquired about 1810-1815.

Facing page.

The most distinguished piece of furniture in the house is the great Chippendale sofa in the drawing room with boldly sweeping back and arms, Marlborough legs, and broad gadrooned skirt; legs, feet, and skirt are all ornamented with "Gothic" carving. This piece was originally owned by Governor John Penn, for whom it was made by the accomplished Philadelphia cabinetmaker Thomas Affleck. Also made by Affleck for Penn, between 1763 and 1766, and acquired from him by Benjamin Chew were the two upholstered side chairs here, which belong to a remarkabe set of nine at Cliveden. The pair of Hepplewhite armchairs is painted white and gilded, and the splendid mirror is one of the pair in the room related to the two on the fireplace wall. The carved and gilded griffon between the windows, which may originally have supported a marble slab, belongs to the 1810-1815 period, as do the gilt wall brackets and the bronze and cut-glass Argand lamps with their original glass chimneys, and the neoclassic card table and sewing table.

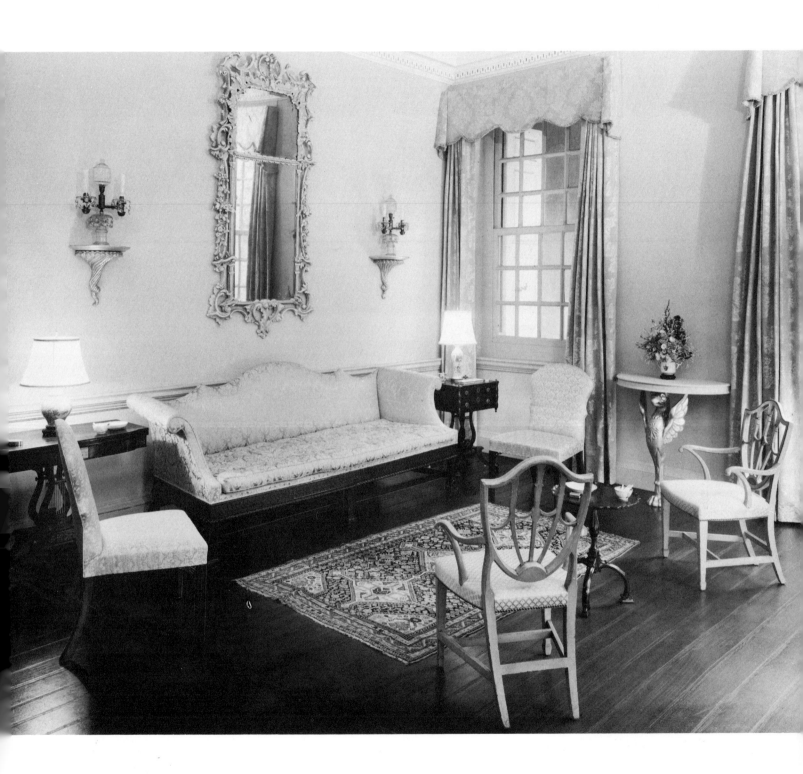

Continuing tradition in Newport

Mr. and Mrs. Henry A. Wood Jr., Newport, Rhode Island

AMONG THE MOST DISTINGUISHED eighteenth-century houses in a city renowned for its colonial architecture is the Robinson house in Newport, Rhode Island, now the summer home of Mr. and Mrs. Henry A. Wood Jr. of Boston. One of several handsome contemporary dwellings still standing together on "The Point," it fronts on Washington Street, while in back the lawn runs down to the waters of the old harbor. Here in colonial days, and for a century longer, stood a wharf, shop, woodshed, and other outbuildings, connected by a flagged walk with the house. This is a large, three-story, two-chimney, gambrel-roofed affair, its clapboard exterior painted gray. It has undergone few architectural changes, and it has been owned by one family for close to two hundred years.

The Robinson house started its existence about 1725 as a two-story dwelling with one chimney. By 1759 it had had three owners, and had come to be known as "the old tavern." In that year it was purchased by Thomas Robinson, called Quaker Tom, a prosperous merchant of Newport. He added several rooms and a third story, gave the house its gambrel roof, installed the staircase and, it is believed, most of the fine woodwork and fireplace tiles. Not till 1879 was another major change made. Then the old kitchen was converted into a back sitting room designed by Charles Follen McKim. Porches on the back and on the north side were added at the same time.

Quaker Tom and his wife, Sarah, moved into the house with family heirlooms, some brought from England be-

The Robinson house in Newport, built mostly about 1760 enlarging a dwelling of the 1720's. *Photographs by Hopf.*

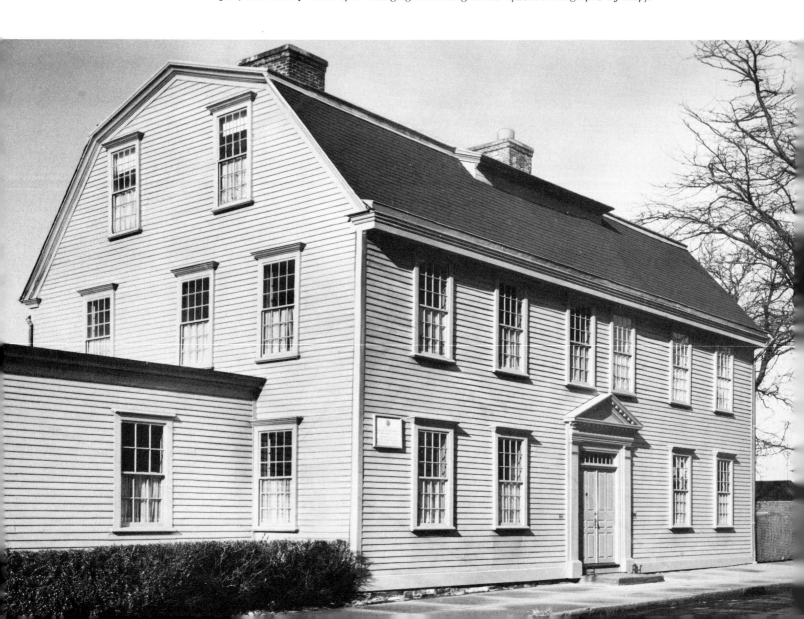

fore 1658, and added furniture made by their neighbor John Goddard. Many of their pieces are still here, along with family china, silver, books, and paintings. Among these is a set of Sèvres china sent to Sarah Robinson by the Vicomtesse de Noailles; the Vicomte, Lafayette's brother-in-law and an officer of the French expeditionary force which landed in Newport in July 1780, had been quartered in the Robinson house.

Through generations this historic house and its contents have been cherished by Quaker Tom's descendants, so that, as Downing and Scully bring out in *The Architectural Heritage of Newport,* "the interiors present a more authentic picture of the mid-eighteenth century than any other in Newport."

The front door opens on a hall from which the stairs with their carved balusters and molded rail rise in three runs to the second floor. These and the paneling of the hall were installed about 1760 by Quaker Tom Robinson. The carved drops are replacements put in by McKim in 1879. The leather fire buckets carry the name *T. Robinson* and the date *1811.*

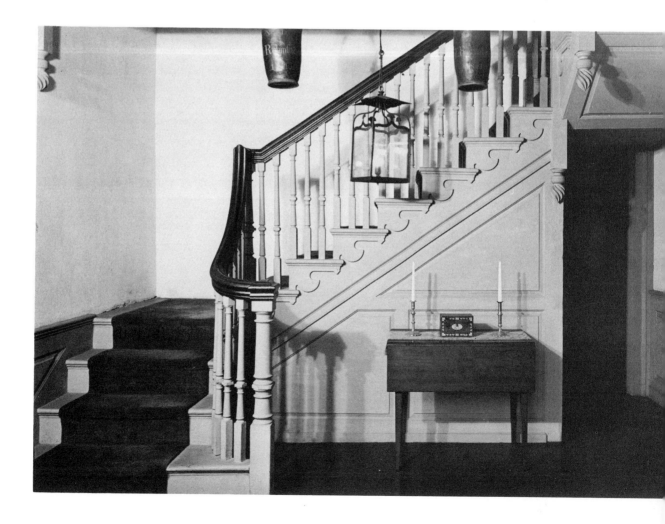

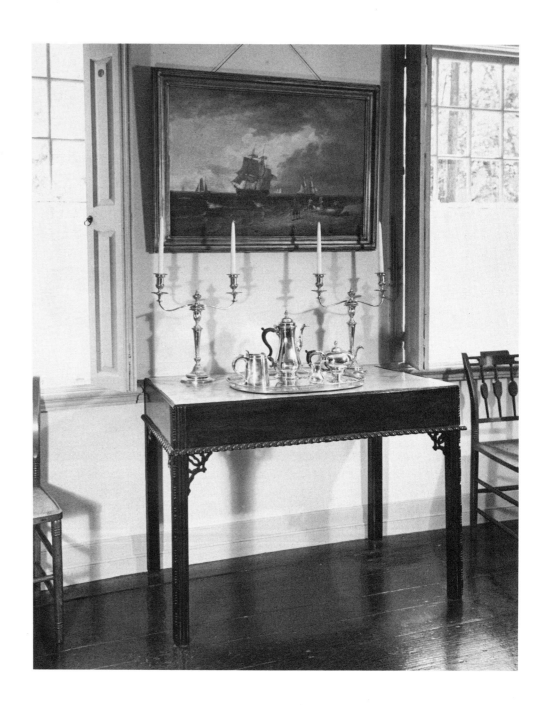

One of the Robinson daughters married a Philadelphia Quaker, and among their family possessions are excellent pieces of Philadelphia Chippendale furniture made about the same time as the blockfront items by Goddard. This superb marble-topped mahogany table in the dining room is credited to Thomas Affleck. The ship painting above it is by the Philadelphian Thomas Birch. The silver teapot and creamer are by the South Kingston, Rhode Island, smith Samuel Casey, born 1723; the tankard was fashioned by Edward Winslow of Boston and has the date 1728 engraved with initials on the handle. Coffeepot, salver, and candlesticks are English.

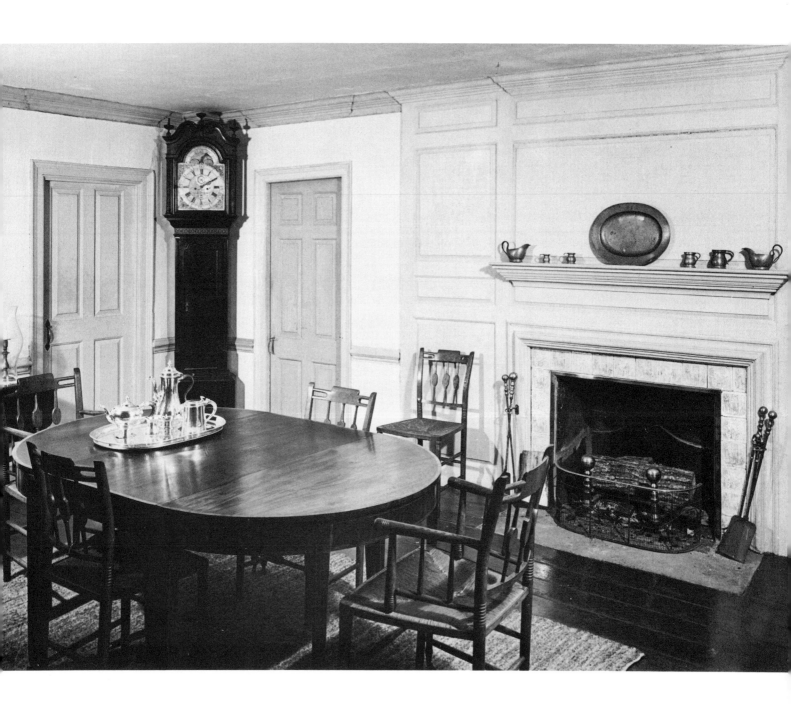

The dining room, in the early part of the house (c. 1725), has raised paneling on the chimney breast, and similarly paneled doors, a molded chair rail, and a molded cornice with unusual projections over doors, windows, and fireplace. The woodwork is painted gray green. A bolection molding and lavender-printed tiles frame the fireplace opening. A three-part Hepplewhite table is used in this room with a set of New England Sheraton fancy chairs, and a Georgian tall clock stands in the corner.

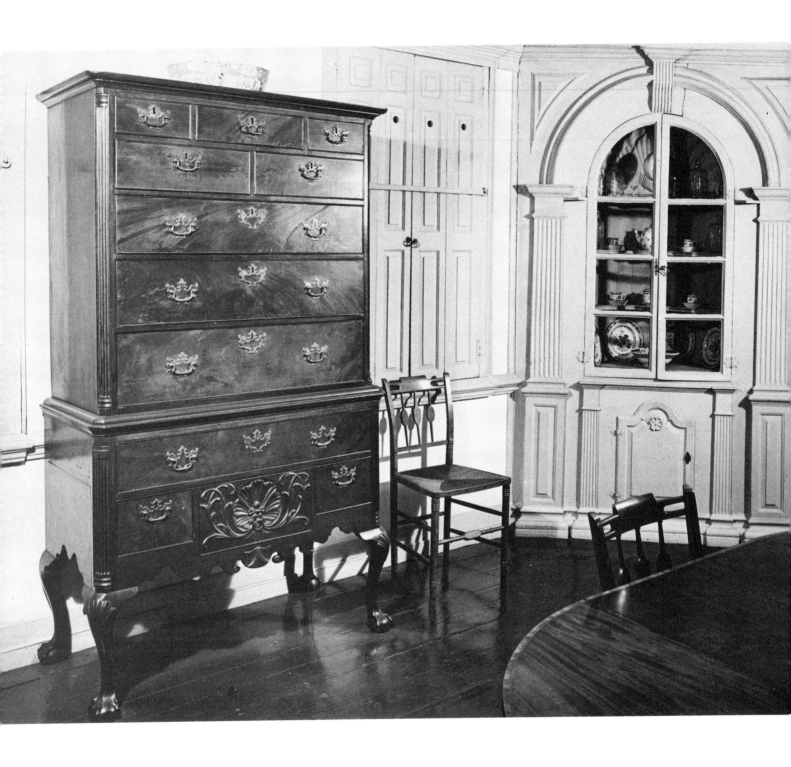

One of the most interesting architectural features of the house is the corner cupboard in the dining room, part of the original woodwork. Its bolection molding, the heavy tab in the cornice, and the small arched, paneled door with gouged flower ornament are all very early colonial features. Within, on the second and third shelves, are prized pieces from the Sèvres tea set sent to Mrs. Thomas Robinson by the Vicomtesse de Noailles. This lady's letter, in English, dated at Paris in October 1781, expresses her gratitude for Mrs. Robinson's "friendly kindness for my husband" and begs to present "some tea cups of a Manufactory we have here." The letter is carefully preserved with the teapot, sugar bowl, and four cups and saucers, which are decorated with delicate floral sprays and marked on the base. The Chippendale highboy is one of the Philadelphia heirlooms.

The back sitting room, with windows facing the harbor, was originally the kitchen, and now is a period piece of another sort. The present woodwork and tiled hearth were installed by the architect Charles F. McKim, who in the 1870's was a leading exponent of the "Queen Anne" style and "colonialized" numerous old Newport houses before he and his partner Stanford White began adapting the styles of European palaces for American millionaires. The great nine-foot sofa is one of the finest Philadelphia pieces of its kind, with strong Marlborough legs and noble sweep of back and arms. The circular folding table beneath the delicately scrolled mirror on the far wall is the work of John Goddard.

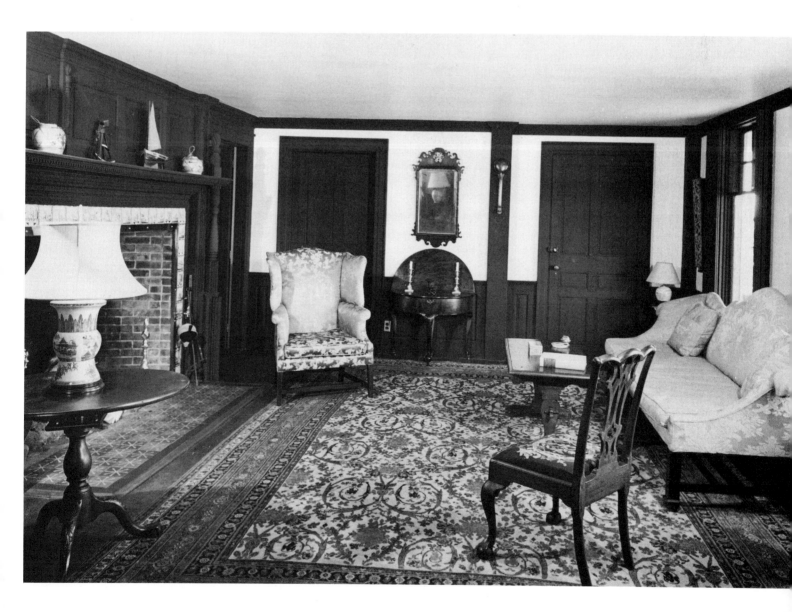

The great room, as it has always been known in the family, is one of those added in 1760 by Thomas Robinson. It has a paneled dado, and a paneled chimney breast of later style than that in the dining room. As elsewhere in the house, the original inside shutters, wrought-iron hardware, and brass jamb hooks remain in place. The fireplace tiles are printed in dark green; the woodwork is buff. Outstanding here is a fine desk and bookcase with the closed bonnet and carved shells typical of the work of the Goddard-Townsend cabinetmakers who were neighbors of Quaker Tom on Easton's Point and from whom he got his new furniture about 1760. The seventeenth-century cane-back chair by the fireplace is one of his wife's heirlooms from England. From the Philadelphia branch of the family is the Chippendale side chair by the desk which has a pierced "Gothic" splat and excellent carving on back and knees.

A simple pine dresser in the great room displays a handsome garnish of blue and white Canton ware. The cupboards below are literally crammed with additional pieces of family china — China Trade ware, Sèvres porcelain, English creamware and delft, and such later heirlooms as Haviland.

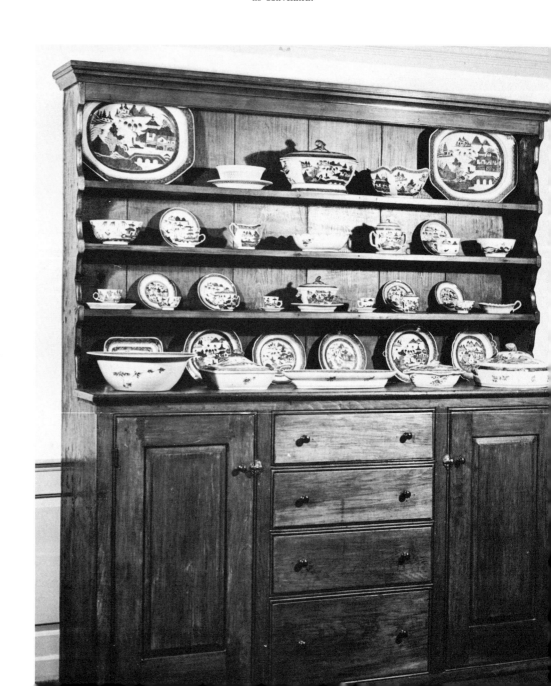

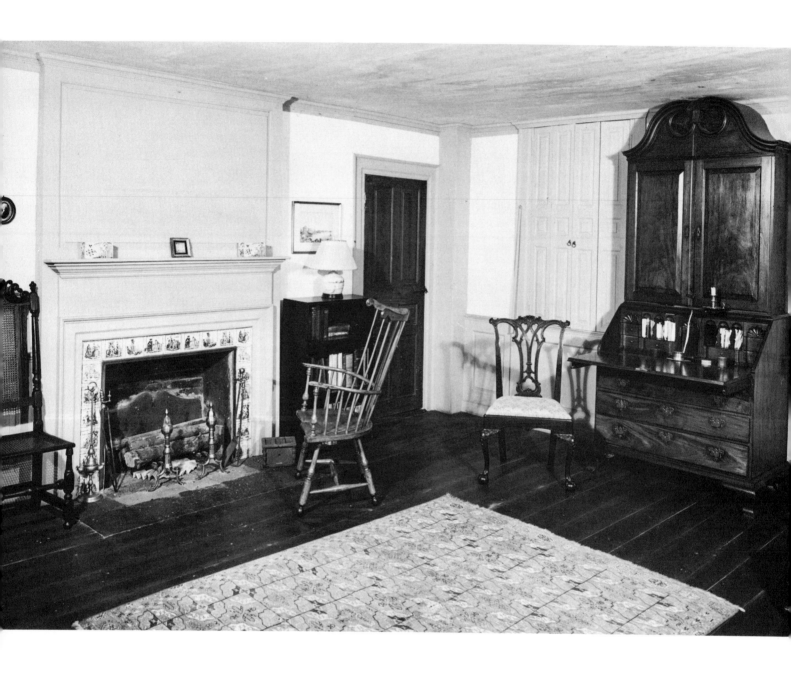

In the great room are walnut caned chairs and a day bed by Thomas Goddard (1765-1858), son of John, who in his later years made furniture in the revival style that has been called Jacobethan.

There are eleven fireplaces in the house including one on the third floor, eight of them framed in eighteenth-century tiles installed by Thomas Robinson. Those here, in a small room behind the entrance hall, are decorated in polychrome, some with vignettes of amusements and diversions, the four bottom ones with Biblical scenes.

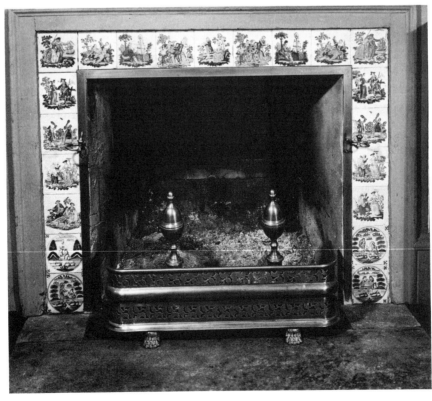

English elegance in Milwaukee

Mr. and Mrs. Robert Uihlein Jr., Milwaukee, Wisconsin

IN THE HOME of Mr. and Mrs. Robert Uihlein Jr., of River Hills, Milwaukee, antique English furniture and decorations are combined with modern upholstered pieces, and the light neutral colors of walls, carpets, and other textiles make a perfect foil for the dark, gleaming wood surfaces. This combination of old and new in a single interior has gained wide acceptance, but all too often it is a formula applied with little taste and less understanding of antique furniture. The rooms shown here owe their distinction in almost equal measure to the interest and high quality of the furniture and to the sympathetic setting which has been provided for it.

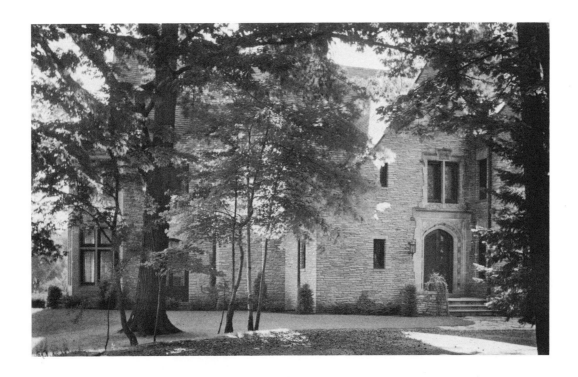

In the entrance hall is a George II marble-topped table with cabriole legs, paw feet, and gadrooned apron, a fine piece that dates from around 1750. Two early Chippendale side chairs with square tapering legs, molded feet, and pierced splats flank the table, and a George II gilt mirror with scrolled pediment and prominent volutes hangs above it. The pictures are English aquatint views of about 1800. *Photographs by James D. McMahon.*

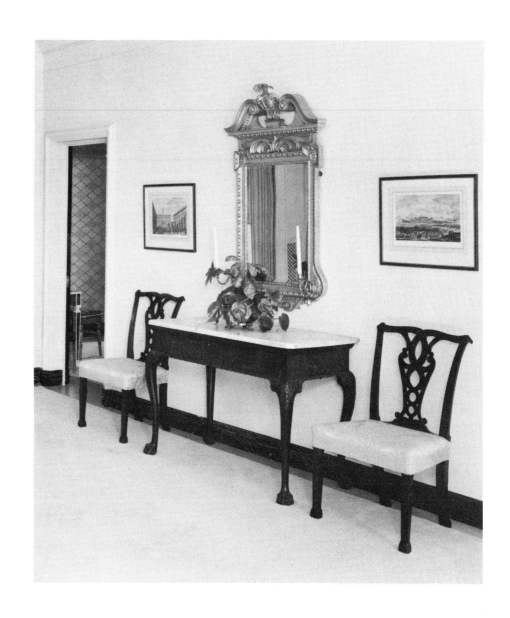

Near the far end of the entrance hall stands a Chippendale tall-case clock, made about 1760, with scrolled pediment, carved hood, and colonnettes. The Chippendale chair-back settee, with its ball-and-claw feet, carved knees and cresting, and scrolled, pierced splats, is noteworthy. At the foot of the stairs an antique mahogany plate carrier of about 1760 now holds a growing plant.

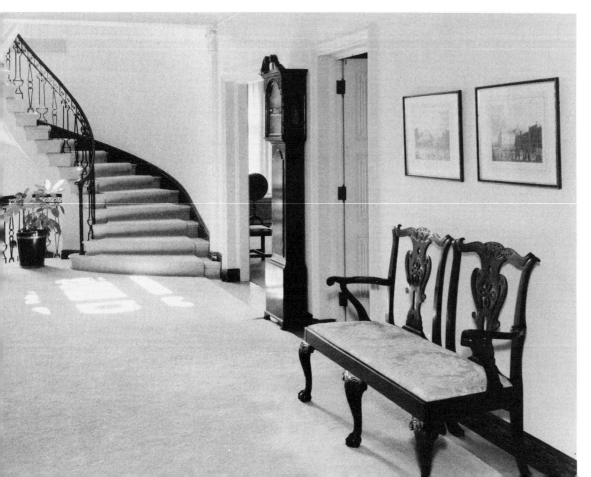

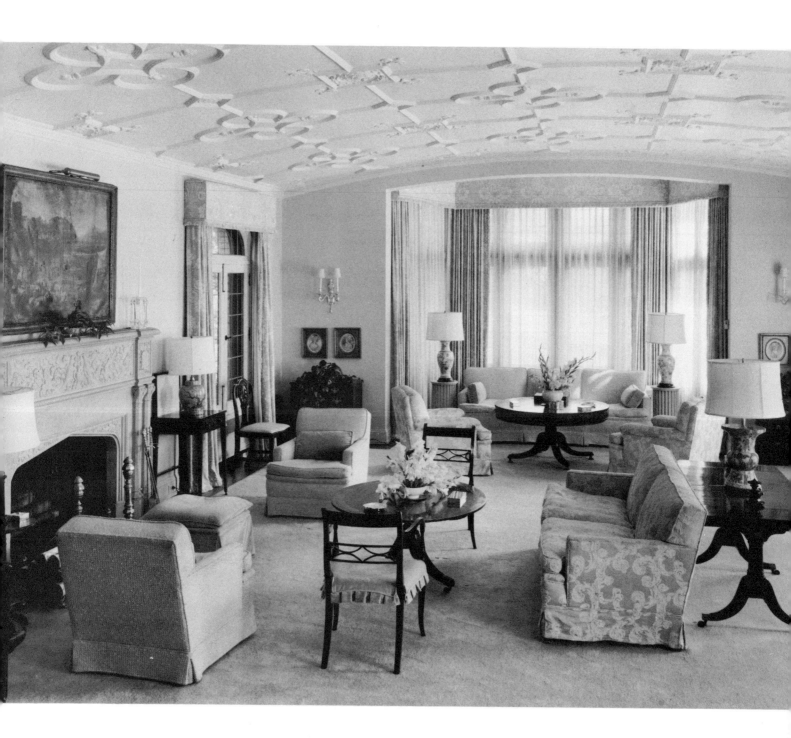

A general view of the living room shows how skillfully the furniture has been arranged to serve the requirements of comfort as well as to bring the antique and modern pieces into pleasant contrast. The drum table before the sofa in the window recess was lowered to make a coffee table, as was the late eighteenth-century Sheraton mahogany breakfast table in front of the fireplace. The Regency painted chairs that face this piece date from about 1805.

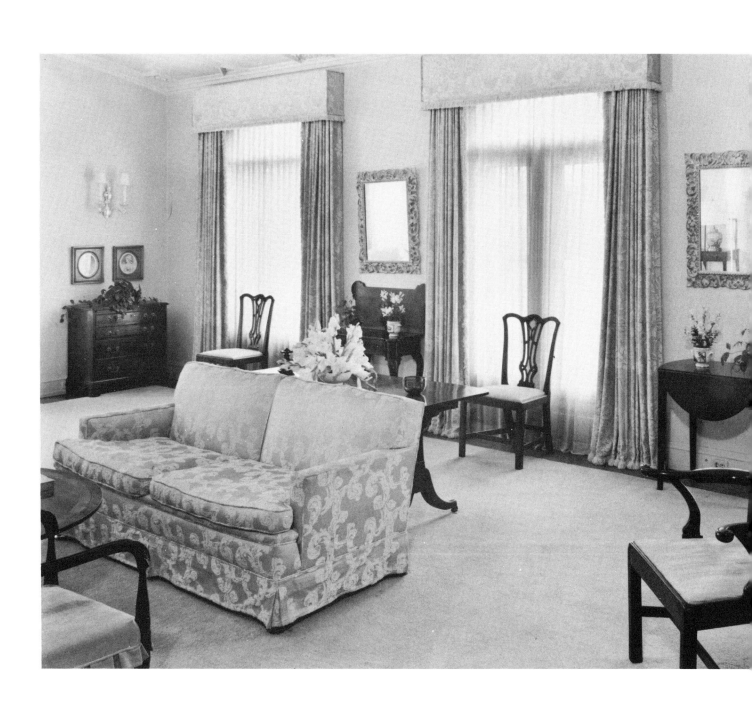

Facing page.

A pair of Chippendale side chairs with square legs and gracefully pierced splats (c. 1760) is placed against the French doors of the living room. A mahogany card table of about 1755, with shaped skirt and cabriole legs, and a pembroke table (c. 1785) of convenient size stand under the two square mirrors in carved wooden frames. The small Chippendale chest of drawers on bracket feet, at the left, is both useful and decorative.

A fine Hepplewhite mahogany breakfront secretary of about 1785 stands in one corner of the living room. The small writing table with attached adjustable fire screen, at the right of the fireplace, is an especially interesting piece that dates from about 1790.

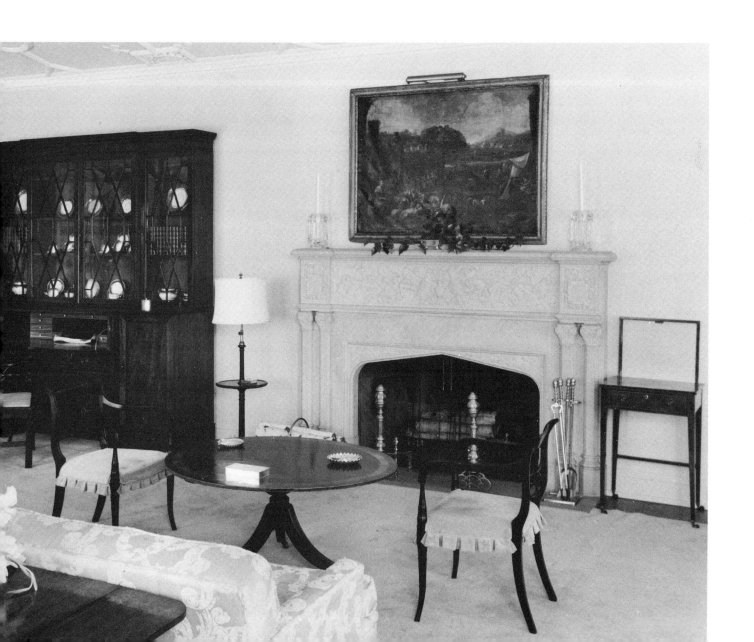

All the furniture in the paneled dining room is Georgian.
A Sheraton three-pedestal dining table of about 1800 is
used with a set of eight Chippendale chairs dating from
around 1765 which have carved, interlaced back splats.
The candelabra on the table and the matching candle-
sticks on sideboard and serving table are Sheffield plate,
made by Matthew Boulton about 1810.

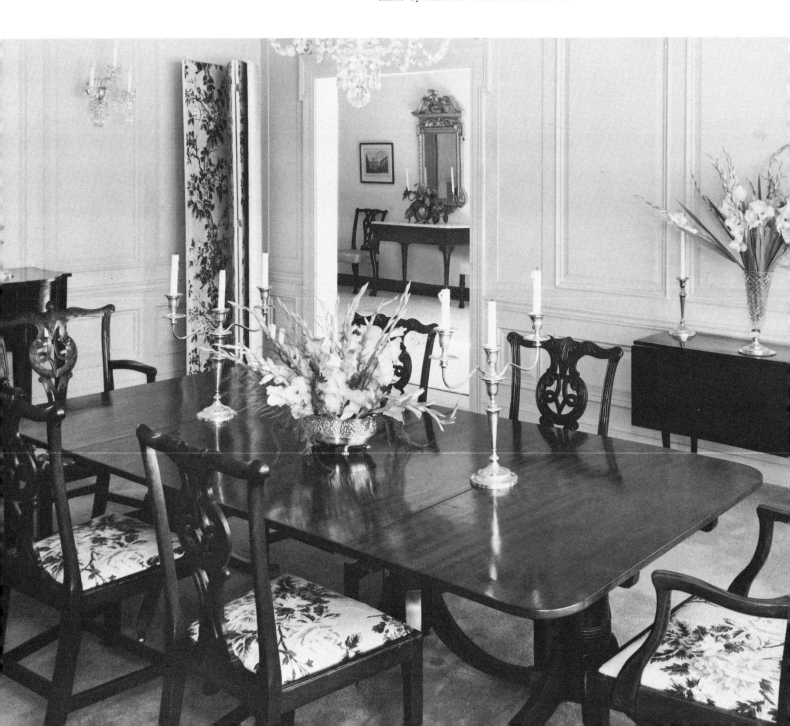

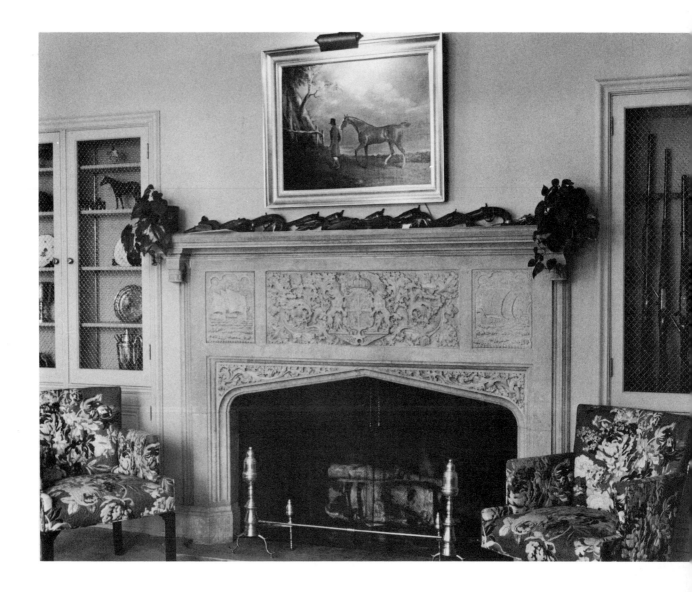

The den has been arranged to display a large collection of guns, mainly antique, and other sporting trophies. Over the mantel hangs a painting by the English artist Ben Marshall (1767-1835) who, like his better-known contemporary George Stubbs, won numerous aristocratic patrons with his portraits of horses and riders. The picture is appropriately hung in the home of Mr. Uihlein, who is a noted polo player and captain of the Milwaukee team.

Collector's choice

Mrs. Giles Whiting, New York City

WHEN IS A GROUP of antiques a collection, and when is the person who "just picked them up to live with" a real collector? Mrs. Giles Whiting disclaims the title of collector as though it were an undeserved compliment; yet her sizable aggregation of distinguished American antiques, acquired over the past forty years, is widely known as an outstanding collection. Some of her furniture has been illustrated in standard books on the subject, and seen in such historic displays as the Girl Scouts Loan Exhibition of 1929, the 1936 exhibit at Ophir Hall, and the showing of New York furniture at the Museum of the City of New York in 1956-1957.

The collection is divided between Mrs. Whiting's country house on the Hudson and her New York City apartment, and it was in the latter that the pictures shown here were taken. While emphasizing the quality of the American furniture, they demonstrate too the discrimination that has brought together so many significant pieces with appropriately decorative objects in a dignified and charming setting. This could have been achieved only by a true collector.

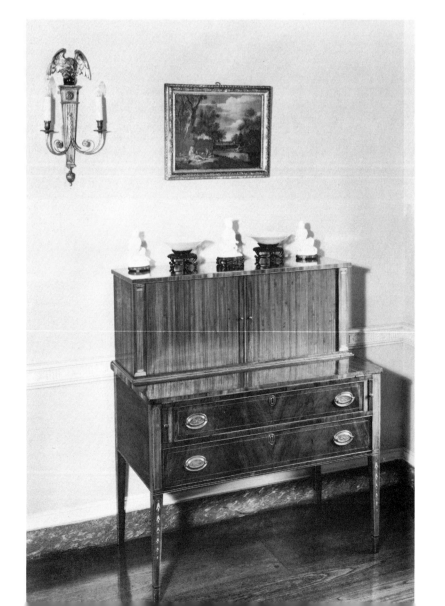

In a gray parlor off the drawing room is a New England tambour desk of the Federal period, a type that appears to have been made only in America. The mantel, of the same period, is by Samuel McIntire; its delicate carving is enhanced by the white and gilt Hepplewhite mirror above it. The mahogany commode or butler's desk (c. 1815-1820) is by Duncan Phyfe; it is one of several pieces in Mrs. Whiting's collection made as wedding furniture for Sophia Miles Belden, whose portrait hangs in the apartment. The oval painting above is dated 1772 and signed by Antoine de Favray (1706-1789). An attractive country table in pine with inlaid top (left foreground) contrasts with sophisticated New England pieces, of which the circular pembroke table with claw-and-ball feet is unusually fine. *Black and white photographs by Taylor and Dull.*

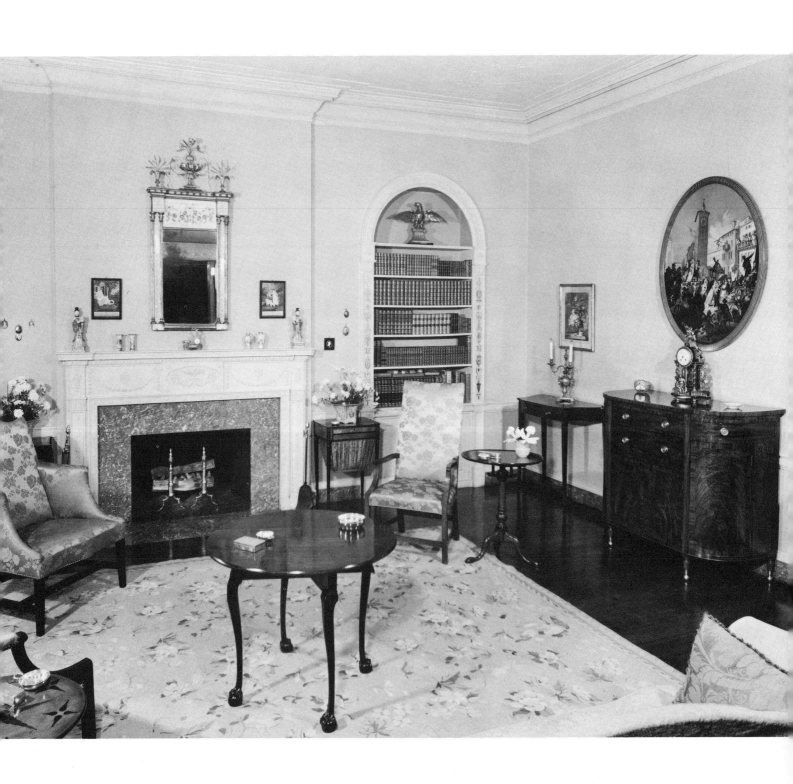

The long drawing room is literally filled with fine American furniture. The large sofa with its rococo curves in the Chippendale manner and the tapered legs heralding the Hepplewhite style must be noted, and so must the Queen Anne wing chair and the mahogany New York tilt-top table with carved piecrust edge. But each piece here and in the view shown in color deserves attention. The small six-legged Queen Anne walnut pembroke table (left foreground) is a New England piece believed to be the only one of its kind. The Newport blockfront dressing table on the far wall belonged, according to family tradition, to Governor Jonathan Trumbull of Connecticut. Between the windows hangs an elaborate early Georgian mirror in walnut and gilt.

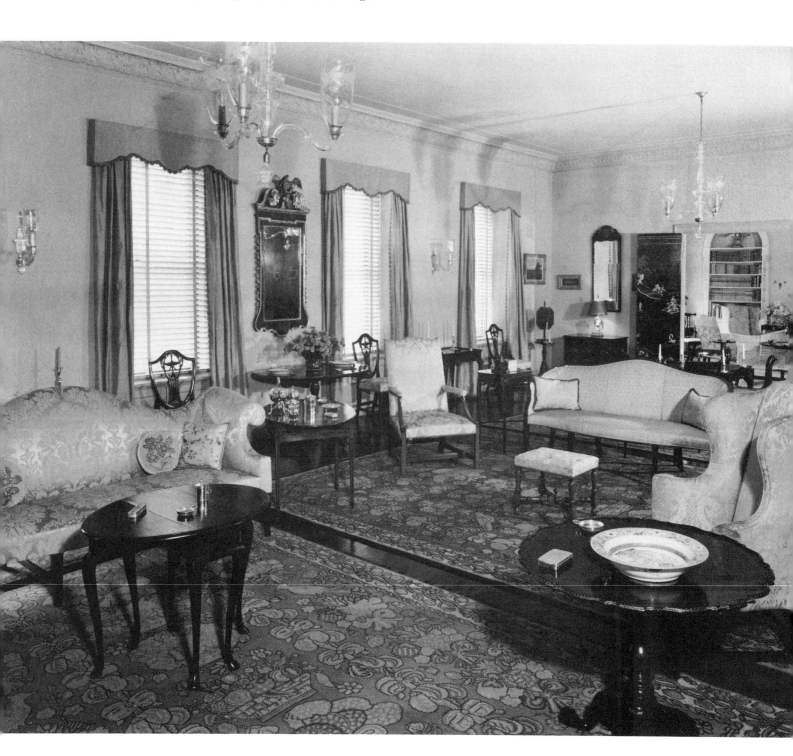

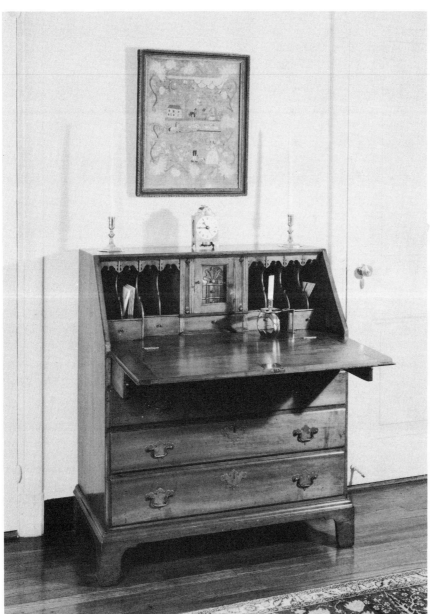

One of the few country pieces in this city apartment is a maple desk of conventional slant-top variety. As with many desks in this form, the chief interest is in the interior; its individuality suggests a Connecticut origin. Tiny carved scallop shells decorate the pigeonholes and the two vertical drawers, while the central tier of drawers has a modified block-and-shell treatment. The glass door protecting this compartment is another unusual feature.

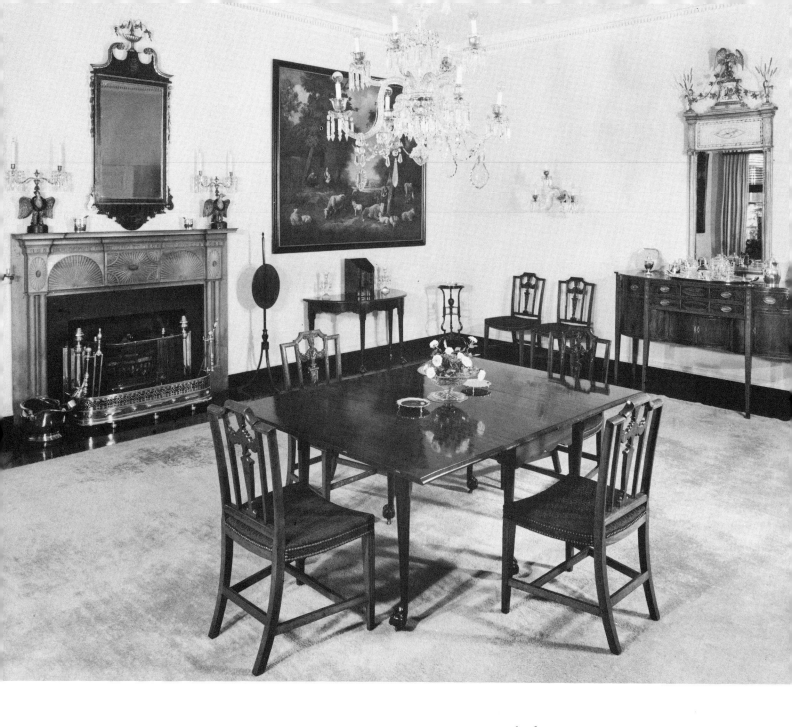

The dining-room chairs are a set of twelve in an unusual
Hepplewhite design with splat of richly carved leafage,
swags, and pendent husks; they retain their original dark
blue haircloth seats. They are believed to have belonged
at one time to Captain John Singleton of Sumter County,
South Carolina. The skillfully shaped contours of the
Hepplewhite mahogany sideboard, and the arrangement
of its veneer panels and inlaid decoration, disguise its
considerable size, while the gilt mirror above adds to the
effect of lightness and grace. The mantel (c. 1800) is a
Hudson Valley type, characterized by carved fans and
sunbursts.

A New England cabinet or secretary in the dining room
displays pieces of Meissen porcelain and English luster-
ware, yellow and silver. The piece itself, which has a
writing flap, is of inlaid mahogany with satinwood panels
in cornice and skirt, and its delicate interpretation of the
neoclassic style relates it to the work of Salem cabinet-
makers of the Federal period.

The spacious hall is furnished chiefly in maple and fruit woods which, in these pieces of clean, simple line, and in this marbled setting, take on an unexpected elegance. The dominant piece is the ten-legged settee of late Sheraton design, with shaped top rails and rope-carved central slats. The New England Queen Anne maple tea table in front of it has a finely figured tray top. Above hangs a gilded mirror with exceptionally delicate neoclassic decorations, and on the floor is an eighteenth-century Samarkand.

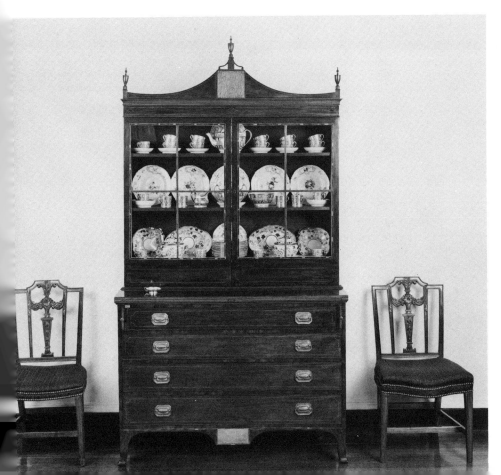

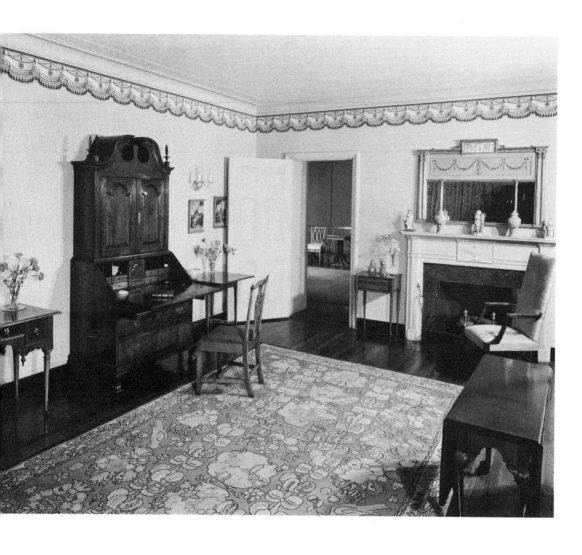

Over the mantel in a large bedroom on the second floor of the apartment hangs a gilt mirror believed to have been carved by Samuel McIntire for one of Salem's handsome Federal houses. In neoclassic style with columns and a deep painted frieze ornamented with festoons and swags, it has a Wedgwood jasper plaque inset in the cornice. From New England too is the dainty mahogany and satinwood sewing table of the same period beside the fireplace. The secretary here, with scrolled broken pediment and arched-panel doors, is of the early eighteenth century and was found in the Hudson Valley; its unusual Spanish feet have been partially restored. The Queen Anne lowboy of light native woods (left) has straight legs ending in double-pad feet.

Color plate, facing page.

In the drawing room are gathered numerous choice examples of New England furniture of the Federal period. The graceful Hepplewhite sofa has carving attributed to Samuel McIntire of Salem. The shield-back side chairs are from a group of seven in this distinctively Rhode Island design which features a *kylix*, or low footed dish, in the pierced splat. A snow scene by Childe Hassam hangs above the dainty New England secretary, whose writing section has a curved tambour lid. Colorful needlework rugs complement green walls and draperies. *Photograph by Henry Fullerton.*

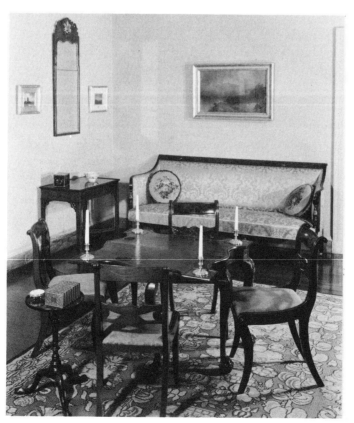

Four neoclassic side chairs with spread eagles carved in the backs are part of the Belden wedding furniture made by Phyfe; also by Phyfe is the eight-legged sofa. The boldly contoured gaming table, a fine example of New York Chippendale, was exhibited at the Museum of the City of New York in 1956-1957. Under the Queen Anne mirror, one of a pair, stands a rare Chippendale table with fretwork brackets and cross stretcher, and fluted and beaded legs.

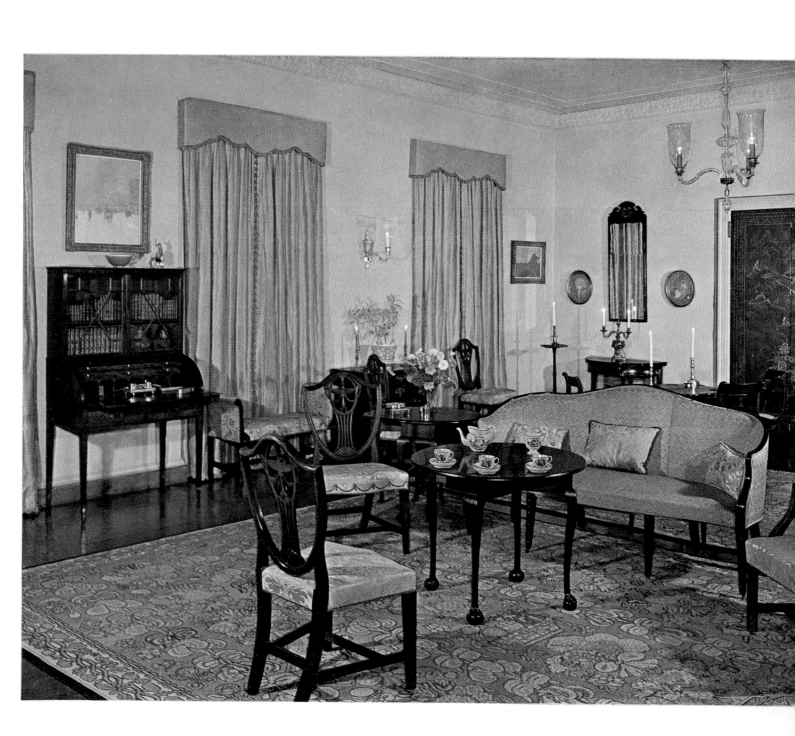

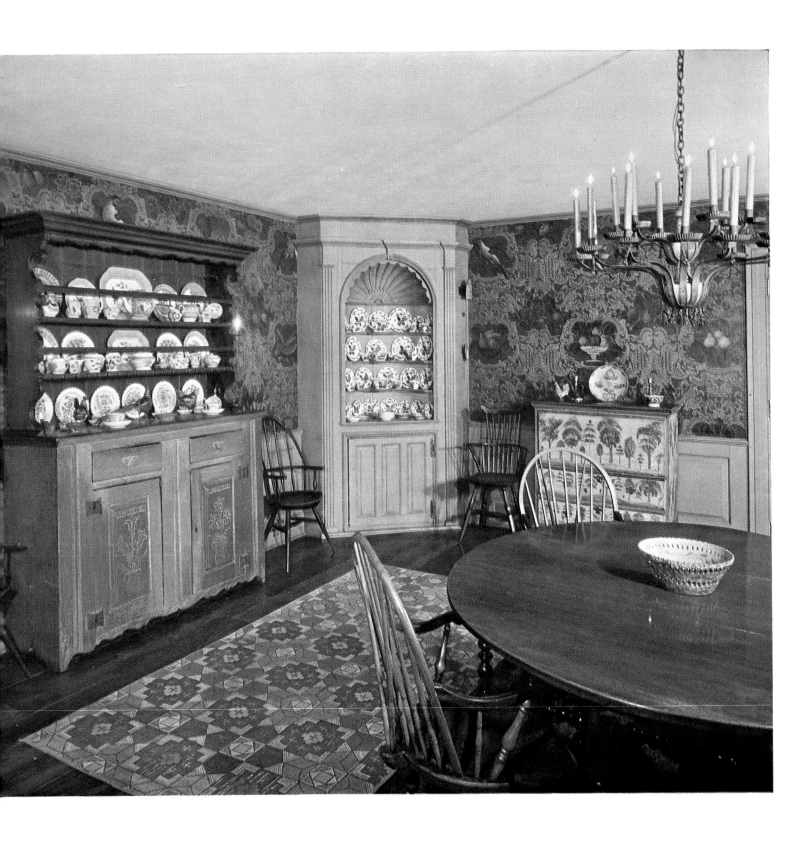

Three hundred years of American craftsmanship

Mr. and Mrs. Mitchel Taradash, Ardsley-on-Hudson, New York

FROM THE MOMENT one enters the home of Mr. and Mrs. Mitchel Taradash at Ardsley-on-Hudson, New York, one is in the midst of an outstanding collection of American antiques. Facing the front door is a fine William and Mary burl-maple six-legged highboy. With it in the entrance hall are rare Duncan Phyfe chairs with harp backs and dog-paw feet, a handsome pair of Bilbao mirrors, an unusual barometer — not to mention an early slat-back child's chair. Most imposing of all is the splendid New England chest-on-chest with *bombé* base. These pieces, in their quality and their variety, set the standard for all the rest of the house. The furniture ranges in date from the late 1600's to the early 1800's; it represents the most sophisticated of American workmanship, and also the most original and colorful of provincial types; and each example is of superior merit. The furniture is in fact a collector's collection, and it is amply complemented by the ceramics, silver, paintings, lighting devices, rugs, and other decorative adjuncts. These are all agreeably and invitingly disposed in a setting which, while not actually old, is thoroughly in sympathy with eighteenth-century furnishings of such distinguished quality.

Color plate, facing page.

In its warmth and color and informality, the Pennsylvania German room is exceptionally appealing. Though quite different from the eighteenth-century mahogany elsewhere in the house, each item here too is a significant example of its type. Old wallpaper, painted paneling, and hooked rugs provide a colorful background for country furniture and pottery — and these are colorful too. A collection of spatterware garnishes a Pennsylvania dresser which has painted floral panels, and a collection of gaudy Dutch fills the built-in corner cupboard. While these English earthenwares are a good half century later than the shelves on which they stand, their informal character is in keeping with these and with the eighteenth-century windsor chairs, painted chest, and tin chandelier, and even with the large, well-turned gateleg table which dates close to 1700. *Photographs by Gottscho-Schleisner.*

Three large dressers in the Pennsylvania German room are filled with gaily colored pottery. This one, as hinted by the gracefully scrolled side, is an attractive example in pine of rural Pennsylvania work of the eighteenth century. In it is displayed a fine array of spatterware, produced in the early 1800's by English potters to captivate the color-loving Pennsylvania "Dutch." Within the wide "spattered" or sponged border, a floral motif or a house or a peacock is rendered with telling stylization and bold sense of design. Placed in witty juxtaposition to these painted peacocks are three expressive fowl fashioned by some sympathetic Pennsylvania wood carver of the nineteenth century.

In the entrance hall an eighteenth-century Spanish floral carpet interrupts the pattern of the black-and-white marble floor. Here one is greeted by rare harp-back chairs by Duncan Phyfe and a finely figured William and Mary highboy, and one has a glimpse of further treasures in the living room beyond. One of these is a mahogany and satinwood tambour desk of the distinctive type associated with John and Thomas Seymour of Boston. Others include a Philadelphia tripod table with fluted pedestal and claw-and-ball feet, and a group of Queen Anne and Chippendale chairs from Newport and Philadelphia.

A sofa at one end of the living room has characteristic Duncan Phyfe details in the carved swags and "thunderbolts" on the back rail, reeded legs and seat rail, and gracefully curved arms with carved colonnettes. The Philadelphia Chippendale tea table in front of it is unusual in the gadrooning of the frame and the double-beaded border of the top. On the floor is a seventeenth-century Isfahan carpet of fine color and large size. Philadelphia Queen Anne chairs of the finest quality flank the splendid New England secretary with its scroll top, paneled doors, *bombé* base, and boldly carved claw-and-ball feet. The Simon Willard banjo clock has its original eagle finial. The Chippendale mahogany mirror with gilded decoration is of particularly graceful design.

Bilbao mirrors — those decorative looking glasses with pink marble frames and gilded ornament which are believed to have been brought from Spain in the late eighteenth century — are a rarity anywhere, yet in this house they are found in pairs. This pair in the living room hangs above two fine Philadelphia Chippendale lowboys. Between them a Philadelphia sofa with richly scrolled contour, formerly in the Haskell collection, faces a Philadelphia Chippendale tea table with gadrooned apron and carved knees. Claw-and-ball feet on all four legs distinguish the New England corner chair, one of several in the room. The footstool with dog-paw feet is one of a pair by Phyfe.

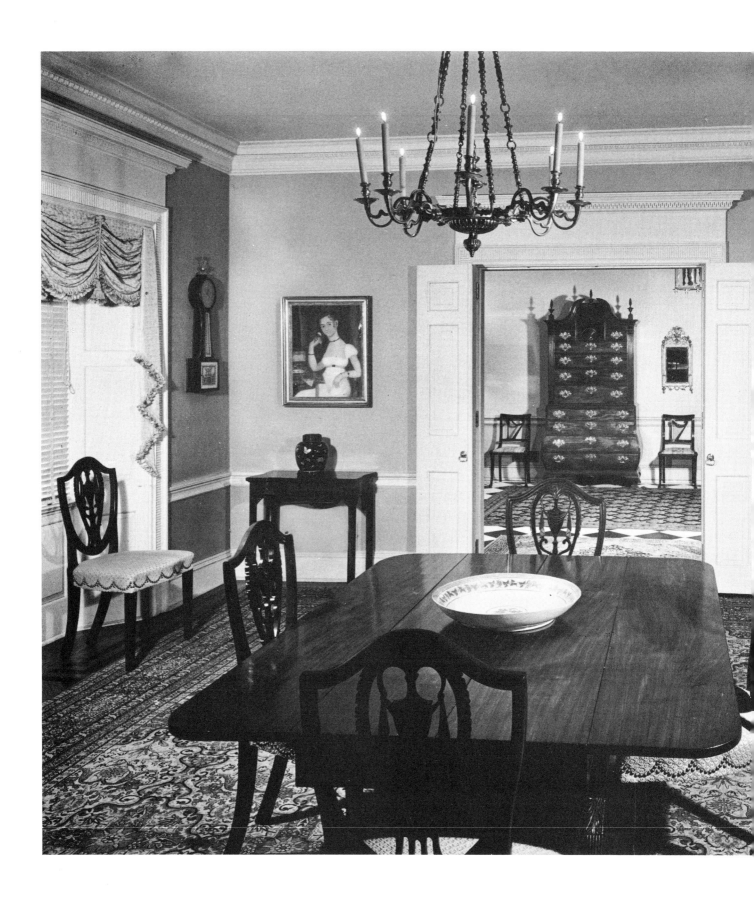

The drop-leaf table in the dining room has the richly grained mahogany and the carving and fluting on the legs that are characteristic of Duncan Phyfe. Unusually fine detail in the urn-and-swag design and the carving of their shield backs add interest to the New England Hepplewhite chairs. Above the pair of Newport card tables hang two interesting provincial portraits of the early 1800's. The large carpet with its many borders and its complex design of interlocking medallions is a Kermanshah of the eighteenth century. In the hall beyond may be seen a New England chest-on-chest with *bombé* base, a splendid example of pre-Revolutionary type.

The furniture in this room is no less noteworthy from the collector's point of view than the more sophisticated mahogany items in the living and dining rooms. It represents early colonial craftsmanship — between about 1690 and 1720 — in the gateleg table with its crisp turnings, the uncompromising Carver side chair by the door, the William and Mary highboy of New England maple, and the pine desk and chest of drawers. The Spanish-foot chairs, which retain seventeenth-century reminiscences in their turned legs while adopting the Queen Anne back splat of the early eighteenth century, have the carved crestings characteristic of the work of John Gaines of Portsmouth, New Hampshire. The painted cock on the highboy is a vigorous bit of early wood sculpture, and the tin chandelier with turned wood shaft is another gracefully designed country creation.

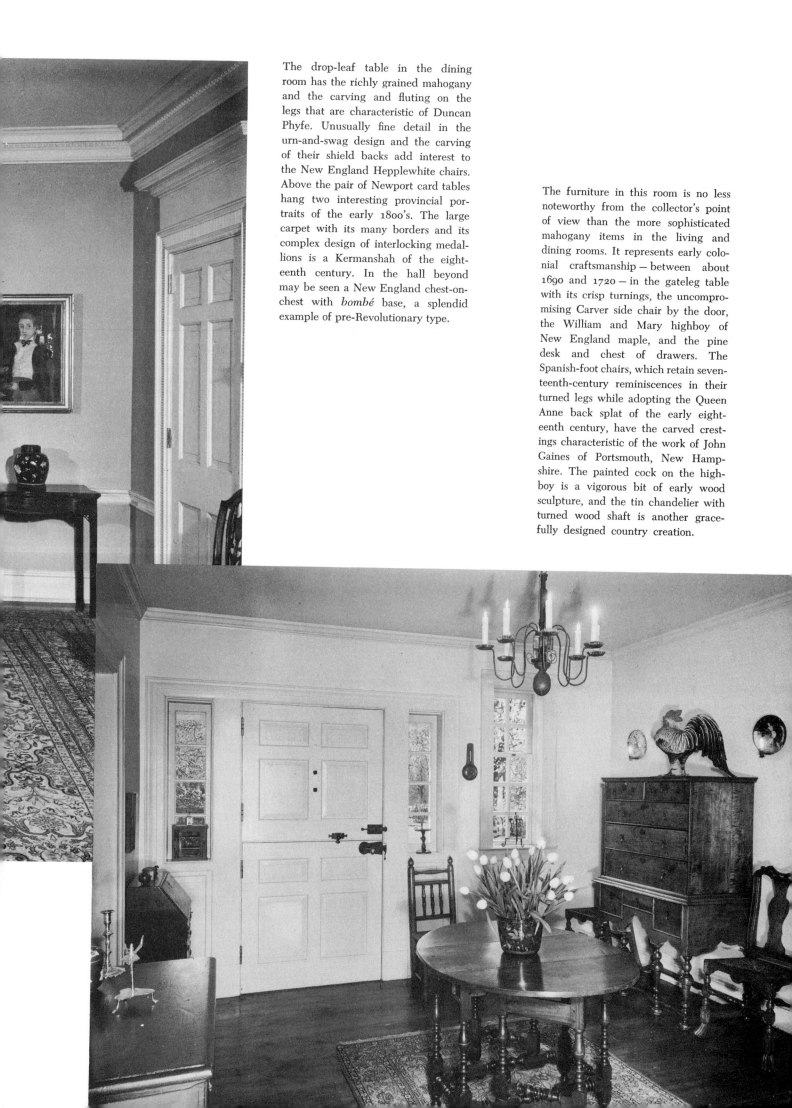

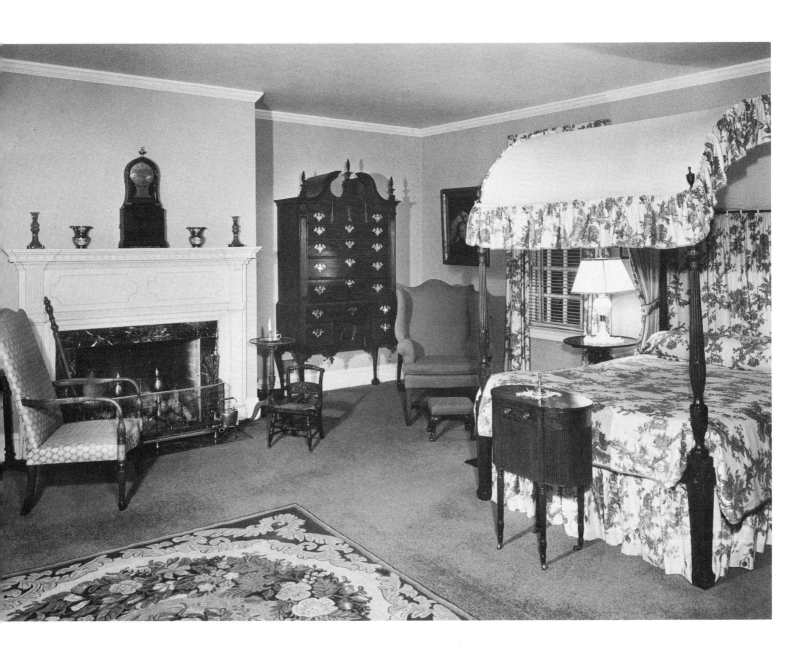

Beside the fireplace a child's Hitchcock armchair with stenciled decoration faces a Martha Washington chair of Salem origin, whose reeded posts and front legs show Sheraton influence. The field bed has reeded posts with sheaf-of-wheat carving rising from spade feet, and an arched canopy. Duncan Phyfe is believed to have made the Sheraton mahogany sewing table with tambour frame and reeded legs, while the Chippendale scroll-top highboy with claw-and-ball feet came from New England. The small claw-and-ball-foot stool in front of the New England Hepplewhite wing chair is a great rarity in American eighteenth-century furniture. Also rare is the Simon Willard mantel clock, which has a silver dial.

A large bedroom is hung with the blue-and-white resist-printed fabric which, in color and design, provides so congenial a foil to eighteenth-century mahogany, while contrasting color and design come from the large seventeenth-century Isfahan carpet. Here is another fine New England scroll-top secretary, this one with serpentine base and gilded finials. Here also is a whole group of Chippendale chests of drawers, each better than the next. The one at the left, with scrolled and carved apron, is of New York origin, and so is the Queen Anne side chair before the window. On the dainty sewing table in the corner stands a rare lighthouse clock by Simon Willard, painted white for a bride.

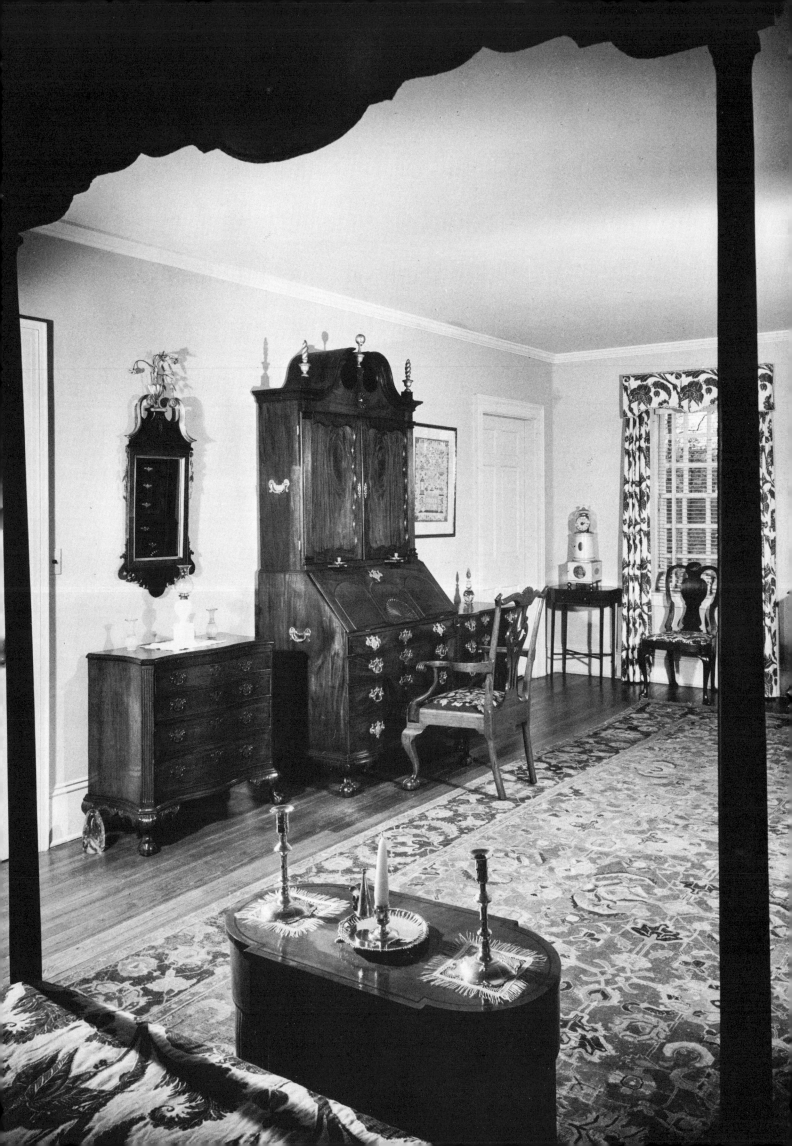

French provincial in New England

Mr. and Mrs. Frederic C. Peck, Greenwich, Connecticut

Set in rolling meadows dotted with apple trees, the house is built on a symmetrical E-plan with hipped roofs and is painted gray with white shutters, quoins, and other trim. Holly bushes in tubs stand at the entrance and fruit trees are espaliered on the side walls. Between the windows above the front door the shadow of a wrought-iron stylus, falling on painted numerals, marks off the hours. *Photographs by Taylor and Dull.*

ANY IDEA THAT the French styles are too formal, uncompromising, or exotic for our American countryside should be dispelled by these views of the home of Mr. and Mrs. Frederic Carleton Peck in Greenwich, Connecticut. In this small house, where the owners spend all the summer months and weekends in the winter, French furniture and decorations of the eighteenth and early nineteenth centuries have been chosen with a knowing eye for line and scale, and arranged against backgrounds that bring out all their color, gaiety, and charm.

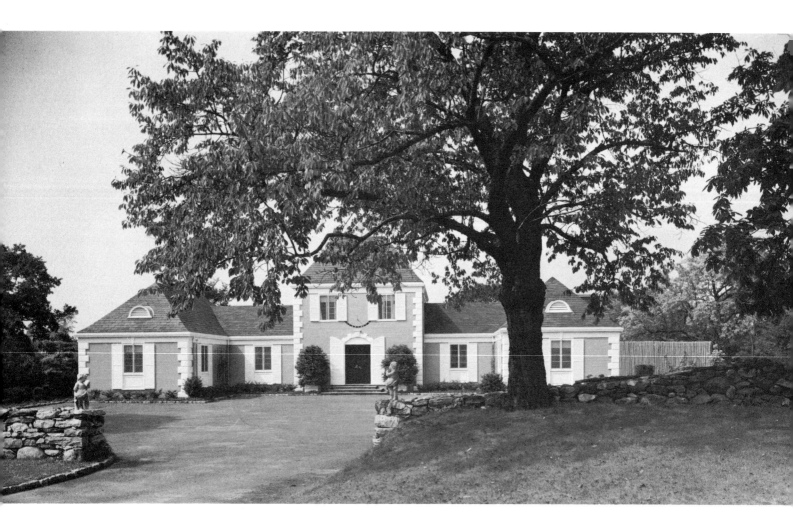

At the end of a short hallway downstairs is seen a glazed cabinet with drawers (it may have been made to hang on the wall) and a mirror in a frame carved with such symbols of felicity as a pair of billing doves, a bridal wreath, and Hymen's torch. On the cabinet stands a Baccarat figure supporting a terrestrial globe. To bring more color into this little passage, Mrs. Peck has used as floor covering a set of needlework *cantonnières* (narrow panels hung at the corners of four-post beds to cover the junction of the curtains) mounted on lengths of old tapestry dyed a deep aubergine. The light enters through ruffled curtains of apricot taffeta.

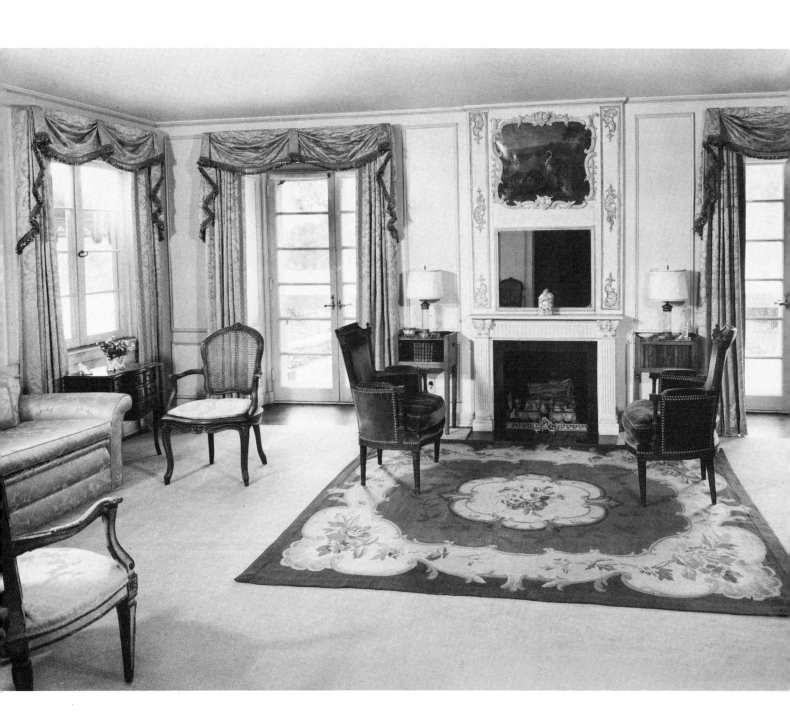

An eighteenth-century *trumeau* surmounts the fireplace in the living room. This is the piece Mrs. Peck says she "built the house around," and the color scheme of its painted panel, depicting a pair of plump white turkeys with red wattles against a leafy green background, is repeated throughout the house. In this room the walls are off-white with moldings picked out in a soft gray-green that matches the carved *appliques* of the *trumeau*; the carpet and the damask draperies at the windows and French doors repeat the gray-green color. The Aubusson rug is in several soft shades of red, from dark rose to copper, and the two Louis XVI *bergères* are covered in rust-color velvet. On the marble mantel is an unusual watch holder of Chinese export porcelain; the delicate fender in the fireplace is gilt bronze. To the left of this group, a modern sofa upholstered in gray damask is flanked by a Louis XV open-arm chair with caned back and seat and (only partly visible in the picture) a fine Louis XVI armchair, painted gray and gilded.

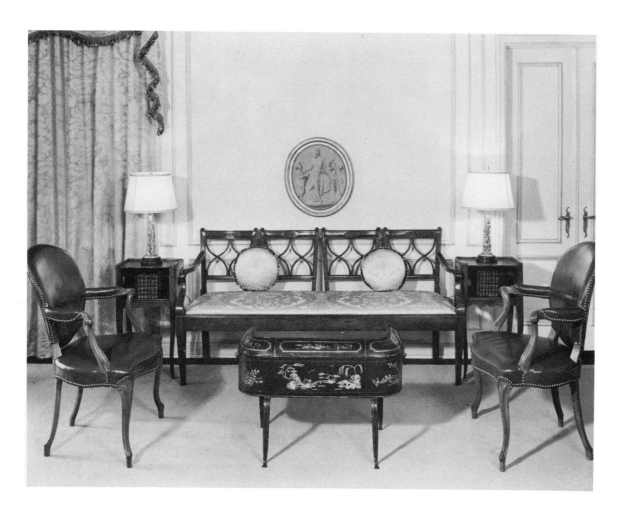

A mahogany chair-back settee, its seat covered in gray silk damask, is centered on another wall of the living room. On either side, small commodes of the type often called *tables de chevet* hold lamps made of tall, icicle-shape nineteenth-century French glass paperweights. A framed panel of needlework in grisaille hangs above the settee. The Louis XV fruitwood armchairs are covered in rose-red leather and an old tole plate warmer with chinoiserie decoration in gold on a dark red ground is used as a coffee table in front of the settee.

The capacious piece of furniture that serves as a sideboard in the Pecks' dining room represents one of the many provincial variations of the useful buffet. The top lifts up to give access to the compartment beneath it; the doors — to one of which is attached the grooved central panel — open to reveal shelves running the width of the piece.

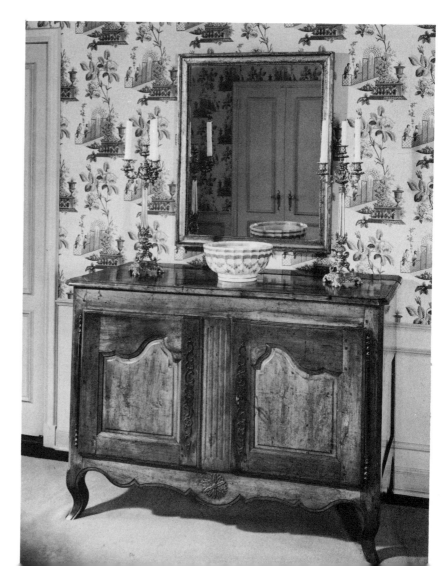

The small library on the ground floor has paneled gray-green walls with lightly gilded moldings. On one side of the room a Louis XV *canapé*, or sofa, covered in velvet of a darker gray-green has as congenial neighbors a capacious fruitwood writing table of the same period and a marble-topped *bouillotte* table with a pierced brass gallery. The matching Louis XV *fauteuils*, examples of one of the most popular, long-lasting, and generally serviceable chair styles ever evolved, are covered in green and tan striped silk. Over the sofa hangs a pair of nineteenth-century French portraits, unidentified but arresting in their old gilt frames. An antique Chinese carved and lacquered panel has been mounted on a base designed in the Louis XV style to serve as a coffee table.

On the other side of the library stands a *secrétaire à abattant* in the classical style of the early 1800's, with round colonnettes at the corners. A clock of black *tôle peinte* on the wall above it repeats the sharp contrast of the coffee table across the room. At left is an interesting painted candlestand with small, rectangular top. The damask upholstery of the *bergère* beside the table and the loose velvet cushion of the Louis XV *fauteuil* in front of the desk are the same shade of deep, reddish tan.

A fine Louis XV walnut gaming table with its elaborately shaped folding top cross-banded and covered with old needlework stands beneath a water color by the modern American artist Max Weber.

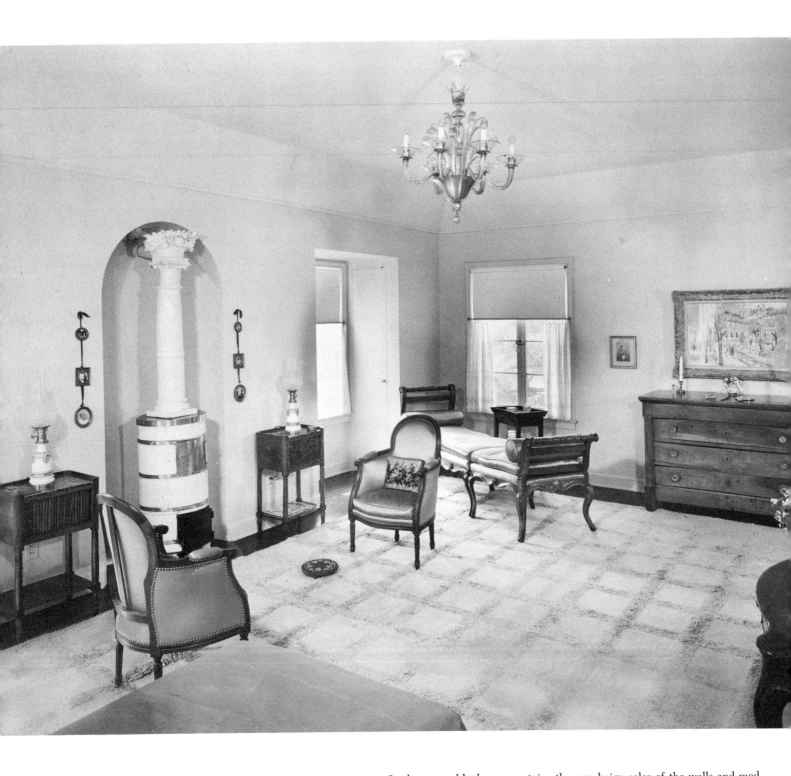

In the owners' bedroom, upstairs, the rose-beige color of the walls and modern rug set off the gleaming white faïence stove, bound in polished brass, that serves very efficiently to heat the room. On either side of the stove niche, fruitwood tables with brown marble tops and tambour fronts hold nineteenth-century oil lamps with turquoise blue and white porcelain bases. The two *bergères* are upholstered in satin of a deeper tone than the wall — almost a light copper color — and the same fabric is used on the graceful Louis XV chaise longue in two parts that occupies the corner. A small, tray-topped table like the one that stands behind this piece is often called in French a *vide-poches* — something to empty your pockets on. The chest of drawers at right is a provincial version of the Empire style; its color brings it into harmony with the other fruitwood pieces in the room. The small pillows in the two chairs and the footstool on the floor between them are nineteenth-century beadwork.

Wallpaper printed with a bold design simulating drapery dramatizes the guest bedroom without dominating the furniture that stands before it. The colors in the paper are gray, green, white, and a soft rust-red which is carried down over the baseboard. Two Louis XVI armchairs with medallion backs, upholstered in green satin with a white dot (counterpoint to the wallpaper, which has green dots on a white ground) are set before the window with a cabinet in the form of a miniature *armoire* between them. At right is a Directoire marble-topped mahogany commode with satinwood banding. The gilt-bronze wall sconces are designed as winged figures; beneath them are old painted screen fans propped up on their long handles. At left, a black-painted hanging shelf holds a collection of paperweights and other bibelots above a marble-topped table. Under the near window is a delicate little eighteenth-century *bureau de dame* with cylinder top.

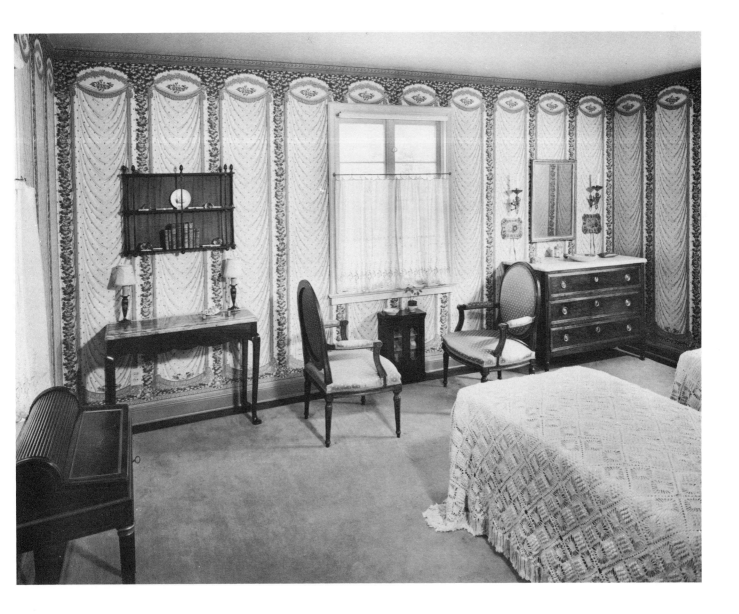

Edward Hicks heirlooms

Mr. and Mrs. J. Stanley Lee, Newtown, Pennsylvania

NEWTOWN IN BUCKS COUNTY, Pennsylvania, is a quiet town in the middle of rich, rolling farmland which has changed little in the past two hundred years. The township lands were purchased from the Indians in 1682 but first settlement was not made until the end of the century. The town gained fame during the Revolution as the headquarters from which Washington launched his fateful Christmas attack on Trenton. Today, it has added renown as the home of Edward Hicks, Quaker preacher and painter, whose distinctive primitive paintings began to attract national and international attention in the 1930's, almost a hundred years after his death.

Descendants of Edward Hicks live in Newtown today, not far from the house he built in 1821, which remained in the family until a few years ago. Cornelia Carle Hicks, a great-granddaughter, who was the last member of the family to own it, lives nearby with her sister and brother-in-law, Mr. and Mrs. J. Stanley Lee. Collectors themselves, they cherish the letters, documents, furniture, paintings, and tools that belonged to the man who was to become one of America's best-loved nonacademic painters. Their house is filled with treasures which have been handed down through generations of the Hicks family — from the will of Edward's grandfather Gilbert, to the high chair used by Edward's own children and grandchildren.

Edward Hicks was born in what is now Langhorne,

Pennsylvania, in 1780. His father and grandfather were royalists and had both served the crown. The Revolution and the death of Hicks' mother scattered the family, and young Edward was adopted and brought up by a Quaker family named Twining. His father wished him to become a lawyer but Edward was apprenticed to a coachmaker where he developed a skill at painting and lettering, and after completing his apprenticeship he continued at his craft. In addition to signs he painted fireboards and coaches, and by 1818 was listing landscapes in his ledger. Painting and preaching were his main activities for the next thirty years. He was a favorite speaker at Quaker meetings and traveled widely to take part in the services of Friends. All this time he was painting; sometimes he sold his work, at other times he gave it away. He is believed to have made over one hundred versions of *The Peaceable Kingdom*, and a study of these reveals a great deal about his progress as an artist. In the last ten years of his life he produced his most important landscapes, including *The Residence of David Twining* and other farm paintings; *The Grave of William Penn*; and additional versions of his favorite subject, *The Peaceable Kingdom*. The last of these was intended for his daughter Elizabeth, and he was working on it when he died in 1849. The painting hangs today in the dining room of the Lee house in Newtown, not far from the site of the shop where it was painted.

The red brick house in Newtown, Pennsylvania, built in 1836, which Mr. and Mrs. J. Stanley Lee have lived in for over forty years. The house is not far from that built by Mrs. Lee's great-grandfather Edward Hicks. *Photographs by Allan W. Brady.*

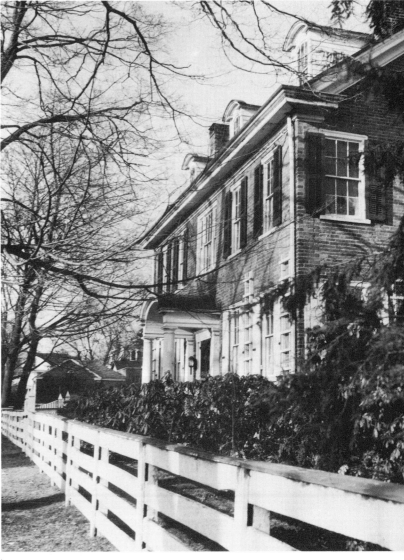

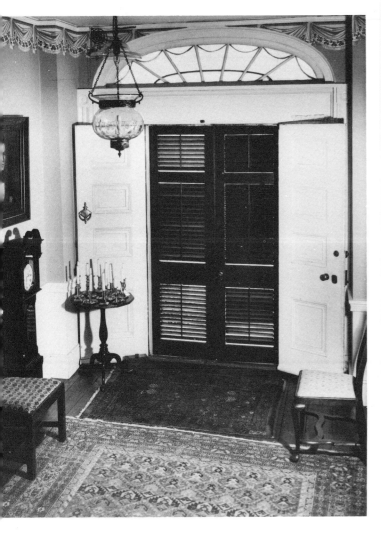

In the spacious hallway hangs a portrait of Isaac W. Hicks by Edward's cousin Thomas, who was to become a successful portrait painter, far better known in his day than the Quaker artist. The walnut chair is one of a set of six mentioned in the will, dated June 28, 1777, of Gilbert Hicks, Edward's grandfather. Against the opposite wall is another Hicks piece, one of a set of six chairs which belonged to Edward's wife, Sarah Worstall. The pine doorstop was made in Hicks' shop.

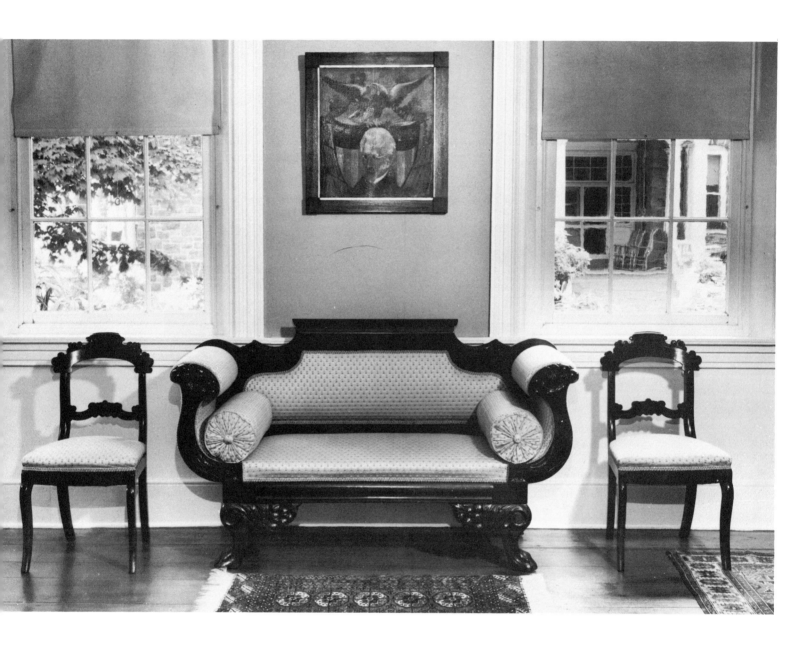

The painting, on carriage-curtain cloth, was copied with variations by Hicks from an engraving by Thomas Illman after one of the numerous portraits of Andrew Jackson painted by Ralph E. W. Earl (c. 1785-1838). It hangs in the living room over a small rosewood sofa with the heavy naturalistic carving and exaggerated scrolls of the late Empire style. This sofa and the two rococo-revival side chairs (c. 1850) came from the family of Mrs. Lee's and Miss Hicks' grandfather, Stacy Brown of Brownsburg, Pennsylvania.

In a corner of the dining room stands the mahogany grandfather clock with painted dial mentioned in Gilbert Hicks' will. The Philadelphia mahogany side chair with shell carving, beside it, came from Graeme Park, home of the royal governors; it was given to Edward's son Isaac Worstall Hicks and his bride, Hannah Penrose, who were married at Graeme Park in 1857. The silver candlesticks, brass and iron andirons, and fire tongs belonged to Edward Hicks. Above the fireplace is the last picture painted by the artist. One of over a hundred versions of *The Peaceable Kingdom*, it was intended for his daughter Elizabeth.

The old kitchen of the Lee house is now a charming breakfast room with many Hicks pieces. The maple hutch table, convertible to a settle, was used by Hicks' apprentices in his shop. Also from the shop are the copper kettle on the hearth and the mortar and pestle in the window (the latter was used to grind paint). The windsor armchair with bamboo turnings, painted a soft gray, is one of a set of two arm and six side chairs, a wedding present to Edward Hicks and Sarah in 1803.

In a small guest room over the old kitchen are many more reminders of Edward Hicks. The painted slat-back armchair (mounted on rockers at some later date) was decorated by the painter with the distinctive geometric outline which he used often on picture frames and which also appears on the tole tray here, which he painted. The high chair was decorated by him, and the table was used in his house. The sampler with its precise depiction of a Georgian house and formal gardens was worked by Hannah Jarretts, who became the mother of Isaac's wife, and is dated 1798.

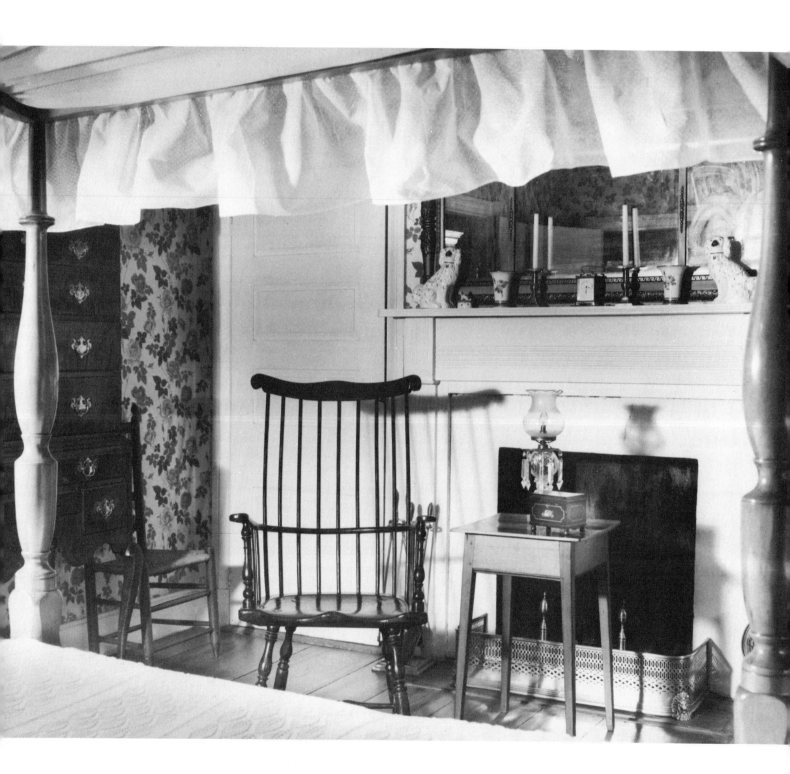

In Mrs. Lee's bedroom are Edward Hicks' canopied bed
of pine and sycamore and the black windsor comb-back
armchair in which he sat for his portrait by Thomas. The
small table and the slat-back chair in the corner were
also owned by the painter, who made and decorated the
black box on the table for his daughter Mary.

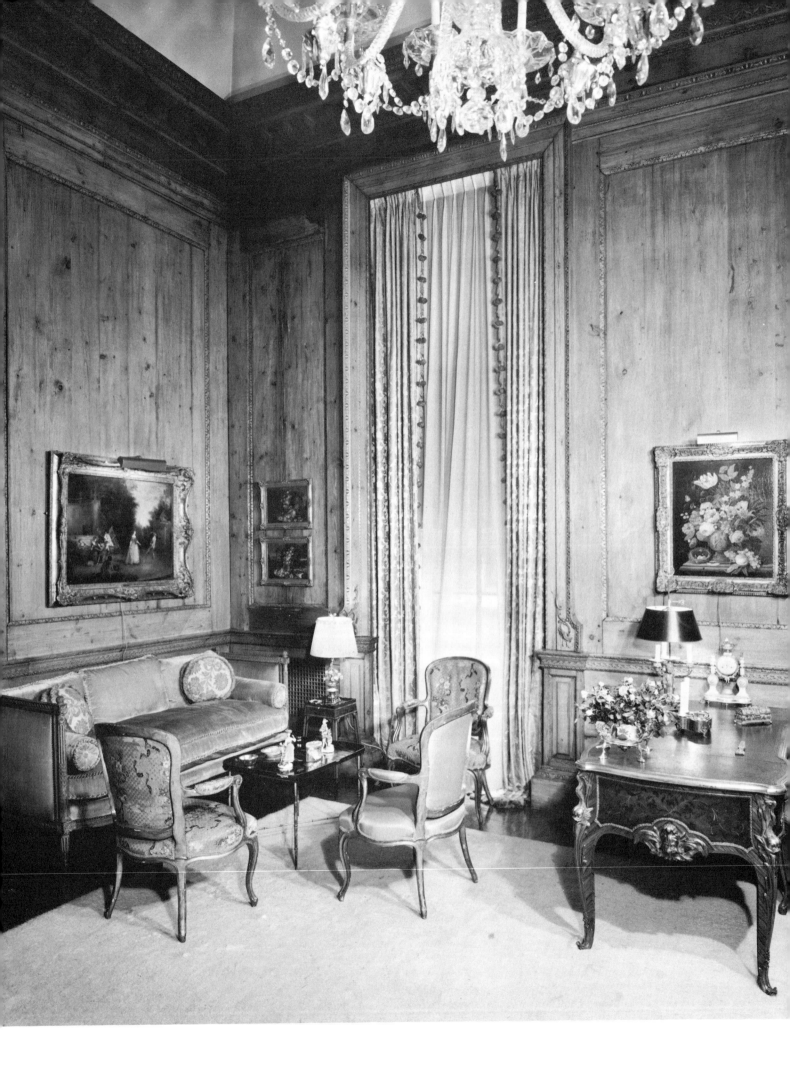

Period pieces and paneled rooms

Mr. and Mrs. Leslie R. Samuels, New York City

IN THIS DAY OF DEMOLITION and new building few city dwellers—few people anywhere, for that matter—are able to provide an antique background for their antique furniture and decorations. More often than not, a Georgian secretary or a Louis XV commode or a Goddard blockfront chest will of necessity be placed against a bare wall and overhung by steel beams scarcely disguised by plaster and paint. Antiques can, of course, be quite at home in a modern setting, but they are at their best in the kind of room for which they were made. So that pervasive cloud of demolition shows its silver lining when fine old architectural elements from razed buildings find their way into the homes of collectors. Georgian paneled rooms and French *boiseries* installed in a city apartment relieve it of stereotyped modernism and give it richness and distinction.

Such is the case in the New York City home of Mr. and Mrs. Leslie R. Samuels. For twenty-five years the owners have been collecting choice antiques from many parts of the world. Their first love was English things of the Georgian period; gradually their interest spread to

French and other Continental antiques of the same era. In time they developed too an enthusiasm for the arts of China, just as did the people of the eighteenth century, and they added early Chinese ceramics as well as lacquer work and sculpture to their collection. European chinoiserie in various forms also attracted them, and, as might be expected, Oriental porcelains and paintings made for export to the Occident. They have, for instance, a China Trade dinner service of three-hundred-odd pieces with armorial decoration executed in *famille rose* colors. While many of their pieces are elegant if not sumptuous, they also have a keen fondness for the charming and often naïve earthenware of eighteenth-century Staffordshire: their large group of Ralph Wood pottery figures is an important collection in itself.

A decade or so ago Mr. and Mrs. Samuels acquired a Park Avenue triplex apartment which they felt provided the ideal setting for their large and varied collection. Some years earlier, it had been occupied by another collector of European antiques, who had installed in it one of the finest seventeenth-century English pine rooms ever brought to this country, as well as Georgian architectural elements, early French polychromed *boiseries*, parquet floors, and rare Chinese painted wallpapers. This luxurious background emphasizes and enhances the quality of the Samuels collection, and here its owners enjoy living with their antiques in an old-world atmosphere remote from the hubbub of the encircling city.

Facing page.

At one end of the long drawing room, three Hepplewhite armchairs in the French taste are at ease with a Louis XV marquetry desk, or *bureau plat*, which has gilt-bronze mounts and leather top. The small marble and gilt clock on the desk is signed on the dial by the maker, J. A. Lepaute of Paris (1709-1789). Above it hangs a Dutch flower painting by Jan van Os (1744-1808); the other paintings are a pair of still lifes by Giovanni Nanni (1487-1564) and, over the sofa, a *Fête champêtre* by Bonaventure de Bar (1700-1729). *Photographs by Taylor and Dull.*

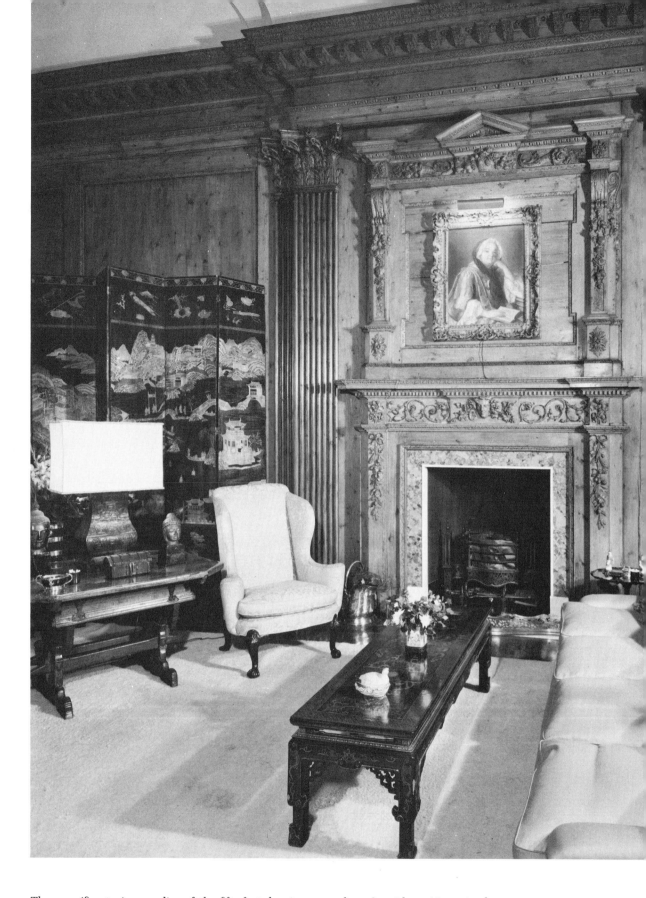

The magnificent pine paneling of the fifty-foot drawing room, from Spettisbury Manor in the west of England, has the classical dignity of the finest seventeenth-century work in its elaborately carved cornice, Corinthian pilasters, and chimney breast ornamented with cornucopias, garlands, scrolls, and a mask in the center of the mantel. The portrait of a lady above the mantel is a pastel by Maurice Quentin de la Tour (1704-1788). Against the mellow background of the paneling, the rich dark lacquer and mother-of-pearl inlay of a pair of six-panel Coromandel screens make pleasing contrast. On the octagonal top of the heavy trestle-base oak table are Cambodian bronze heads, and on the Chinese black lacquer table the nesting partridge is one of a pair in Chelsea porcelain.

Such a paneled room as this drawing room calls for furniture that is not only ample in scale but architectural in character, like the handsomely carved early Georgian looking glass here and the gilded marble-topped table below it, both of which show the influence of the architect-designer William Kent (1686-1748). The English Queen Anne chairs (c. 1715), with carved scrolls framing their backs and with outthrust back legs, have their original tapestry coverings in greens and browns. The lamp is made from a K'ang Hsi *famille verte* vase (late seventeenth century); it is flanked by a pair of Worcester porcelain covered vases in white, pierced and ornamented with applied flowers and masks (c. 1768-1770).

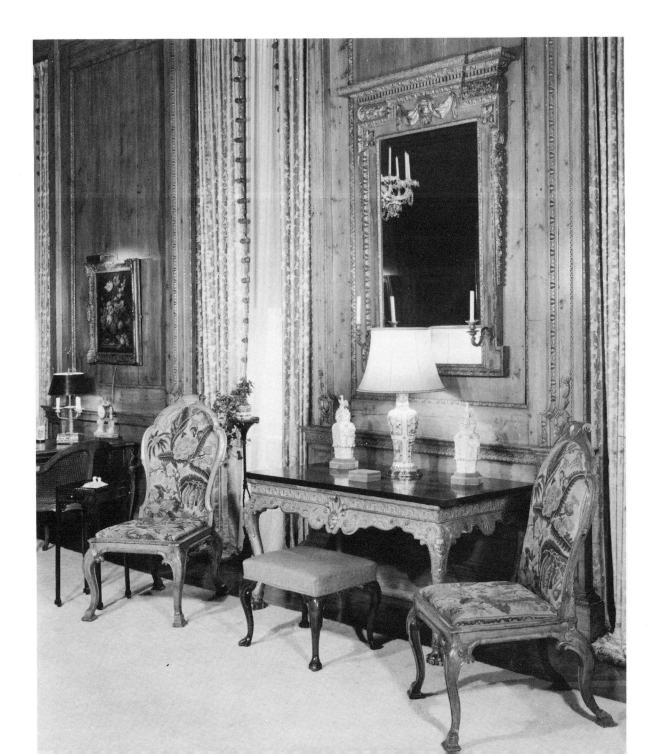

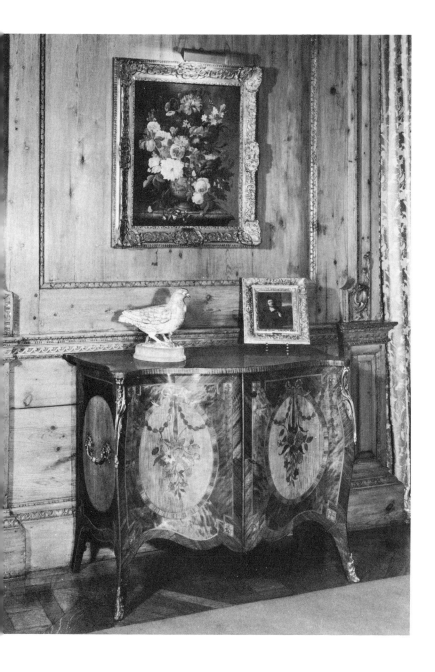

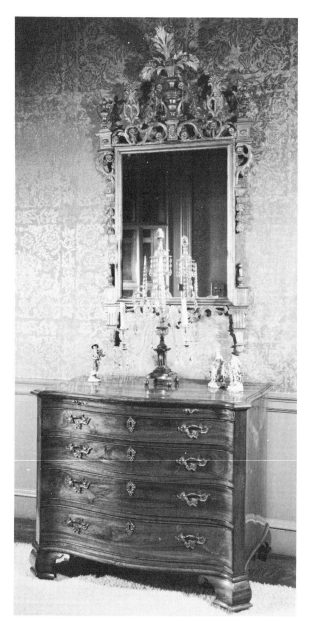

A mahogany and satinwood marquetry commode (c. 1770) in the drawing room is one of a number of pieces in the Samuels collection that exemplify the skill with which English craftsmen interpreted the Louis XV style. Its considerable mass is disguised by its serpentine form, and its graceful curves are accented by ormolu mounts and handles. The pigeon on its top is a tureen of Strasbourg faïence by Paul Antoine Hannong (c. 1750) that appears as soft as feathers. The portrait of a divine is by Karel de Moor (1656-1738); above hangs another flower painting by Van Os.

In contrast with the commode in the French taste, the "commode chest of drawers" — as Chippendale called the form — appears unmistakably English; yet it shows French rococo influence in the brasses, and possibly too in the unusually curved bracket feet (c. 1760). It is of sabicu, a dark brown West Indian wood rather like mahogany in texture. The carved and gilded mirror is Italian. The porcelain figure at left is Meissen, modeled by Kändler (c. 1750), and those at the right are Chelsea and Derby.

Along the sweeping stairway that rises from the entrance hall hang portraits by Henri Pierre Danloux (1753-1809) and John Hoppner (1758-1810), and at its foot stands a George II walnut wine cooler in the form of a giant goblet, carved with leafage and incised with a Bacchanalian scene. The black lacquer Adam chair is one of a set of four. In the bookcase may be seen a part of the extensive Samuels collection of English earthenware figures, which comprises most of the well-known models by Ralph Wood; among the rarities are a figure of the Duke of Cumberland, an exceptionally good St. George and the Dragon, an extraordinary cockerel, a man and woman of unusual size, and an excellent Hudibras.

On the stair landing, Irish glass wall brackets, each with corona and festoons of faceted drops, sparkle on either side of a choice Adam oval mirror with carved and gilded decoration of plumes, ribbons, and festooned husks (c. 1770). The neoclassic delicacy of the Adam console, which is carved, white-painted, and gilded, is balanced by the solidity of the mahogany Chippendale chairs (c. 1760). Chelsea figure groups stand on either side of the English marble and ormolu clock of the late 1700's.

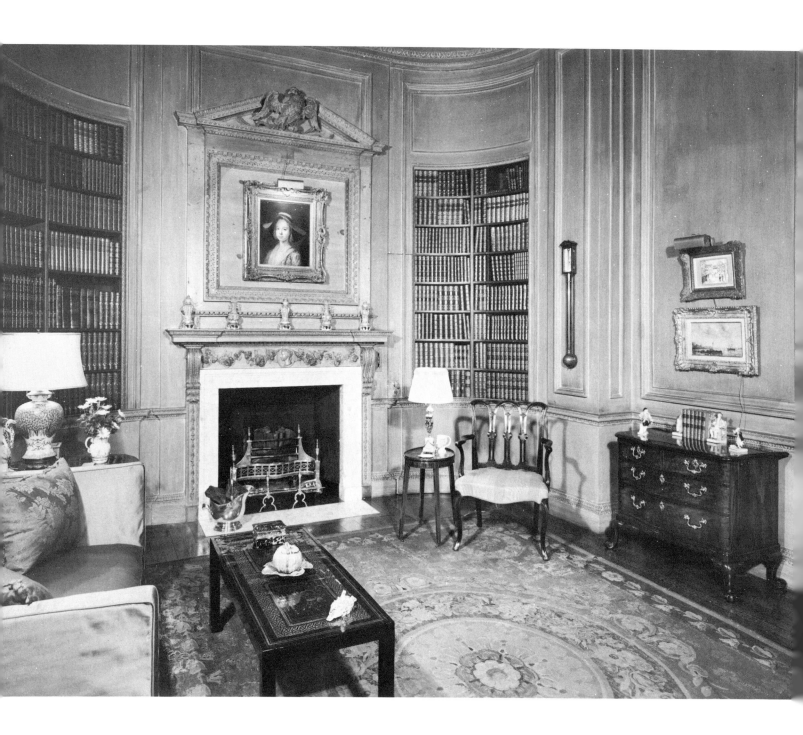

In the library the pine paneling with its handsomely carved detail came from England, the mantel from an early Georgian house in London's Grosvenor Street. Both ends of the room have curved sections; those beside the fireplace are filled with bookshelves which, on the right, conceal a door. The painting hung in the overmantel panel is attributed to William Hogarth (1697-1764) and is believed to portray the artist's daughter. The K'ang Hsi mantel garniture of the late seventeenth century is a rarity for the small size and the "bamboo" forms of its five pieces, decorated in yellow, greens, and aubergine. The Hepplewhite armchair (c. 1770) shows French influence in its delicate cabriole legs, as does the Chippendale mahogany commode (c. 1765) in its rococo brasses and unusual scroll feet. Soft shades of rose and blue in the Louis XVI Aubusson rug lend mellow warmth to this harmonious room.

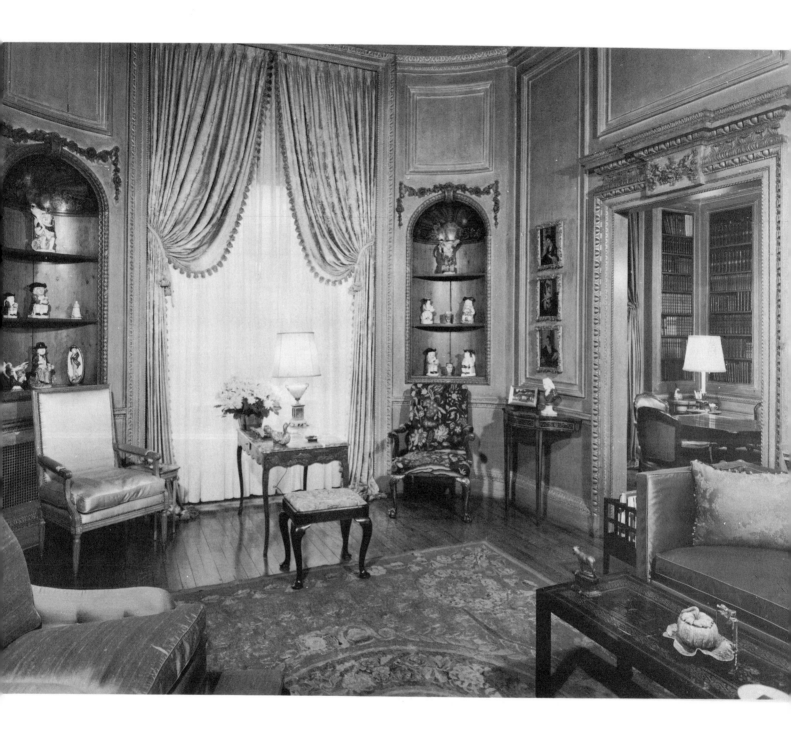

At the other end of the library arched cupboards framed by carved swags are fitted with shelves and decorated at the top with painted shells, flowers, and masks. Here are displayed further examples from the Samuels collection of English eighteenth-century earthenware — these a group of toby jugs, mask jugs and mugs, and Bacchus jugs. On the wall may be seen three of a set of six gilt-framed Chinese paintings on glass (c. 1765), portraits of English ladies after such artists as Reynolds and Ramsay. The elegant little console below them (c. 1785), formerly in the Leverhulme collection, is cross-banded in mahogany over gray sycamore and ornamented with inlaid paterae, stringing, and marquetry. The needlework on the George I armchair is contemporary.

Two rooms with painted woodwork, installed by a former owner of this apartment, came from the Château de Courcelles in the department of Sarthe, in northwestern France. With their heavy oak-beamed ceilings and paneled walls richly ornamented with polychromy, now muted in tone, they are rare examples of Louis XIII *boiserie* (1610-1643). In the so-called medallion room (below) two French walnut stools with needlepoint coverings have the intricately turned legs and stretchers of fine seventeenth-century work. The high-back "nursing chair" with rolled arms and turned legs is one of a seventeenth-century pair, while the white-painted chairs at the right, in their original needlework upholstery, are from a Louis XVI set of four. The other polychromed room is shown on the facing page.

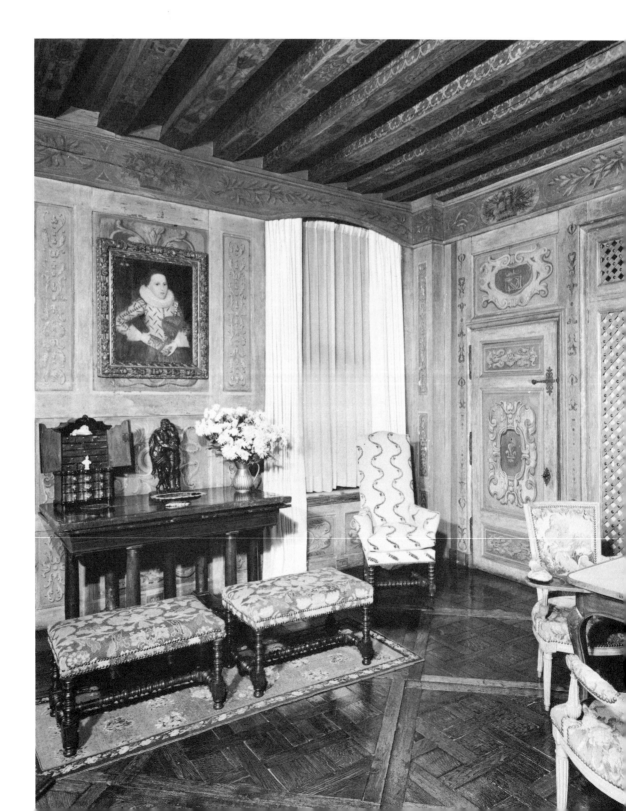

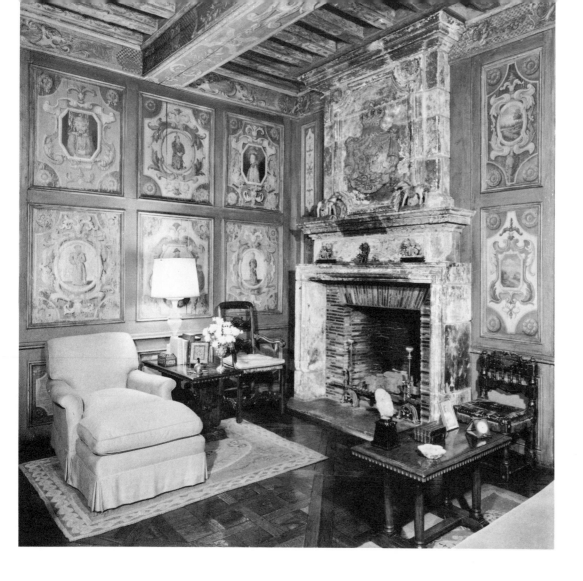

In this polychromed room, an early example of French chinoiserie, all the panels are different and each frames a "Chinese" portrait or scene. The heavy stone mantel with its carved armorial device is also painted. Even the bricks, long and thin, are of the period, though not from the same source as the room. The ornaments on the mantel are T'ang roof tiles and Ming pottery figures.

In the hallway between drawing room and dining room, a spinet signed *Baker Harris Londini Fecit 1763* forms the center of a harmonious group; its graceful mahogany case, ornamented only with line inlay and cross-banding, rests on a simple stand. The slip seat of the Queen Anne walnut stool is covered in fine early needlework. Above the unusually delicate mahogany *torchère* of the Hepplewhite period, one of a set of three, hangs a Victorian mechanical bird in a gilded cage, and on the wall above the spinet is a carved and gilded festoon of trophies, one of four in this hall made in France in the eighteenth century. The candlesticks are of Irish cut glass, hung with faceted drops.

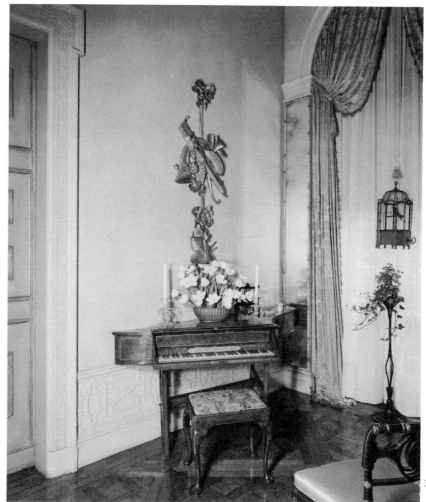

The Louis XV *boiserie* in the bedroom is painted a soft gray, and a Louis XV Aubusson rug on the parquet floor adds shades of blue, green, rose, beige, and brown. The bed is upholstered in French eighteenth-century painted linen and covered with a quilted cotton bedspread of the same period. In the corner is a *secrétaire à abattant,* or fall-front desk, by Simon Guillaume (1751-1782). Bits of Sèvres porcelain, French bibelots, and Meissen flowered wall brackets add accents of color.

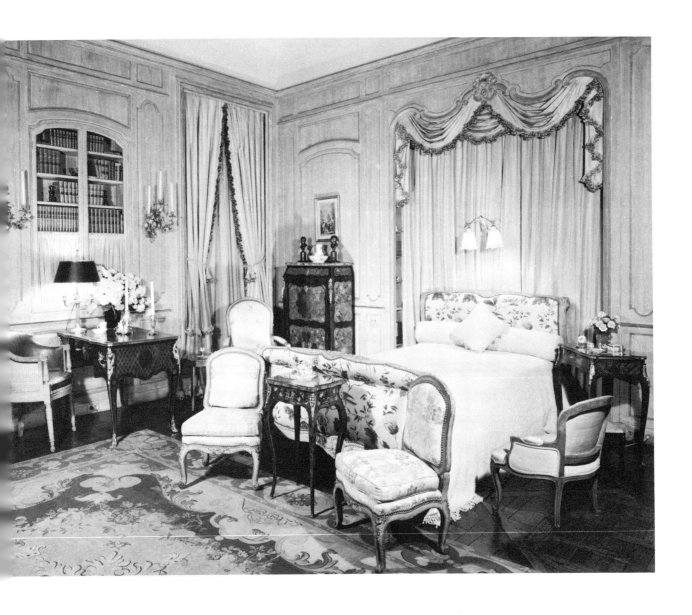

Connecticut salt box

Mrs. C. McGregory Wells Jr., Stafford Springs, Connecticut

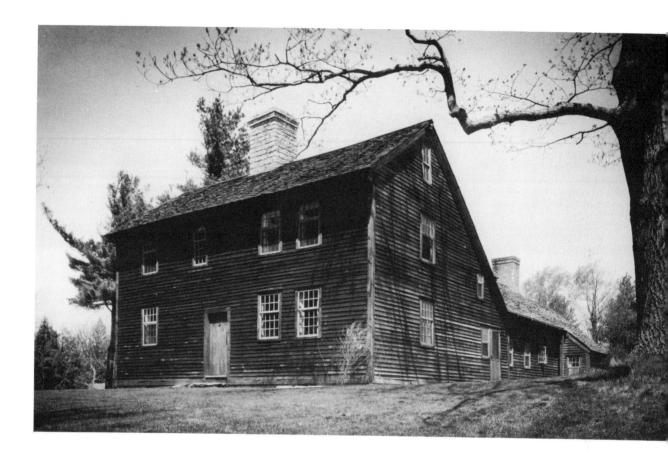

The house was moved to its present situation from Shoddy Mill Road in Andover, Connecticut. A typical lean-to, or salt box, to use the more colorful term, it has a central chimney — of stone, as is usual in Connecticut — and is covered with riven oak clapboards. The door is battened, and the early doorway simply framed without moldings; a molded fascia, or facing board, boxes in the ends of the eaves. The fenestration is unusual; Connecticut houses of this type more often have either five or nine windows, symmetrically arranged. As you approach the house today it looks as solitary and self-sufficient as it must have appeared in the early eighteenth century; such modern installations as garages, a swimming pool, and an ell with guest rooms are all but invisible, so well has the site been planned. *Photographs by Robert J. Kelley.*

ON A GRASSY HILL that rises in the woods near Stafford Springs, Connecticut, is the home of Mrs. C. McGregory Wells Jr., an early Connecticut salt box furnished with seventeenth- and eighteenth-century antiques. Though these pictures bring out the high quality of the furniture and the interest of the house itself, they can only suggest some of the other reasons why this house is noteworthy: the taste and discrimination with which the rooms are arranged but not overfurnished, for instance, and the fact that a large part of the furniture was made in Connecticut. Though Mrs. Wells married into a family of collectors, her own serious interest in antiques is a relatively recent development, and these pictures show what she has achieved in only eight years or so.

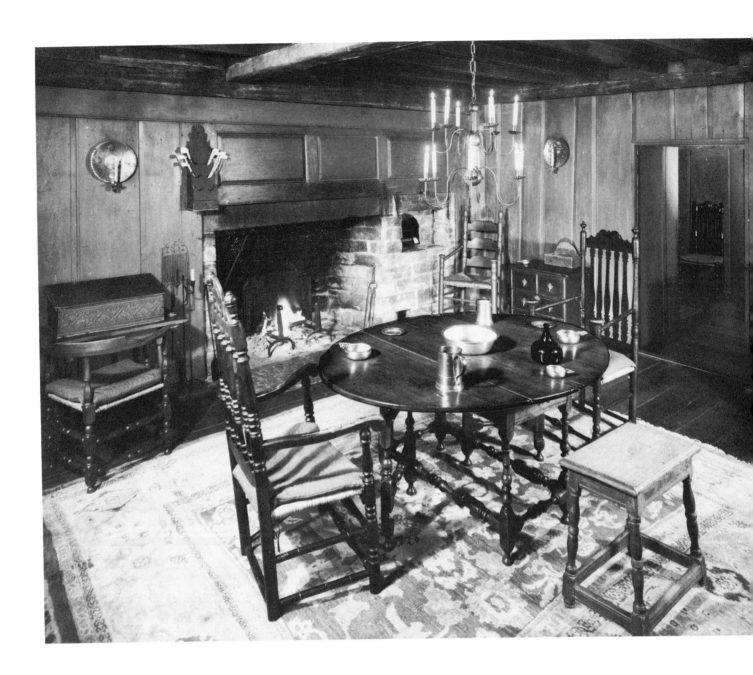

The main living room, like most of the rest of the original house, still has its old sheathing, with bead-and-bevel sections at the vertical joints and panels over the fireplace. As in other rooms, it is stained an old red that welcomes both sunshine and firelight. The furnishings recall a description of the typical colonial interior in a recent book on American architecture: tables, stools, and chairs, in not too great numbers, little upholstery, a few chests, and many boxes to preserve salt, tobacco, candles, and pipes, as well as to house the Bible. A fine Rhode Island gateleg table is surrounded by banister-back chairs, of which Mrs. Wells has a large and interesting collection, and a Connecticut joint stool, one of two in the room. Two early Connecticut chests, the smaller, painted black, from Guilford, and the other from Avon, stand near the door in this picture, and at the other side of the fireplace, on a small table, is a carved Bible box.

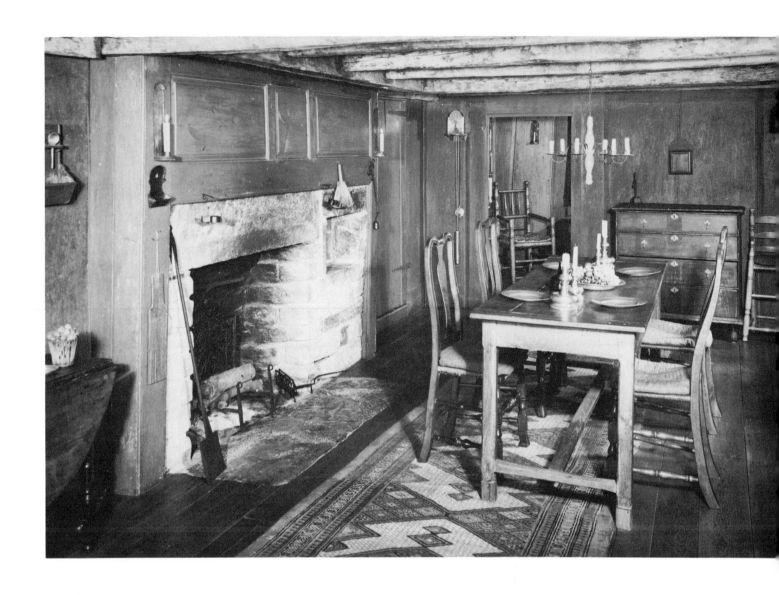

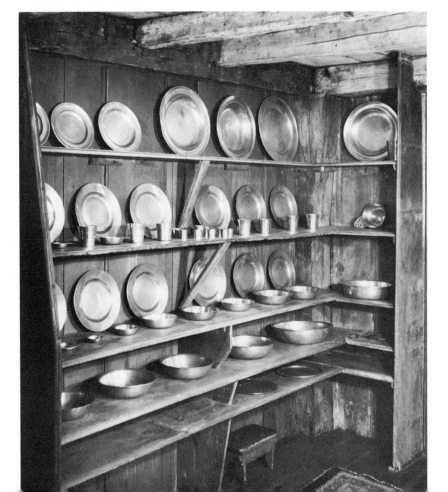

A brass "wag-on-the-wall" clock marks time in the dining room. At the right of the ball-foot chest, a child's turned, slat-back chair stands like another reminder of passing time in this quietly inviting room. Chairs with Spanish feet, turned stretchers, molded back stiles, and carved and molded top rails represent the transition from seventeenth- to eighteenth-century styles. The seventeenth-century pewter candlesticks on the table are part of a large collection of early American and English pewter that is attractively displayed on open shelves at the other end of the room. The exceptional width of the sheathing is seen in this picture.

In the lower bedroom, white plaster walls and blue woodwork are a foil for the painted six-board chest and the old red and white check curtains at the head of the folding bed. The bedcover is an embroidered blanket from Southbridge, Massachusetts.

In an upstairs bedroom, the wide sheathing was left unstained because of the faint design imprinted on the wood by wallpaper that may have been applied as long ago as the eighteenth century. Two drawings of ships, scratched on the wood, also came to light when the modern coverings were removed. An early blanket chest with unusual turned feet, one of the most picturesque of the banister-back chairs, and a corner of one of the linsey-woolsey coverlets used throughout the bedrooms are seen in this view.

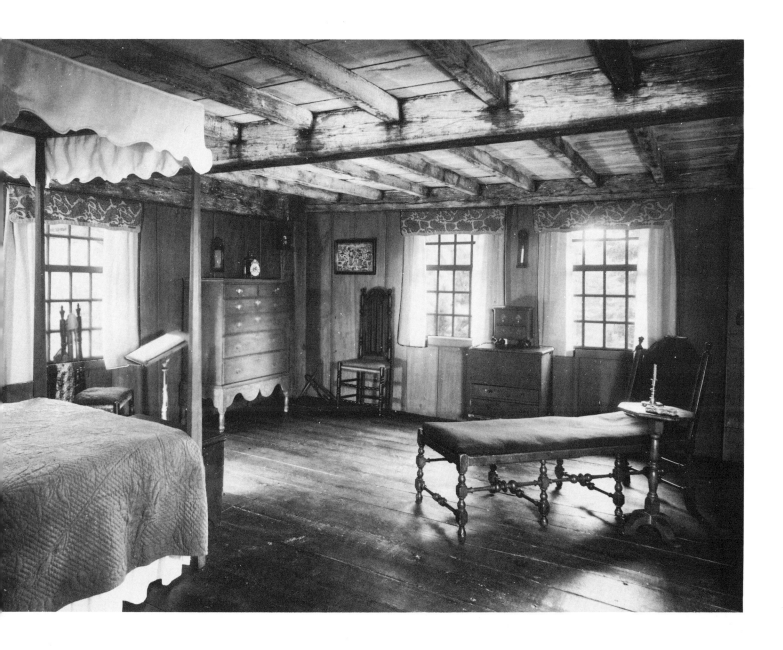

Several of the choicest pieces of furniture are in Mrs. Wells' bedroom up-stairs. The late seventeenth- or early eighteenth-century day bed is illustrated in Nutting's *Furniture Treasury* (No. 1603). The miniature ball-foot chest that stands on a small blanket chest with feet of the same shape is — under-standably — one of its owner's greatest favorites. A typical Connecticut country piece is the tall chest with deep, shaped apron and turned feet. As in all the other rooms of the house, structural elements — here, the summer beam carrying the joists, the corner posts, and the chimney girts — have been left exposed with excellent effect.

Lakeside *pavillon*

Mrs. Lowe Fallass, Cross River, New York

FOLIE DU LAC, the home of Mrs. Lowe Fallass in Cross River, New York, is the achievement of a lifetime of collecting. In this charming lakeside *pavillon* are brought together superb French paintings, drawings, sculpture, and furnishings of the eighteenth century which Mrs. Fallass began to acquire in Paris in the 1920's and has added to ever since. Some of them have adorned three houses in France which she owned at various times.

Just before World War II, Mrs. Fallass returned to the United States bringing many of her cherished possessions with her. Here she built Andelys, a house also at Cross River, which she named for the Normandy village where she had a *manoir*. It contained many pieces of provincial furniture and achieved a gracious rustic charm.

Gradually Mrs. Fallass added more formal pieces to her collection, from such outstanding collections here and in France as the George Lurcy, the Thelma Chrysler Foy, the Touzain, Bickert, Condé Nast, and Renard, and she conceived the idea of building a French house which would provide a more suitable setting. After years of studying French eighteenth-century architecture, it was she who chose the details of the exquisite small house which she calls *Folie du Lac*. The classical façade is crowned with balustrades and urns. On the garden side of the house a broad terrace is bounded by four columns supporting eighteenth-century stone *putti*. In summer, white peacocks stride about here and on the steps leading down to a large artificial lake where black and white swans sail by. The park surrounding the house is planted in the French romantic manner of the late eighteenth century.

Inside the house old painted *boiserie*, with parquet and marble floors, provides the perfect setting for the treasures it contains, and these works of art are arranged with the apparent ease that is itself an art. Some of the woodwork was brought from France by Mrs. Fallass; some has been added in this country. A subtle mastery of color is evident in every room, with frequent variations introduced through the use of massed flowers and green plants. It is unusual in this country to see a French collection installed in a landscape and architectural setting which so fittingly enhance the beauty of each piece.

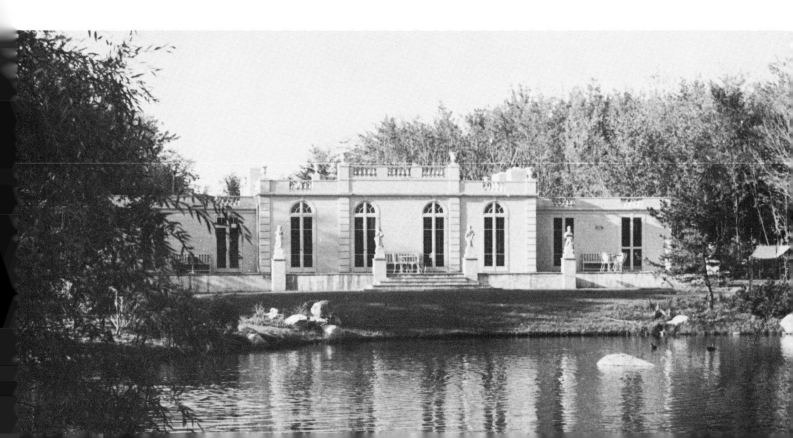

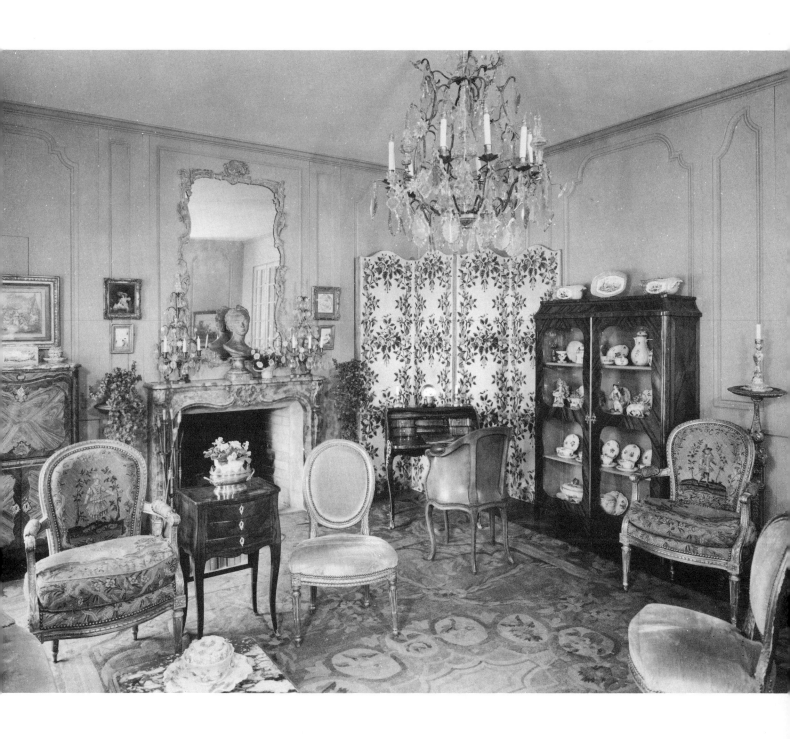

The Louis XV woodwork of the *salon* is painted a rich light blue with the overmantel mirror picked out in faded green and gold. All the Louis XVI chairs and the settee (a corner is seen at bottom left) are signed by Georges Jacob (M-E 1765). The two armchairs have original needlework backs and seats in a design of dancing chinoiserie figures. An unusual walnut five-legged Louis XV chair stands before a Louis XV desk of tulipwood and amaranth signed by Nicolas Petit (M-E 1761). The *armoire vitrine* (right) and the *secrétaire* (left) are superb examples of Louis XVI inlay, while the three *torchères,* of wood carved and gilded, are of the Régence period. Within the *armoire* are porcelains from the Ludwigsburg, Meissen, and Chelsea factories; on top are Sèvres *cachepots* and a plate in the celebrated *rose Pompadour.* The terra-cotta bust on the pink marble mantelpiece is by Lemoine, and on the walls are a signed Fragonard drawing, a pair of *gouache* portraits by Isabey in their original *bronze-doré* frames, an oil by Laurent, and a water color by Jean B. Huet. The Louis XV rock-crystal chandelier and lusters reflect the soft blues, reds, and gold of the room and of the eighteenth-century Aubusson rug.

Folie du Lac. The garden side, seen from across the lake.
Photographs by Taylor and Dull.

The opposite end of the drawing room is dominated by a gold and green *trumeau* hanging above a black lacquered Louis XV *bombé* commode signed *L. Foureau,* which has chinoiserie decoration and ormolu mounts in the style of Caffieri. Two Régence carved and gilded consoles with marble tops flank the commode. At the left is a delicate Louis XV writing table veneered in stripes of satinwood and harewood, and at the right a Louis XV three-drawer marquetry table in the manner of Roussel (M-E 1745). Pastoral scenes in grisaille *gouache* by Jean Pillement, signed and dated 1787, hang above the consoles; below them are equestrian studies by J. Parrocel (1648-1704) and on the wall at left, drawings by Boucher and Huet. Choice *objets d'art* in the room include the superb rococo clock on the commode, Battersea enamel and China Trade porcelain, a pair of green dry-lacquer vases in elaborate Louis XV ormolu mounts, and a Louis XVI cylinder waterfall clock of rock crystal and ormolu.

The library is small and intimate, with soft, subtle colors. The graceful Louis XV *boiserie,* curved at both ends of the room, retains its original paint, and above the fireplace and the door opposite are inset canvas panels painted in the manner of Boucher. On the mantel, which is of carved wood painted to simulate marble, stand a terra-cotta bust from the *atelier* of Houdon and a pair of tole *cachepots* filled with fragile porcelain tulips. Miniature portraits hang from the old silk ribbons on either side, and on the open shelves are pieces of Tibetan sculpture and a pair of rare early eighteenth-century bowls of Chinese porcelain. The mahogany writing table and the walnut cane-back armchair are provincial interpretations of eighteenth-century styles. Louis XVI silver candlesticks stand on the table; the prancing horse beside them is a seventeenth-century bronze. The Louis XV *fauteuil* at the right is one of a pair still covered in their original needlework, whose muted tones are repeated in the eighteenth-century Ghiordes prayer rug.

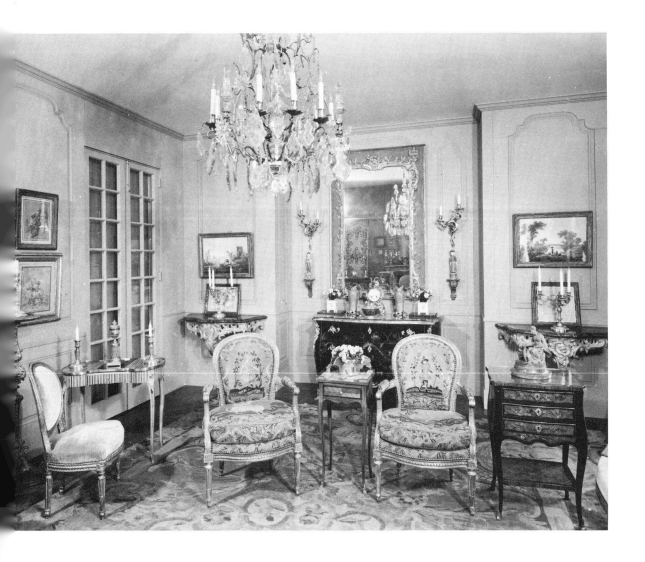

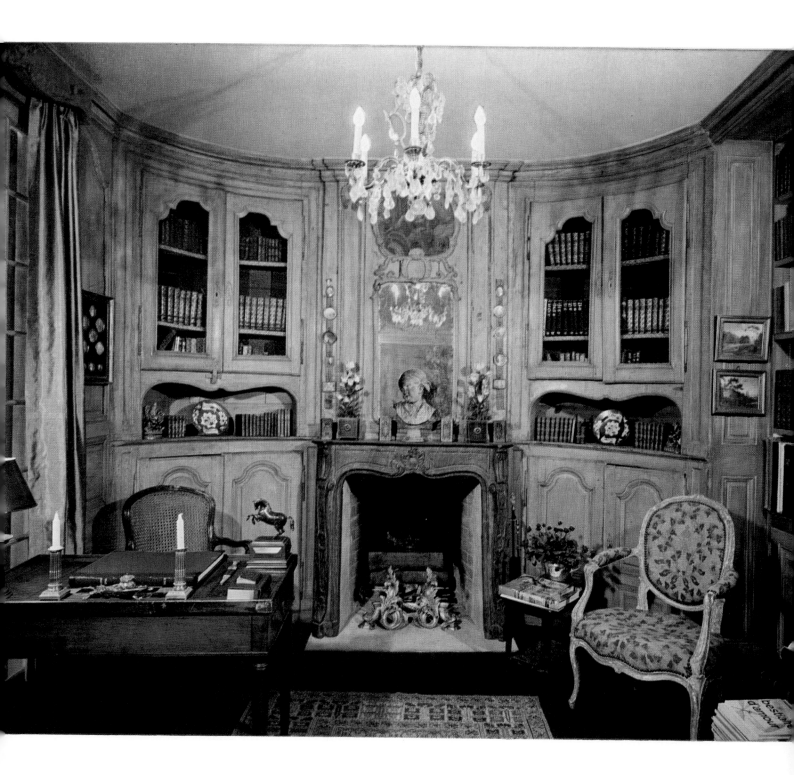

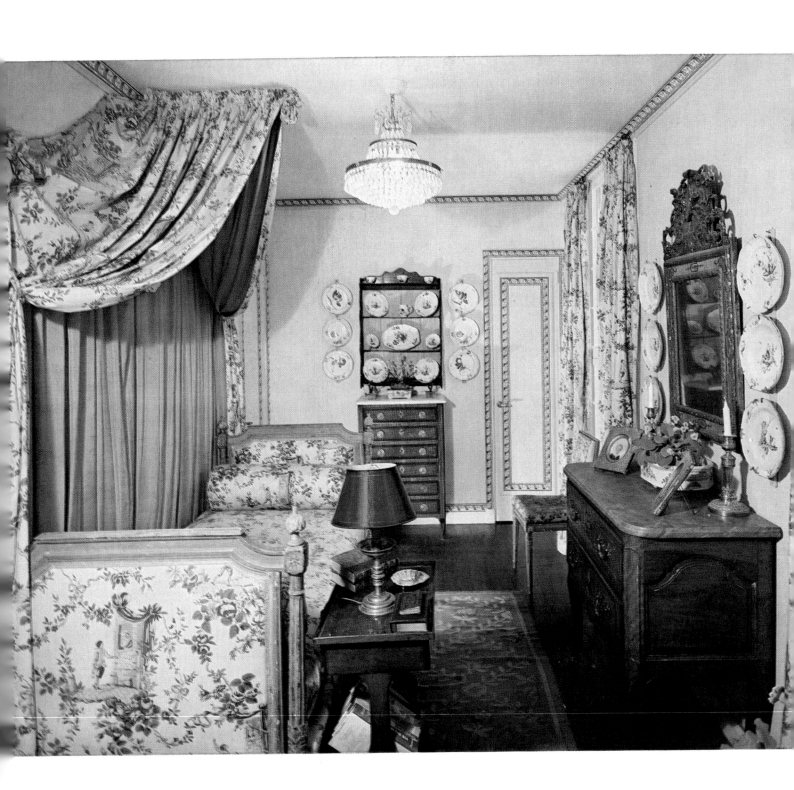

Color plate, facing page.

This bedroom, which Mrs. Fallass calls her "little nothing room," demonstrates what a person with great taste can achieve with leftovers from her collection. The room is very small, and the individual pieces of furniture seem almost to have been designed to fit their respective places. The dominating effect of vivid color is achieved by the quantity of glazed printed cotton used on the bed and at the windows; its tones of rose and light blue against a cream background are echoed in the border paper applied to walls and door moldings, and the grouped faïence plates further heighten the intensity of color. The Louis XVI bed, in its original gray paint, has wonderfully sophisticated carving. Of similar quality is the small Louis XVI chair beyond the commode, which also has its old gray paint and its needlework upholstery as well. The cabinet pieces and the small table in the foreground — more provincial in character — are made of walnut and oak.

The walls of Mrs. Fallass' bedroom are hung with blue and white French printed cotton with rustic scenes, as is the elaborately draped gray-painted Louis XVI bed. The chairs with white-painted frames are Louis XVI, and the *semainière,* or seven-drawer chest, in the corner is of the same period. A Régence gilt mirror hangs above the Louis XVI marble mantelpiece. The water colors at either side are attributed to Hubert Robert (1733-1808), while the smaller ones below are signed by Thomas Rowlandson (1756-1827). The painting of a young girl with a pigeon which hangs over the bed is signed *Jean Raoux* (1677-1734). The rug is an Aubusson of the late eighteenth century.

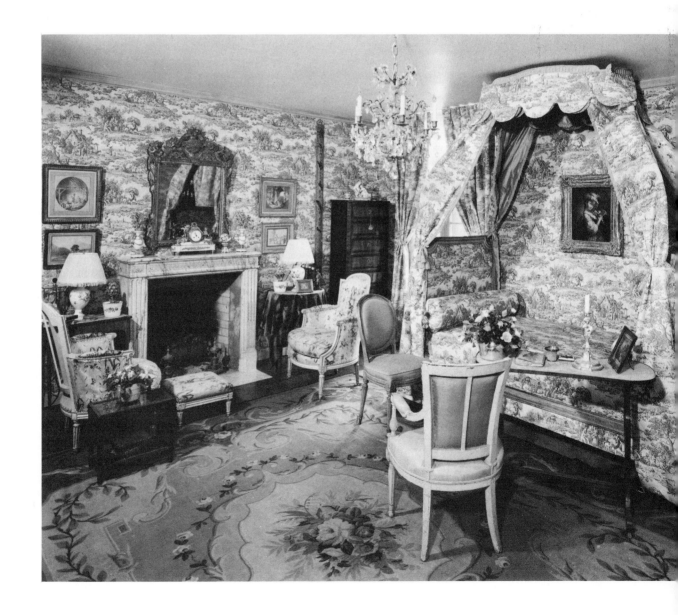

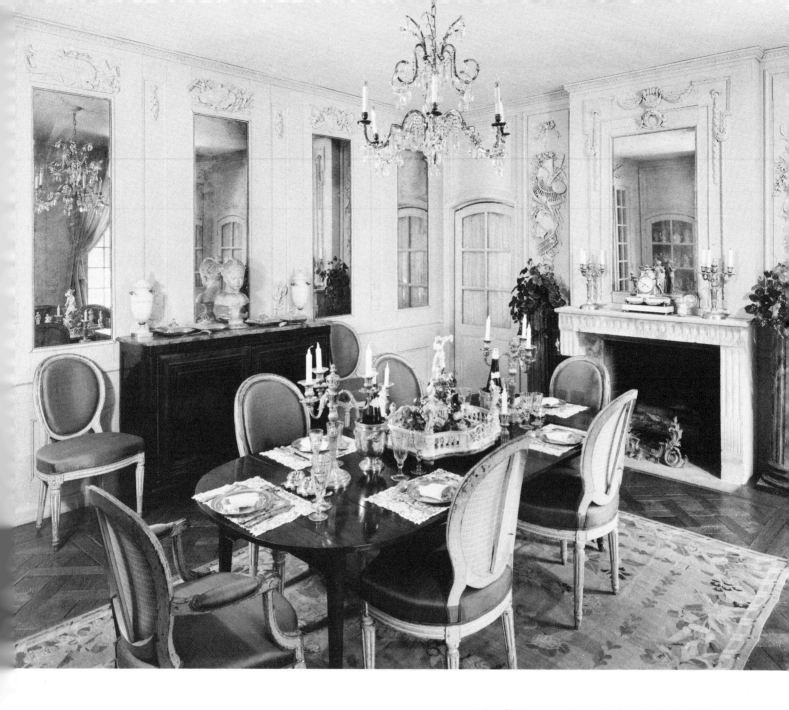

The dining room is predominantly Louis XVI, in tune with the *boiserie,* which is painted a soft gray and decorated with exquisite carved trophies of gardening implements. The mahogany extension dining table is a great rarity — a Louis XVI piece in English style — and used with it are contemporary chairs with painted frames, upholstered in pale gold silk. The table is set with an elaborate Irish vermeil dessert service of the late 1700's; the white porcelain centerpiece, with its mythological statuary, is from the Vienna factory. On the marble-topped mahogany sideboard, which carries reminiscences of the Louis XV style, are a bust of a small girl by Roubrae and a pair of Louis XVI alabaster and ormolu urns. Lighting for the room is provided by four Louis XVI ormolu candelabra and an airy gilt-bronze and rock-crystal chandelier of the same era. The Aubusson rug is spread on a floor of eighteenth-century *parquet de Versailles.*

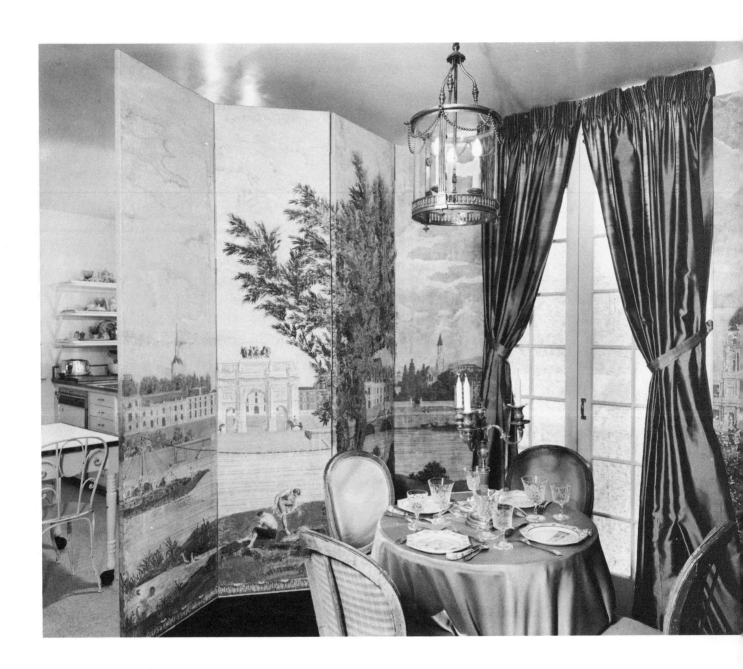

The kitchen at *Folie du Lac* gives elegant support to Mrs. Fallass'
belief that informal dining can most effectively and easily be
handled right in the kitchen. She had strips of the Dufour wall-
paper *Monuments de Paris* made into two four-panel screens, with
which she blocked off a third of the kitchen space, and she placed
a small table between the screens; the spot affords a marvelous
view of the terrace and garden. Sometimes the table is set with
eighteenth-century silver plates and flatware; here it is shown with
Creil plates whose black transfer-printed decoration repeats the
scenes-of-Paris theme. Surrounding the table are four Louis XVI
chairs retaining their original gray paint, and a superb Louis XVI
brass lantern with cylindrical glass sides hangs above.

Seventeenth-century manor house

Colonel and Mrs. Miodrag Blagojevich, Drayden, Maryland

WEST ST. MARYS MANOR is a gem of late seventeenth-century architecture of southern Maryland, situated in a strikingly beautiful landscape on a rise of land not far from the spot where St. Marys River empties into the Potomac. This is the oldest of the approximately one hundred manors established in the seventeenth and early eighteenth centuries in Maryland, where the English manorial system was introduced by the first settlers. In all respects they patterned their homes and institutions on those of England. Their land system revolved around the rights of the lords of manors whose great holdings amounted to a thousand acres or more and who presided over such feudal survivals as the court leet, or court of record, and the court-baron, an assembly of tenants. Early maps of Maryland show that West St. Marys be-

came in time more than a single manor. It was named Honour of West St. Marys, which meant that it had become a seigniory or group of manors held under one head.

The origin of this extensive domain was a gift of land to one Captain Henry Fleet, a Virginia trader who aided the first settlers, arriving in Chesapeake Bay on the *Ark* and the *Dove*, to establish their capital, St. Marys City. The land grant which Captain Fleet received in 1634 is the oldest recorded in Maryland.

The manor house has survived to the present in a remarkably good state of preservation. Erected in the late seventeenth or early eighteenth century, it was built on still earlier foundations and incorporates part of the older structure. Local characteristics are represented in the double chimneys at either end with a pent between, and

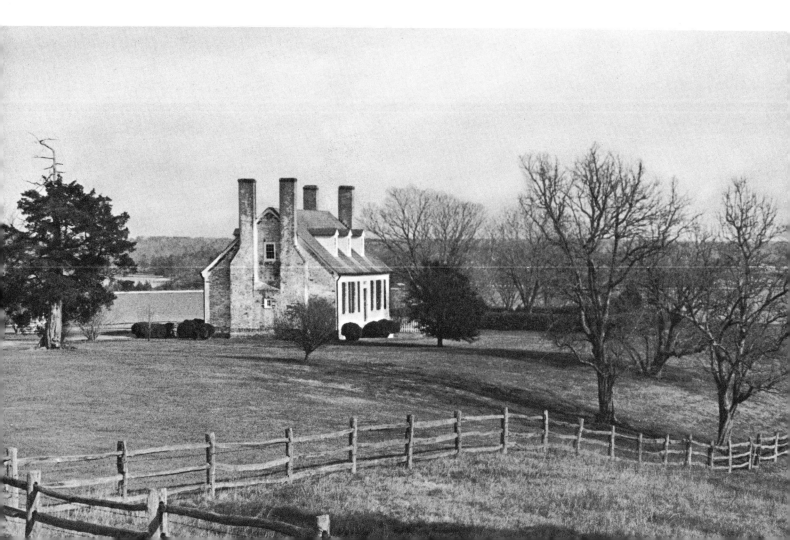

a steeply pitched roof with narrow dormers. The main entry opens on a hall which runs the depth of the house and is divided midway by an arch. The stile-and-rail paneling of pine would seem to have been added about 1730-1740. Oak is the principal structural wood but the window sills and the block-and-turned balusters of the stairs are of walnut.

Because of its architectural interest and historical importance, West St. Marys Manor well deserves the many years of devoted labor which the present owners have given to its restoration. The initial phase consisted of returning house and grounds to their original appearance, and providing such antique furnishings as were more or less readily available. Then Colonel and Mrs. Blagojevich began conducting a patient search for the scarce William and Mary furniture, especially from the middle Atlantic coast region, which they felt was most suitable for their house. This they have been gradually substituting for the New England and Philadelphia Queen Anne and Chippendale pieces formerly in their collection. English Jacobean furniture has given way to seventeenth-century New England press cupboards, chests, Carver and Cromwellian chairs. Soon to disappear too are the Isfahan and Kuba carpets in the withdrawing and dining rooms; they will be replaced by reproductions of painted floorcloth, which seems a more likely treatment for the early 1700's when "Turkey carpets" were generally table rugs.

Notable among the more recently acquired pieces are a Pennsylvania William and Mary high chest, lowboy, and tall clock. Special care has gone into the choice of accessories, the metalwork, delftware, silver, early looking glasses, seventeenth-century prints, maps, and paintings, all of which re-create a home of the early 1700's where still earlier pieces are among the heirlooms and 1710 is an approximate terminal date. West St. Marys Manor has become a delightful and instructive example of the William and Mary house in America.

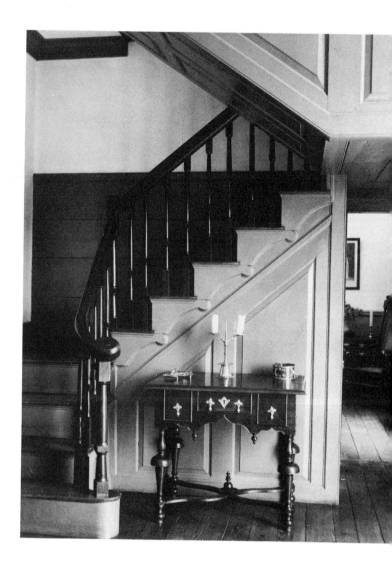

A William and Mary walnut lowboy with bowl-turned legs of fine design, diagonal stretcher, and gracefully arched skirt is a rare example from Pennsylvania, about 1700.

West St. Marys Manor.
Photographs by Colonel Blagojevich.

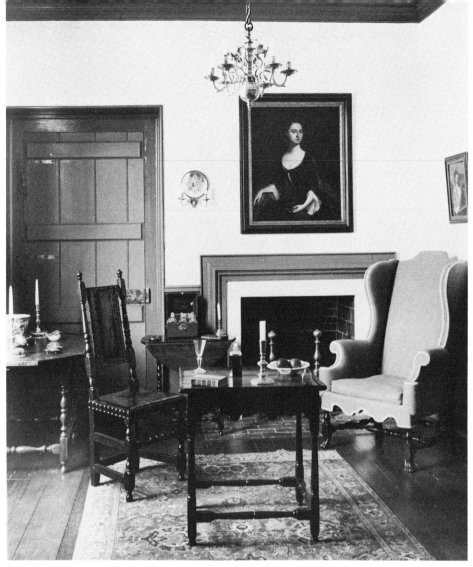

In the withdrawing room off the dining room the William and Mary walnut tea table with scalloped apron is an unusual Southern piece of the early 1700's. A Massachusetts Spanish-foot wing chair is covered in red wool. Also from New England are the leather-upholstered side chair, 1700-1710, and the mixing table of about the same date with a turned maple frame whose octagonal top is inset with slate probably imported from Switzerland.

Of special note in the withdrawing room is the Philadelphia William and Mary walnut five-leg high chest with paneled ends. Over it hangs an early reflector in a walnut frame; a fragmentary label on the back suggests that it is also from Philadelphia. A New England leather-upholstered maple armchair has strongly carved ram's-horn arms. The old wellhead may be seen from the window.

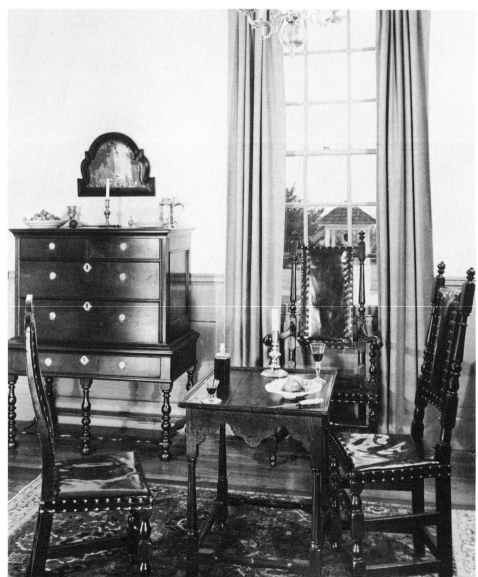

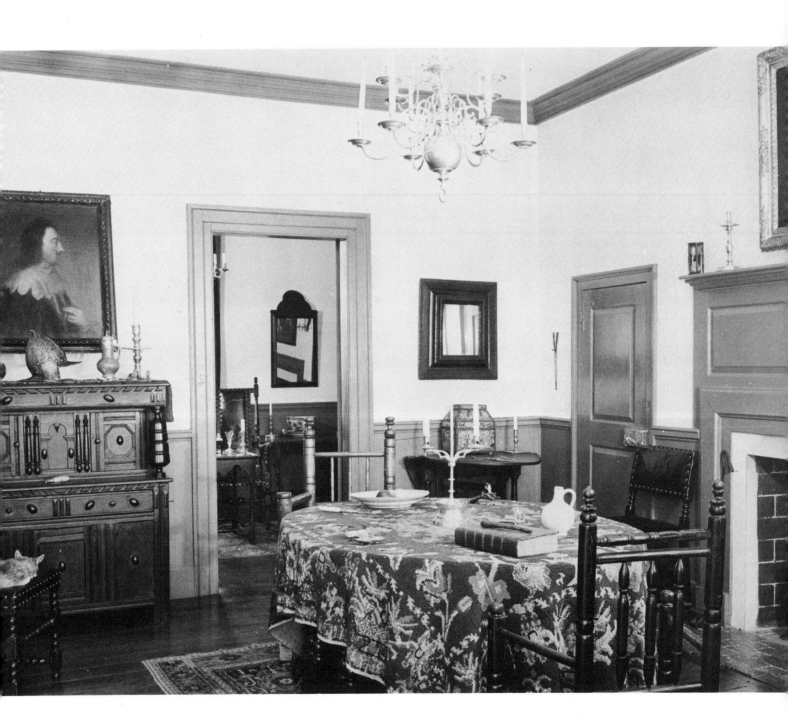

In the dining room an oval gateleg table is covered with a
seventeenth-century needlework table rug which is probably
of European origin. Carver chairs, Cromwellian chairs, and
a press cupboard of oak with diagonal dentil are all from
New England. The door at left of the fireplace is that of
the closet, which is the pent seen in the exterior view. An
English looking glass with convex molded frame, almost
square in design, represents the earliest type of wall mirror
used in America.

The furniture in the study is of Pennsylvania origin of the early 1700's. A Spanish-foot armchair stands beside a William and Mary desk. The unusual side chair has a carved crest over a panel of cane, a leather seat, and its original tortoise-shell graining.

An exceptional William and Mary tall clock in the study is by Henry Taylor of Philadelphia (d. 1760), who learned his craft from the Stretch family. While Peter and Thomas Stretch preferred the early, square dial, Taylor has used the arched dial showing Queen Anne influence. A Pennsylvania two-drawer table with rectangular stretcher stands under a hatchment of painted wood, c. 1730, of the type used at funerals to display a family's coat of arms.

Family heirlooms in New Jersey

Mrs. Joseph S. Frelinghuysen, Far Hills, New Jersey

Brookwood, the home of Mrs. Joseph S. Frelinghuysen in Far Hills, New Jersey, presents that happy combination of family heirlooms and personal acquisitions which gives a house individuality and a sense of lived-in continuity. There have been Frelinghuysens in New Jersey, active in the affairs of colony, state, and nation, since 1720 when the Reverend Theodorus Jacobus came from Holland to settle in Somerset County. When the late Senator Joseph S. Frelinghuysen and his wife built Brookwood in 1927 they were able to incorporate in the structure architectural elements from old family houses in the vicinity and to gather within it pieces of furniture that had come down in the family. The house was designed in modified Federal style by the architect John Russell Pope expressly to accommodate certain old doors and mantels and to provide a suitable setting for early furniture. To the Frelinghuysen heirlooms, which were chiefly eighteenth-century items of New Jersey origin, Senator and Mrs. Frelinghuysen added over the years French furniture and decorations inherited from her mother, American antiques they collected themselves in Charleston and elsewhere, and the comfortable miscellany that links them all together in an attractive and livable whole.

Several mantels in the house are interesting New Jersey interpretations of the Adam style. Two came from the homestead in Raritan which John Frelinghuysen, a general in the War of 1812, acquired in the early 1800's when it was already an old house and to which he added these up-to-date embellishments. From the same house came the front door illustrated here. Also installed at Brookwood, as the outer entrance to a small vestibule, is a heavy batten "Dutch" door in two sections, with original

iron hinges and a great lock. This and another of the mantels came from a family home built in 1751 in Raritan, known as the Dutch parsonage, which Senator Frelinghuysen presented some twenty years ago to the Daughters of the American Revolution.

Of special interest too are the numerous examples of New Jersey furniture, which include chairs of various types, tall clocks, and case pieces. Probably the finest is the lovely sideboard in the dining room attributed to Matthew Egerton of New Brunswick. A group of South Jersey glass collected by Mrs. Frelinghuysen has been presented to the New Jersey Historical Society.

The paneled front door with its brass box lock and the door frame with its leaded lights were brought to Brookwood from the family homestead in Raritan, where they were installed by General John Frelinghuysen when he acquired the old house in the early 1800's. The Chippendale chairs with their curious, almost solid splats are New Jersey items.
Photographs by Taylor and Dull.

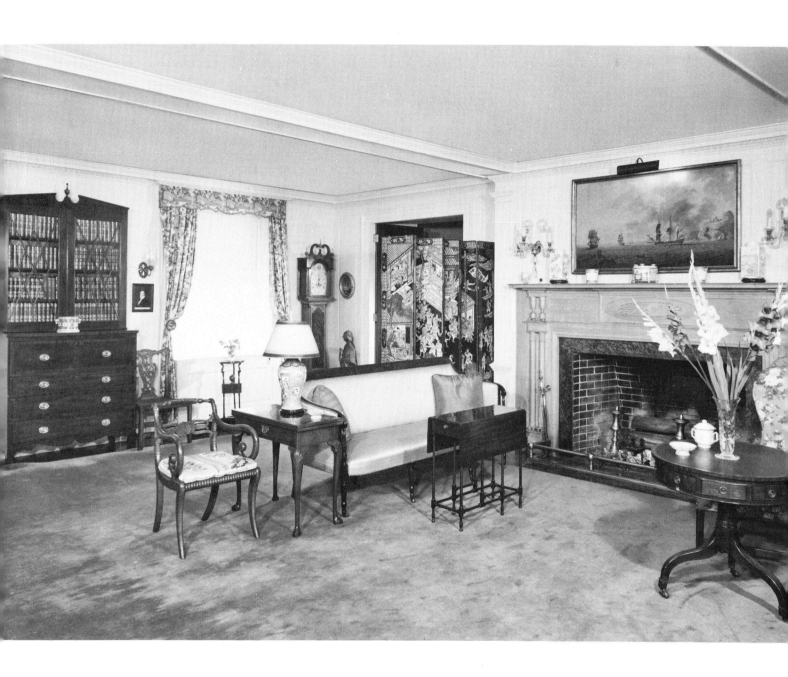

In the drawing room is installed the largest of the New Jersey mantels, from the old Raritan parsonage. One of the many heirlooms from General John Frelinghuysen is the mahogany secretary with unusual low pediment, a New Jersey piece. The sofa is by Duncan Phyfe, who, it is remembered, spent the last of his life in New Jersey; and the tall clock in the corner is by Isaac Brokaw, who worked in Bridge Town, now Rahway, after 1790. An Empire side chair, one of a handsome set in maple, stands beside a folding Queen Anne table in cherry which was found in Virginia and is believed to have been originally at Marmion. The chair by the window is one of a rush-seated pair that offer an interesting version, possibly New Jersey, of the Chippendale tassel back. Spider-leg table and drum table are English.

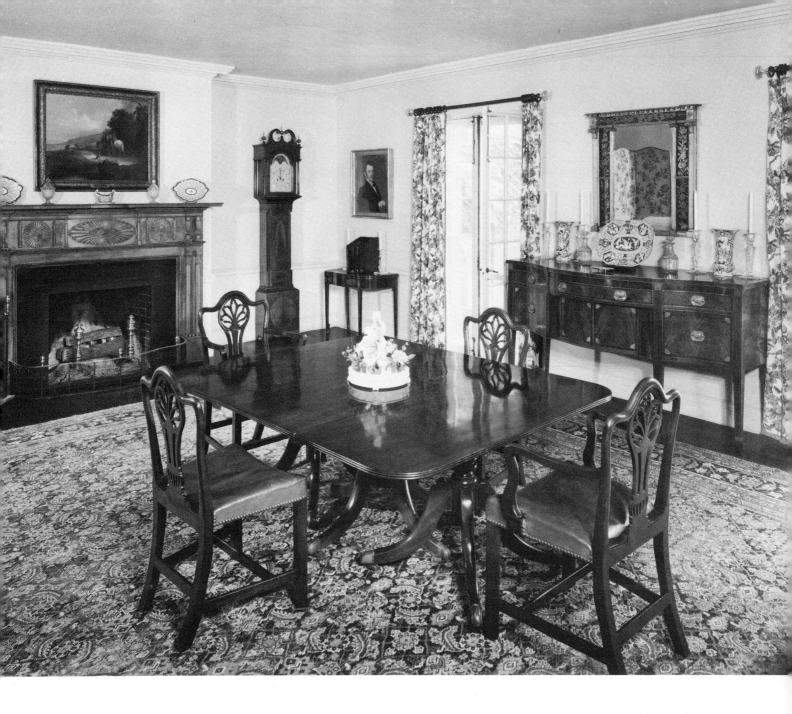

In the dining room, with another inherited mantel, on which family pieces of Worcester porcelain are displayed, stand the graceful New Jersey sideboard attributed to Matthew Egerton and a tall clock with the name JOAKIM HILL, FLEMINGTON on its enamel dial. The painting over the mantel is by Alvan Fisher; entitled *An Eventful Day with Henry Clay*, it depicts two horsemen, one of them Henry Clay, the other Frederick Frelinghuysen, who ran for Vice President with Clay in the campaign of 1844. General John is shown in the portrait above the Hepplewhite side table; a companion portrait of his wife also hangs in the room. The side table was found in Charleston and is believed to have been made there. The Chippendale chairs and Sheraton table are English. The centerpiece of Italian porcelain was acquired in France by Mrs. Frelinghuysen's mother.

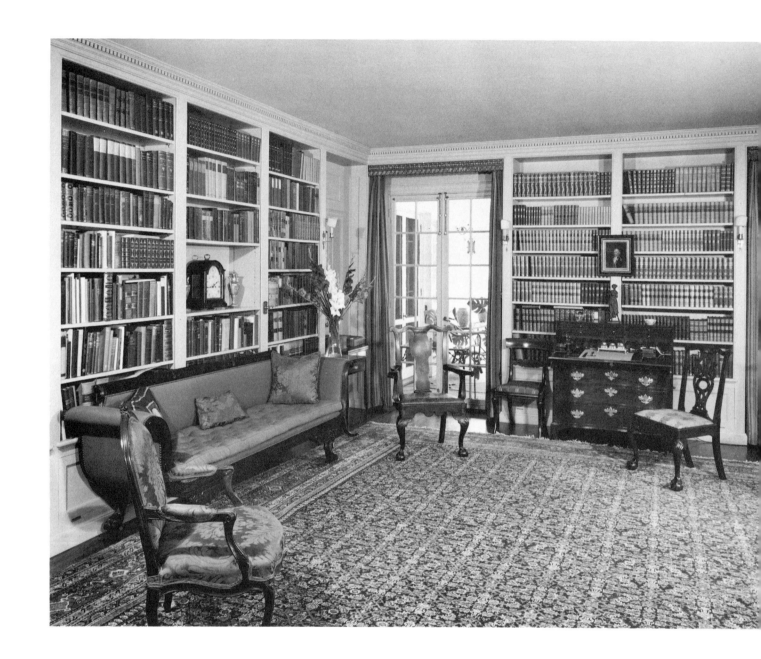

Rich reds and blues in curtains, upholstery, and rugs, and soft green on the walls give a warm setting to books and furnishings in the library. A nineteenth-century armchair in Louis XV style is one of several French pieces inherited from Mrs. Frelinghuysen's mother. They mingle comfortably with Philadelphia Chippendale chairs, a Chippendale slant-top desk, and representatives of the late classic revival as seen in the American Empire sofa and klismos chair. The small oil portrait above the desk, by an unknown painter, is of the Revolutionary general Frederick Frelinghuysen, father of General John.

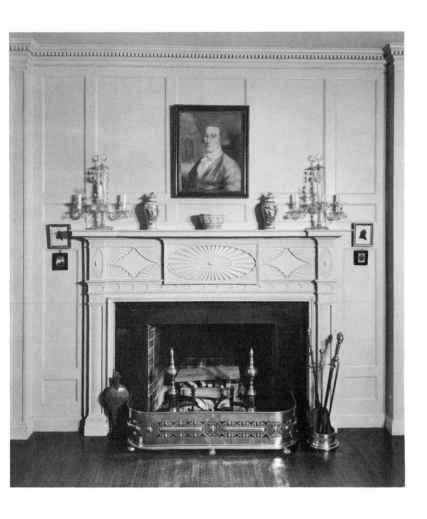

The carved mantel in the library, like the others brought from old family houses, is a local interpretation of the Adam style, done soon after 1800 when General John Frelinghuysen modernized the homestead where it originally stood. This one is painted to match the surrounding paneling, as it probably was originally; the others are in the natural soft color of the pine. Their carved paterae, fans, and flutings are considered typical of New Jersey work of the Federal period; similar examples are found also in New York State. The China Trade porcelain urns have stood on this mantel for generations. Brass tools and fender of the early 1800's brighten the fireplace, and family silhouettes and miniatures hang at the sides. The pastel portrait of Joseph Warren is attributed to Copley.

A pleasing example of New Jersey cabinetmaking is this cherry cupboard, another heirloom from General John. An unusual feature is the band of burl veneer, probably walnut, in the frieze just below the cornice. The scroll tops of the doors, the fluted corners, the drawers overlapping the case, the scroll bracket feet, and the general proportions are typically pre-Revolutionary, but the brasses of the lower case, which are original, suggest a date close to 1800 and it is likely that, like so much American work, the piece was made after the turn of the century in perpetuation of an earlier style. The slat-back chairs are also of New Jersey make, probably of the first half of the 1700's.

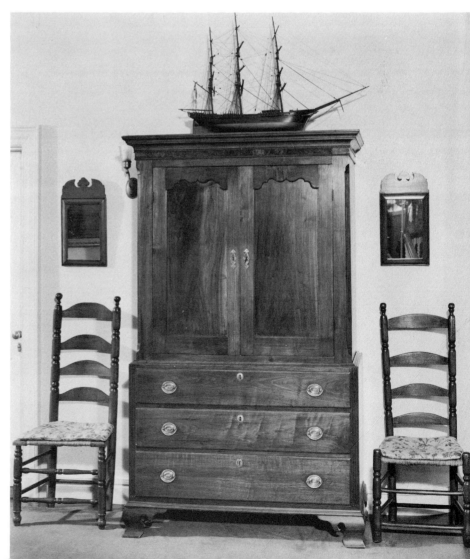

Facing page.

A cherry lowboy in the spacious entrance hall has the high slipper foot, ridged down the front, which is said to be a New York characteristic, and indeed the piece has descended from the Hudson Valley wife of an eighteenth-century Frelinghuysen ancestor. The cherry wing chair, probably a country piece, retains the vertical roll of the arms typical of the Queen Anne period but has straight legs in Chippendale style. The walnut highboy under the impressive stairway is a Pennsylvania piece with trifid feet. The large painting of the death of General Warren at the battle of Bunker Hill is attributed to the studio of John Trumbull. From the Raritan homestead comes the nineteenth-century hanging lantern.

The broad stairway with its spiral balusters leads to a large upper hall dominated by a portrait of Mrs. Frelinghuysen and her son painted by Muller Ury in 1923. Beneath it stands an American Empire couch which can be converted into a bed by letting down the back. The chest-on-chest of maple is recognized as the work of the Dunlap cabinetmakers of New Hampshire by the characteristic carving of its frieze, deep drawers, and skirt. The banjo clock is signed on the dial *Willard's Patent*.

Georgia plantation

Mr. and Mrs. Henry D. Green, Madison, Georgia

MR. AND MRS. HENRY D. GREEN had been collecting American antique furniture, especially Southern pieces, for twenty years before they found the old house that would provide the right setting for their collection. Then they acquired Greenoaks, a plantation near Madison, Georgia.

In 1803 this property was drawn by John Walker in a lottery by means of which the state of Georgia divided up a large tract ceded it the year before by the Creek Indians. Through purchase Walker added to his lot, and on his original acreage built two houses. The first was small, two rooms and a loft. The other, built about 1815, represents a simple, late Georgian type of architecture which traveled with settlers down the great valley of Virginia, through the Carolinas, and into the Georgia Piedmont. A development of the early dog-trot plan, it

consisted of two stories with two large rooms and central hallway on each, a lean-to comprising three small rooms at the rear, and a one-story porch across the front. About twenty feet behind stood the detached kitchen building. This type of house, which bears little relation to what settlers were building in coastal Georgia, is akin to houses in the up-country, or Piedmont, areas of the Carolinas and Virginia, but in Georgia the buildings are generally higher and more attenuated, the material is local heart pine, and details of construction represent local solutions to local problems.

When Mr. and Mrs. Green bought Greenoaks Plantation in 1954 they found the house, fortunately, little altered since its construction in 1815, though during the Victorian period the dining room in the lean-to had been enlarged and connected with the old kitchen by means

Greenoaks Plantation, near Madison, Georgia. *Photographs by Andrew N. Foster.*

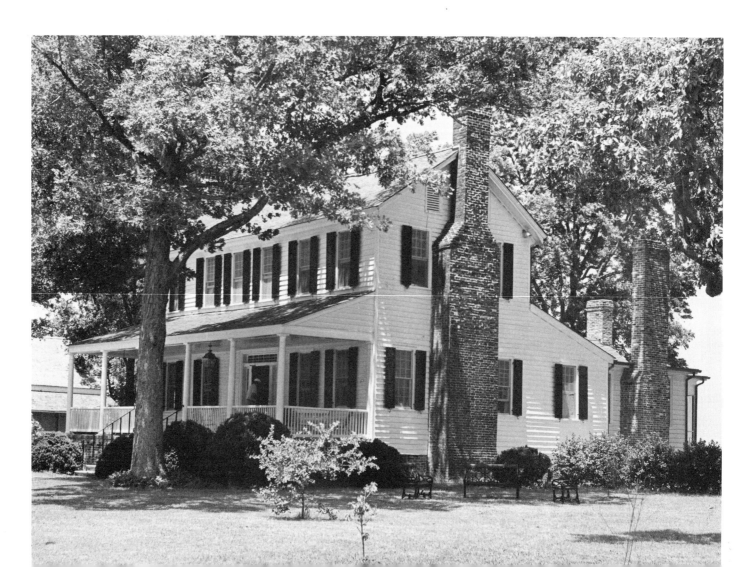

of a new pantry, and the front porch had been elaborated with semicircular ends and much scroll-saw work. The project undertaken by the Greens, after three years of planning and with the help of the architect Elliot Dunwoody Jr. of Macon, consisted mainly of restoring the porch to its original condition, installing old paneling and a china cupboard in the dining room, providing new bathroom and kitchen facilities, and skillfully adding at the rear a family room which was the fully sheathed main room from a small local house.

The family moved into Greenoaks in 1957, placing their antiques against an appropriate background carried out in eighteenth- and nineteenth-century colors and fabrics. Their project is not yet finished — what collector's house ever is? Here traditional gardens of boxwood, bulbs, crape myrtle, and magnolias are still being developed, and the original two-room house will eventually be restored as a guest house.

A maple tall-case clock in the entrance hall, with twisted finials, carved and gilded shell and rosette, and delicately carved ogee feet, was made by Willett Stillman of Westerly, Rhode Island, in 1795.

The entrance hall of Greenoaks Plantation has a simple dado, as characteristic of the Georgia Piedmont region as the pair of straight-legged Chippendale side chairs in apple wood, which show an unusual treatment of the tassel motif in their pierced splats. On the small-scale New Jersey Queen Anne lowboy with high-arched skirt, bracelet at the ankle, and scrolled adaptation of the Spanish foot are a pair of bell-metal candlesticks from the first half of the eighteenth century and a China Trade porcelain punch bowl with Masonic decoration. The mahogany Queen Anne looking glass above is American.

The stairs rise from the rear of the central hall. An exceptional Georgia piece is the Federal worktable in walnut and Southern pine with string-and-bellflower inlay. Four brass chambersticks are ready to be carried to the bedrooms upstairs, which are likewise furnished with antiques, mostly of Southern origin. Against the wall at the left a Connecticut Chippendale side chair stands beside a New England pembroke table in maple. Bell-metal candlesticks here have the mid-drip pans of the seventeenth century; the sugar bowl is spatterware.

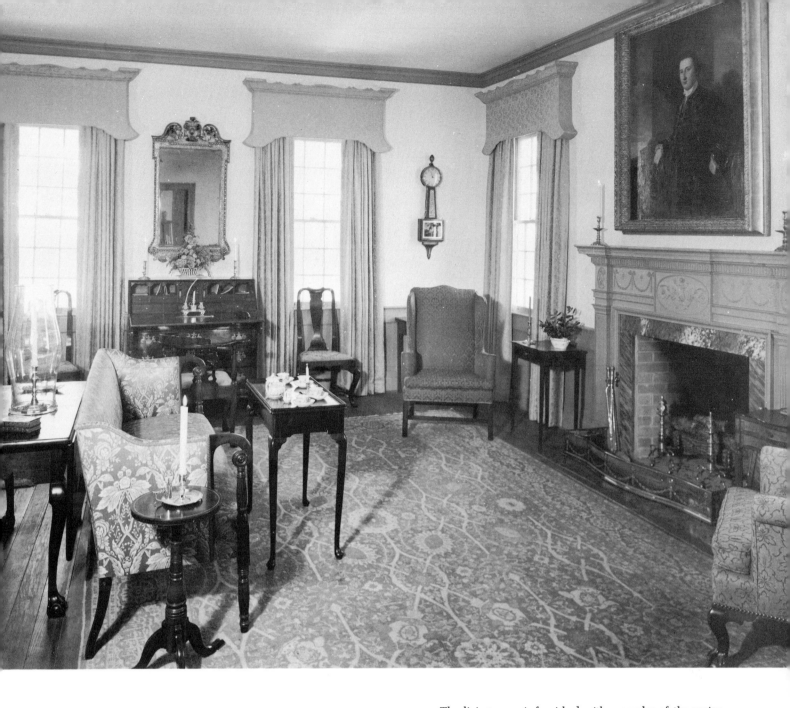

The living room is furnished with examples of the major American styles of the eighteenth century. The fine stucco mantel, attributed to Robert Wellford of Philadelphia, speaks for the classical style, as do the Salem Sheraton sofa and, more modestly, the damask-covered easy chair in the corner, an unusual Southern piece. Chippendale is represented by the mahogany drop-leaf table, said to have belonged to Richard Henry Lee, and by the distinguished Massachusetts serpentine desk, which was found in north Georgia. The candlestand by the sofa was made in Georgia. Flanking the desk is a pair of fine Rhode Island Queen Anne mahogany side chairs; also Queen Anne, from New England, is the slender mahogany tea table, on which is a miniature Staffordshire tea service. The gilt looking glass between the windows is English of the mid-eighteenth century.

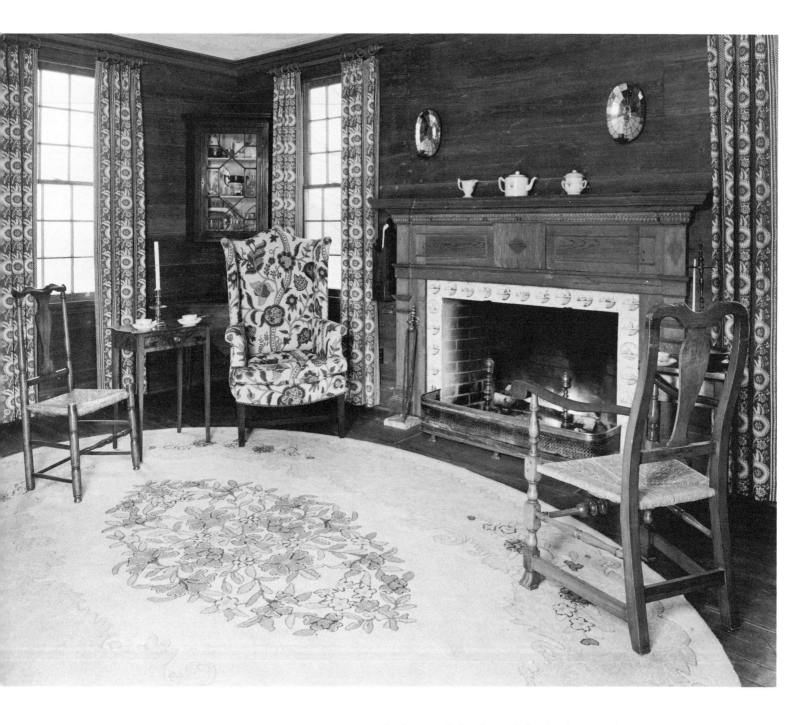

The horizontal sheathing of the family room, from an early local house, is of heart pine, as is the generous mantel with its moldings, dentils, and unusual ribbed-diamond carving. The tiles are English delft, the oval tin sconces with mirror reflectors, American. In the New England armchair, right, the Queen Anne yoke crest and vase-shape splat are combined with the turned stretchers and front legs and the Spanish feet of an earlier style. The Federal candlestand with drawer has a delightful four-sided serpentine top. Probably of Southern origin is the easy chair with high, narrow back, tapered legs, and saddle seat. In the Sheraton hanging corner cupboard behind it are pieces of early glass and Staffordshire pottery, and the handkerchief table of cherry and pine is a Georgia piece.

The dining room in the lean-to is of generous proportions and the Greens have installed an interesting mantel, dado, and china cabinet from other Georgia houses contemporary with Greenoaks. Around the large mahogany drop-leaf table (c. 1790), which came from Maine, is grouped a set of fine Sheraton mahogany chairs of comparable date, found in Savannah. The Queen Anne looking glass (c. 1740) hanging above a low Chippendale chest of drawers was in the collection of the late Luke Vincent Lockwood. The China Trade porcelain garniture on the mantel shelf dates from about 1780, and the brass chandelier is of the early eighteenth century.

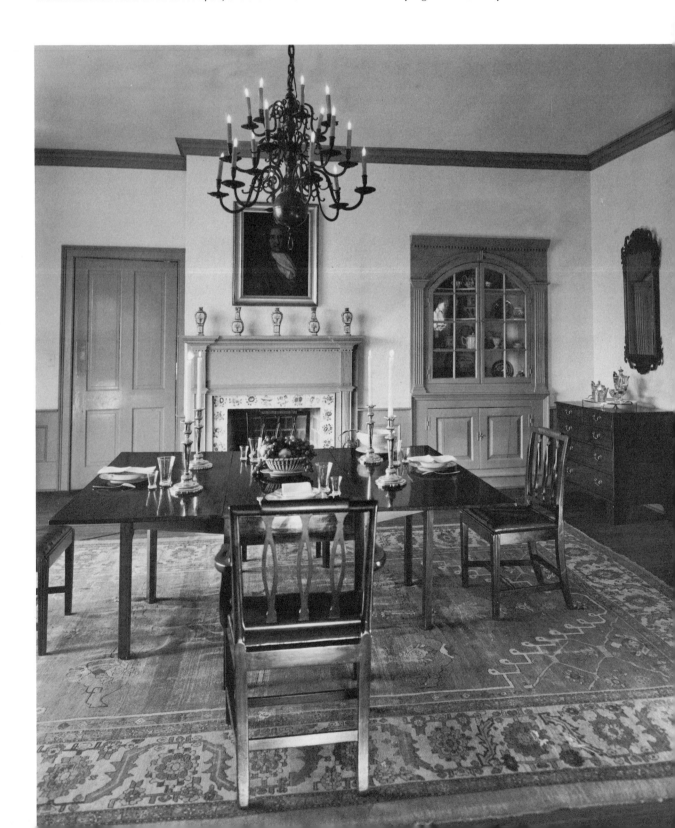

The kitchen retains its old brick fireplace with raised hearth; on the hand-hewn beam above is displayed a collection of Pennsylvania German slipware. The Pennsylvania table, set for family luncheon, is surrounded by six matching Sheraton side chairs and armchairs made in Georgia. The glass-front dresser with bold cornice and reeded pilasters came from near Lancaster, Pennsylvania.

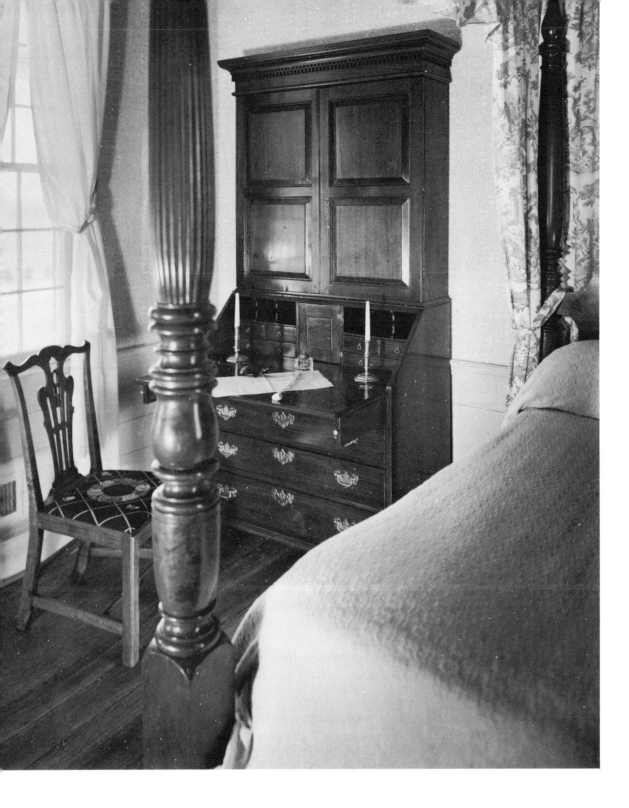

A glimpse of the first-floor bedroom shows more of the owners' Georgia furniture in the Sheraton bed with nicely turned and reeded foot posts and in the handsome walnut secretary with dentiled cornice and fielded door panels.

Lifetime collection

Mrs. J. Stogdell Stokes, Bryn Mawr, Pennsylvania

SOME PEOPLE COLLECT ANTIQUES as appropriate furnishings for an old house. This house illustrates the opposite process: recently built, it was designed especially for the antiques that furnish it. They are the cream of a lifetime collection.

J. Stogdell Stokes was long interested in American antiques, especially those of the Pennsylvania and New Jersey of his ancestors. Over the years he and Mrs. Stokes acquired a large and distinguished collection of furniture made in that region in the seventeenth and early eighteenth centuries, and also of pottery, ironwork, lighting devices, glass, fractur work, and wood carvings. These antiques were gathered in the pre-Revolutionary farmhouse in Pennsylvania where they lived for most of their married life. Now some of them are in the Philadelphia Museum of Art, of which Mr. Stokes was president for many years; others have been dispersed; and a choice selection furnishes the small house in Bryn Mawr which Mrs. Stokes had built after her husband's death. Picking out her favorite pieces, she engaged the architect Sydney E. Martin to design a setting expressly for them and for her. It is of stone, the typical material of the region, and in exterior appearance and interior detail has the character of the eighteenth century, though it is not an exact reproduction. In this felicitous setting Mrs. Stokes and her fine antiques are perfectly at home.

One of the most unusual, and charming, pieces in the house is the Pennsylvania Queen Anne lowboy whose shaped contour seems almost akin to the blockfront developed in Newport a generation or so later. This admirably designed piece is of walnut and has its original engraved brasses. On it are displayed three rarities from the Stokes collection of Pennsylvania lighting devices, each more interesting than the others. From the turned wood screw standard in the center hang two iron betty lamps whose covers have little roosters for handles. The cup-shape iron lamp on the left swings on a wrought-iron standard with graceful scroll handle. The device on the right, standing on high scrolled feet, supports a crusie which may be raised or lowered by means of a shaft and key in the standard. Various other early lamps and candleholders may be seen about the house; some of these have been converted for electricity. *Photographs by Cortlandt V. D. Hubbard.*

In the entrance hall a rare Pennsylvania William and Mary walnut lowboy whose trumpet-turned legs are joined by a flat, scrolled, cross stretcher is flanked by a pair of late seventeenth-century highback chairs with heavy semicircular crest typical of Pennsylvania. The Pennsylvania chest is of the rare type painted with unicorns as well as floral motifs. In the far corner a slat-back chair with big mushroom armrests, made close to 1700, is partially visible.

On the dining-room chimney breast hangs a primitive version of *Penn's Treaty with the Indians,* after West's painting, which was known in this country through engravings. The rare tin sconces are painted dark red. There are excellent Pennsylvania windsors here; that at the right has the stretchers surprisingly at right angles to the usual arrangement, that at the left has carved arm supports. The dresser is garnished with colorful English earthenware — gaudy Dutch, Pratt ware, and pieces from Clews' blue-printed *Dr. Syntax* series.

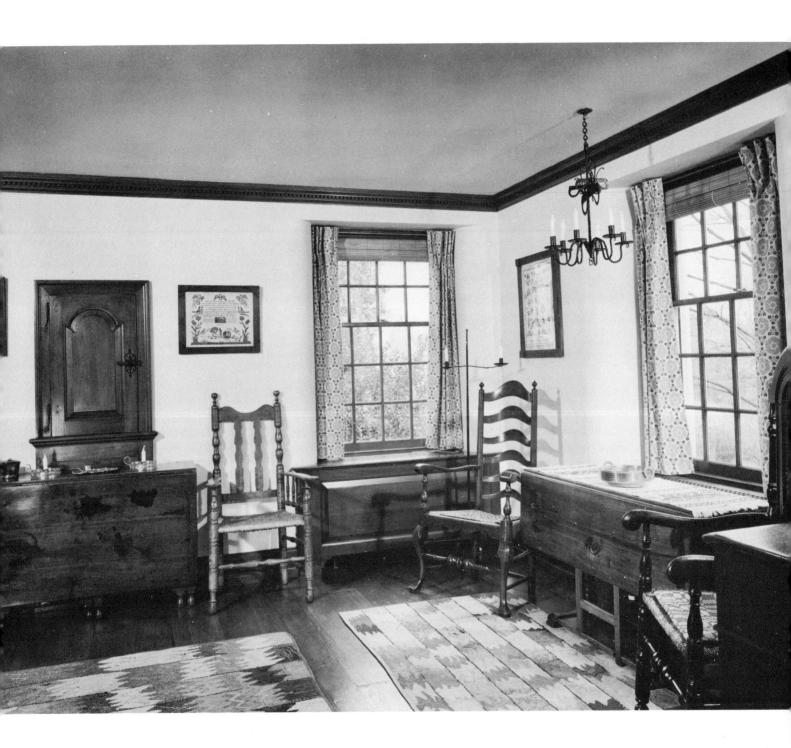

Early Pennsylvania chairs of various sorts are used in the dining room, with gateleg tables. The six-slat armchair with cabriole legs dates about 1720-1730. Pennsylvania fractur work and an embroidered sampler give color on the white plaster walls. Numerous hooked and braided rugs are used in the house, and short curtains with small printed patterns. Here again are interesting lighting devices — the iron candlestand with toggle arms, and the elaborately wrought chandelier. The small paneled door provides easy access to the kitchen for serving; its Pennsylvania iron latch and tulip hinges are old.

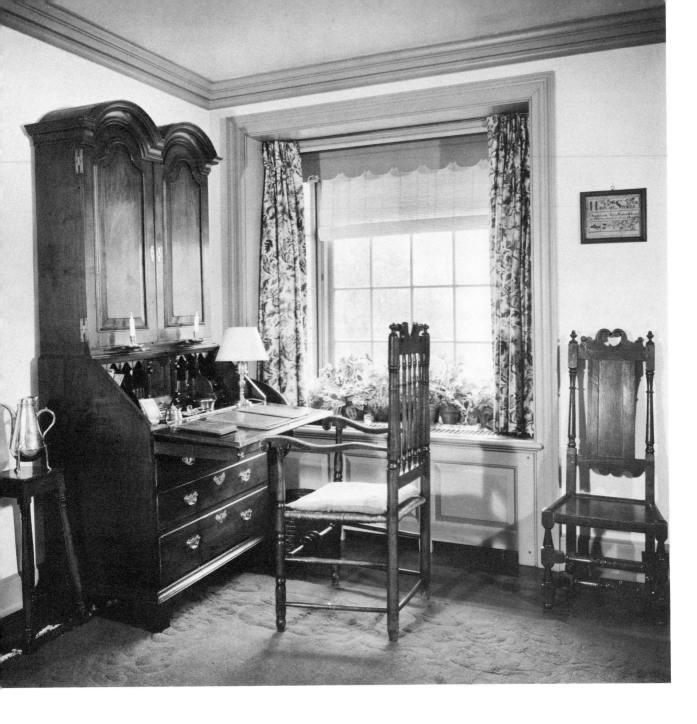

One of the most important pieces in the house is the Pennsylvania walnut secretary in the living room, whose upper case is double-domed and has arched paneled doors; these early eighteenth-century features are rare in American furniture. Beside it are a banister-back armchair and an unusual turned stretcher stand with small top and strongly raked legs. The turned chair with panel splat and seat and pierced heart in the scrolled crest is a Chester County type. Above it hangs the illuminated penwork birth record of Hannah Stokes.

The arched fielded panels and narrow mantel shelf on the chimney breast, the heavy bolection molding framing the fireplace opening, the deep window embrasures with raised panels below, and the moldings of cornice and other woodwork, though new, are all in the early eighteenth-century tradition of Chester County. Gathered about the fireplace are a Spanish-foot wing chair probably of New York origin, a Philadelphia Queen Anne armchair, Pennsylvania gateleg table, turned stretcher stool, William and Mary armchair (one arm and post visible in foreground), and a sturdy upholstered oak bench made in the late seventeenth century. The slipware plates on the mantel and the bowls and mortar on the table beside the Schimmel eagle are only a part of the Stokes collection of Pennsylvania pottery. The wrought-iron candelabra on the mantel are Pennsylvania; the central carved figure group is Continental European.

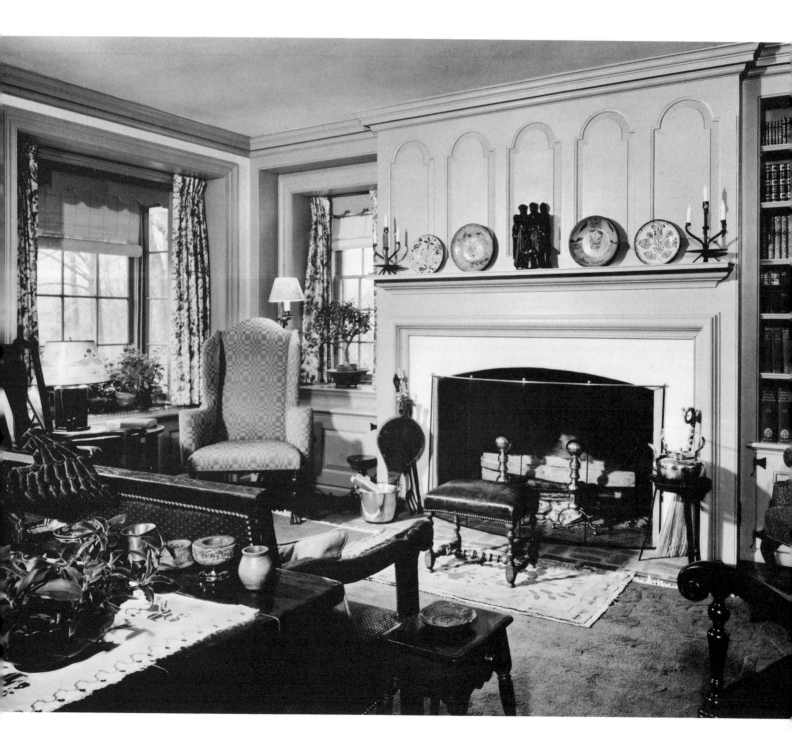

157

A Queen Anne side chair in the living-room corner has many desirable Philadelphia features: high shaped back, splat outlined with unusually lively scrolls, compass seat, and crisply carved trifid feet. Distinguished in form and detail is the Queen Anne walnut five-drawer dressing table with arched apron. The mirror with brass candleholders attached to the frame bears the label of John Elliott of Philadelphia. The flat-top tall clock visible beyond is by Peter Stretch of Philadelphia (1670-1746). Through the door to the dining room, at the right, may be seen a walnut corner cupboard of the early 1700's, whose raised panels, dentil cornice, and molded base served as models for the new woodwork in this room. The arched slat-back chair is a Delaware Valley type.

A windsor bench in the upper hall has many features to appeal to the collector: eight turned legs, turned stretchers and posts, shaped seat, molded back rail with well-carved knuckles. The Pennsylvania slat-back chair beyond is perhaps the most delightful of several in the house, with its very high back, six undulating slats, and ball-turned stretcher. Typical of Pennsylvania in its broad proportion, though none the less a rarity, is the William and Mary walnut chest-on-frame, its turned legs joined by scrolled flat stretchers.

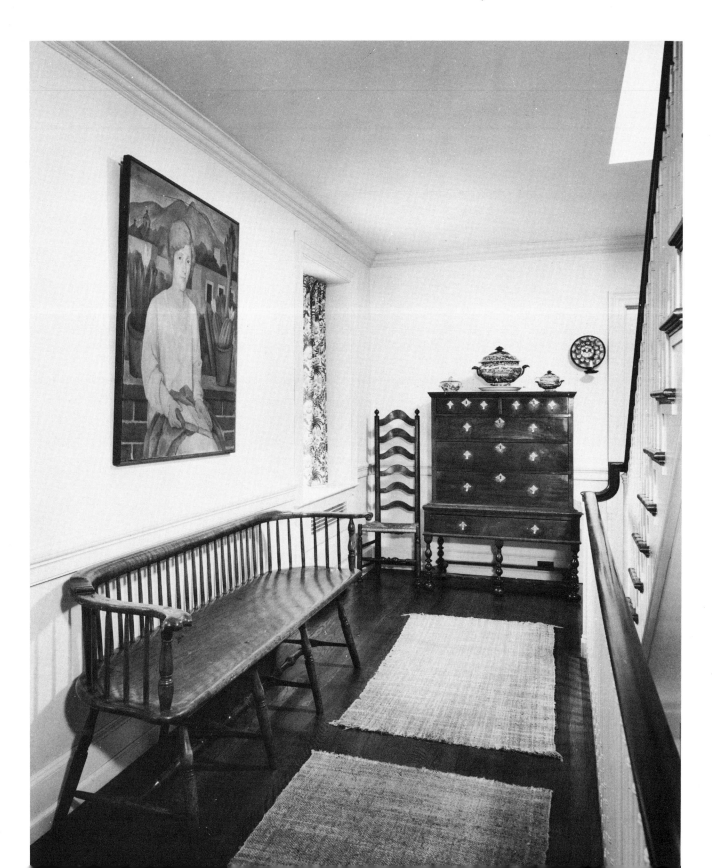

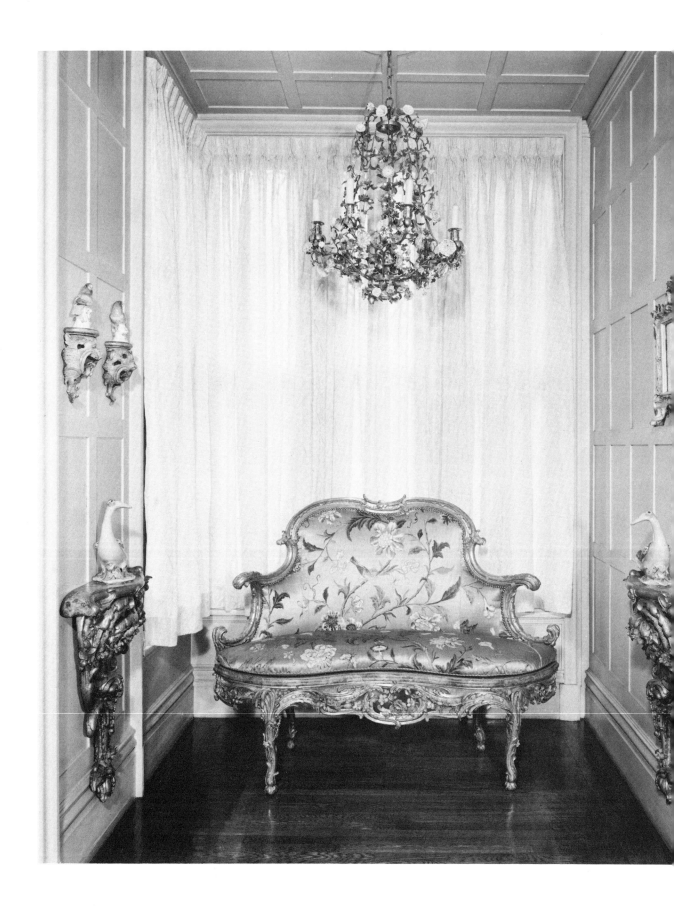

Continental craftsmanship

Mrs. Lesley G. Sheafer, New York City

PERHAPS IT IS GOOD for a serious collector to live in an apartment, without benefit of attic or cellar: when space is limited and a home must also be a display case for treasured possessions, every item must meet the requirements of daily living and measure up to the standard of the collector. Viewed from this aspect, Mrs. Lesley G. Sheafer's apartment in New York City might serve as a classic example. Her gracious and comfortable rooms contain an extraordinary collection of eighteenth-century furniture and decorations and an equally important collection of porcelain from Europe's finest and earliest factories — all authenticated, all in perfect condition, all beautiful.

Most of the furniture is French of the Louis XV period, and there are examples by some of the greatest cabinet-makers of that great age. The rococo, characterized by brilliant and audacious asymmetry, was introduced in France shortly after the Duke of Orleans became regent in 1715 and it was the court style throughout Louis XV's reign. By about 1760 its sophisticated elegance had become almost standardized; furniture frames had slight ornament, and were expensively upholstered in flowered brocades and velvets from Genoa and Lyons, or in wonderful Gobelin or Beauvais tapestry.

German rococo was different. The light construction was in striking contrast to the preceding heavy baroque, and the style was distinguished by carved decoration of natural flowers and foliage. Cuvilliès, a Belgian dwarf, page to Prince Karl Albrecht of Bavaria, was one of the chief designers of German rococo architecture and furniture. Hoppenhaupt, Wagner, Köhler, Hulsemann, Kieser, Melchior Kambly (whose Potsdam factory produced the best ormolu mounts), and the brothers Spindler all produced furniture with portions of the frame beautifully carved in naturalistic ornament, generally gilded and colored. Comparatively little German rococo was made and much vanished during the last war. Mrs. Sheafer's set in the dining room is a rare and important example.

Her porcelain collection includes pieces from the leading German and French factories. Of the more than fifty birds, most were modeled by Kändler of Meissen. The wall brackets on which these are displayed and the numerous sconces in carved wood, porcelain, and ormolu show interesting variety of design in the asymmetrical scroll. The pictures that hang among these eighteenth-century treasures include paintings and drawings by such latter-day masters as Renoir, Degas, and Toulouse-Lautrec.

Mrs. Sheafer has not used color schemes in the usual sense of the word. The whole apartment glows with soft hues, not massed, but diffused from furniture, textiles, porcelain, lighting fixtures, paintings, clocks, silver, gold, natural woods, lacquer. Color is everywhere, with occasional accents of white, all in harmony.

Facing page.

A small curved settee in an alcove off the dining room is one of a pair *en suite* with the dining-room furniture. The frames are gilded and painted in natural colors, including a soft blue which is the ground color of the old satin upholstery. In French rococo the flower was diminished to a small attribute, but in this German set wonderfully designed natural flowers are used in profusion: grouped, swung, interwoven with curves which, like Daphne, turn into foliage. Aprons on settee and chairs are united with the cabriole legs which are formed, with artistry and ingenuity, of naturalistic vegetation. The two consoles here are entirely asymmetrical, even the tops, which simulate green marble; in the enormous rooms of Seehof Castle, for which they were made by Ferdinand Dietz, they were wall brackets. The porcelain ducks are Chinese. *Photographs by Taylor and Dull.*

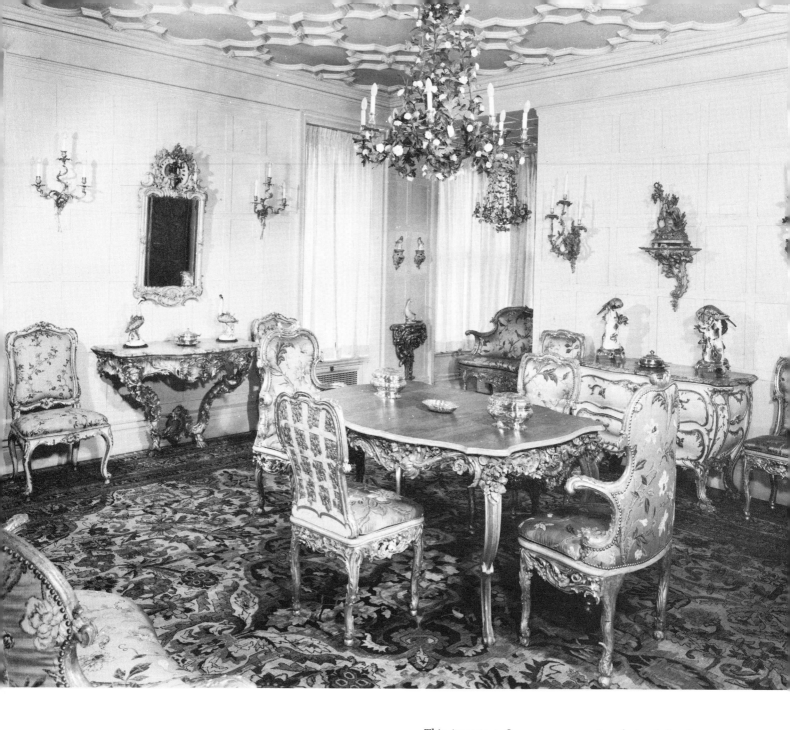

This important German rococo suite of six chairs, two settees, and a table was given by the Markgräfin of Bayreuth to Count von Seinsheim, Bishop of Würzburg from 1755 to 1779. It was made in 1765 by Johann Köhler; the table is nearly identical with the library table of Frederick the Great, brother of the Markgräfin, in his New Palace built at Potsdam in 1763. On the backs of the side chairs a wooden lattice with carved and painted flowers is unusual and charming. The console table, one of a pair in a sculptural design representing the Four Seasons, and the white and gold commode are by Ferdinand Dietz, cabinetmaker, who worked 1760-1773 at Seehof Castle, the bishop's summer residence near Bamberg in Bavaria. On a bracket above the commode is a model for a statuary group made by Dietz for the garden at Seehof. Also from Seehof is the chandelier, wreathed in white porcelain roses and green leaves of painted bronze. The mirror with carved and painted frame is one of a pair from Ansbach, and the two white and gilt chairs on the same wall are Venetian rococo.

In the large *salon*, the dark mahogany of a Louis XV writing table serves as a foil to the contemporary set of six armchairs and a sofa, which are upholstered with superb Gobelin tapestry woven with scenes from Aesop's fables in floral borders on a rose ground. A pair of Louis XV *tables de salon*, stamped N. PETIT, are delicately inlaid with floral marquetry and fitted with drawers and slides. The *encoignure* is one of a pair made by the great German cabinetmaker Johann Friedrich Spindler, in Bayreuth, 1760; the construction is unusual, the front divided into two one-door cupboards, and gilt mounts and stiles carved, not ormolu. The miniature German faïence stove beside it is one of two flanking the doorway which are signed *Stockelsdorf 1773 / A. Leihamer, fecit / Buckwald, Directeur*. On the writing table are a pair of Chinese porcelain vases mounted in ormolu, and a Louis XV inkstand in lacquer, *bronze doré*, and Mennecy porcelain (c. 1750). The picture is a drawing by Degas.

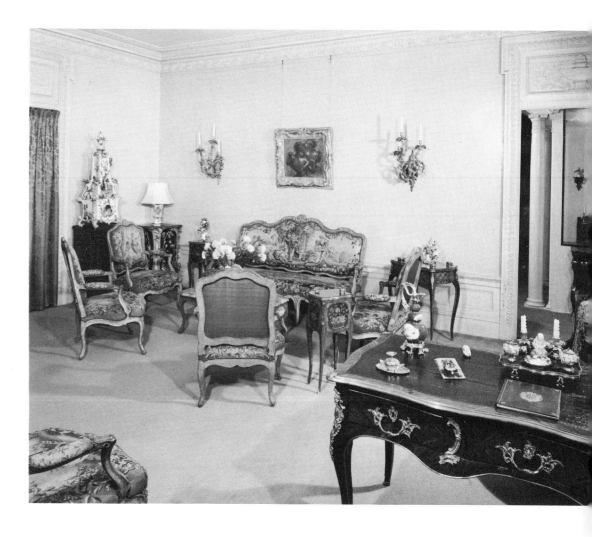

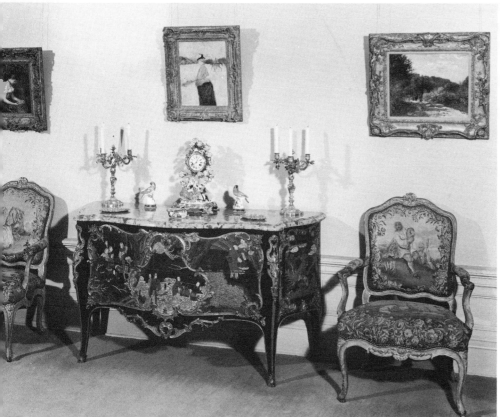

This magnificent commode with Oriental lacquer panels, made about 1750 for the Duke of Gramont, is stamped B·V·R·B, the initials of Bernard II van Risen Burgh, a *maître-ébéniste* whose identity was long obscure. His work is characterized by richness and artistry. The ormolu clock in *bocage* of colored porcelain flowers, with a three-figure crinoline group by Kändler on its base, is flanked by Meissen parrots and *bronze-doré* candelabra with *rocaille* knops in the shaft and interesting leaf *bobèches*. The center painting is by Toulouse-Lautrec; that on the left, of a girl reading, is by Renoir, as is also the landscape with figures.

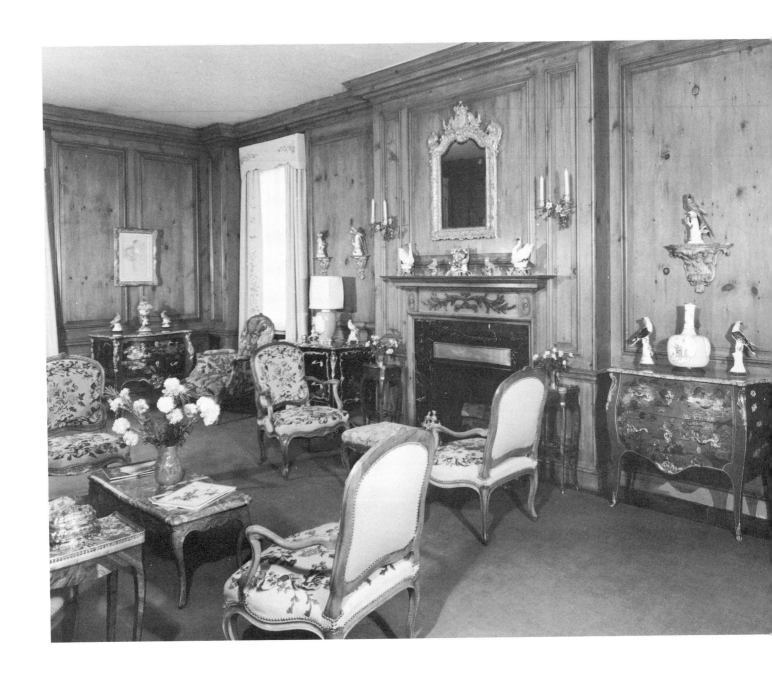

The living room is paneled, its fireplace frieze carved
with bold foliage; above is a Louis XIV mirror (c. 1720)
whose gilt frame has the royal coat of arms and initial
L in the cresting. There are four French commodes of
1745-1750, all different but all *bombé* with marble tops,
decorated on front and ends, and with an apron complet-
ing the curves of the cabriole legs; two are black lacquer,
a third is red. On one stands a large blue-ground Meissen
vase with the magic mark AR for Augustus Rex; on an-
other, a yellow-ground vase with the same mark. Of three
small Louis XV tables with marble tops and ormolu
grilles, the two flanking the fireplace have chamfered cor-
ners and stretcher shelves. The Louis XV armchairs form
a set of eight with matching settee. A large Louis XV
bergère by the window is upholstered in petit point, as
is the taboret before the fireplace.

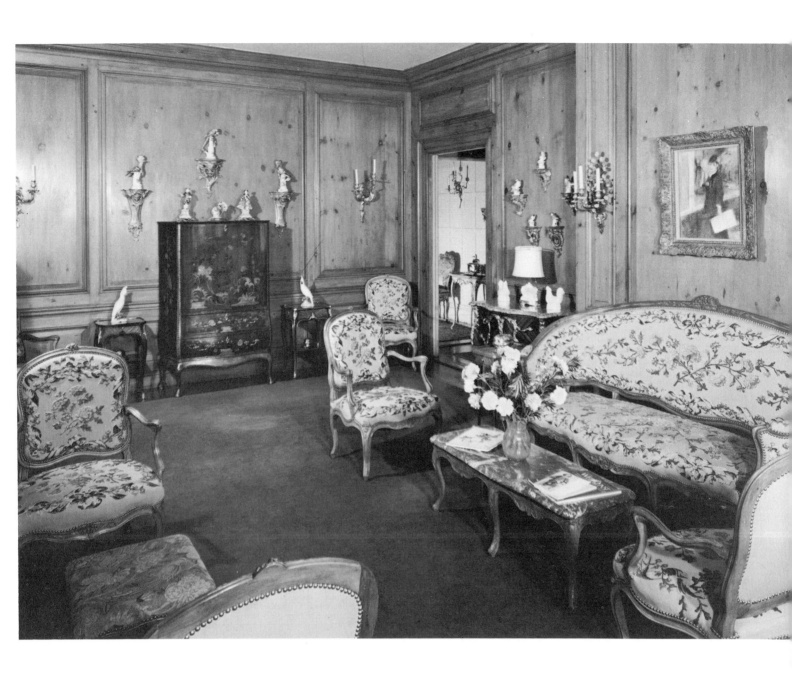

The fall-front secretary, as important as it is beautiful, was made in the famous Roentgen factory at Neuwied, 1765-1770, when David Roentgen was taking over the management from his father, Abraham, and it shows the influence of both. The *bombé* base with hoof feet had been made by Abraham for years; the plain rectangular upper section, without cornice or pediment, shows a new trend. It is decorated with the marquetry for which David was famous. Over the settee hangs a fine pastel by Renoir. The commode beyond has tendril handles "growing" from the ormolu mounts; on it are pieces of rare early St. Cloud porcelain, one an aubergine-shape incense burner which has been adapted for use as a lamp base.

Philadelphia furniture in Bucks County

Mr. and Mrs. Hiram D. Rickert, Yardley, Pennsylvania

MR. AND MRS. HIRAM D. RICKERT, who own Windfields, in Yardley, Pennsylvania, belong to the fortunate but comparatively small group of collectors who have never lived *without* antiques. The first Rickerts to come to this country belonged to a Saxon sect related to the Quakers; they arrived here in 1682 under the protection of William Penn, and the family has been active in local, state, and national affairs ever since. Unobtrusively functioning as solid citizens in every generation, its members must be credited with a substantial part in the founding of two railroads, a canal, and a university; streets and a town bear their name.

It is not surprising, then, that the family pieces in the Rickert collection, acquired over the centuries by prosperous people living near one of the nation's great centers of culture, are excellent representatives of their periods and styles. Most are textbook examples of Philadelphia Chippendale, though other periods and other parts of this country and of the world have contributed too.

Mr. Rickert began his collecting well aware of the fine points of early American craftsmanship. He has become familiar with the literature of the field, and he has enjoyed the friendship of leading scholars as well. With such a background his own acquisitions have been uniformly admirable, and today the collection goes far beyond its heirlooms, exceptional as these would be in any other con-

text. For instance, in a category where fine carving is taken for granted, the matching Philadelphia highboy and lowboy here are remarkable for the extent and richness of their decoration; a cabriole-legged stool not only adds a shell to a rare form, its seat is subtly shaped as well; and so on throughout the house.

The Rickerts' connoisseurship is not by any means confined to American furniture: they have a significant group of early American silver bearing such great names as Wynkoop, Richardson, Revere; paintings by Inness, Gainsborough, Peale, Sully; Remington bronzes; Dutch delft, English porcelains, Oriental rugs, French textiles; and everywhere there is the soft glow of Chinese porcelains, jades, and other precious materials.

The house itself is largely the creation of its present owners. They took a modest Bucks County stone farmhouse which had been "modernized" in Victorian days and restored it to its original date of about 1770 by closing up two entrances, installing a handsome pedimented doorway, and remodeling the dormers; the addition of three wings provided necessary space and gave the house a pleasantly rambling character. Interior architectural features have been lovingly preserved in the older portion and meticulously matched in the new.

The landscaping of Windfields is one of its great charms. Like the quality of the collection, this might be expected,

since one of the many irons in Mr. Rickert's fire is nearby historic Moon's Nursery — the oldest such enterprise in the country. Established by Quakers in 1767, it was the source of trees and other plantings for Mount Vernon and for countless other colonial and Federal estates.

The Rickerts have had the help of Jane Ashley, A.I.D., in creating the impeccable background which so enhances their collection. This was not a matter of simply turning over the decoration of their home to a professional. Miss Ashley and the Rickerts have been close friends for many years, and it was in fact Mrs. Rickert who originally persuaded Miss Ashley to take up interior decorating as her life's work. These extraordinarily harmonious rooms are as much a reflection of Miss Ashley's intimate knowledge of her friends' tastes and way of life as of her own discrimination and professional skill.

Windfields,
the Bucks County, Pennsylvania,
residence of Mr. and Mrs. Hiram D. Rickert.
Photographs by Taylor and Dull.

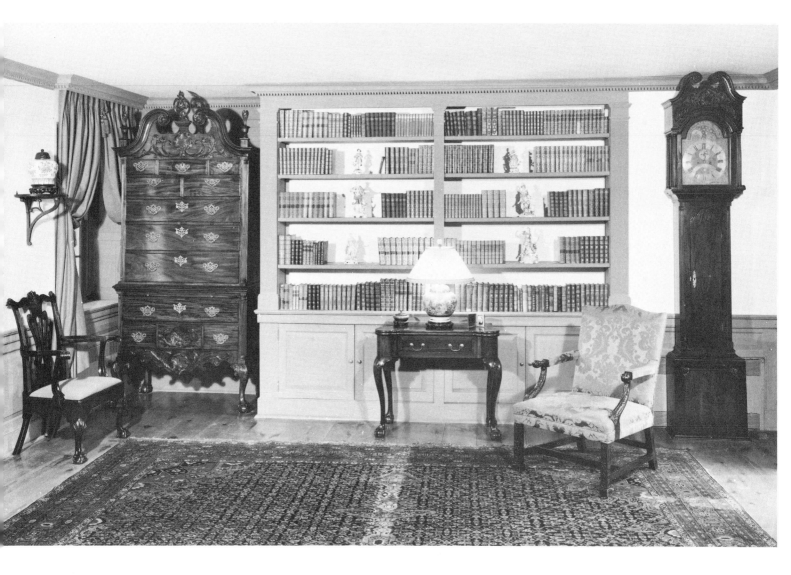

A matching lowboy not shown in either of these views of the living room adds to the importance of the superb Philadelphia bonnet-top highboy, with its deep apron echoing the carving in the center drawer above. The clock, marked *Jos. Ellicott Buckingham No. 64,* is another Pennsylvania product. So are the chairs; that on the right, with its distinctive carving on Marlborough legs and arm supports, is one of several pieces in the collection which invite attribution to Thomas Affleck (Philadelphia, 1740-1795). Books, a Ming lamp on the Queen Anne card table, Chelsea and Bow porcelain figures on the shelves, a pair of K'ang Hsi blue and white vases (one not visible here), and the large Isfahan rug are well-chosen additions.

Color plate, facing page.

Typical of the Rickert collection is the secretary which dominates this end of the room, a Philadelphia piece impressive in scale, design, and execution; Queen Anne side chairs and a Chippendale corner chair match it in quality. The Chinese paintings on glass (Ch'ien Lung, c. 1790) are in harmony. Chinese Chippendale carving on leg and bracket of the wing chair relates it to the open-arm chair on the other side of the room. Even in the company of such superlative pieces the little stool before the fireplace, with its ball-and-claw feet, acanthus-and-shell carving, and shaped seat, catches the eye.

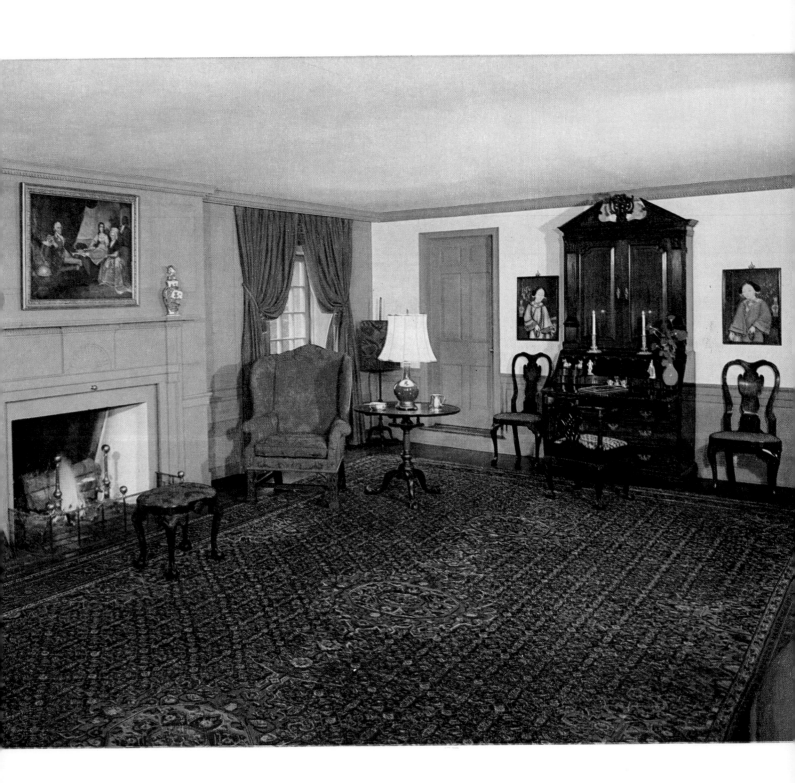

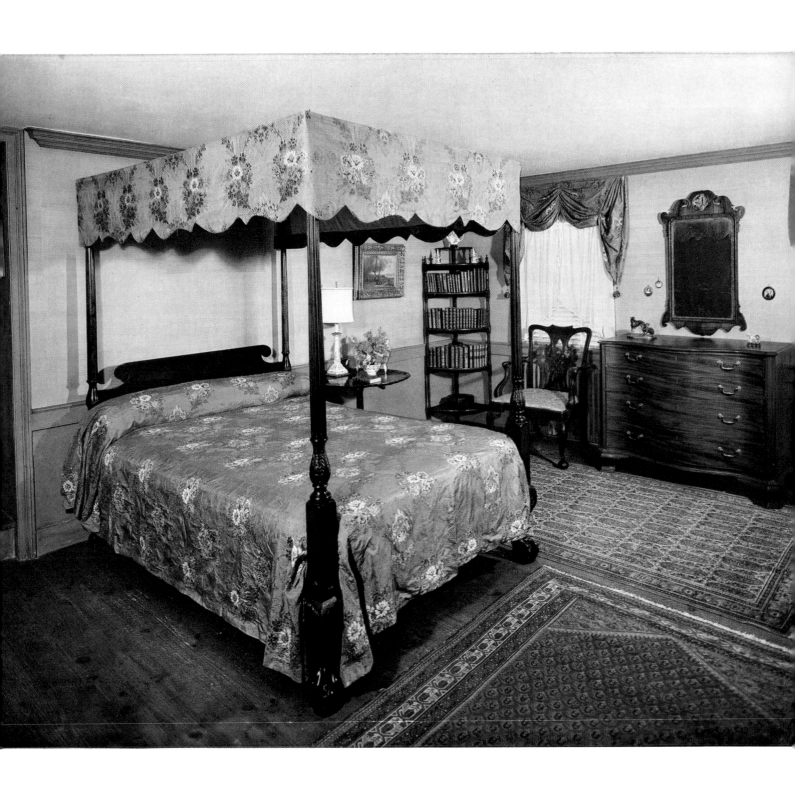

Color plate, facing page.

The exquisite fabric draping windows and bed in Mrs. Rickert's bedroom is an antique French silk; the bedstead itself contrasts slender fluted posts with substantial scale-and-acanthus-carved legs and boldly modeled claw-and-ball feet. Pleasing proportions and satisfying contours mark the serpentine chest, attributed to Jonathan Gostelowe (Philadelphia, 1745-1795) because of its close analogy to labeled examples by this maker; reflected in its mellow surface are bronze greyhounds by Frederic Remington (1861-1909) and a jade horse. The looking glass is of the type made — and imported as well — by John Elliott (Philadelphia, 1713-1791).

Federal furniture from the Boston-Salem area in this room includes a Hepplewhite armchair, an unusually appealing sewing table of satinwood and mahogany, a delicately scaled tambour desk trimmed with line inlay, and a Sheraton side chair. The portrait of Henry Wadsworth Longfellow by Thomas Sully (1783-1872) gives us an unaccustomed glimpse of the poet as a young man.

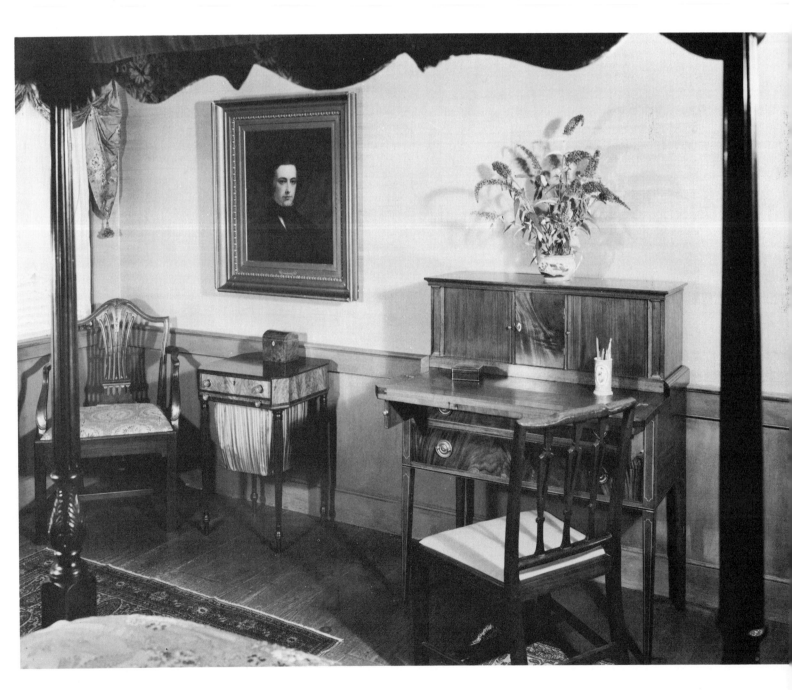

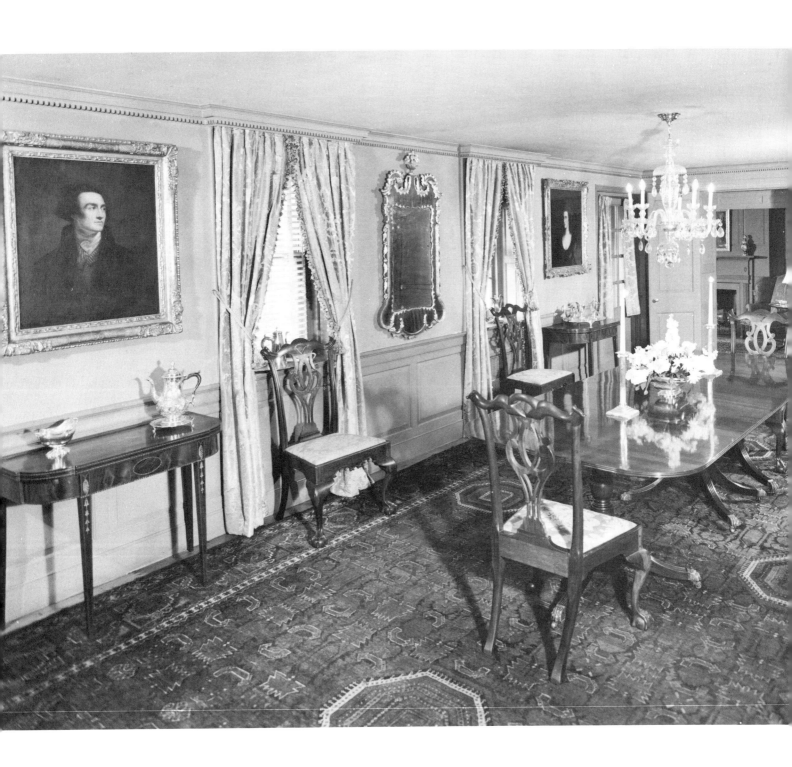

Portraits believed to be of the Earl
and Countess of Roscommon, ances-
tors of Mrs. Rickert, look down on
the dining room. Both of these were
painted by James Northcote (1746-
1831) who spent five years in the studio
of Sir Joshua Reynolds. This room, like
the living room, is alive with color:
blue walls, gold draperies and uphol-
stery, red and blue Bukhara rug, warm
tones of mahogany, silver, and gilt.
The Philadelphia chairs here are ex-
ceptional; so is the beautifully inlaid
side table at the left, which adds an
eagle on the top and a shell inside to
the more usual shell and bellflower mo-
tifs visible here on frieze and legs. The
clock, made by Simon Willard (1753-
1848), bears on its dial the legend
Warranted for Mr. John Kimball.

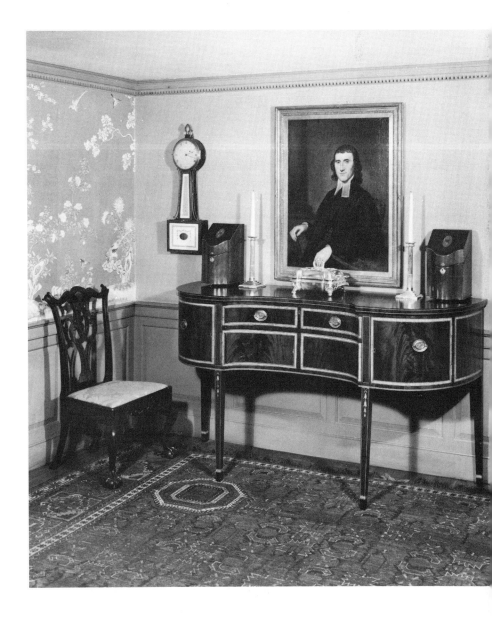

Another view of the dining room,
showing a section of the rare an-
tique Chinese paper which covers one
wall. The banjo clock is, of course,
Simon Willard's "Improved time-
piece." Charles Willson Peale (1741-
1827) painted that speaking likeness
of an unknown clergyman about 1790.
The shape of the sideboard and the
pattern of its inlay are both unusually
striking.

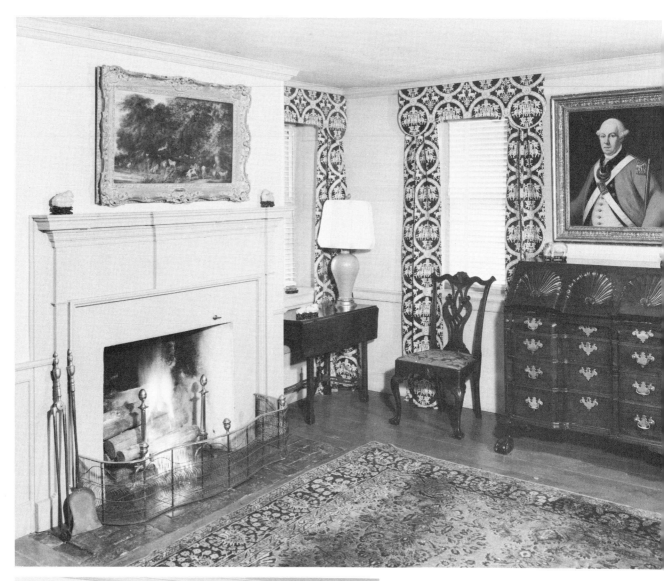

A somewhat spectacular New England slant-front block-and-shell desk shares honors in this view of the study with a pembroke table with pierced saltire stretcher and block feet, a delightful example of its genre. The landscape is by Thomas Gainsborough (1727-1788), and the military gentleman, Sir Richard Sutton, is believed to have been painted by John Singleton Copley (1738-1815) during that artist's American period. The small carvings are of jade, and the rug is a Saruk.

A portrait of an unidentified lady by an unknown artist, strongly reminiscent of the well-known painting of Evelyn Byrd now at Colonial Williamsburg, forms a pleasant group with a graceful Philadelphia wing chair and a crisply carved marble-topped table.

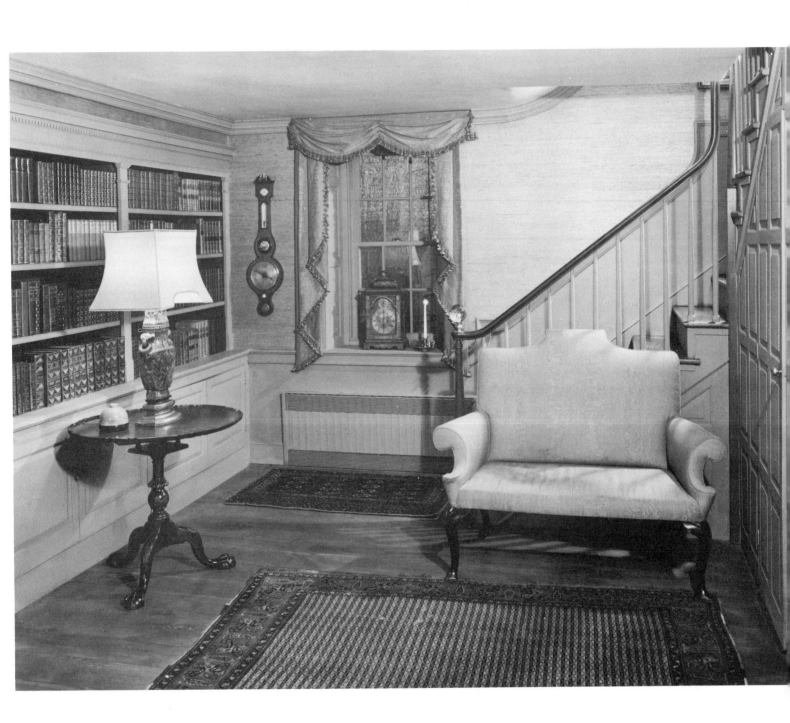

There are quantities of books all over the house, but the small room that also serves as entry and stair hall is called the library. A rose-color Queen Anne settee with great style — another witness to the taste of earlier members of the family — fits snugly into the turn of the stairs here. The tilt-top table, very like one in the Karolik collection at the Museum of Fine Arts in Boston, holds a chalcedony lamp and an exceptionally fine peach-bloom coupe, or brush pot. James Smith of London, clockmaker to George III, made the bracket clock on the window sill, and the barometer is also English. The large rug is a Senna and the smaller, a Bukhara.

Selectivity and sentiment

Mr. Phelps Warren, New York City

FOUR STEPS WERE NECESSARY in the planning of the New York apartment of Phelps Warren before the owner could begin living with his antiques.

The first step was the selection of the furniture from an available collection acquired over the years by inheritance, hand-me-down, and purchase — the mysterious process of accretion which is a special province of acquisitive people. In the culling process, sentimental value was a prime consideration. These were the things he was brought up with; they were reminders of other houses, other places, other people, other ways of life. This was not just furniture, but *antique* furniture, embodying warmth and love and taste and good living, and sentiment played a major role in the first step of selection.

But sentiment was of necessity tempered by considerations of usefulness; there is little room in the small apartment for furniture which is only ornamental. Then decorative value was weighed. And finally, the compatibility of each piece with its future neighbors was thoughtfully considered. Mr. Warren recognized from the start that the final furniture selection would result in an American-English-Continental mélange, but this was never deplored; indeed, in one house or another, in one combination or another, much of the furniture collection had long been happily living together.

When furniture questions had been decided, alterations were planned in the interior architecture of the apartment. An entrance hall was created from the end of an excessively long living room, to accommodate a cherished hall bench with two matching chairs and a console. For a grouping of sofa, small tables, chairs, and a much-loved framed needlework panel, a niche was formed on a long wall in the living room. Overdoor niches were built in two other locations. Cupboards for display, bookcases, mirror panels, wall brackets to hold lighting fixtures — all these interior architectural devices were employed to provide the most effective and sympathetic setting for the antiques.

Forsaking the sideboard as an anachronism in an apartment that did not boast a room exclusively for dining, Mr. Warren had a special dust-and-tarnish-proof cabinet built for the storage and occasional display of useful and ornamental silver. And not the least of the architectural renovations was the creation of an outsized, concealed storage closet, shelved to hold the inevitable accumulations and collections of an antiques enthusiast, and large enough to house furniture used only occasionally (including a coffee table which purposefully appears for coffee and then retires, leaving a welcome uncluttered view of the sofa).

Third, the furniture in its architectural setting required a scheme of color sympathetic to the antiques of many countries and periods and to the colors of Oriental rugs used on bare floors in summer and of old damask draperies. A basic color palette of muted earth colors (chamois, tortoise shell, bronze, *tête-de-nègre*) was chosen and pervades the apartment from the front door through halls, rooms, even kitchen, occasionally heightened with contrasting colors. Thus, in the living room, crystal, gilt bronze, gilded wood, and brass lighten the somber color of the painted wall cases while on the facing wall the teal upholstery of the sofa takes its color from the peacocks in the altar frontal above, the only blue note in the room.

The final step — never really completed — concerned the decorative, accessory things, the useful and ornamental antiques, such as vases, candleholders, and the like, of silver, brass, porcelain, wood, glass. This is where the contents of that ample store closet come into play; new arrangements and combinations continually suggest themselves, are tried, rejected, approved, altered. Piquancy is achieved through novel juxtaposition of ornaments, shapes, colors, styles, textures; the "set piece," the static "arrangement," is rejected in favor of continual change. This is a phase which one hopes will never end because the enjoyment of antiques living with each other is one of the delights of living with antiques.

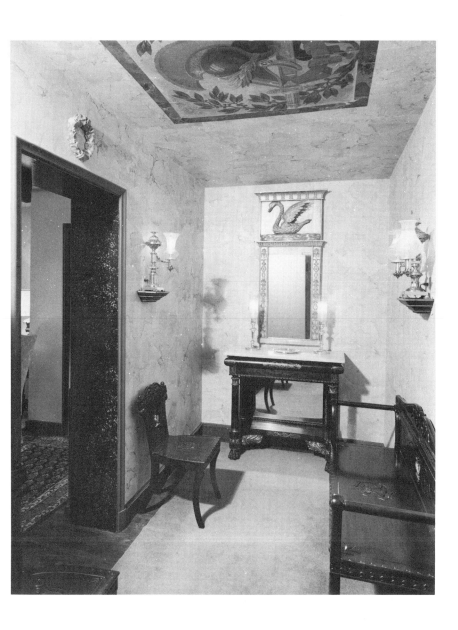

The hall ceiling and walls are covered in gold and yellow marble paper; on the ceiling is an eighteenth-century decorative French heraldic panel painted on canvas in brilliant color. The swan of the gilded Italian mirror is carved in high relief, repeating the deeply carved and gilded decoration on the console, which is attributed to Lannuier. The English settee and matching side chairs, c. 1810, have seats carved with the Prince of Wales' three-feather emblem and *Ich Dien* banner; their backs are further ornamented with brass pheasants in recessed carved shields. The console lights, Sheffield, c. 1825, are trumpet columns on circular bases decorated with oakleaf bands in graduated sizes. To create this hall for the furniture as shown, the wall at the left was built across the end of the living room. *Photographs by Taylor and Dull.*

An American eighteenth-century tall-case clock stands dramatically before wallpaper panels showing a sixteenth-century Venetian building printed in muted earthy colors. A marble bust, appropriately named *Venice*, surveys the scene (somewhat celestially) from a blue niche created for her. It is the work of Larkin Goldsmith Mead (1835-1910), brother of William Rutherford Mead of McKim, Mead and White and brother-in-law of William D. Howells, in whose absence from Venice Larkin Mead served as acting vice-consul about 1865.

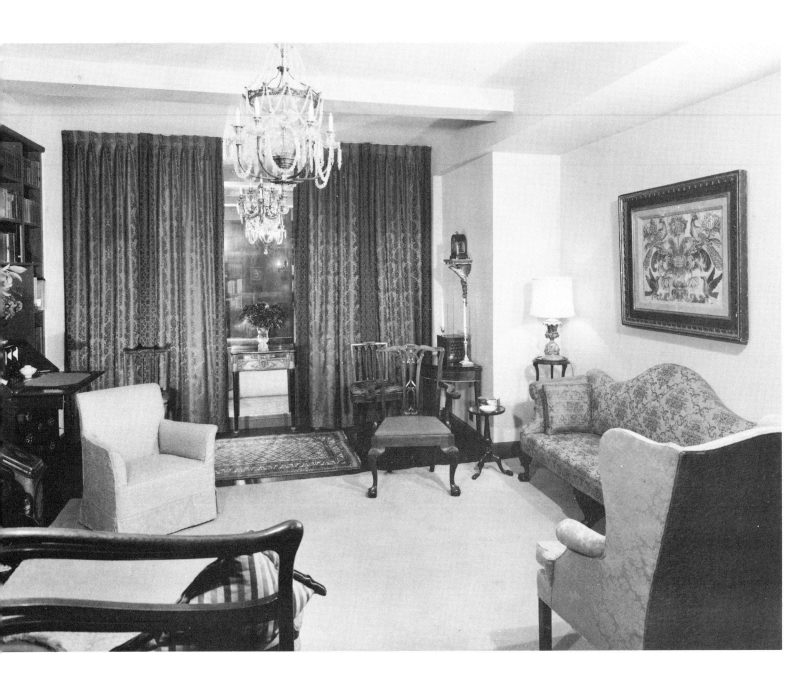

In the living room the glow of chamois-color walls and carpet is heightened by red damask curtains bordered with ecclesiastical purple. On a mirror panel between the windows is one of a pair of Italian caryatid gilt and crystal sconces, c. 1800. The framed Spanish altar frontal above the sofa is couched and laid silk, mid-eighteenth-century Spanish. The mahogany armchair, perhaps New York, c. 1760-1780, is documented as a "family piece" by photographs of it *in situ* in homes of four preceding generations. A carved and gilded American eagle bracket supports a clock inscribed *George Prior London* and attributed to the later (1800-1830) of the two makers of that name. Below it, a pair of Sheffield candlesticks in the Adam taste, from a set of four by Hawksworth Eyre & Co., flank a veneered mahogany and satinwood cellaret on an American Sheraton demilune card table.

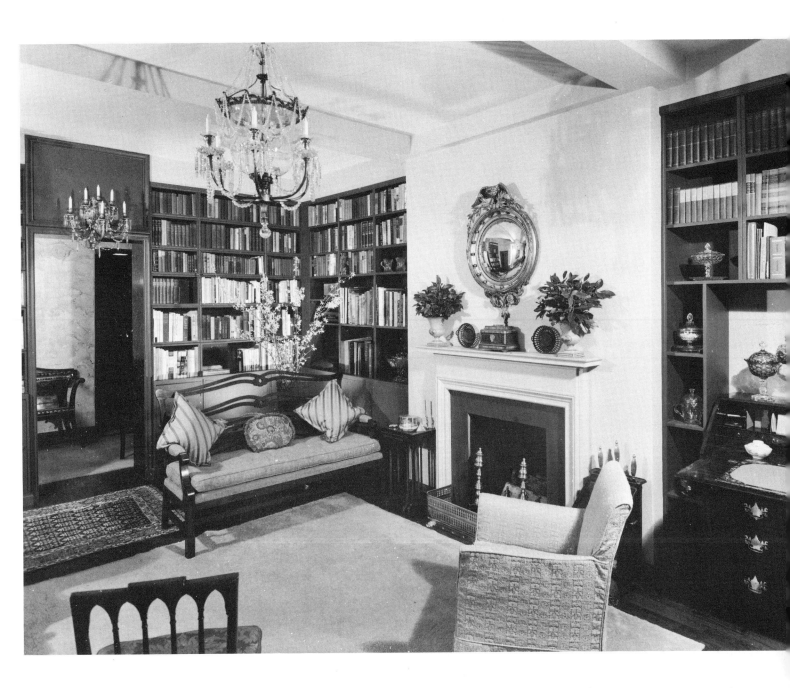

On its living-room side the wall built to create the hall becomes a book wall (only half the width is shown), painted gray *tête-de-nègre*. The convex mirror in gilded frame hangs on a chamois-color plain wallpaper. At right, the slant-topped desk is recessed in a niche planned to minimize its generous depth. The unusual settee, five feet long, has a ladder back of four shaped and pierced spans. On the mantel is a pair of chocolate-brown pottery open-work baskets by Store and Golding, 1760-1830, seldom encountered makers of Isleworth, Middlesex. In recesses flanking the chimney breast are examples from a collection of English-Irish and Continental glass, 1775-1825. The chandelier, a modern fixture composed of old metal and crystal parts, and the Italian sconces at the ends of the room, light by candle only.

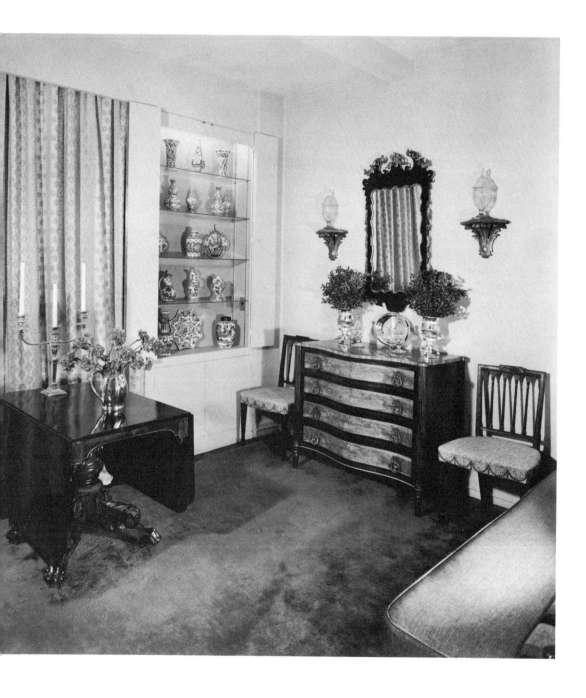

Feathered golden satinwood dramatizes the mahogany chest of drawers here, its rich color emphasized by the orange and gold upholstery on side chairs from a set of twelve attributed to Slover and Taylor, c. 1802, New York cabinetmakers. The American Empire library table used for dining, with its deeply carved pedestal, bracket legs, and solid top, reflects in its prodigal use of mahogany the later work of Phyfe. The silver pitcher is one of a pair by Gale, Wood and Hughes, New York silversmiths (c. 1835). Examples from a collection of early Dutch blue and white pottery are in the lighted cabinet. The textured grasscloth walls of this room take their color from the white background of this faïence; the Chinese carpet repeats its "Muhammaden blue," while the curtains are an orange-gold print on coarse-textured gray linen.

English and French antiques in the South

Miss Flora Barringer, Columbia, South Carolina

English and French antiques of many periods are combined in quiet harmony in this Southern house. The tone is set in the entrance hall, where a nineteenth-century French paper by Dufour provides a colorful background for eighteenth-century Adam, Hepplewhite, and Queen Anne pieces. Calculated emphasis is given to a reproduction of an elaborate English chinoiserie mirror in the possession of the Museum of the City of New York: its rococo curves are a foil to the simplicity of the Adam console table it surmounts. The Dufour paper, with its Oriental figures and buildings in shades of brown, beige, soft yellow, and coral, is complemented by antique Spanish rugs with gold grounds displaying angular arabesques in green. Upholstered Hepplewhite side chairs flank the Adam console with its urn-carved frieze, and in the corner are a Queen Anne knee hole desk and stool. A pair of Meissen birds and a Swansea bowl are part of a small but choice collection of porcelains that take their place effectively in the decoration throughout the Barringer house. The glass bell lantern rimmed with ormolu festoons is English. *Photographs by Louis Reens.*

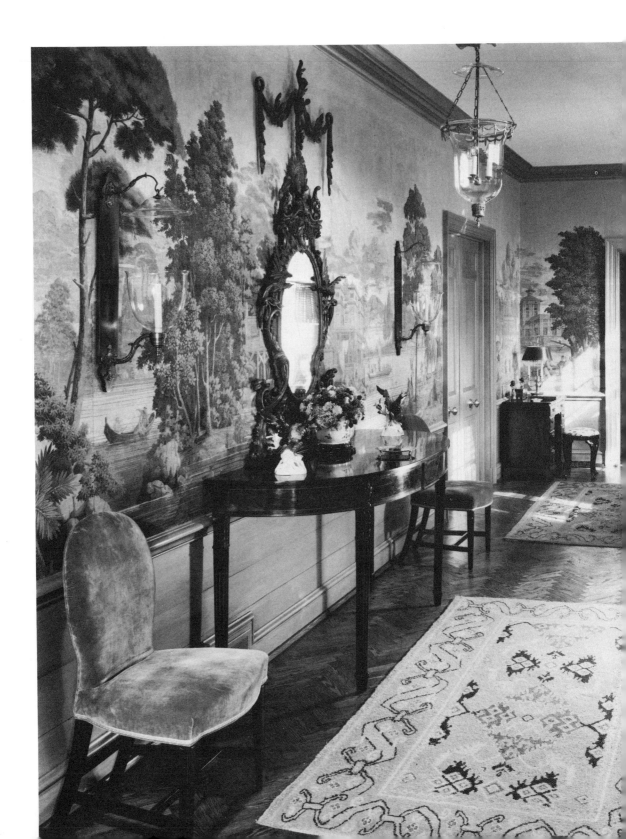

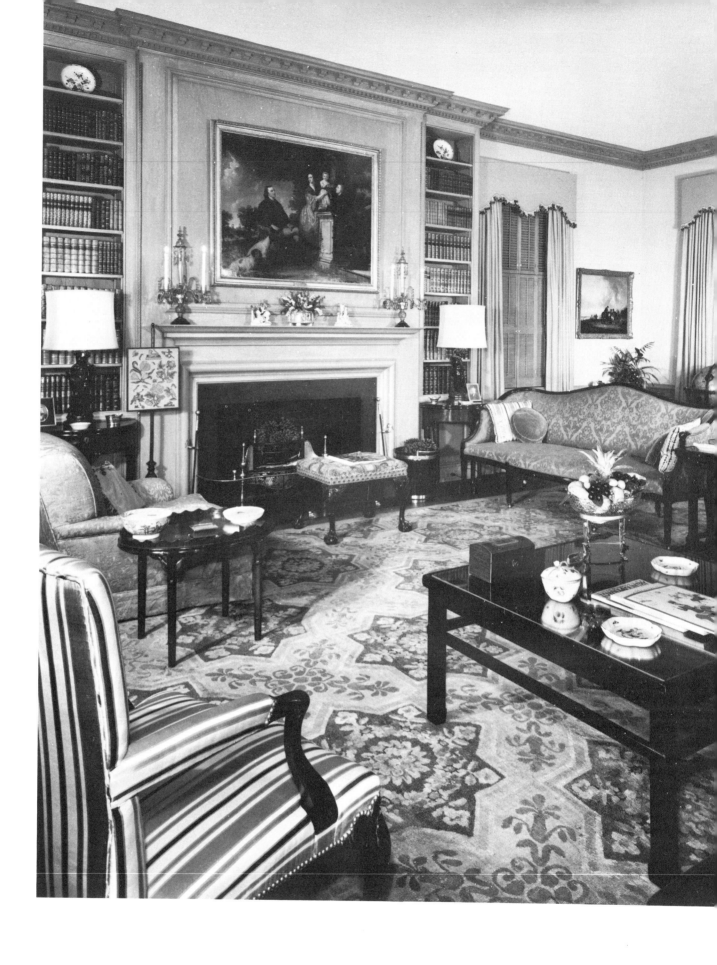

In the living room an overmantel panel is handsomely filled by an English conversation piece showing the Derby family at a balustrade in a park, painted about 1770 by Benjamin Wilson (1721-1788). At either end of the mantel shelf an English cut-glass candelabrum with notched candle arms, small canopies, and faceted drops represents the great period of English glass cutting, the 1760's and 1770's. Between them are a Worcester porcelain crocus pot and Meissen figurines. The Chippendale stool in front of the fireplace is covered in old needlework, and a Hepplewhite sofa stands at the right. The antique Aubusson of large proportions translates an Oriental rug motif, an eight-pointed star, by filling it with a typically French floral pattern.

A Chippendale desk and bookcase at one end of the living room is notable for the carving of the broad fretwork in the frieze below a dentil band and the towering pierced cabochon cartouche in the open pitch pediment. Carving on the scrolled edge of the recessed panels, at the division of the two sections, and again on the base above the ogee bracket feet is executed with richness and restraint. The Chippendale armchair with pierced Gothic splat retains the looped arm of the earlier period, which allowed plenty of room for flowing skirts.

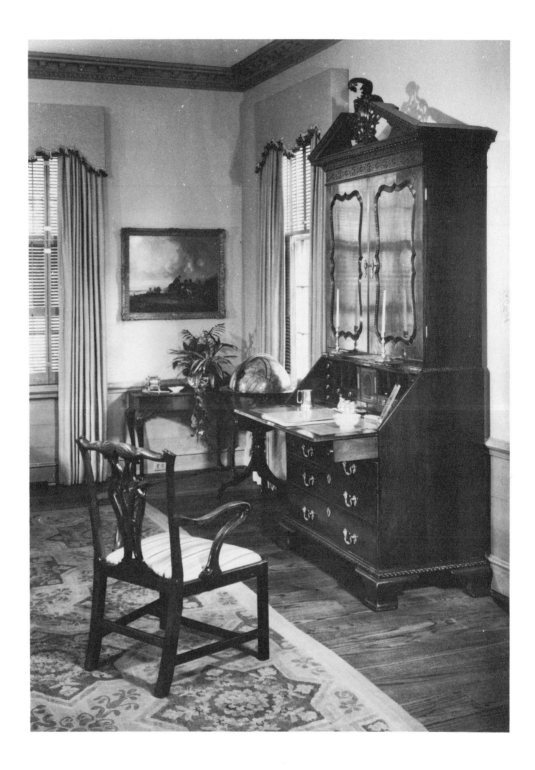

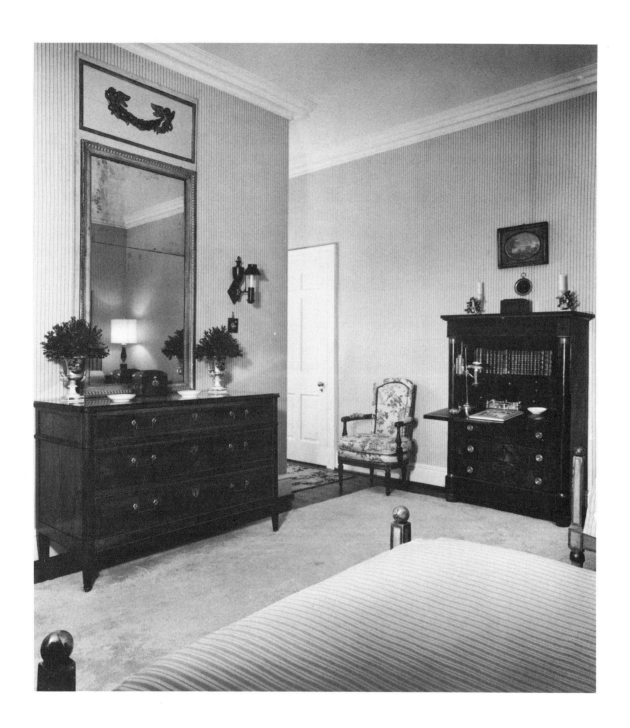

In the guest bedroom cheerful yellow walls are the background for the subdued gilt ornament of the *trumeau* above the Louis XVI commode. Toile, printed in a yellow pattern of flowers and birds, covers the fruitwood armchair. The Empire fall-front *secrétaire* has ormolu mounts. *Porcelaine de Paris* urns on the commode and Meissen candlesticks on the *secrétaire* are part of a pleasing group of decorations which includes English aquatints and French tole lamps used as wall lights.

Nineteenth-century brownstone

Mr. Lee B. Anderson, New York City

THE REMARKABLE GROUP of American romantic paintings assembled by Lee B. Anderson decorates the walls of his mid-nineteenth-century Manhattan town house. American Empire furniture, Tiffany lamps, and ornamental glass create a setting for the paintings that could hardly be more appropriate.

The house, one of a block of sixteen designed by James Renwick Jr. in 1855 (nine years after he had completed fashionable Grace Church nearby), is a handsome example of the type built in and around the Gramercy Park-Stuyvesant Square area in New York City during this period. Unfortunately, few of these houses are left; those that have survived usually owe their existence to groups of interested individuals who, like Lee Anderson and his friends, have managed to buy and restore them.

In this sympathetic setting are displayed the works of a hundred and eighty-two different artists painting between 1780 and 1880. The collection shows the owner's gradual change of taste. He began collecting the work of moderns Arthur Dove, Stuart Davis, Braque, and Picasso, but soon the paintings of Ralph A. Blakelock and Albert P. Ryder attracted his attention. His interest in American romantic landscapes of the nineteenth century grew and he gradually brought together his specialized collection of this genre. Among the artists whose works are represented are Benjamin West, Francis Guy, Gilbert Stuart, eight members of the painting Peale family, Washington Allston, Thomas Sully, Thomas Cole, and other major artists of the Hudson River school— Asher B. Durand, Martin J. Heade, Eastman Johnson, and Jasper Cropsey. Artists who pictured the American West, such as Seth Eastman, Charles Wimar, Albert Bierstadt, and John Mix Stanley, and their contemporaries who studied and traveled abroad and recorded what they saw (there are Italian views by fifteen painters as well as landscapes of Baffin Bay and the coast of China) are all represented.

The collection is rich in associations of master and apprentice, of patron and painter. The close relationship between artist and writer during the mid-nineteenth century is of special interest to Mr. Anderson. He finds the painting of the period characterized by a simplicity and freshness very close in feeling to the writings of Melville, Cooper, and Irving. George Loring Brown's romantic *Pompey's Tomb*, in his collection, was one of Hawthorne's favorite paintings, Cropsey's *Ode to Coleridge* was inspired by the poet's *Genevieve*, and many American painters visited the Brownings while studying in Rome.

Poets and painters alike are at home in the brownstone setting illustrated here, one which would have been familiar to most of them and pleasurable to them all.

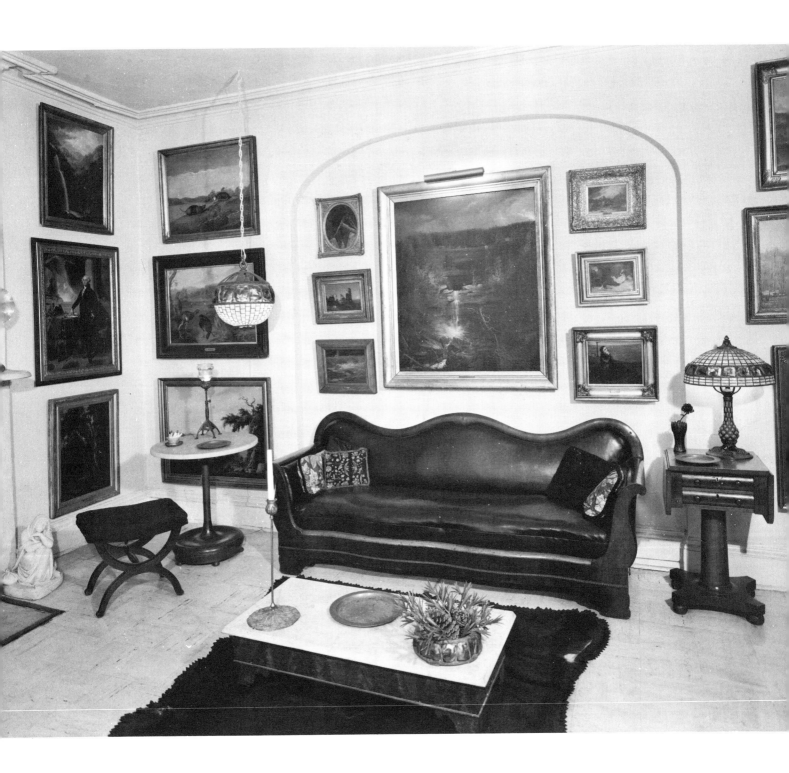

Dominating the wall above the Empire sofa in the living room is *Katterskill Falls,* painted in 1827 by Thomas Cole. Another view of the falls, this one by Robert Havell Jr., hangs on the fireplace wall above a portrait of George Washington by Gilbert Stuart. Framed by lamps and table by Louis Comfort Tiffany and an Empire table from Maine are landscapes by such noted nineteenth-century artists as the Audubons (father and son), Robert Salmon, Thomas Sully, Jasper Francis Cropsey, Seth Eastman, John LaFarge, and James McNeill Whistler. *Photographs by Taylor and Dull.*

On another wall of the living room hang *Along the Mississippi* by John Banvard and, below, *Fording the Stream* by Thomas Birch. The rosewood-veneered melodeon and its matching stool exemplify the latest phase of the neoclassic taste. They were made in New Hampshire between 1836 and 1845; the melodeon is labeled *A. Prescott / Concord.* Upon it are a Duncan Phyfe clock in the form of a lyre, and a bronze candelabrum and pieces of ornamental glass by Tiffany in the *art nouveau* taste of the end of the century.

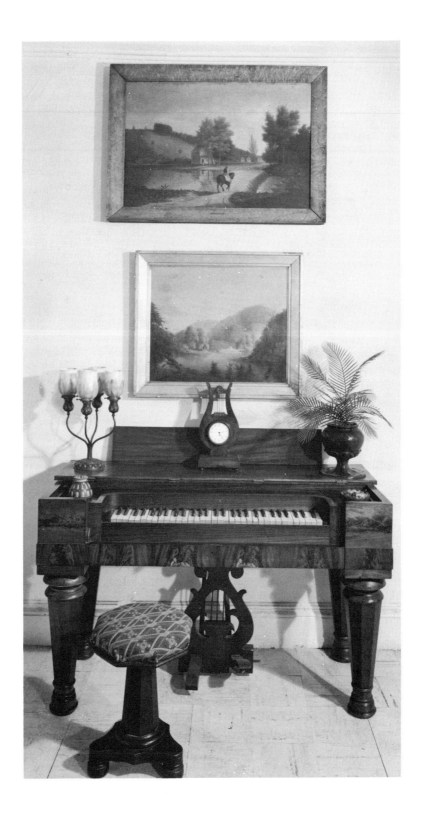

The hallway is a gallery in itself. Here, outside the dining room, are snow scenes by Joseph Morveller, George R. Bonfield, and George H. Boughton; a Catskill mountain view by James H. Cafferty; and *Colonel Astor in Hunting Clothes* by John George Brown.

In the dining room the marble mantel and wrought-iron screen are original, like all those in the house. The decorative overmantel painting by Charles Willson Peale came from the Gouverneur Morris family. Table and chairs are American Empire pieces. Against the wall is an early Belter *étagère* (c. 1850) displaying some of the owner's collection of Staffordshire plates decorated with views after artists represented in his collection of paintings.

On another wall of the dining room hang *On the Schuylkill* by James Peale and *Niagara Falls* by his nephew Rembrandt Peale. The armless love seat (c. 1855) is veneered in mahogany and upholstered in black leather.

Italian views are the theme of the study. To the left above the mahogany sleigh bed (c. 1820) is the view of *Roca de Leca* by Albert Bierstadt, which was presented by J. C. Delano to his daughter and her husband, John A. Weeks, in 1866. Below that hangs the *Ruins of Pompeii* by Robert S. Duncanson, one of the country's first Negro painters, who was a close friend of Harriet Beecher Stowe. The large painting of *Hagar and Ishmael in the Wilderness* is by William Rimmer; the artist's wife was his model.

The almost sculptural quality of the horse painted by Theodore Marsden is accentuated by the ceramic figures on the chest of drawers below it. On the right is *The Last Shot* in parian ware, after a model by John Rogers; on the left, the *Greek Slave,* a Bennington piece after the statue by Hiram Powers. A rare eighteenth-century view in oils by William R. Birch hangs above an Oriental view by Winckworth Allen Gay. The *Estate in England* was painted by John Vanderlyn while on a walking trip with Washington Allston.

A corner of the bedroom with exposed brick fireplace wall displays paintings by marine artists Fitz Hugh Lane and Francis A. Silva, *Hudson River* by John B. Bristol, and a view of Lake George by Thomas Moran, who is best known for his scenes of the Far West. Tiffany's *Beach in Italy* hangs appropriately above the Tiffany lamp and candleholder.

"Carpenter Gothic," as it is sometimes called, simulating medieval ornament in wood, achieves its own distinctive and pleasing character through the use of vertical sheathing and scroll-sawn bargeboards, crockets, and trellises. At Roseland these details are painted dark red to contrast with the pink of the house. The gable end is set parallel to the street and flanked by porches. A picket fence in the same pattern as the porch columns divides Roseland from the street. This view shows the porte-cochere at the main entrance; the chimney stacks, made of glazed pink stoneware molded in Gothic designs; and the quatrefoil pattern of the pierced porch columns, a motif repeated in the carved decoration of the parlor furniture. The Woodstock elms are famous. *Photographs by James C. Ward.*

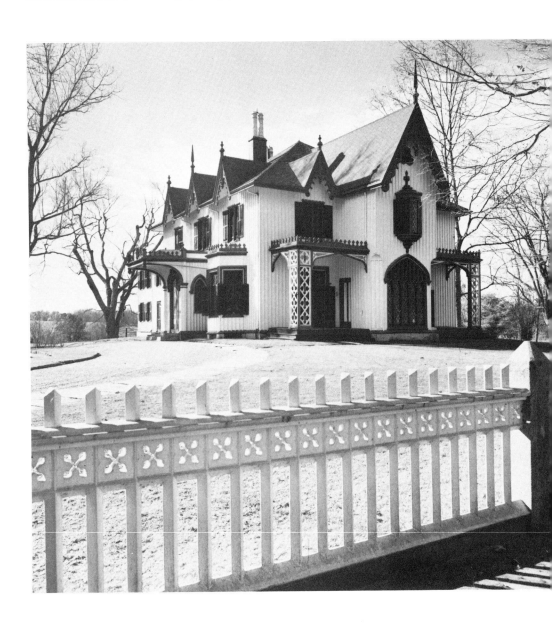

Gothic revival mansion

Miss Constance Holt, Woodstock, Connecticut

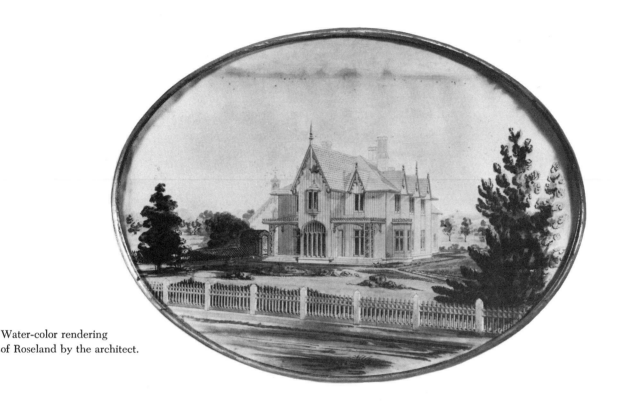

Water-color rendering
of Roseland by the architect.

THE MARQUIS DE CHASTELLUX, who traveled in Connecticut in 1781 and 1782, wrote that he was "particularly struck with the position of Woodstock-meeting, which is placed on an eminence, commanding a very gay and well-peopled country." A house erected more than half a century later on one side of the irregular green of what is now West Woodstock would have heightened this happy impression. It is Roseland, a Gothic revival mansion named for the extensive rose gardens that once surrounded it and now known to many thereabouts as the Pink House. For Roseland has in fact always been painted a bright, cheerful pink, with its ornamental bargeboards, crockets, and pinnacles, its oriel window and trellised porches picked out in dark red — a combination of colors that make blue skies and the green and gold of foliage seem more vivid.

Andrew Jackson Downing, the great champion of the Gothic, felt that a modified version of this style, what he called the Rural Gothic or Tudor, "with high gables, wrought with tracery, bay windows, and other features full of domestic expression," was the best choice for a private house. By contrast to the contemporary Italianate styles, for example, that suggested "the gay spirit of the drawing room and social life," the Gothic seemed to him to speak of "quiet domestic feeling and the family circle." The Gothic house should have — as Roseland does — "secluded shadowy corners . . . nooks where one would love to linger . . . cozy rooms where fireside joys are invited to dwell."

Houses of this type are still not extremely rare in New England, though their numbers are being depleted at a frightening rate. But few have been as well preserved as Roseland, or as lovingly maintained by successive generations of the same family down to the present. And fewer still have as much of their original furniture. Many such houses were probably furnished by their first owners with a mixture of Gothic, Grecian, and hand-me-down, and Gothic furniture, never made here in great quantity, is scarce today. Roseland, however, still has the furniture designed for its double parlor by the architect of the house and repeating, in its carved decoration, the quatrefoils and foliated arches of the exterior trim.

The architect was J. C. Wells of New York, who was

also responsible for the First Presbyterian Church, erected in 1846 on Fifth Avenue between Eleventh and Twelfth Streets. His client was Henry Chandler Bowen (1813-1896), a successful merchant, one of the founders of *The Independent,* and, later, sole owner of the paper. Roseland Park, Woodstock's fine wooded recreational area, was presented to the town by Henry Bowen in 1876. He also inaugurated the Woodstock Fourth of July celebrations that for fifty years attracted nationwide attention because of the prominence of the speakers. At the Woodstock celebration in 1877 Oliver Wendell Holmes read two poems composed for the occasion. In one of these, *A Family Record,* he evokes the memory of his own Woodstock ancestor, Dr. David Holmes, who served as a surgeon in the French and Indian and Revolutionary Wars. But many in his audience had even older ties with the town. Henry Bowen himself was a descendant of that earlier Henry Bowen who with twelve other "planters," or potential plantation holders, was sent out from Roxbury, Massachusetts, in 1686 to spy out and take possession of the land for the new town of Woodstock.

Wabbaquasset ("mat-producing place") was the Indian name of the village closest to the present site of Woodstock. It was part of the Nipmuck or fresh-water country that was divided, for missionary purposes, into Praying Villages. John Eliot preached there in 1674. The old Connecticut Path, for long the route of settlers leaving Massachusetts to found new towns, the vital link between the Connecticut colonies and the Massachusetts Bay settlements, passed through what is now Woodstock. Judge Samuel Sewall gave the town its name in 1689/90 "because of its nearness to Oxford [Woodstock is about as close to Oxford, Massachusetts, as the royal hunting park and lodge were to the English university town] . . . and the notable meetings that have been held at the place bearing the name in England."

As Clarence Winthrop Bowen, compiler of the monumental *Woodstock Genealogies,* pointed out in an address read on the occasion of the town's bicentennial (1886), the new-world Woodstock has kept up that tradition of "notable meetings." It has been host to all the Presidents from Grant to McKinley. Hayes, Harrison, Cleveland, and McKinley were overnight guests at Roseland, occupying the spacious upstairs suite still referred to as the Pink Room. Ulysses S. Grant, who was also invited to Woodstock by Henry Bowen and State Senator Buckingham, did not spend the night, but after lunching at Roseland he enjoyed the bowling alley behind the house. The President made a ten-strike but declined a second ball and walked out lighting a "segar." The bowling alley, still standing ready for use with its old equipment, may be one of the earliest surviving examples in the country. It is attached to the gabled carriage house, which has ornamental bargeboards like the mansion, and the whole long structure is painted the same pink with maroon trim.

But the name of Woodstock has still more associations for us than it had for Samuel Sewall, and as we enter Henry Bowen's mansion by the castellated porte-cochere under a heraldic shield, or, sitting in one of the deep bay windows of the parlors, watch the light that comes through the colored glass windowpanes tracing Gothic diapers on floor and walls, we may be put in mind of the "ancient and venerable turrets, bearing each its own vane of rare device," and the "antique apartments," with their trophies and massive fireplaces, that Sir Walter Scott described in his novel *Woodstock.* This is what the architect of Roseland and his client would have wished. With the growing appreciation of nineteenth-century romantic architecture it has come to be realized that the eclecticism of the period is due, on the whole, not to lack of inventiveness but to what Wayne Andrews defines as an attempt to introduce into building "the fourth dimension, time itself." Like the Grecian and other revival styles, the "Gothick," of which Roseland is such a compelling example, represents, in his words, "so many efforts to explore the poetry of time."

A particularly arresting architectural detail is the arched passage between the front and back parlors. Two closets and two sliding doors are contained in the partition. All the doors and the soffit of the arch, like the rest of the woodwork on the ground floor, are grained to simulate light oak. The doors are actually carved in pointed, trifoliated Gothic arches, but the soffit is painted in *trompe l'oeil* to give the same effect. The gilded eagle that topped the flagpole on the lawn when Henry Bowen celebrated the Fourth of July now has its eyrie here. Throughout the house the doorknobs are ceramic, marbled blue and white.

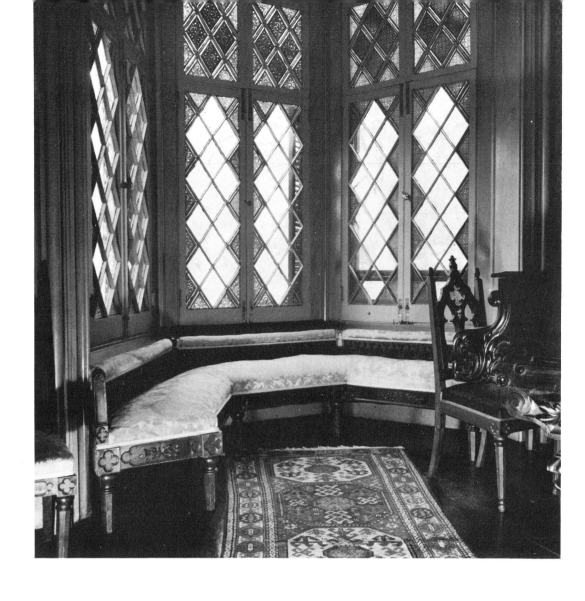

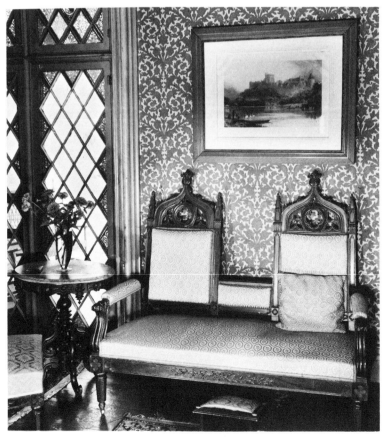

Front and back parlors, identical in plan, open off the central hall, taking up the side of the house parallel to the street. Each has a deep bay window at one end and a door leading into the conservatory between the two porches. This picture shows the end of the back parlor, with one of the two window seats designed, like the set of matching chairs and settee, by the architect of the house. Frosted diamond-shape panes of red, blue, gold, green, and violet glass, set in mullioned casements, let the light through in Gothic diaper patterns or heraldic designs. The glass is thought to be American.

The settee from the set of furniture that matches the window seat is shown here beneath a steel engraving of Windsor Castle. The marble-topped stand exemplifies what was called in its day Elizabethan furniture. French doors at the left open on to the trellised porch. Near them, though not visible here, stands an Aaron Willard table clock, an heirloom, like the fine Hepplewhite chest of drawers in the upper hall, that held its place in spite of the fashion for Gothic. The heavily embossed wall-paper in both parlors, dark green on a cream-color ground, was made in England in the 1860's; *Lincrusta Walton* was the name of the pattern.

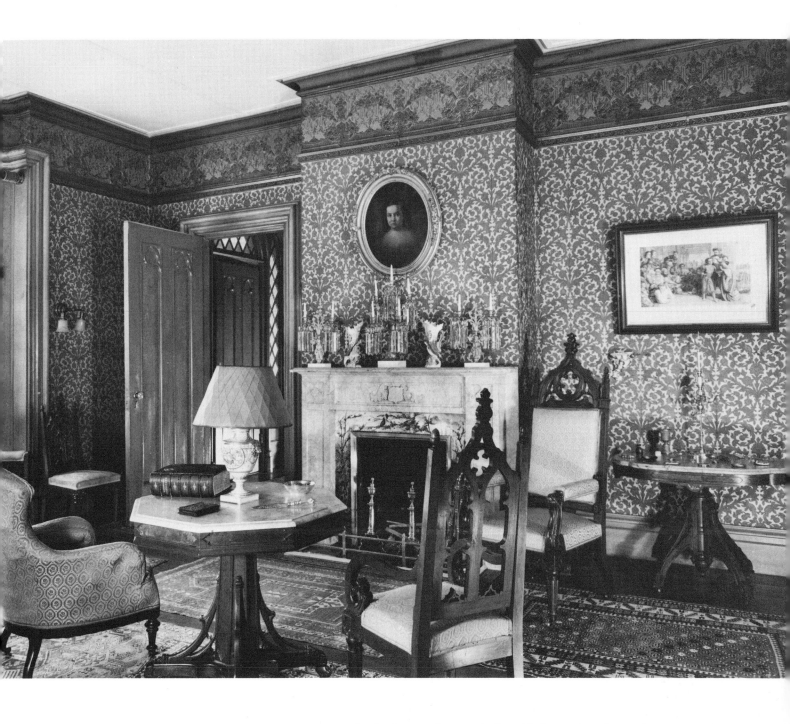

In the front parlor a typically mid-nineteenth-century arrangement puts the marble-topped octagonal pedestal table and two flanking chairs, one an upholstered Grecian form and the other, part of the carved Gothic set, in the center of the room, facing the Italian carved marble mantel. Ceramic tiles of a later date surround the fireplace opening and cover the hearth. On the mantel, beneath a family portrait, is a set of candelabra with supports of cast gilded metal in the form of a Turkish lady — reminding us, like the Turkish brass scimitar and bowl on the table, that the Gothic revival was only one aspect of Victorian eclecticism. On a second marble-topped table, at the right of the fireplace, is a collection of family memorabilia and *souvenirs de voyage* that includes a Turkish mosque lamp, some fine miniatures, and a piece of pottery presented to a member of the family by Mme. Heinrich Schliemann, wife of the excavator of ancient Troy.

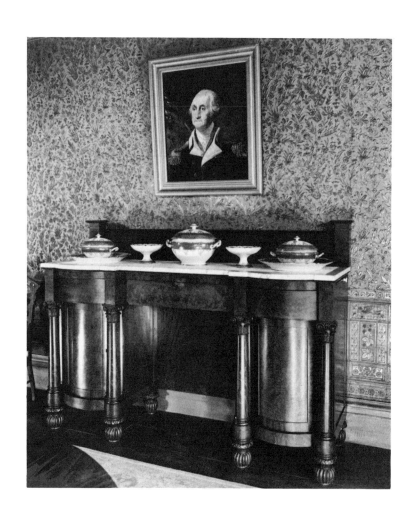

A substantial marble-topped sideboard in the neoclassical style has always stood in the house and probably always looked as much at home as it does now, since Gothic and Grecian furniture seem to have been freely mixed in houses of the period. On the sideboard is part of a Limoges porcelain dinner service with deep rose-color borders and the initials *HCB* in gold; it was made in France for Henry Chandler Bowen. The painting is evidently an old copy of the head of Stuart's *Washington at Dorchester Heights*.

The oriel visible in our exterior view (beneath the front gable, between the two trellised porches) lights a small room on the upper floor and provides an enticing window seat. The cottage furniture, of the type specifically recommended by Downing for bedrooms in country houses, is painted red with line decoration in gold. Reflected in the mirror at right is an unusual stepped semicircular console table.

The extensive gardens that suggested Roseland's name have given way to more restricted plantings within box hedges, but the little garden house in the form of a pedimented Greek temple still stands beside the Gothic mansion — another example of the mixture of revival styles.

The long hall of the apartment is almost a gallery of American antiques. Here a Salem serving table, ornamented on its curved front with a carved basket attributed to Samuel McIntire, is grouped with Hepplewhite chairs made in New York State. The Chinese painting above depicts the harbor of Canton. The silver tankards are both American, that at the left by Lewis Fueter of New York, the other by Samuel Vernon of Newport. *Photographs by Taylor and Dull.*

American furniture and American views

Mr. and Mrs. Robert Lee Gill, New York City

THAT IT IS JUST AS POSSIBLE to live with antiques in a fairly small apartment as it is in a mansion has been well demonstrated by Mr. and Mrs. Robert Lee Gill of New York City. With no effect of crowding, they have managed to bring together an impressive array of fine American furniture. Their major interest, at first, was in the Federal style, and they acquired a group of Duncan Phyfe pieces that was almost a textbook illustrating the transition of Phyfe's work from the earlier Sheraton to the later "Grecian" style. Gradually some of these have been replaced as the Gills have added more and more pieces from earlier periods. What was a few years ago a Federal dining room has become a Chippendale sitting room (dining has been transferred to a sequestered part of the kitchen, as have some of the antiques), and the collection as a whole has become more representative of the eighteenth century.

A dramatic background is created by the hangings in period style; those in the living room display a pair of unusual Hudson River cornices with painted glass panels made about 1812. Lighting devices include some handsome wall sconces, an interesting assortment of candlesticks, and a variety of overlay glass lamps in rich colors, all with old glass globes; there is not a modern lamp shade in the apartment. China Trade porcelain, which forms a noteworthy collection, is strikingly displayed on blue-painted shelves in the living room and provides decorative accents on tables and mantels. American paintings of the early nineteenth century — still lifes, naval scenes, town views, and landscapes — add color and interest.

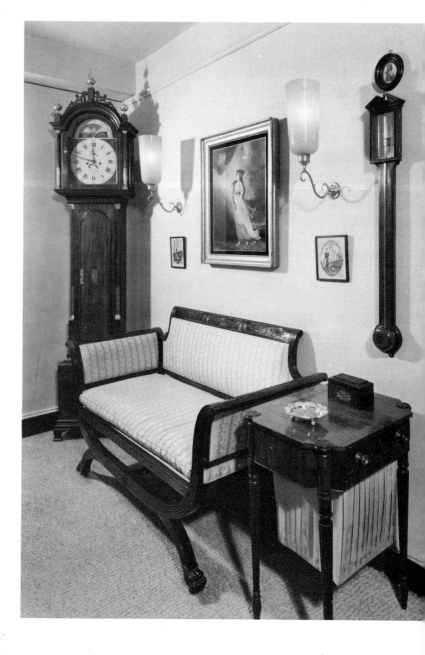

Another group in the hall centers about a Duncan Phyfe settee with crisscross base and finely carved back. Above it a pair of small American water colors dated 1814 hangs on either side of a Chinese painting on glass showing Liberty and the American eagle. The worktable is a Salem piece of about 1790, and the grandfather clock is by Aaron Willard of Boston.

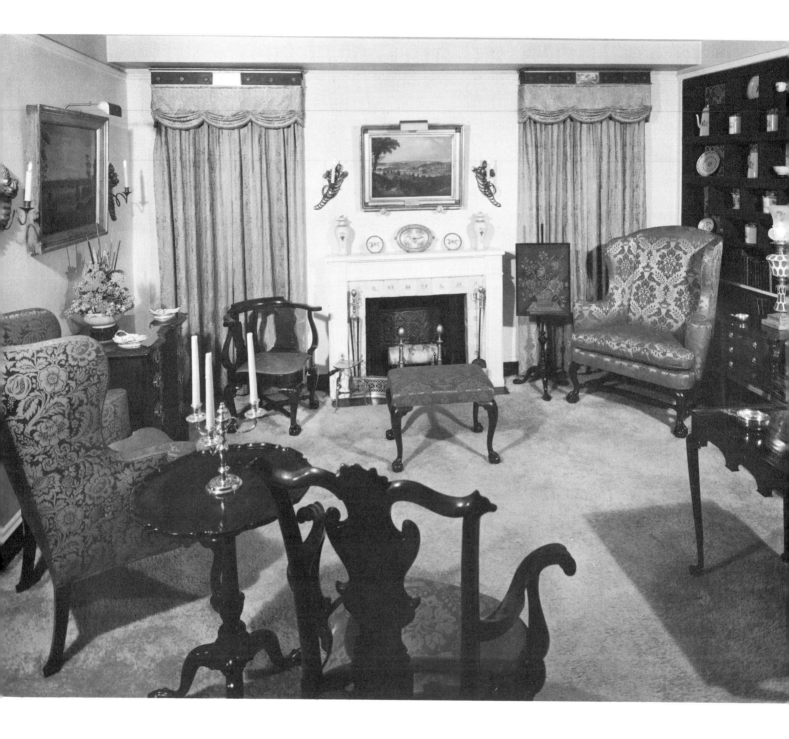

In the living room a rare New York Chippendale stool stands before the fireplace, which is framed with delft tiles and equipped with matching andirons, fire tools, and jamb hooks, and a serpentine fender of about 1780 — all of bell metal. The pole screen with needlework panel is from Philadelphia, while the two handsome wing chairs, one with stretcher and one without, are of Massachusetts origin. Silhouetted in the foreground is the eloquent back of a Philadelphia Queen Anne armchair. A silver porringer by Elias Pelletreau rests on the graceful tea table at right, which is attributed to the Goddard-Townsend cabinetmakers of Newport. Also from Rhode Island are the blockfront chest of drawers at left and the endearing roundabout chair, with carved shell on knee. The carved and gilded cornucopia sconces are believed to be American. Two American views of about the same date make interesting companion pieces. On the left is *New York from Brooklyn Heights*, painted by T. H. Wharter in 1834, and over the fireplace the *City of Washington from beyond the Navy Yard*, painted a year before by George Cooke, the source of the Bennett engraving of this subject.

Across the room one's eye is caught by a Newport blockfront desk of about 1765, with the original brasses. The Gothic-splat chair in front of it was made about the same time in Massachusetts. Above a Phyfe worktable is a looking glass with inlaid mahogany frame attributed to the Seymours of Boston. The China Trade porcelain, here and elsewhere in the living room, includes pieces with ship, Masonic, eagle, Cincinnati, and New York State armorial decoration. Also on the shelves here are red-anchor Chelsea pierced baskets, from a set of six. The painting above the desk gives a glimpse of Morristown, New Jersey, as it appeared to Edward Kranich in 1852; that at the left, by J. F. W. Des Barres, depicts the *Constitution* and *Guerrière*.

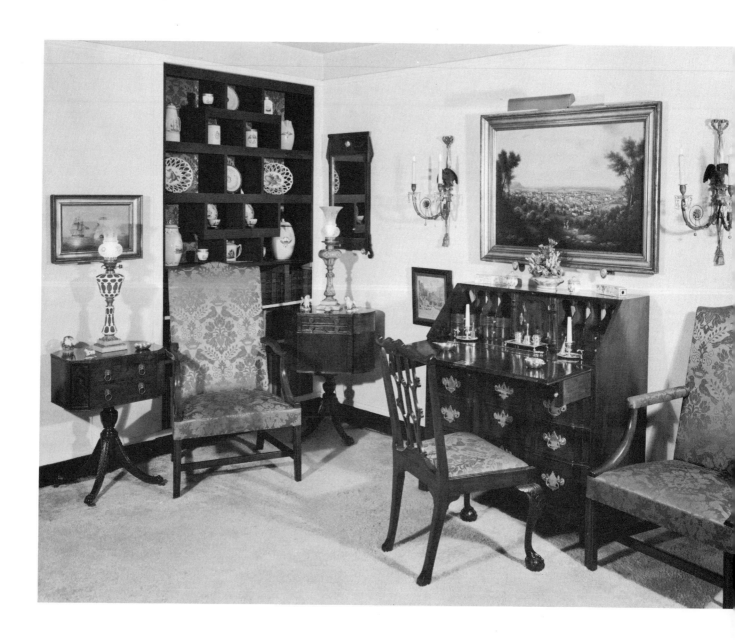

Some outstanding mirrors add to the distinction of the Gill apartment. This one, in Chippendale style of the mid-1700's, has scrolls and curves that seem almost flame-like. The energetic proportions of the New England lowboy, made about 1770, are accentuated by the interestingly scrolled apron and the wide overhang. The wall pockets are of China Trade porcelain, as are the lotus-pattern bowl and the cups decorated with the arms of New York.

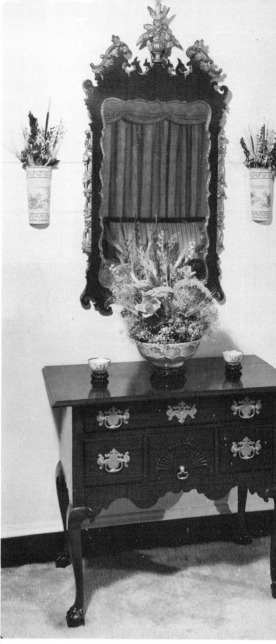

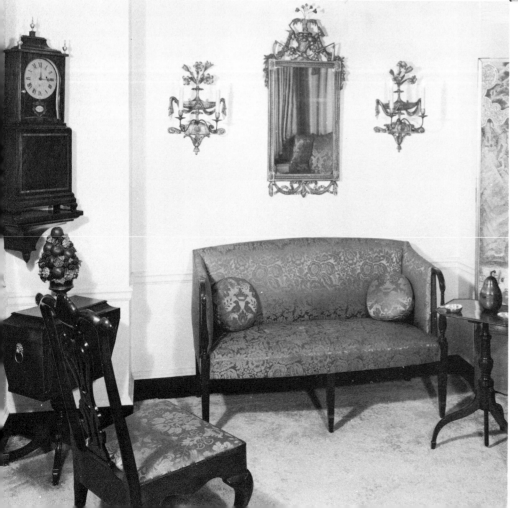

A mahogany Sheraton sofa of small size, with turned and reeded arm supports and tapered legs, was probably made in Salem about 1790. Made a decade or two later, possibly also in Salem, was the elegant mirror hanging above it. It is carved and gilded and has a most elaborate ornament at the top composed of festoons, flowers, a basket of fruit, and harvest implements. A sort of counterpoint is provided by the gilded Adam wall sconces. The small tripod table at the right has a "telescoping" device in the pedestal for raising or lowering the top. In the opposite corner is a Sheraton mahogany and rosewood teapoy on pedestal base, made in New York about 1810, with an Aaron Willard shelf clock above it.

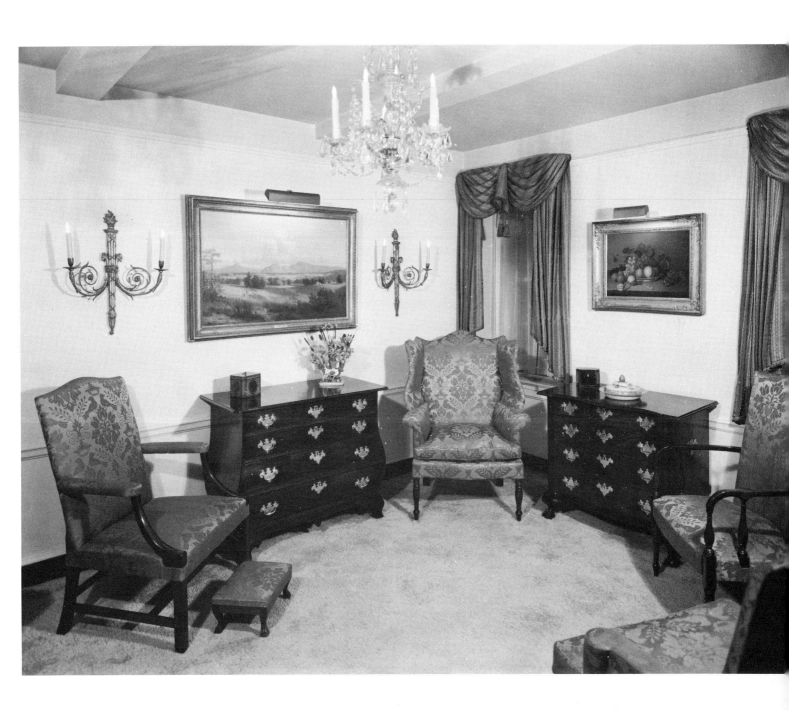

Two mahogany chests of drawers in the sitting room, one *bombé,* the other serpentine, represent Massachusetts Chippendale at its best; both have their original handsome brasses. Above one hangs a view of the Shenandoah Valley painted by Russell Smith in 1846; above the other, a still life by James Peale. The gilt and gesso wall sconces (English, c. 1790-1800) display a striking pattern of fasces, scrolls, and ram's heads. The open armchair at the left has the stopped fluting on the legs which is characteristic of Newport work. Before it is an unusual Chippendale footstool with paw feet. The Martha Washington armchair, from New England, has a curved back and double arm supports.

A fine Queen Anne group in the bedroom is composed of a Massachusetts lowboy with crisply blocked front and a looking glass with molded frame and gilded shell in the crest, and with its original glass. The mirror knobs used here and elsewhere make up an interesting collection.

Facing page.

The bedroom is dominated by a handsome Chippendale mahogany fourposter attributed to John Goddard of Newport. A fine Chippendale tabernacle mirror with bird ornament hangs above a chest of drawers with deep serpentine front and ogee feet, in the bottom drawer of which is an inscription, *This bureau belonged to my mother from 1761 until her death. In the summer of 1849 it came to me by her direction,* signed by J. Reese, a descendant of Jonathan Edwards of Princeton, New Jersey. The grandmother clock in the corner was made by Joshua Wilder of Hingham, Massachusetts, about 1800. At about the same time the dainty Sheraton sewing table at the foot of the bed was made in Salem; it is of figured maple, and has painted decoration. And finally, completing with utmost elegance the progression of styles in this room, the Duncan Phyfe Récamier sofa represents the Grecian taste. It is of unusually small proportions, only five feet four inches long. The foot scroll is decorated with a rosette, the front rail with a stylized design of bowknots and wheat.

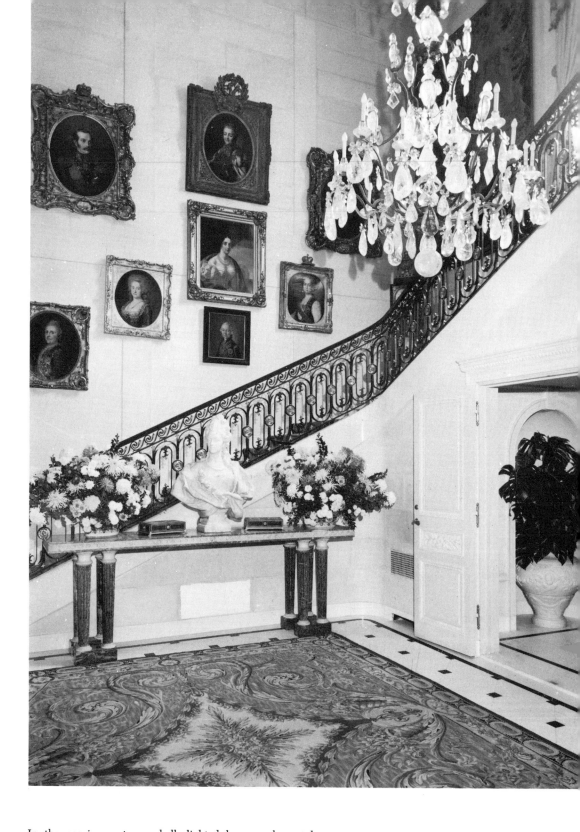

In the spaoious entrance hall, lighted by a rock-crystal chandelier from the palace of Paul I at Gatchina near St. Petersburg, the wall is hung with Russian imperial and court portraits by French, German, Swedish, and Russian painters. That at the top is of Catherine the Great and is attributed to Alexander Roslin. The portrait at lower left is again of Catherine, dated 1762 and signed by Pierre Etienne Falconet, son of the eminent sculptor. Other subjects are Catherine's son the Grand Duke Paul, who became Paul I; Alexander II as Grand Duke; the Countess Branicki, a niece of Potemkin; and the Princess Dashkov, who participated in the palace revolution that put Catherine on the throne in 1762. *Except as noted, all photographs by James R. Dunlop.*

Russian, French, and English treasures

Mr. and Mrs. Herbert A. May, Washington, D.C.

ON A RISE OF GROUND in northwest Washington, D.C., overlooking the beautiful wooded valley of Rock Creek Park, is Hillwood, the home of Mr. and Mrs. Herbert A. May. The house is surrounded by gardens, formal and informal — a French parterre, a rose garden, a Japanese garden, a "friendship walk," and natural woodland trails — and from the terrace one has a splendid view of the Washington Monument rising above the trees that screen the intervening distance. The interior has been adapted to Mrs. May's needs and tastes, with installation of paneling in eighteenth-century style and even the creation of complete new rooms for the display of her extensive art collections.

The collections center around Mrs. May's two chief interests, the art of eighteenth-century France and the art of Imperial Russia. They include not only painting and sculpture but also — indeed primarily — furniture, porcelains, tapestries, glass, gold and silver, enamels, and jeweled objects. Mrs. May's first collection was in the field of French eighteenth-century decorative arts and she has never lost her fondness for them. Her interest in Russian art was kindled in 1927 when she acquired a rare Fabergé box from the Yussupov collection, but it was in 1936-1938, when she was in Russia with her former husband, the United States Ambassador to the Soviet Union, that she began to collect Russian art in earnest. Anyone who has visited the imperial palaces in and around St. Petersburg and Moscow has seen how much French work is to be found there and how strong French influence was on native craftsmanship. Thus it does not seem strange that French and Russian art should be brought together as they are at Hillwood, where they reflect Mrs. May's own life and interests.

From the very entrance of the house one sees the art and craft of these two great cultures in fascinating juxtaposition. The central hall is hung with imperial Russian portraits, while in the wide transverse hall that leads from it are masterpieces of eighteenth-century French painting, sculpture, and furniture. Standing in the center of this transverse hall one can look in one direction through the Russian porcelain room at the Beauvais tapestry in the French drawing room beyond; while in the other direction one sees a small oval room filled with Sèvres porcelain, beyond which lies the dining room.

That tapestry in the *salon* is one of several Beauvais works in the house which are renowned for their brilliant color. Also noteworthy in the French collection are unique or rare pieces of furniture stamped by such leading eighteenth-century *ébénistes* as Riesener, Roussel, B·V·R·B, Jacob, Séné, Carlin. The goldsmiths' work includes two unique heart-shape boxes in gold and enamel made in Paris in the 1750's and a gold box presented to Marie Antoinette about 1778. The collection of Sèvres porcelain is important for its many pieces in *bleu céleste* (turquoise) and *rose Pompadour*, as well as other colors. Among the paintings is Nattier's portrait of the Duchess of Parma and her daughter, Eleanor, painted at Compiègne in 1750 while the duchess was visiting her father, Louis XV.

In the Russian collection, besides the portraits of czars, czarinas, and members of the court which hang in the entrance hall, there is a significant group of icons dating from the sixteenth century to the nineteenth. Most of these have silver, silver-gilt, or jeweled *rizas* — metal frames that adorn and sometimes all but cover the paintings. The emphasis in the Russian collection, however, as in the French, is on the decorative arts. The silver, niello, and porcelains constitute collections in themselves which are believed to be the most important of their kind outside Russia. A group of chalices is probably unmatched anywhere. There are also Russian textiles, embroideries, and ecclesiastical robes and altarpieces. Unusual for this country are the examples of Russian eighteenth-century furniture, chandeliers, and rugs.

As though these specialized collections were not enough, there are also fine examples of early English furniture at Hillwood, German work in ivory and silver, Chinese porcelains and stone carvings. It is a house that is lived in, but it is a treasure house, too, and Mrs. May is well aware of its interest to students. She is generous in showing her collections, and has arranged and identified them in wall cases and cabinets in such a way that they may be not only seen but studied. Already Hillwood is virtually a museum, and Mrs. May intends that one day it will be open to the public.

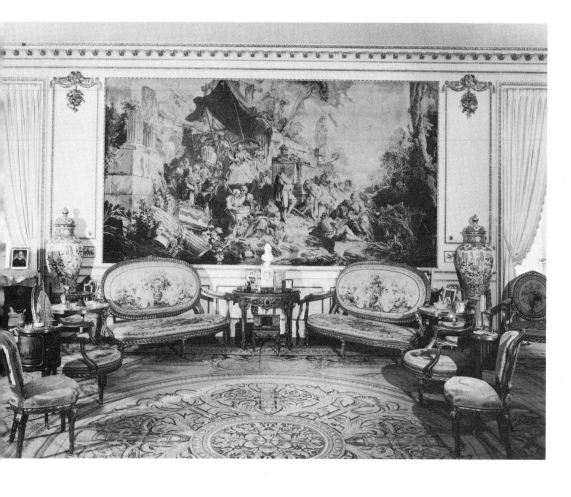

Color plate, facing page.
The drawing room is a French *salon*, its white and gilt paneled walls providing a foil for the rich colors of tapestries, porcelains, and paintings. Among the fine eighteenth-century French furniture here is a suite of twelve gilded chairs and two sofas upholstered in Gobelin tapestry designed by Tessier; it is said to have been presented by Louis XVI to Prince Henry of Prussia, brother of Frederick the Great. The wall cases on either side of the fireplace are filled with Sèvres porcelain in *rose Pompadour* and *bleu céleste*. On the mantel, which is of white marble decorated with *bronze-doré*, are a marble statuette by the elder Falconet and a pair of porcelain vases in turquoise and gold with fine ormolu mounts, made in St. Petersburg in the reign of Catherine II. The portrait, in its original frame, is of the Empress Eugénie, painted by Winterhalter in 1857.

The drawing-room walls are hung with Beauvais tapestries designed by Boucher. Visible in the color view is *Bacchus and Ariadne* from the *Loves of the Gods* series, and on the opposite wall (above) are scenes from *Les Fêtes Italiennes*. On either side of this large hanging is a Chinese temple vase in *famille rose* porcelain of the K'ang Hsi period. The round table in the center of the wall is said to have belonged to Marie Antoinette; it is of carved and gilded wood set with amethysts, and the top is of tiger's eye (mica turned into chalcedony) bordered with lapis lazuli. The biscuit bust on the table is of Catherine the Great, from the Imperial Porcelain Factory at St. Petersburg, which had been established under the Empress Elizabeth but achieved success only after Catherine's accession. Covering the floor is a very large Savonnerie rug of neoclassic design made about a hundred years ago.

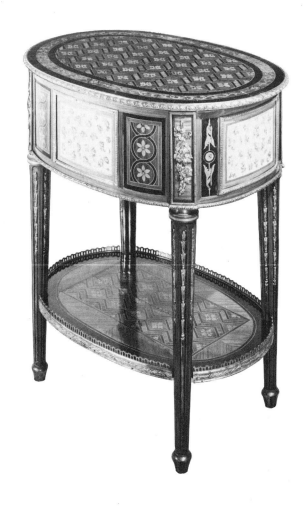

A Louis XVI table with geometric and floral marquetry, ormolu mounts and edgings, and inset Sèvres porcelain plaques bears the stamp of Nicolas-Louis-Cyrille Lannuier, who became master in Paris in 1783. This *ébéniste*, whose stamped pieces are rare today, worked particularly for the Prince of Condé, making furniture for his château at Chantilly. Nicolas was the elder brother of Charles-Honoré Lannuier of New York, the Franco-American cabinetmaker who was influential in bringing the Empire style to America.

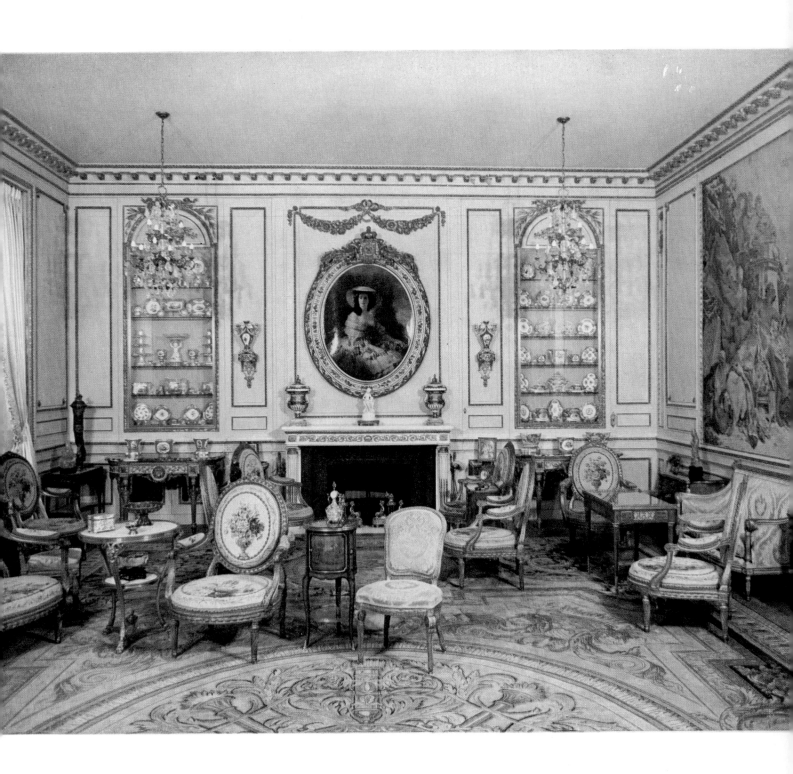

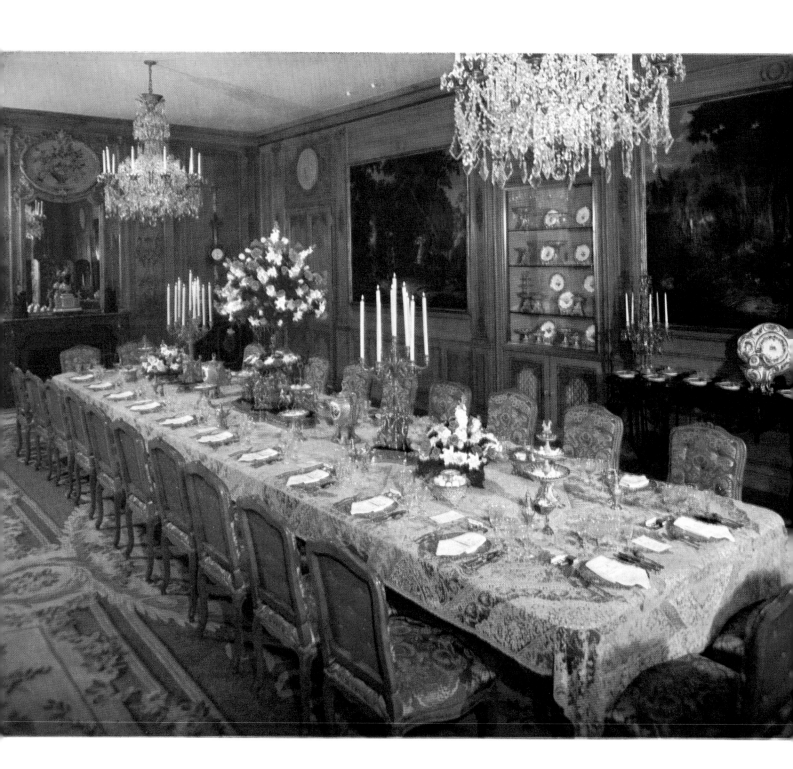

Color plate, facing page.

In the dining room the eighteenth-century French *boiserie* panel above the fireplace, now set with a Gobelin tapestry, was used as a model for carving the rest of the paneling. The scenes by Dirk Langendyk representing a stag hunt and a boar hunt are part of a rare series of four Dutch wall paintings of about 1775. The table is set with a service of *vieux Paris* porcelain in rose and gold marked with the name Demont. The large tureen with plateau on the console is hard-paste Sèvres porcelain, c. 1780, after a model by Duplessis.

The library walls are pine-paneled in the Georgian manner. The fine English furniture here ranges in period from a William and Mary walnut circular stretcher table and Queen Anne armchairs upholstered in early needlework to Sheraton and Regency commodes. The large portrait at the left is of Mrs. May, painted some years ago by Frank Salisbury. The oval portrait is of her mother, Mrs. C. W. Post; its elaborate lime-wood frame is a remarkable bit of carving attributed to Grinling Gibbons (1648-1721). Small objects in this room suggest the range of the owner's collecting interests: miniature furniture, Scottish tobacco mulls, gold boxes, English porcelain, miniature portraits, all represented here by outstanding examples.

Facing page.

In the broad transverse hall are superb French furniture, paintings, bronzes, and porcelains. The marquetry commode at the right is one of a pair attributed to the German cabinetmaker Abraham Roentgen, and the bronze on it is one of a pair representing satyrs, signed by Clodion. Above hangs a portrait of the Marquise de Lafayette, mother of America's hero, by Largillière. The commode at the left bears the stamp of the French *ébéniste* Godefroy Dester. The bronze on it, cast by the *cire perdue* process, is also signed by Clodion. The two pairs of vases on the commodes, each believed to be the only one of its kind, were made at the Imperial Porcelain Factory in the reign of Nicholas I. In the oval room beyond is displayed part of Mrs. May's collection of Sèvres porcelain grouped by colors — yellow, *rose Pompadour,* apple green, *bleu céleste,* and so on.

At this end of the transverse hall, which leads to the porcelain room and the dining room, are the Roentgen commode and Clodion bronze matching the pieces at the opposite end. The vases on the commode are of Sèvres *bleu céleste* porcelain, and above hangs a portrait of the Countess of Provence by Louis Michel van Loo. The Louis XV armchairs are upholstered in contemporary tapestry woven with scenes from La Fontaine's fables. On either side of the doorway are matching palace vases made in the Imperial Porcelain Factory. Signed V. Schechetinov and dated 1837, these were a diplomatic gift to Mrs. May while she was in Russia. Savonnerie carpets, especially made for the house, cover the marble floor.

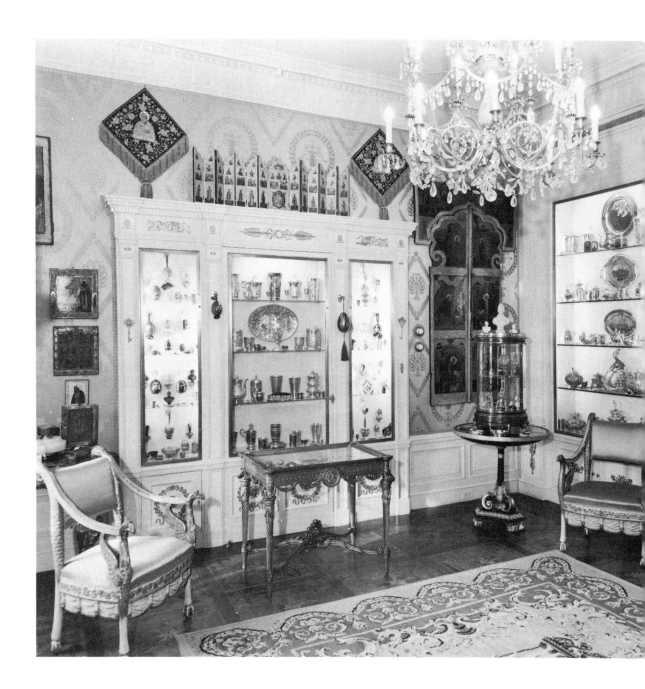

The heart of the Russian collection is in the icon room, which houses
not only some remarkable icons but also a great variety of rare decora-
tive objects produced by Russian craftsmen for the imperial family and
court from the seventeenth century on. In the wall cases and vitrines
are gold and jeweled boxes; cups and other forms in silver, some gilded
and many decorated in niello; enameled Easter eggs; exquisite creations
by Fabergé; trinkets and treasures in porcelain and papier mâché; and
a large group of seals and other *pietra dura* carvings. The icons that
hang here date from the sixteenth century to the eighteenth. The late
eighteenth-century chandelier is Russian, as is also the tapestry rug
which shows the Orlov coat of arms.

A twelve-sided room was designed to hold the collection of Russian porcelain, which includes the four services ordered by Catherine the Great between 1777 and 1785 for use on the occasions of her dining, once a year, with the knights of the four imperial orders. They were made at the porcelain factory set up at Verbilki near Moscow by Francis Gardner, an English entrepreneur, which operated from about 1765 onwards. Each service was decorated with the badge, ribbon, and star of its order. Also displayed in this room is a group of Russian glass. The marquetry panel in the floor depicts the imperial eagle.

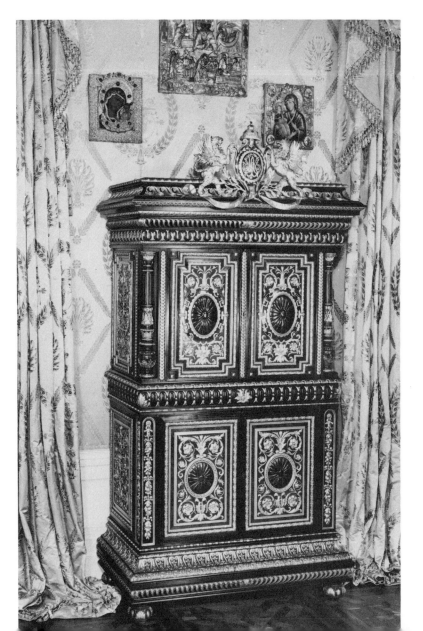

An ebony cabinet lavishly adorned with ormolu, in the icon room, was made in St. Petersburg by the firm of Nichols and Plincke for presentation in 1873 as a twenty-fifth wedding anniversary gift to the Grand Duke Constantine and his wife, Princess Alexandra. Originally there were miniature portraits in the centers of the four panels; these have been replaced by medallions of lapis lazuli. The icon of St. Nicholas the Miracle Worker at the center above the cabinet has a *riza* in elaborate silver *repoussé* made in Moscow in 1775. At the left is a seventeenth-century icon of Our Lady of Smolensk, and at the right, Our Lady with Three Hands, painted by R. E. Vasilevsky in 1743, with a silver *riza* added in Moscow in 1790. *Photograph by Leet Brothers.*

Country house in Delaware

Mr. and Mrs. Lammot Copeland, Greenville, Delaware

A wide central hall runs through the house. The fully paneled entrance, from a house in Powhatan County, Virginia, frames the stairs, which have delicately turned mahogany balusters and a handrail that came from a house in Charleston. Under the stairs an ornate English red-lacquer clock of the early 1700's, made by Robert Higgs of London, stands on a Philadelphia chest of drawers with serpentine front, canted and fluted corners, and bold ogee bracket feet. *Photographs by Gilbert Ask.*

ALL THE CHARACTER of the old with all the comfort of the new — that is what most collectors would like to achieve in their homes, though not all of them do. Usually compromises of one sort or another are necessary. If the house is genuinely old it is likely to have its little inconveniences. If it is new, even though old in style, it may lack the individuality of a house old in fact. The Delaware home of Mr. and Mrs. Lammot Copeland, illustrated here, achieves the happy combination with remarkable success.

It is not actually an old house: it was built in 1936. But the handsome interior paneling and other woodwork, the mantels, the staircases, the flooring, the wallpaper, are of the eighteenth century. They were collected from various early houses, chiefly in Virginia, also in the Carolinas, and skillfully built into a new structure designed by the architects Victorine and Samuel Homsey of Wilmington. The building is not a literal copy of an early house in appearance or arrangement, for it was designed specifically for modern living, but its brick exterior and its interior plan were borrowed from Southern colonial tradition and modified with discretion. The architectural elements used in the interior give the rooms the character of authentic an-

tiquity, while behind the scenes there are all the conveniences that modernity can offer.

Coming as they do from different sources, the old rooms offer unusual variety in their architectural detail, and each has its own qualities of richness and originality. These qualities are echoed in the furnishings, which are all antique. The furniture is American of the eighteenth century, with judicious admixtures of Chinese. Chinese porcelains and Oriental rugs add much in color and pattern. Pictures on the walls include early prints, French, English, and American, family portraits old and new, decorative Chinese panels, and European paintings. The lighting devices, wired for electricity, are old, and so are the fireplace fittings. All the fabrics of curtains and upholstery are of the eighteenth century.

These furnishings have in themselves the individuality we admire in all antiques — the touch of the craftsman. They also reveal in their selection and arrangement the individuality of their owners, who have expressed their own taste in choosing these antiques to live with. In combining the best of the old with the best of the new they have created a home that has a real personality.

At the other end of the hall, beyond a molded arch, the painted birds and flowering trees of an early Chinese paper cover the wall. Two Chinese pottery flower stands here were brought from the Orient by Mr. Copeland's great-grandfather. The Chippendale sofa and chairs are typical Philadelphia pieces; the side table with purplish marble top came from New Hampshire.

215

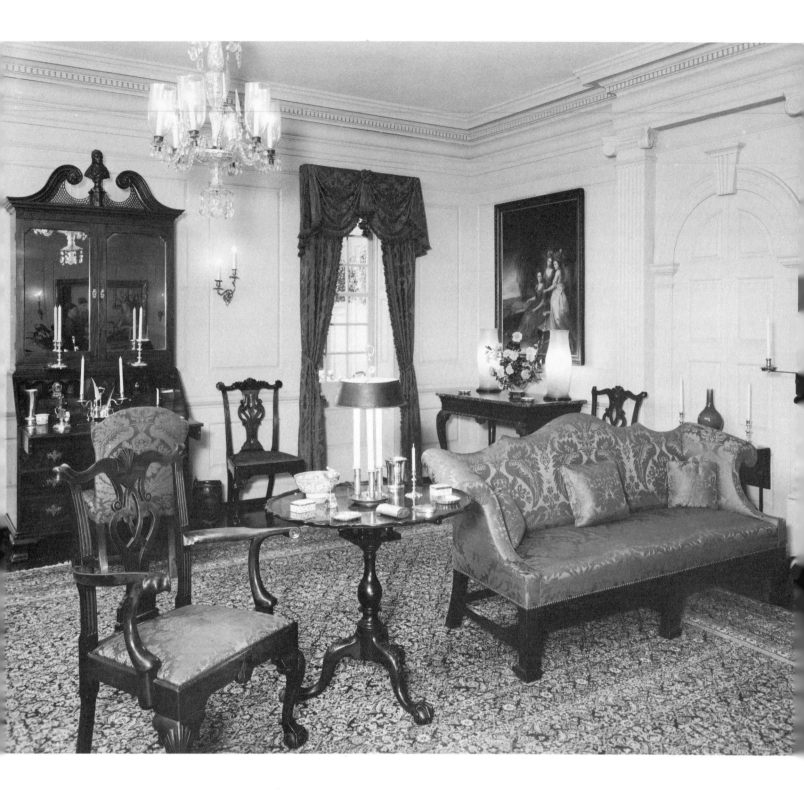

The woodwork of the living room came from what was known as the Old Brick House in Pasquotank County, North Carolina. It has raised panels, a deep dentiled and molded cornice, fluted pilasters with Ionic capitals, and arched cupboards, all carved with a vigor and boldness that reach their culmination in the most unusual mantel treatment. Though the craftsman remains anonymous, the source of his mantel design has been identified as Plate 74 of Batty Langley's *The Builder's Jewel: or, the Youth's Instructor, and Workman's Remembrancer* (London, 1751), an American edition of which was published in Charlestown, Massachusetts, about 1800. The woodwork is painted a soft rose. The curtains, and the matching damask on sofa, stools, and chairs, are a rich wine red. All the furniture is of Philadelphia origin except the English stool before the fireplace, and a New York card table and pair of chairs from the Rensselaer Nicolls family. Each piece deserves special attention; most noteworthy are the secretary with pierced pediment and mirror doors, and the sofa with scrolled back and Marlborough legs. The pair of chandeliers and the glass sconces on the walls are Irish. The large rug is a Feraghan in the Herati pattern. Of particular interest are the pieces of China Trade porcelain in the cupboard at the right of the fireplace.

In China Trade porcelain of the eighteenth century figures are far rarer, and more diverting, than tableware. Mrs. Copeland has collected a fascinating group of birds, beasts, and fish made in China for the European market, extraordinarily varied in species and in treatment. Some of them are arranged in an arched corner cupboard in the library. The cupboard, which has a rosetted keystone, fluted pilasters, and scrolled shelves finished with a carved lambrequin, came from an eighteenth-century house in Powhatan County, Virginia.

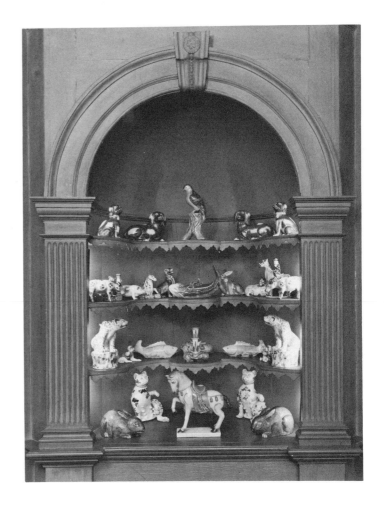

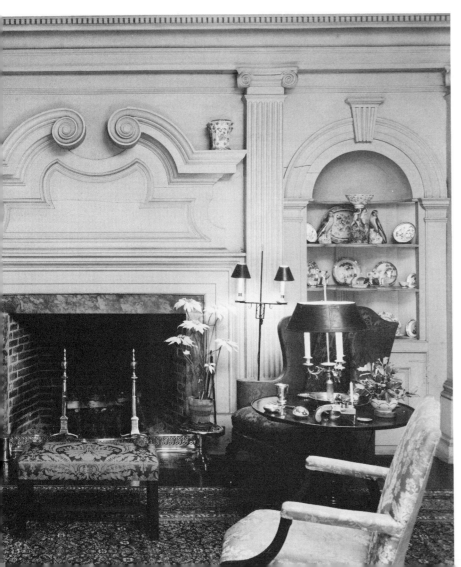

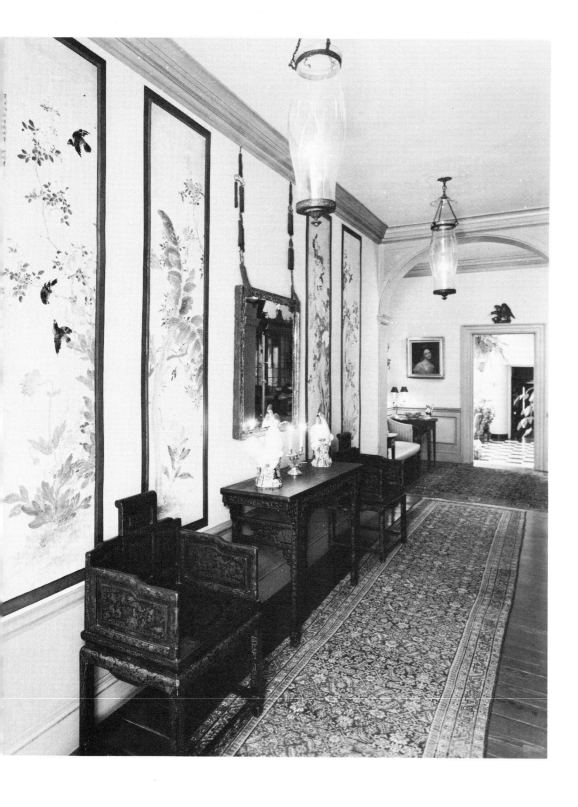

In a transverse hall leading to the conservatory the Chinese motif is repeated with added emphasis, in a set of painted wall panels, K'ang Hsi lacquered table and Ch'ien Lung chairs, and a pair of China Trade porcelain roosters.

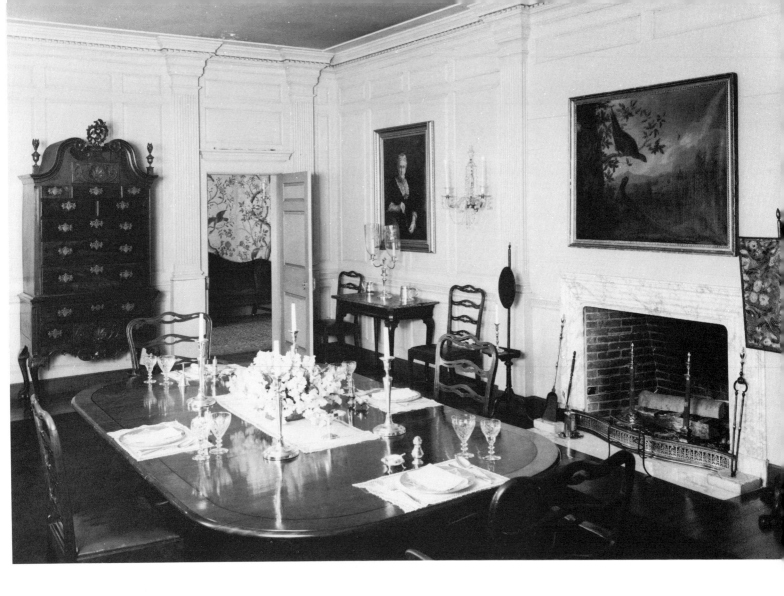

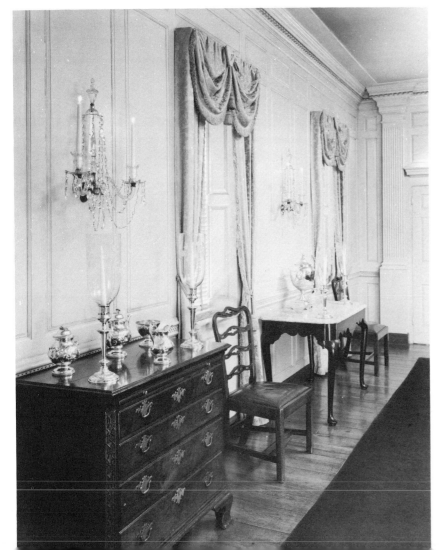

The paneled woodwork of the dining room, from a house in Stafford County, Virginia, is painted yellow to match the curtains of eighteenth-century gold damask. It is distinguished by its fret-carved chair rail and the carved dentil of its cornice. The pedestal table is English; the other furniture is for the most part from Philadelphia. The highboy with its pierced cartouche and the chest of drawers with fret-carved corners are among the outstanding pieces in the house. Noteworthy too are the slab-topped tables. Such items are rare in American furniture, but there are several in this house besides the two seen here. The painting over the fireplace is an English landscape in its original eighteenth-century gilt frame.

219

The paneling of this bedroom is painted a soft blue, the bevels of the panels picked out in a darker shade. Curtains and bed hangings are yellow striped with blue; old yellow bourrette is used on the day bed, chair, and bed; the Chinese rug is blue. The day bed is an important Chippendale piece, with its straight legs, cross stretchers, and gadrooned frame, and the bed is very finely carved.

As contrast to the Southern paneling in most of the house, one small room is stenciled in the manner of New England farmhouses. The painting, an overmantel panel from New England, is a hunting scene of the eighteenth century. Here too are an early gateleg table with Spanish feet, a joint stool of the very early 1700's, bits of early brass, tin, and pewter, and a decorative tin chandelier. The bracket clock of about 1710 is English. The Tabriz rug is brilliant in design and color.

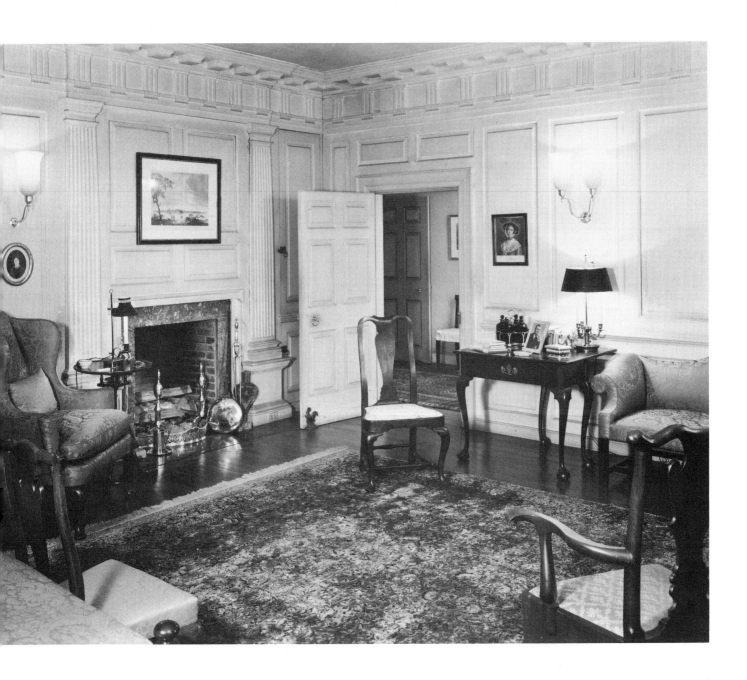

The paneling of this large bedroom is topped by a fine modillioned cornice and deep frieze that give it unusual distinction. This woodwork, which came from a house in King and Queen County, Virginia, near the North Carolina border, still retains its original oyster-white paint. New England Queen Anne and Chippendale furniture looks at home in such a setting. Used throughout the house are French brass or tole candlesticks and candelabra, so many and so varied as to make a real collection. Two of them are seen here.

Salt box in California

Mrs. Marjorie L. Adams Jr., Van Nuys, California

ON A TREE-SHADED ACRE in California's San Fernando Valley, surrounded by modern "ranch" houses painted pink, red, yellow, green, and blue, stands a weathered salt-box house that looks as though it had come straight out of seventeenth-century New England. This attractive interloper was built in the 1940's in sympathetic adaptation of early houses still standing in Massachusetts and Connecticut. Eventually it became the home of Mrs. Marjorie L. Adams, who finds it the ideal setting for antiques collected during nearly twenty years.

Like its austere prototype, the house has a long, sloping roof, huge central chimney of old brick, and lean-to additions. It is clapboarded, and the trim of the small-paned windows is painted white. A nail-studded batten door with heavy old hardware leads to a small entrance hall from which the narrow stair rises in front of the chimney. Walls are pine-sheathed and white-plastered; floors are of random-width pine planks. Each room is furnished in the spirit of the house itself. Most of the antiques are New England country pieces of the early eighteenth century. Braided rugs are used on the floor, and short simple curtains at the windows. The result is an easy, hospitable, yet disciplined atmosphere, unexpected, perhaps, in its setting but not incongruous.

Salt-box house of early New England type in Van Nuys, California, the home of Mrs. Marjorie L. Adams.
Photographs by George de Gennaro.

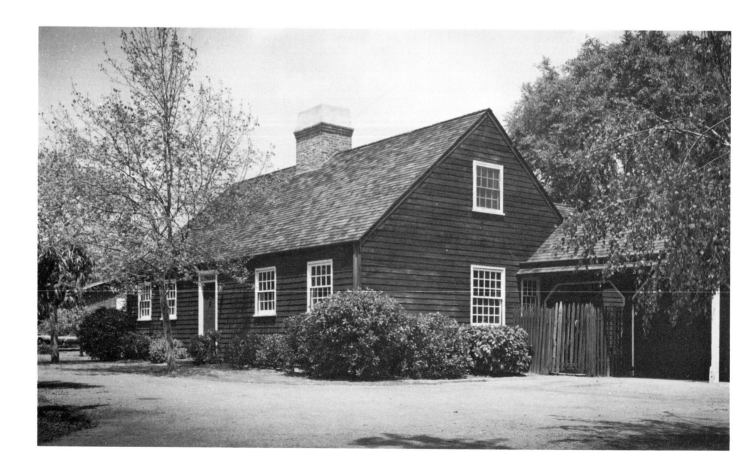

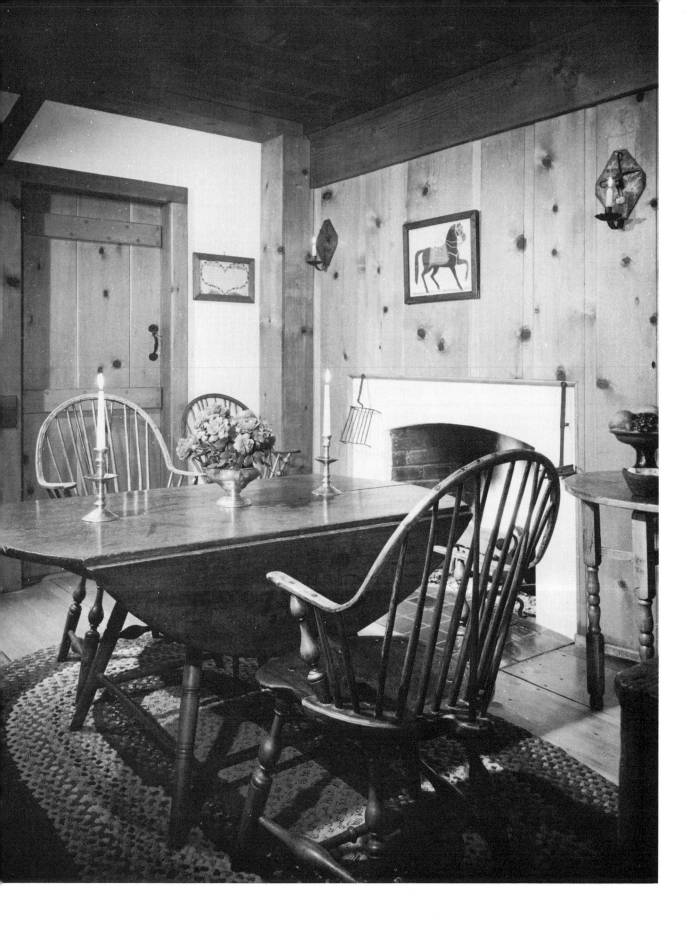

In the dining room, New England brace-back windsor chairs with vigorous turnings are used with a drop-leaf table whose legs are strongly raked. Bowl and candlesticks on the table are of pewter. Beside the fireplace stands a small folding, or "tuck-away," table of maple and pine. Tin sconces hang on the walls with a Pennsylvania water color and, at left, a fractur birth certificate with vital statistics framed in a heart.

The living-room fireplace is constructed in the seventeenth-century manner, deep and wide. Early ironwork around and in it includes basket-top andirons, broiler, toaster, skewers, brazier, trammeled candleholder, and delicate pipe tongs. A brass sausage-turned candlestick with mid-drip pan stands on the oval stretcher table before the fireplace; at the right is another stretcher table with round top and triangular base, c. 1710. The armchairs with their turned frames are a late seventeenth-century type; the little pine desk on a stretcher frame is an unusual variant of an early form.

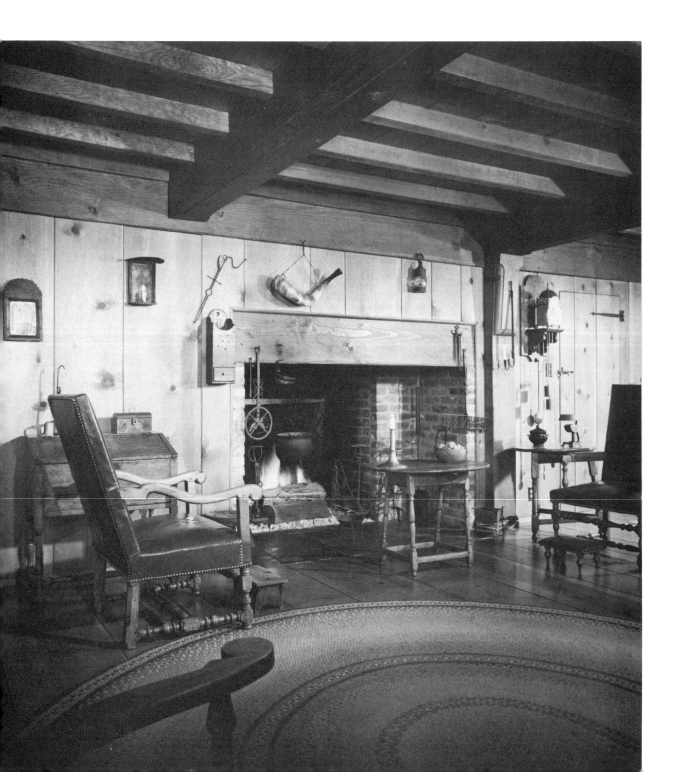

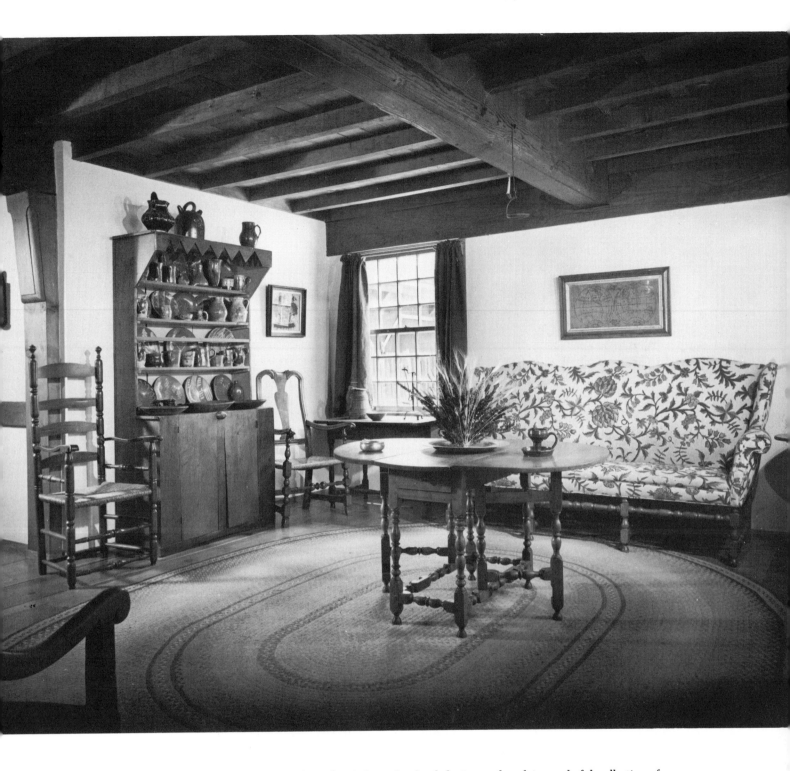

Garnishing the shelves of a hooded pine cupboard is a colorful collection of glazed and slip-decorated redware from New England and Pennsylvania; several pieces bear the name of the nineteenth-century potter John Bell. The slat-back chair, still in its old red paint, has turned stretchers between arms and seat. The gateleg table is of maple, and the original butterfly hinges support its drop leaves. Throughout the house are lighting devices of the kinds once used in such a dwelling: here a betty lamp hangs from the summer beam, a pottery grease lamp stands on the gateleg table, and a wrought-iron splint holder may be seen on the stretcher table by the window.

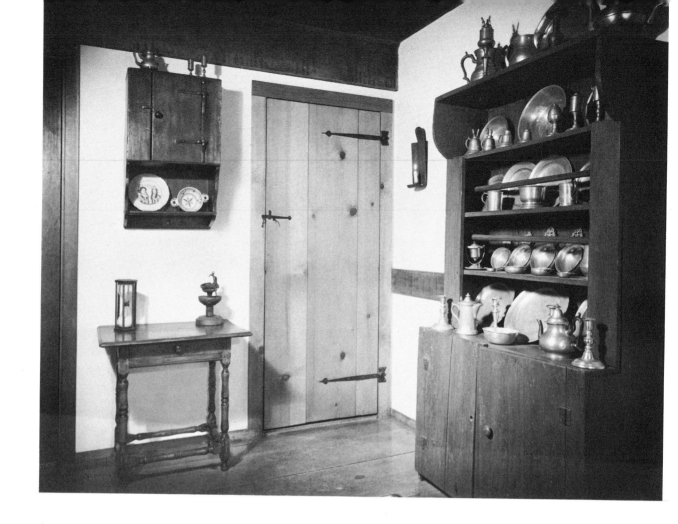

A large hourglass and a betty lamp on turned wooden stand are placed on a small stretcher table whose top has a molded edge; on the shelf of the hanging cupboard above is an English delft plate with portraits of William and Mary. The collection of American pewter in the red-painted pine cupboard includes porringers, dishes, basins, and a variety of lamps.

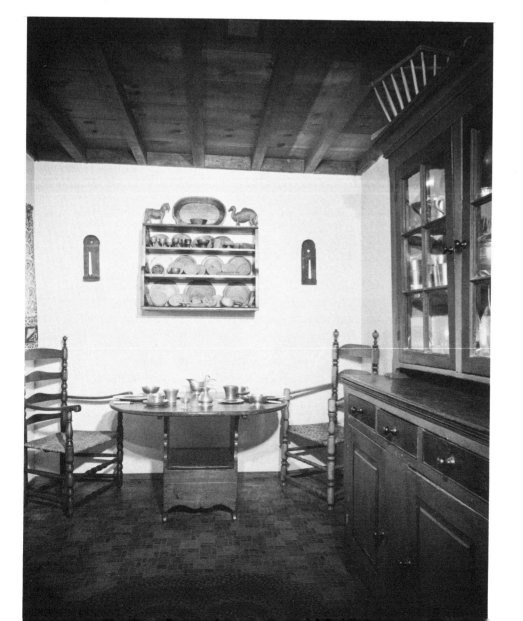

At one end of the kitchen a pine hutch table is set with pewter from the owner's extensive collection of English ware of the eighteenth and early nineteenth centuries. Another collection is of woodenware: butter molds, cups, plates, and carved animals fill the hanging shelves here.

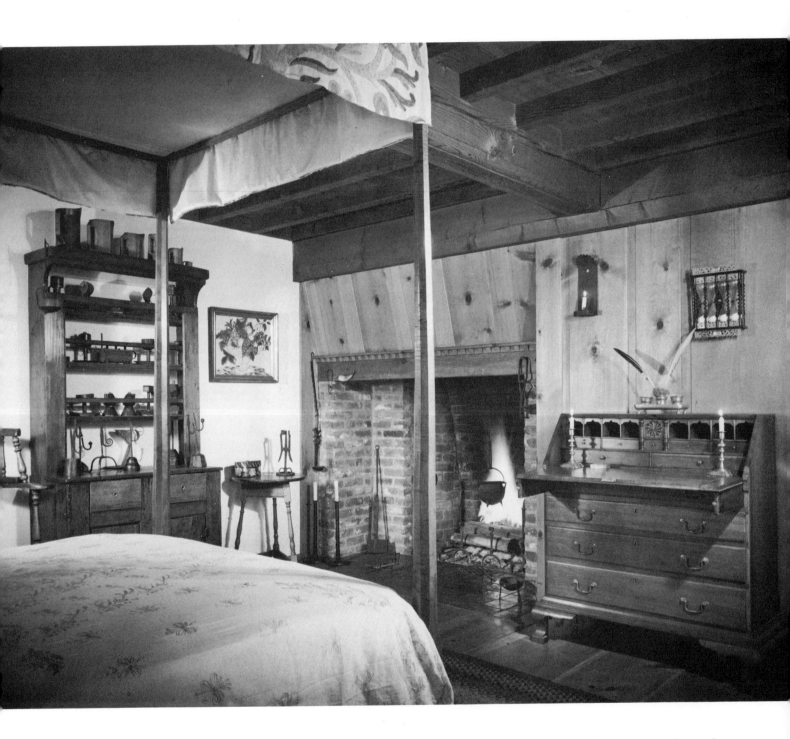

The bedroom on the ground floor has a deep fireplace with ornamented lintel. Beside it is a small stretcher table with triangular base and round top, like that in the living room; on the other side, a mid-eighteenth-century cherry desk equipped with pewter candlesticks and inkstand. The pencil-post bed is of maple. The collection of lighting devices arrayed on the shelves includes a number of tin lamps and wrought-iron rushlight holders.

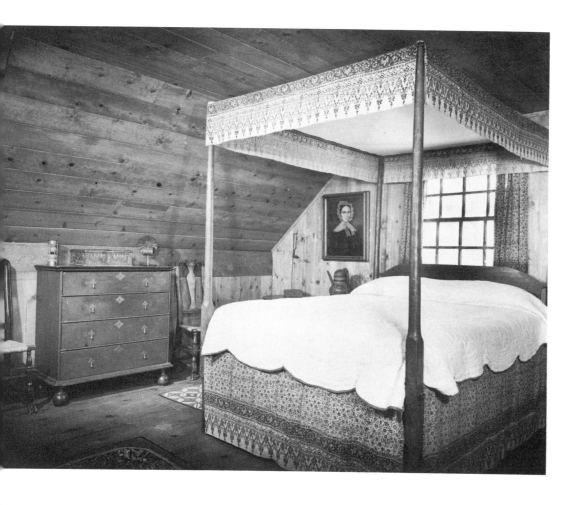

In a bedroom under the eaves a simple red-painted bedstead is hung in colorful India printed cotton. The ball-foot chest of about 1700-1710 is flanked by two New England chairs of an engaging transitional type combining turned legs and stretchers with curved splat backs; both have carved crestings and Spanish feet.

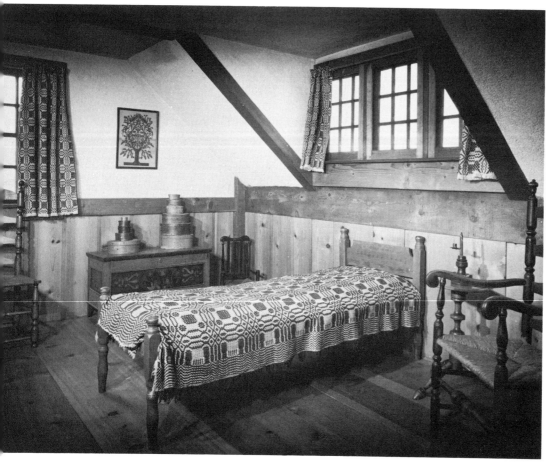

In another upstairs bedroom a double-woven coverlet is used on the early low-post bed, and similar textiles provide curtains at the high windows. Slat-back chairs with turned posts and stretchers and an unusually small banister-back are other appropriate pieces. Piled upon the painted chest is a collection of Shaker wooden boxes, oval and round. The "scissors picture" is intricately cut.

Queen Anne to Federal

Mrs. Andrew Varick Stout, New York City

THE NEW YORK APARTMENT which Mr. and Mrs. Andrew Varick Stout furnished with their collection of American antiques, and which Mrs. Stout has continued to live in since her husband's death, holds many treasures that have been displayed in important loan exhibitions and published in books of reference. Here they are presented in their customary setting.

Mr. and Mrs. Stout did most of their collecting in the 1920's and 1930's, a time that seasoned collectors now look back on as a golden age, when American antiques were really just coming into their own and rarities could be found at considerably less than the exalted prices they command today. New Yorkers both, Mr. and Mrs. Stout were particularly interested in New York craftsmanship, and acquired many notable examples of Duncan Phyfe furniture and New York silver. In addition there are dis-tinguished pieces of Queen Anne and Chippendale furniture, chiefly of Philadelphia origin, and a fine group of China Trade porcelain. Important as a collection, these antiques are also the comfortable furnishings of a home where they have been happily lived with for many years.

The dining-room chairs, thirteen in number, are from a set of twenty-four made by Phyfe for William Livingston, governor of New Jersey. The unusual window bench matches them, with the same lyre back and dog-paw feet, and all are upholstered in a red damask suitably classic in pattern; the color is repeated in the rug and the handsomely draped curtains. By Phyfe too are the matching side tables at the end of the room, on which are pieces of American eighteenth-century silver. The mahogany and satinwood secretary at the right, its shelves filled with early English and China Trade porcelain, is a Seymour piece, and so is the finely carved and inlaid sideboard barely visible at the left. The superb French chandelier and sconces and the English pedestal table are all in the classic taste. *Photographs by Taylor and Dull.*

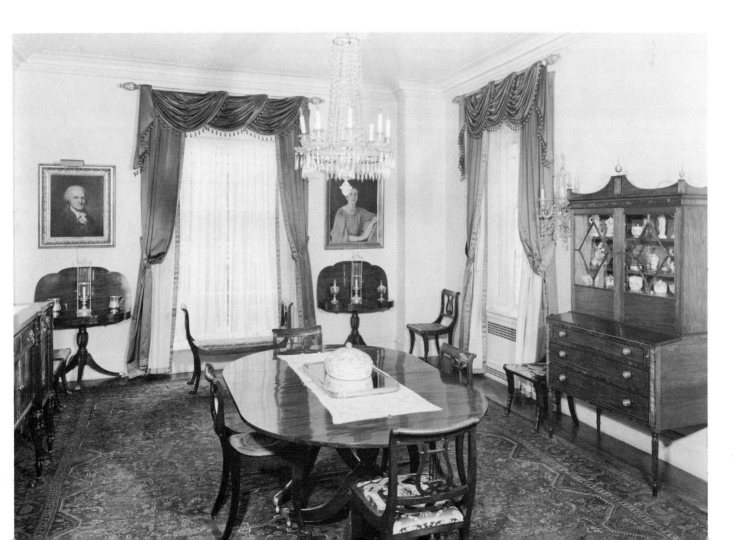

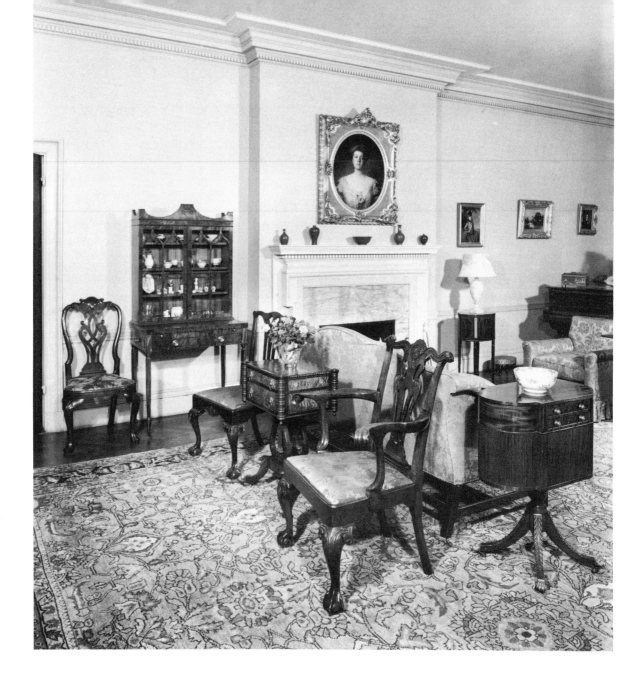

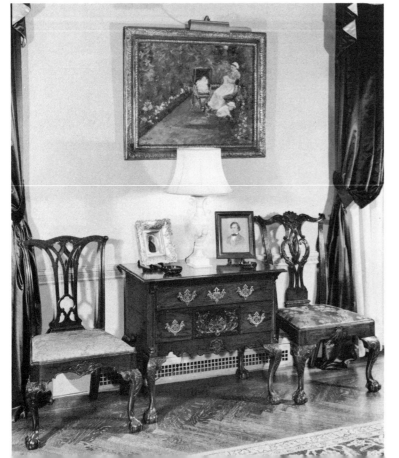

The mingling of Philadelphia Chippendale and Queen Anne with New York neoclassic furniture in the drawing room brings out the best qualities of each — the balance and richness of the colonial, the grace and refinement of the Federal. The elegant lady's desk beside the fireplace and the two little worktables here are attributed to Duncan Phyfe; the one in the foreground is a combination sewing and writing table. The walls of this room are a warm sandalwood color which Mrs. Stout feels is the perfect background for mahogany.

A painting by Mary Cassatt, *La Nourrice*, hangs above a fine Philadelphia Chippendale lowboy whose scrolled apron is accented by foliate carving. The Chippendale side chairs are also of Philadelphia make; that on the right has a tassel in the splat, and bold leaf carving extending far down the legs. The small oval portrait in deep gilt frame, on the lowboy, is a wax profile of Mr. Stout's ancestor Abraham Varick (1750-1810) of New Jersey, by John Christian Rauschner, a Dane active from 1799 to 1808 in New York and later in Boston and Philadelphia.

A breakfront cabinet in the drawing room displays China Trade porcelain, some decorated with the arms of New York; a Worcester tea set in blue and white; and such notable examples of New York silver as a bowl by Jacob Boelen, a miniature tankard by Adrian Bancker, a Peter Van Dyke porringer, an Elias Pelletreau tankard, a creamer and sugar bowl by William Gilbert. Hanging on either side of the cabinet are pastel portraits by James Sharples of the silversmith Gilbert (not visible here) and his wife (at right of cabinet). The Queen Anne lowboy and the Chippendale armchair with looped arms are both Philadelphia pieces. Above the Queen Anne side chair (right) hangs a small oval portrait of Washington by Charles Willson Peale, in its original gilt frame.

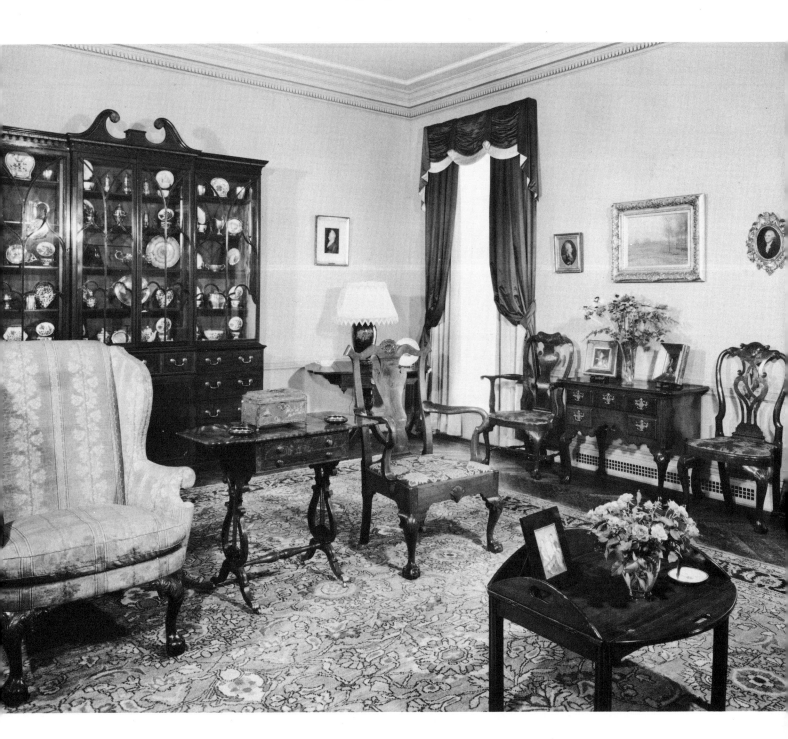

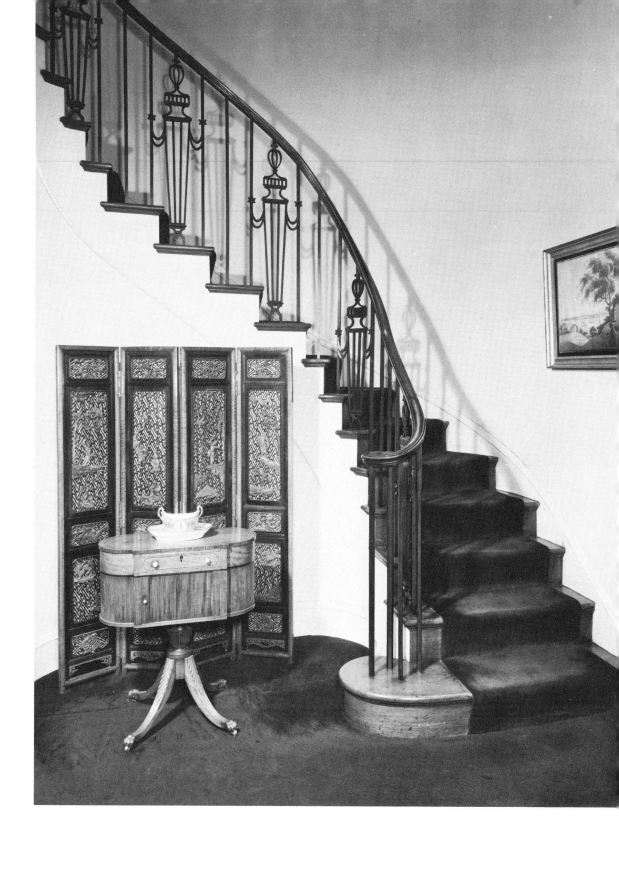

Several pieces in the entrance hall exemplify the surpassing skill of the New York craftsman Duncan Phyfe in his best period, c. 1800-1810. Three are in satinwood: the exquisite small tambour desk with ivory knobs and rosewood inlay, and two little sewing tables, one with tambour and four-legged pedestal base, the other with silk pouch and four straight, tapered legs. The sofa, of mahogany, has incurved ends, reeding on arms, legs, and seat rail, and on the top rail carved swags and thunderbolts. The Hepplewhite side chairs, though not attributed to Phyfe, are of comparable quality, their shield backs and interlaced splats unusually fine in design and carving. Aside from the Winslow Homer that hangs above the desk, the pictures in this hall are early New York views; they include the W. G. Wall aquatint (1826) above the sofa, which Stokes called "the first and most important engraved view of the City Hall," and the extremely rare set of four Jukes aquatints after Robinson, issued 1800-1802 (one shown here on facing page).

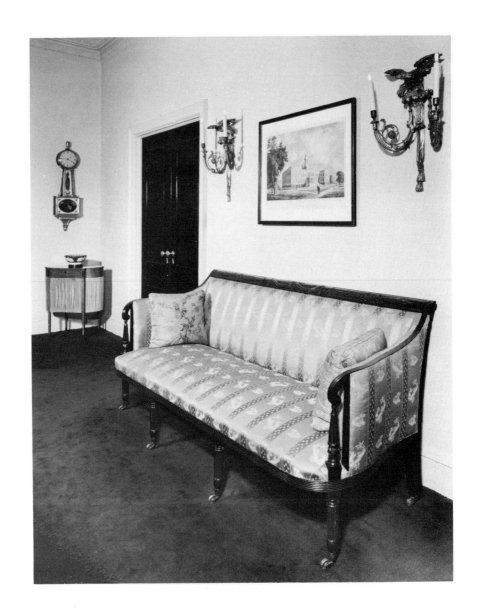

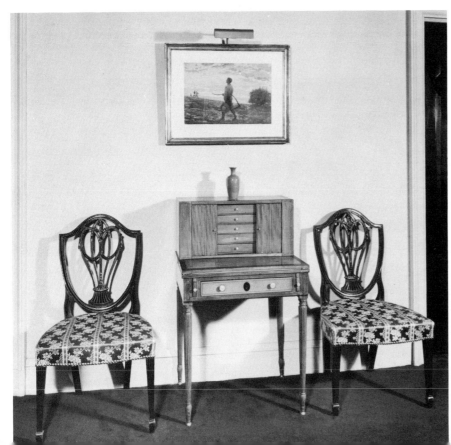

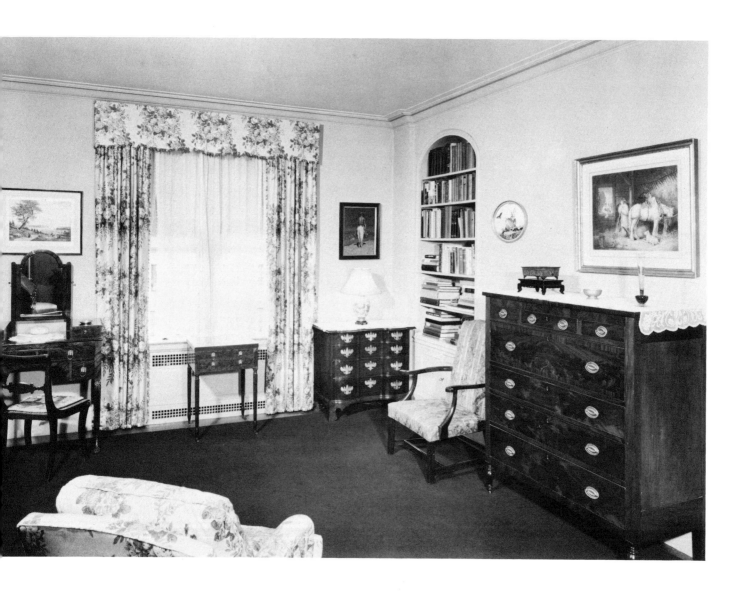

Furniture attributed to Duncan Phyfe in this bedroom includes a chest of drawers, worktable, chair, and dressing table. To these neoclassic pieces the little Massachusetts blockfront chest of drawers with its suave contour and bold brasses presents an interesting contrast.

French rococo and neoclassic

Colonel and Mrs. Edgar W. Garbisch, New York City

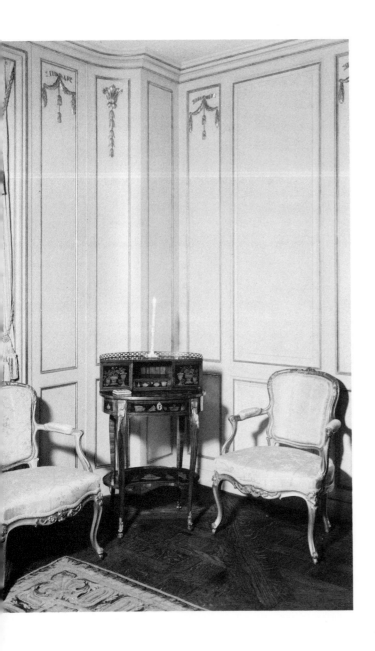

IN THE MINDS OF MANY PEOPLE, the owners of the apartment illustrated here are associated with American art and antiques. Colonel and Mrs. Edgar W. Garbisch spent many years in forming the extraordinary collection of American primitive painting which they presented to the National Gallery of Art in 1954, and they have also long been active collectors of early American furniture for their country house on the eastern shore of Maryland. In their New York apartment, however, they live with French antiques, collected with discrimination and arranged with exceptional taste.

Not only are all these antiques of first quality and interest; they are also admirably adjusted in scale to each other and to the relatively small rooms they furnish. The settings are themselves antique *boiseries*, and Mrs. Garbisch's rare sense of color has contributed to the harmony of each room. All the furniture and decorations are of the eighteenth century. Even the lighting fixtures are old, though wired for electricity. The elegant draperies reproduce antique fabrics and are hung in eighteenth-century style. The paintings are of the succeeding century, and they too are of prime importance, including works by Monet, Renoir, Degas, and Van Gogh. Only behind the scenes does the twentieth century find expression, in such ingenious devices as spotlighting on the paintings, concealed hi-fi equipment that can fill the rooms with music, television sets and storage cabinets hidden behind the carved panels of the woodwork. The paintings provide a sympathetic foil to the rococo and neoclassic furnishings, and the unobtrusive modern amenities enhance the distinction of both.

One of the most interesting of a number of rare small tables is this dainty Louis XV *bonheur du jour* of tulipwood and amaranth with pierced gallery and *bronze-doré* mounts, its surface enlivened with baskets of flowers, vases, and dishes in exquisite marquetry. It stands between a pair of Louis XV armchairs signed by the *maître-ébéniste* Criaerd; the carved roses of their gilded frames are repeated in the design of the pink silk brocade upholstery. *Photographs by Taylor and Dull.*

The living room is a symphony in white and gold, with accents of pink and rich tones of color in paintings, carpet, and porcelains. The eighteenth-century *boiserie* retains its original off-white paint, with carving picked out in burnished gold, and curtains and upholstery are of off-white silk with threads of gold. Against the black ground of the Savonnerie carpet the coat of arms of Louis XIV is mingled with floral motifs. The Louis XVI carved white marble mantel, framing gilt-bronze andirons of the same period from the atelier of Gouthière, is flanked by a pair of marble-topped Louis XVI consoles, carved and gilded, by the famous *ébéniste* Jacob. At the right hangs a Degas pastel, *Danseuses*; at the left, Renoir's *La Loge*. The pair of small gilded Louis XVI settees before the fireplace is signed *A. Gailliard* (M–E, 1781). The frame of the coffee table is an eighteenth-century Parisian silver *plateau* of fine workmanship, gilded and fitted with legs in Louis XVI style. Small marquetry tables here are of great quality. The unusually fine pair on either side of the Louis XVI sofa between the windows is attributed to L. Boudin (M–E, 1761). The Sèvres porcelain garniture on the mantel with covers mounted in gilt bronze is richly ornamented with chinoiserie designs by Lecot, while here and there about the room are other fine pieces of eighteenth-century porcelain and a variety of French enamel boxes. Late eighteenth-century *bouillotte* lamps and Sèvres vases with candle branches are used on the tables, and from the ceiling hangs a brilliant rock-crystal chandelier of the same era, with sparkling drops and sunbursts.

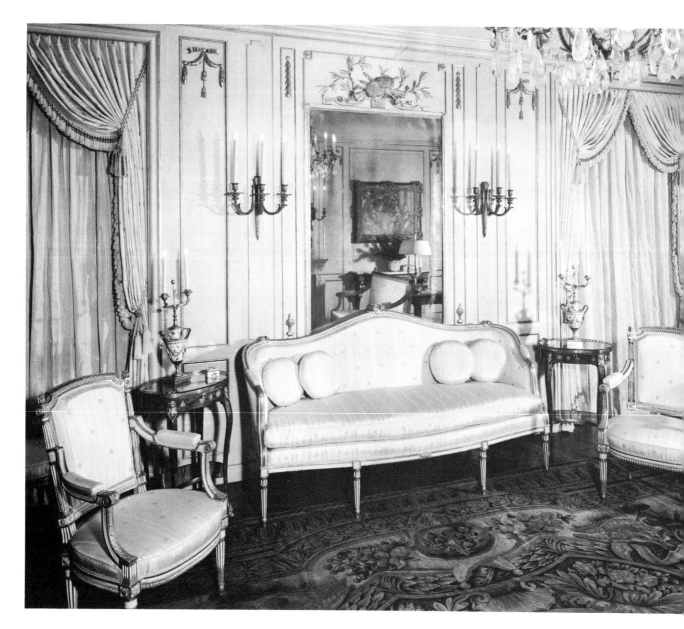

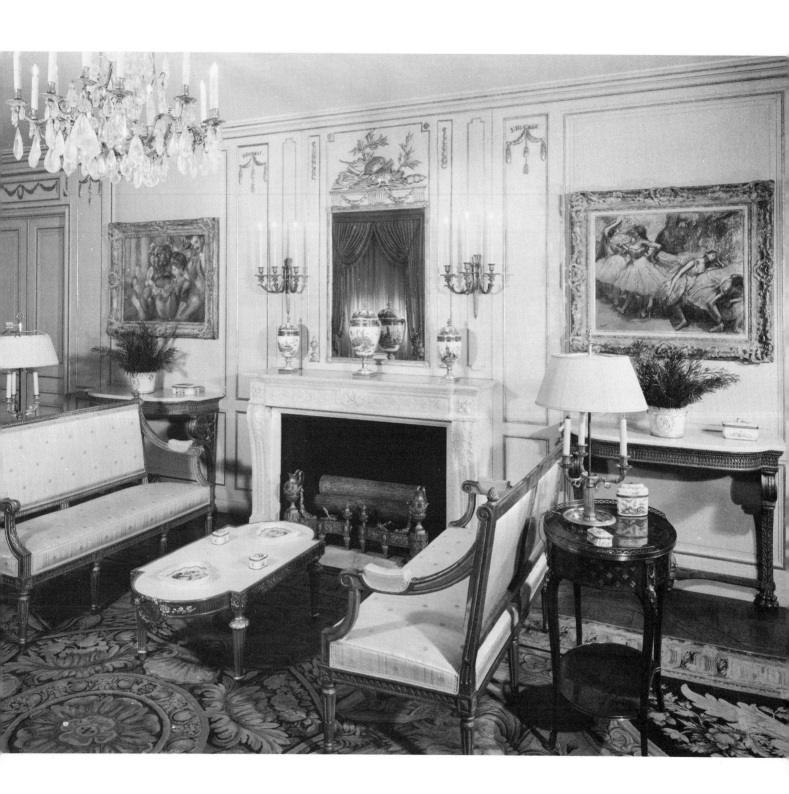

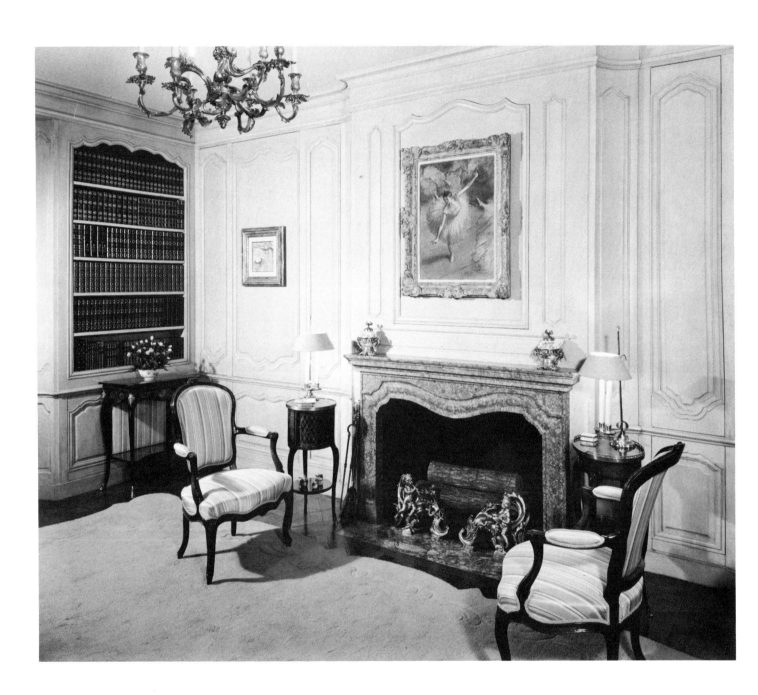

In the library the lovely provincial *boiserie* of the Louis XV period is painted celadon green, a color repeated in the carved rug and in the striped silk of curtains and upholstery. This subdued background is accented by the *rouge royal* marble of fireplace and hearth and by the shining gilt of the rococo chandelier and fire dogs, the latter made by Caffieri. In this room, again, are several fine Louis XV small marquetry tables. That at the left of the fireplace, in tulipwood, is signed by Topino (M–E, 1773). The one below the bookshelves has a silk-lined slide that may be raised as a fire screen. Shades of green in the Degas pastel of a dancer contrast with the soft background. Here again Louis XVI candlesticks of the type known as *bouillotte*, wired for electricity, are used as lamps.

The writing table in the library, a fine Louis XV inlaid piece in tulipwood and kingwood, has a dark brown leather top and shining rococo gilt-bronze mounts. Used with it is a Régence carved corner chair with caned back and seat, entirely gilded. Of the same period is the rare gilt bracket clock made in Paris by Bertol. The *fauteuil* of carved walnut, matching the two armchairs by the fireplace, is signed by Jean-Baptiste Lerouge.

An outstanding piece is this Louis XV serpentine-front commode, whose tulipwood marquetry is complemented by the soft tones of its Siena marble top and set off by extremely fine rococo mounts. The piece is signed by the great Cressent. Above it hangs an impressionist painting, *In the Garden,* by Claude Monet, signed and dated 1875. The bowl is of China Trade porcelain.

The Louis XV provincial paneling in the master bedroom is painted a warm off-white color with panels and floral motifs in shades of rose. Rose marble frames the fireplace, and shades of rose and green accent the painted taffeta window hangings and the brocade upholstery. The Louis XV ormolu brackets on the chimney breast, flanking the original mirror, are rare examples. Between the unusually small painted *bergères* an outstandingly fine large tray of Canton *famille rose* enamel, c. 1760, is mounted on a table frame in Louis XV style. The Louis XV marquetry table with ormolu mounts at the left of the fireplace is of tulipwood and lemonwood; the interesting Louis XV fruit-wood fire screen (right) has a folding shelf inlaid with floral motifs.

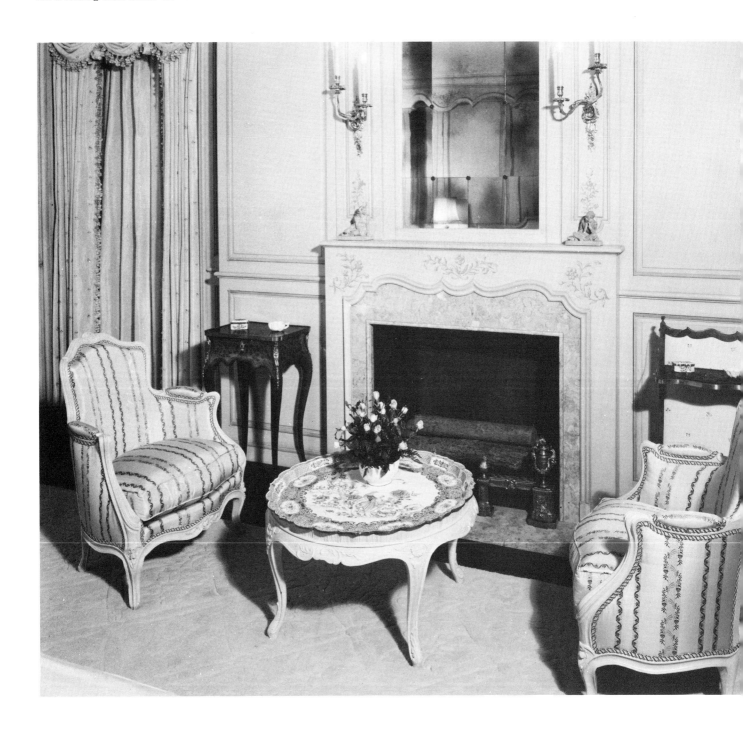

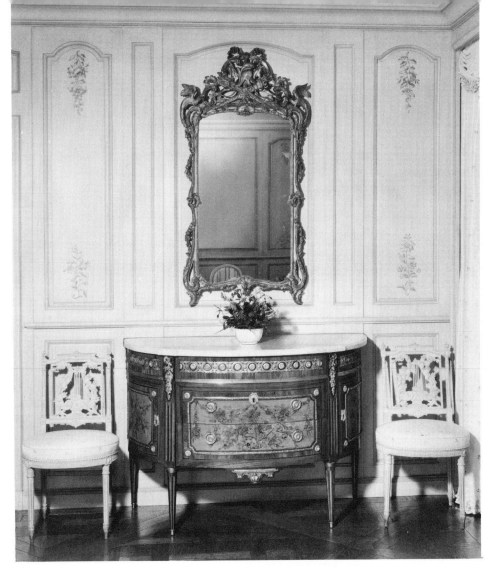

This Louis XVI half-round commode in the master bedroom is one of a pair of first importance. Signed *C. Topino*, it is of tulipwood, with marble top, and is ornamented with floral panels in marquetry on harewood, carved and gilded bands of paterae, simulated fluting in gilt on the legs and posts, and ormolu mounts. The painted Louis XVI chairs beside it are unusual, their backs carved in the form of a lyre entwined with leafage. The rococo gilded mirror is carved with shells, scrolls, floral swags, birds, and military motifs.

A group of miniature pieces in the bedroom hall fits charmingly in a small space. The carved Louis XV chairs from a set of four, their seats scarcely twelve inches wide, are painted white and upholstered in white taffeta scattered with painted miniature flowers. A bouquet of eighteenth-century porcelain flowers is arranged in a Meissen porcelain basket on the marble top of a Louis XV mahogany serpentine console with floral marquetry, and floral motifs brighten the black ground of the Savonnerie carpet. The small oil above was painted by Van Gogh during his Paris period.

Variety in painted decoration

Mr. and Mrs. Howard Lipman, Cannondale, Connecticut

FOR YEARS the New England farmhouse shown on these pages housed the well-known American folk art collection of Jean and Howard Lipman. Its walls were literally covered with primitive paintings, while weather vanes, cigar-store Indians, and other folk sculptures crowded the interiors. The oldest part of the house was built between 1728 and 1732. In 1795 the main house was added, and it remained in the same family until 1888. When the Lipmans bought it about twenty-five years ago the eighteenth-century floors, hardware, and woodwork had not been touched and the house was remarkably unspoiled. Here, surrounded by their treasures, Mrs. Lipman pursued her studies of folk art and wrote her several books on the subject. And during vacations she and her husband scoured the countryside for new finds to add to the collection.

In 1950 the Lipmans found a permanent home for their folk art collection at the New York State Historical Association in Cooperstown, and they firmly gave up collecting. But it was not long before they became interested in decorated furniture and began picking up an occasional piece. One thing led to another, and now they have a remarkable collection of unusual painted items of many sorts from New England, New York, and Pennsylvania, with which they have virtually refurnished their house.

The decoration of the furniture and other objects was done chiefly in the nineteenth century, some in the latter part of the eighteenth. Most of the pieces themselves were new when they were decorated, even those of apparently earlier types; some, however, were already antiques and were brought up to date in this way.

The decorating techniques include stenciling, brush-stroke painting, smoking, imitation graining, marbleizing, "finger painting," and painted patterning with brushes, sponges, corncobs, corks, feathers, combs, and a number of other unconventional implements. A few pieces are decorated with primitive scenes and still life. Mrs. Lipman, who has mastered most of these techniques herself, has published instructions for other present-day craftsmen.

An exact duplicate of this Indian-red New England chest with its decoration of stylized yellow, green, black, and white floral motifs can be seen in the Hall Tavern at Old Deerfield — an interesting indication that early furniture makers and decorators executed a number of identical pieces. On the chest are a Pennsylvania decorated candle box, c. 1800, and a remarkable carved and painted turtle from Connecticut. The double-comb-back windsor is painted dark red with yellow striping. The nautical weather vane on the window sill probably came from Massachusetts. *Photographs by Taylor and Dull.*

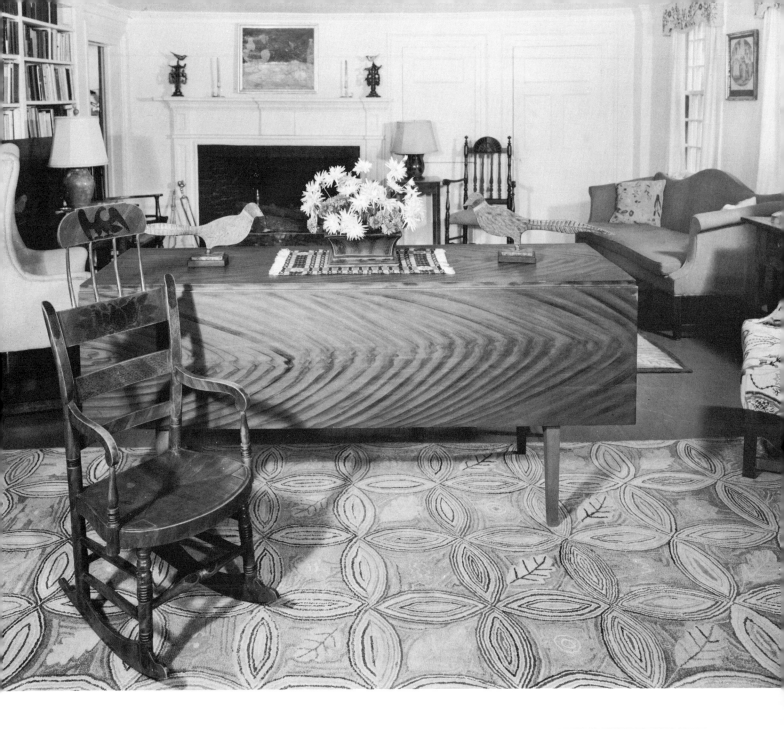

The drop-leaf table in the living room has a birch base and pine top and is boldly painted in black on red. It was found in a Maine farmhouse in which a number of pieces and much of the woodwork were decorated, probably by the same hand. The flat painted pheasants perched on the table swivel on their bases. The chair in the foreground with its high comb and rockers is an amusing variant of a familiar "Sheraton fancy" type, decorated in black on a red-grained background; the wooden seat is carved to simulate rush. On the back of the third splat the stenciled signature of one P. P. BILLINGS NY. identifies the decorator.

Fully qualifying for an American folk art collection as well as for this specialized group of decorated pieces is a pair of ornamental Pennsylvania "bird trees." The painted wooden birds, mounted on the highly stylized branches by wire springs, bob a bit when one treads heavily on the old flooring.

In another corner of the living room a chest with turned legs in late Sheraton style is finger-painted in black on ocher, with black-on-red sponge decoration on top, sides, borders, and knobs. The box on it is sponge-decorated in dark green and red on yellow, and a primitive carved "portrait" of a dignified gentleman stands on a marbleized base. Black paint on a salmon ground enlivens the splay-legged Pennsylvania kitchen table, whose top, held in place with four knob-handled pegs, could be reversed for rolling out dough.

The blanket chest and matching box in the kitchen, found in Mystic, Connecticut, are good examples of mid-nineteenth-century New England finger painting. A bit of vinegar mixed with the second coat of paint was used to make a finely veined seaweedy pattern within the swirls. The background coat is light ocher, the overlay a rich variety of autumn hues — deep yellows, orange reds, browns, and greens. The sign hanging over the chest advertises *E. Fitts, Jrs. Store*, with tall hats featured on the top shelf. Its other side, dated 1832, announces *E. Fitts' Jr. Coffee House.*

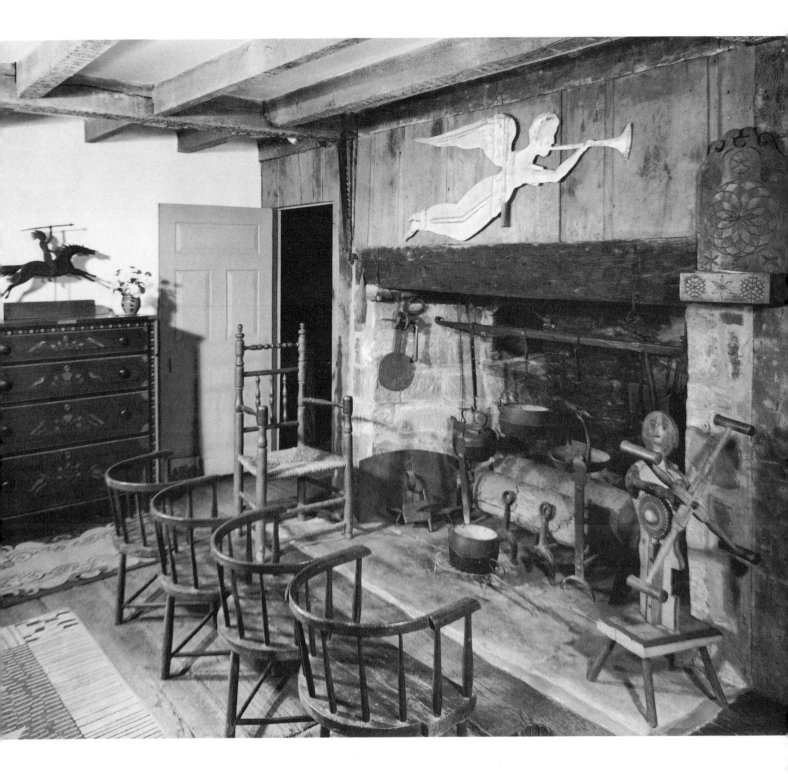

At the side of the kitchen fireplace is an odd, primitive wool winder made in the shape of a woman, with winder in place of arms. The decoration, featuring dotted designs in red and black, is on a cream background. Above the winder hangs an eighteenth-century New England candle box ornamented with geometric motifs carved and painted in yellow and red on dark green. The windsor four-chair bench, though not decorated, is a unique piece of country furniture. Probably from Pennsylvania is the carved and painted weather vane on the chest; the Indian, wearing only a feather headdress, rides his galloping horse with great verve. A Massachusetts church was the original perch of the gilded Gabriel weather vane over the fireplace.

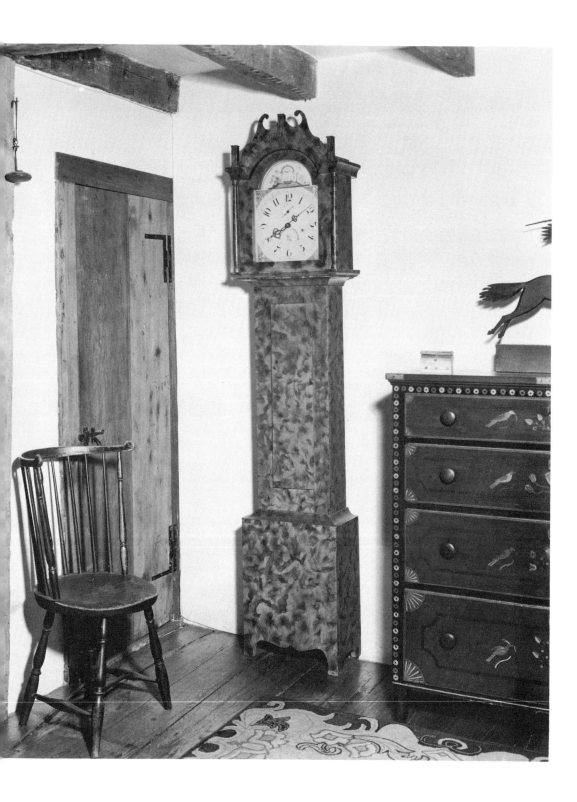

In another corner of the kitchen stands a grandfather clock with Masonic designs on its painted face; it was made by Silas Hoadley of Plymouth, Connecticut (active 1808-1849). The black "smoked" decoration of the case, on a dark ocher background, was achieved by passing a candle over the painted surface to make the soft, all-over pattern. The Pennsylvania chest is a typical Mahantango Valley piece by Jacob Maser, dated 1830. As in his other work, the worm-eating birds, stylized tulips, and flower border are painted in vermilion, yellow, and black, on a dark green background.

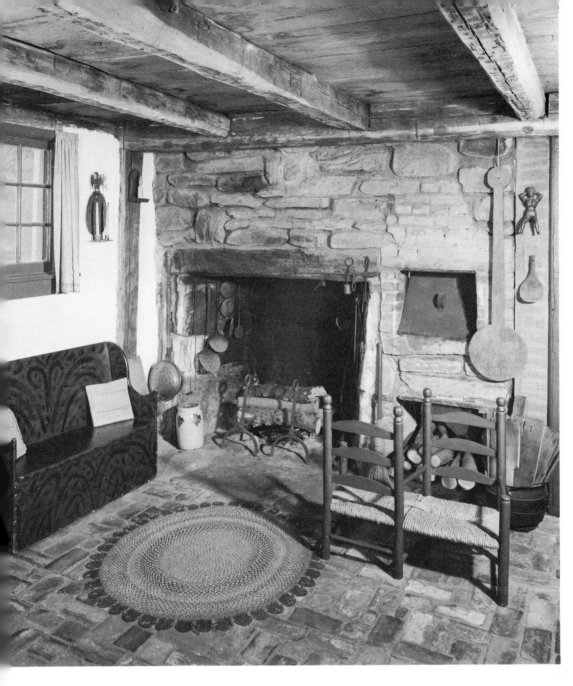

Built about 1730, this old kitchen-living-room, with sleeping quarters above, is the earliest part of the house. Nothing is changed except the brick floor, which was originally hard earth. The little wood-box settle at left is painted in a splashy black design on dark red. It was certainly made for children's use, as was the small double chair.

In another corner of the old kitchen stands a smoke-decorated chest in dull yellow with turquoise borders. *Honesty is my aim. Better to be dead than faithless* is written in German script on the eighteenth-century Pennsylvania bride's box. The comb-back rocker is decorated to the hilt with brush-stroke painting in red, yellow, and green over boldly sponged red and black. On the footstool the initials *M.A.L.* are painted in a garland of bright flowers on dark green. The painted sheet-iron Indian was, it is said, originally nailed over a Pennsylvania doorway.

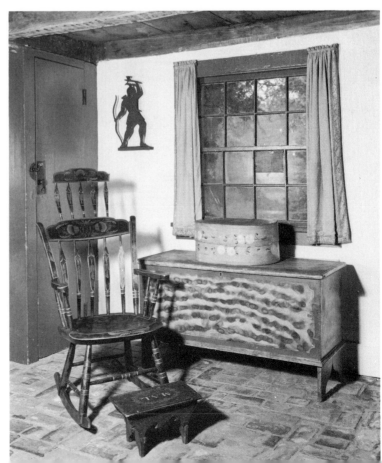

The striking decoration of the two-part Sheraton dining table was achieved with dark gray brush strokes and sponging in an all-over design on a cream background. Over the painted New England serving table, which is marbleized in gray and grained in brown, is a watercolor portrait probably of the 1830's, found in New Hampshire. According to family tradition, it was painted by Willard S. Brooks, chair painter and artist of Hancock, New Hampshire; the subject, his wife, is seated in one of his painted chairs. Very likely the cabinet of small drawers was once used in a store; it is decorated in gray on cream, with black borders and strips for labeling the contents. The bowls of "witch balls," decorative blown glass made in various eighteenth- and nineteenth-century glass factories, look especially cheerful in the morning sunlight.

Examples of gold-stenciled decoration on black and red grained backgrounds furnish the south bedroom. Framed above the resplendent Empire bed is a stenciled linen table cover from New Hampshire; its floral border and fruit still-life in reds, blues, greens, and purples are still bright and clear. The Boston rocker has a red-grained seat with yellow striping and black border, and a multicolored decoration of birds and flowers on the top rail. A wooden frame painted dark green with a simple red design surrounds the dial of the tiny wag-on-the-wall clock.

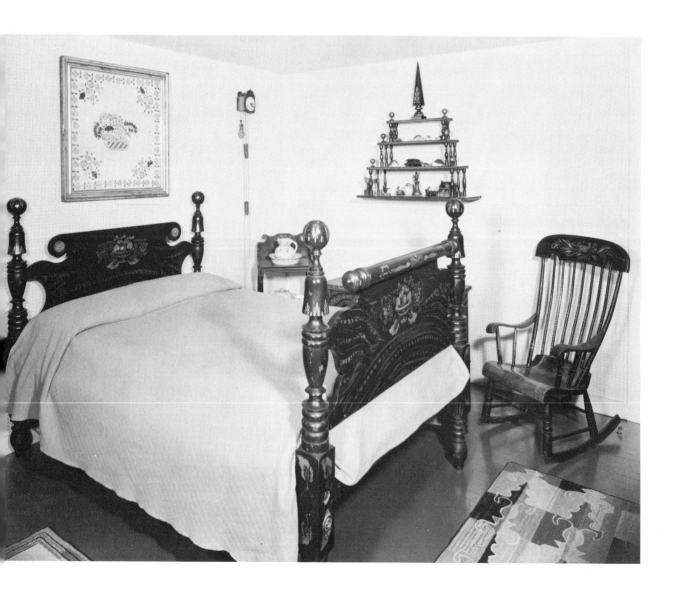

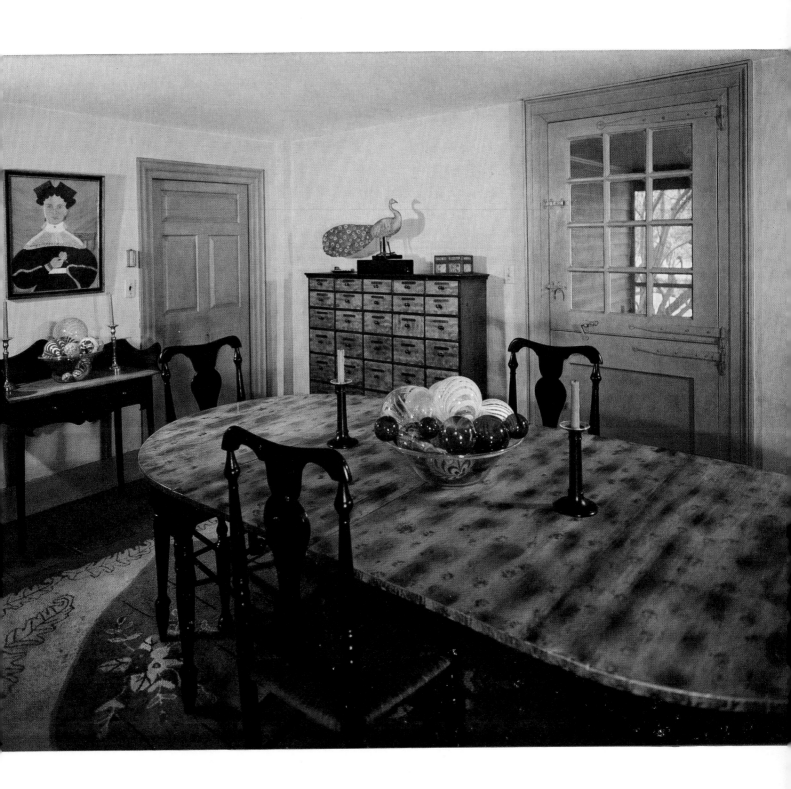

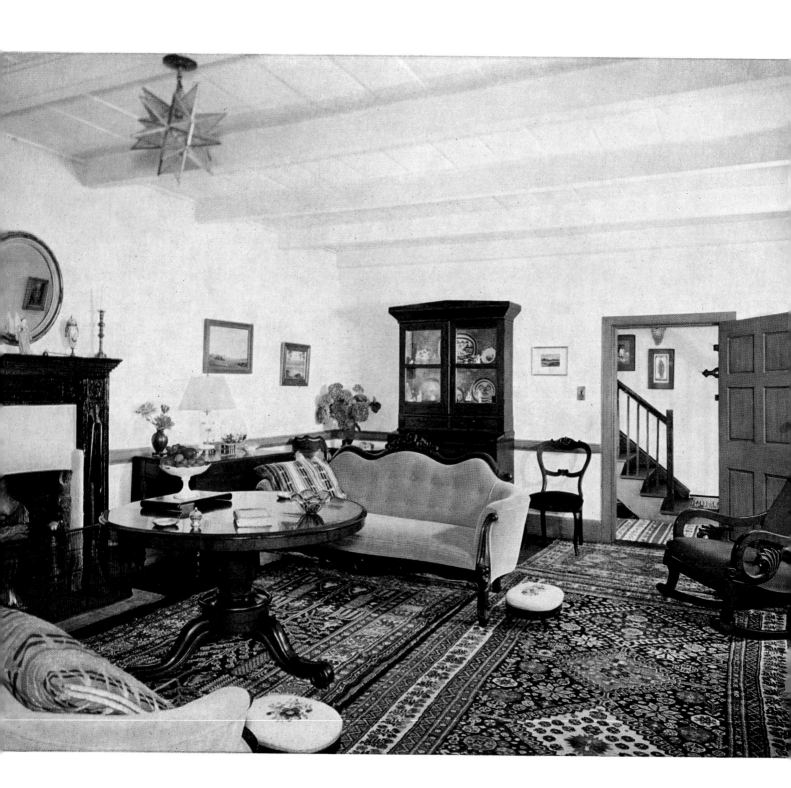

California adobe

Mrs. William M. O'Donnell, Monterey, California

The deep window embrasure in the *sala* reveals the thickness of the adobe walls. Most of the small glass panes are original.

THE CASA SOBERANES in Monterey, California, was built in 1842 by Don José Estrada, ranking officer of the Presidio of Monterey under the Mexican regime, and has been lived in continuously ever since. It is from its second owner, Don Mariano Soberanes, that it takes its name, and during his long tenure it acquired historic associations. As his wife was a Vallejo, the house was frequently visited by members of this famous family from the northern frontier. In 1902 ownership passed to Reuban Serrano and his wife, and in 1941 to Mr. and Mrs. William M. O'Donnell. In 1953 Mrs. O'Donnell, who continues to make her home there, presented the house to the state as a historic monument.

Like many California houses, the Casa Soberanes is built of adobe. Adobe is a mixture of clay, sand, and water, with straw as a binder, poured into boxes, or *adoberos,* and dried in the sun. The resultant large, heavy slabs are laid in walls two to three feet thick, joined with mud or lime mortar, covered with stucco, and whitewashed. The walls of the Casa Soberanes are thirty-three inches thick and the house is typical of the Monterey adobe: a long rectangle, two stories high, with a patio reached by a covered veranda, or *corredor.* Unusual, however, is its cantilevered balcony, supported by ceiling beams that run through the outside walls instead of by exterior columns extending to the roof. The influence of New England settlers in California is seen in the use of small-paned sash windows in place of the traditional iron grilles and heavy wooden shutters.

The Casa Soberanes is often called "the house with the blue gate," because of the color of the entrance through the dense cypress hedge that entirely screens it from the street. Within, there are six rooms and two spacious halls. Some of the Victorian furniture has always been in the house; some came from other old Monterey houses. Representing an important period of California's history and a style characteristic of its culture, the Casa Soberanes is full of tradition in a region where reminders of even the recent past have become all too few.

At the rear of the house the stone-paved covered *corredor* leads to the patio, where old-fashioned flowers grow in stone-bordered beds. The original hand-made tiles and "shakes," or shingles, form the sloping roof.

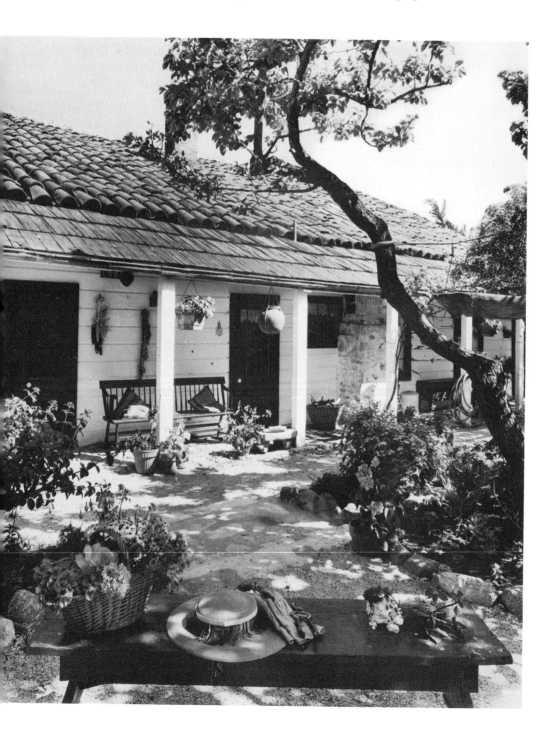

The balcony that runs the length of the house and shades the *corredor* is supported by beams extending through the walls from inside.

In the entrance hall stands a huge wardrobe of the kind frequently used in such closetless houses.

The mid-nineteenth-century spool bed and heavy chest
of drawers are the sort of furniture originally used
in the house. The recessed door opens on the balcony.

Classic revival in Indiana

Mr. and Mrs. James L. Nugent Jr., Evansville, Indiana

The small formal garden shows the influence of Colonial Williamsburg, and the fence is a product of Nugent craftsmanship.
Photographs by Fahrenkrug.

INDIANA, LIKE SO MUCH OF THIS COUNTRY, is traditionally a classic-revival region, and when Mr. and Mrs. James L. Nugent Jr. began to collect American antiques for their home in Evansville they decided to put their emphasis on pieces of the early Federal period. The house itself, which they built in 1949, is an adaptation of the style of the period, with interior architectural detail that accords well with the furniture. The Nugents are systematic in their collecting, budgeting a certain amount each year for antiques and investing it judiciously in pieces of enduring quality. They study antiques wherever they can, in museums and private collections and shops, and profit by the wisdom of experienced dealers and collectors. Like all true collectors, they seek the authentically old and genuine, but they respect honest craftsmanship of any era and Mr. Nugent, who is a competent craftsman himself, takes justifiable pride in certain items illustrated here that he fashioned in his basement workshop.

In the entrance hall an American mahogany mirror of about 1780, carved and gilded, hangs above a Philadelphia Queen Anne tea table with graceful scrolled skirt, cabriole legs, and slipper feet. The square-based brass candlesticks are Spanish, of about 1700, and the sconces are probably English, while the bowl is of China Trade porcelain. The two Philadelphia chairs have trifid feet in front; that at the right is pure Queen Anne, that at the left verges toward Chippendale.

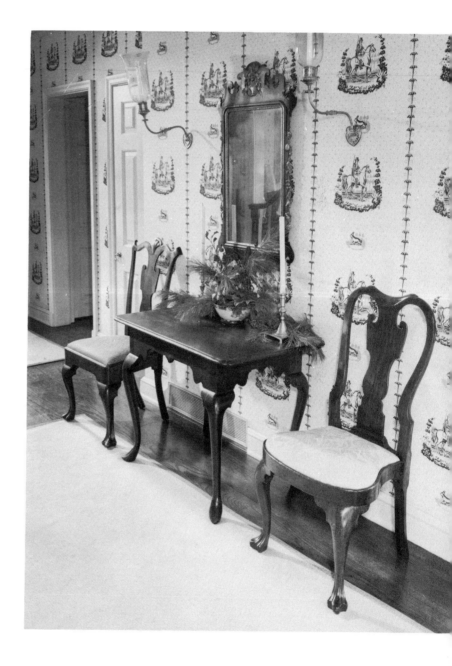

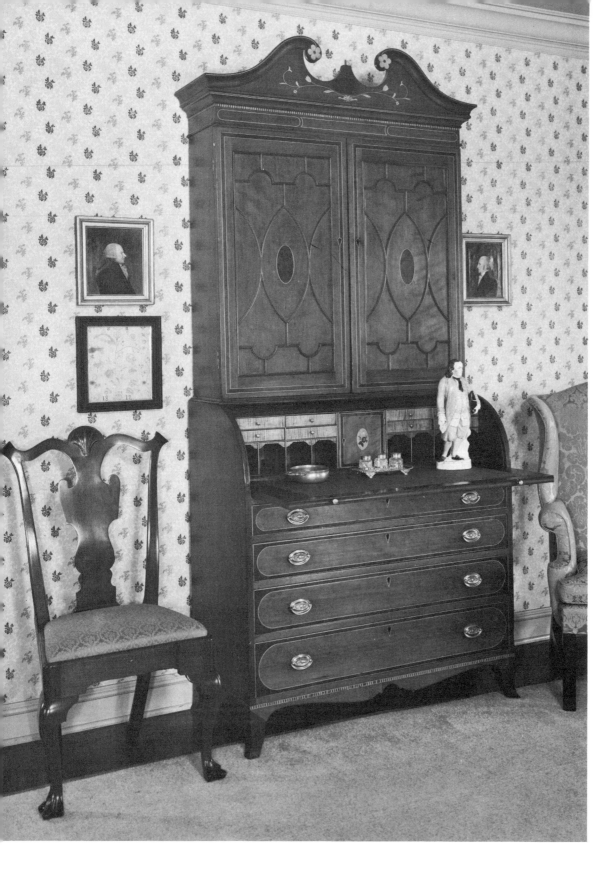

Perhaps the most unusual piece in the collection is the Hepplewhite scroll-top secretary of cherry with satinwood inlay. The molded muntins of the doors frame panels of wood rather than panes of glass, and the writing section closes with a tambour roll top, a feature rare in American work of the time. The piece has a Kentucky history and was probably made there in the early 1800's; the vine and floral motifs of the inlay are known in work from that area. The mahogany chair beside the secretary has the flaring back, shell-carved crest, and trifid feet of Philadelphia, c. 1750. The small portraits of George Washington and John Adams, in their original frames, are contemporary copies in oil of pastels by James Sharples, c. 1810.

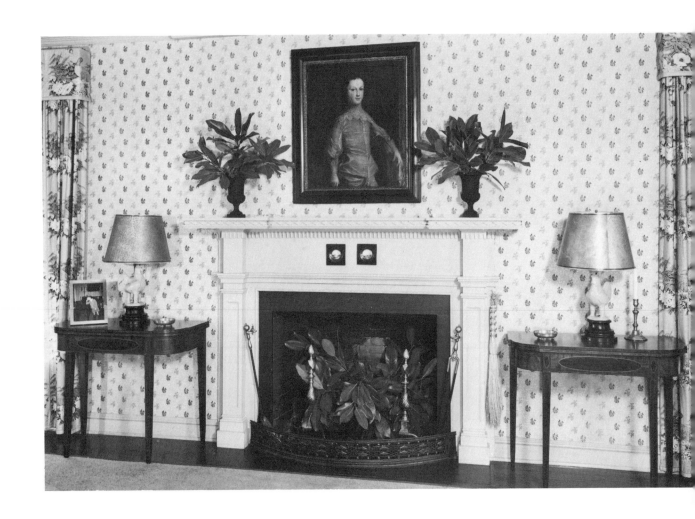

The living-room mantel is the work of a twentieth-century craftsman — Mr. Nugent himself. It is equipped with eighteenth-century American andirons, fire tools, and pierced iron fender, and is flanked by a pair of Hepplewhite inlaid mahogany card tables, c. 1790, from Connecticut. The attractive English portrait of about 1740 shows a pink-coated boy with dog, in contemporary black and gilt frame.

In a corner of the living room a Georgian mahogany wing chair, c. 1770, stands beside a Connecticut tripod tea table in cherry, of the same date. This fine piece, with claw-and-ball feet, shell-carved knees, and bird-cage attachment, shows in the carving of the feet a suggestion of relation to Philadelphia work, such as is occasionally seen in Connecticut furniture. The painting of a frigate with a view of Philadelphia in the background is by Thomas Birch (1779-1851).

Used with the two-part dining table of inlaid mahogany, a Baltimore piece
of about 1790, is a set of mahogany chairs of the same period, carved in a
typical New York design. The unusually handsome corner cupboard with its
heavy molded cornice and paneled doors is from Pennsylvania, c. 1750. A
Hepplewhite mahogany and gilt mirror, probably New York, c. 1790, hangs
above the marble-topped serving table of inlaid satinwood, a Baltimore
piece. The silver coffeepot upon this fine 1790 table is by Samuel Richards
Jr. of Philadelphia. Two years of industry on Mr. Nugent's part produced
the matching pewter chandeliers fashioned after a handsome eighteenth-
century model at Colonial Williamsburg.

The Baltimore Hepplewhite sideboard has bellflower inlay on the legs as well as inlay outlining the veneered panels. Of the same classic era are the candelabra of Sheffield plate. The portrait, dated 1755, is attributed to Allan Ramsay, and is in a contemporary black and gilded frame.

For some years this spade-foot bed with leaf-carved and reeded posts stood in the Hammond-Harwood house in Annapolis; it was made in Charleston about 1790. The mahogany secretary is English, of about 1780.

Seventeenth-century family seat

Mr. and Mrs. David B. Robb, Ardmore, Pennsylvania

PONT READING in Ardmore, Pennsylvania, is the home of the Humphreys family. It was begun in the seventeenth century and added to by successive generations for two hundred years, and except for the years from 1923 to 1948 it has always been lived in by Humphreys. Its purchase in the latter year by Mr. and Mrs. David B. Robb brought it back into the family, for Mrs. Robb is a direct descendant of Daniel Humphreys, who came from Merionethshire before 1683, the year in which he sent for his mother and sisters. He and his sons acquired about one thousand acres of land in what became Delaware County, where they carried on a milling and fulling business.

The name Pont Reading, said to have been taken from the Humphreys home in Wales, is first recorded in 1785, when Charles Humphreys, a member of the Continental Congress, willed the house to his nephew, Daniel Humphreys, colonial printer and publisher of *The Pennsylvania Mercury and Universal Advertiser*. Daniel Humphreys owned the house for four years before selling it to his brother Joshua, "father of the American Navy," who as chief naval constructor designed our first frigates, *Constellation, Congress, President, Constitution,* and *United States,* the last of which was built in his own shipyard at Southwark. Pont Reading was his home until his death in 1838, and during this long residence he made important additions to the house. Joshua's son, Samuel, also chief naval constructor, then lived there, followed by his son, Major-General Andrew Atkinson Humphreys, who was chief of staff to General Meade in 1863. General Humphreys owned Pont Reading until 1883 and his daughter sold the house forty years later.

This long tenure in a single family has been responsible both for the gradual alterations and for the fine preservation of the house, which is of pleasingly harmonized if not unified design. It is an appropriate setting for the many family pieces which Mr. and Mrs. Robb have inherited from their Pennsylvania and New Jersey ancestors.

Many generations of the Humphreys family have added to Pont Reading. Remains of the seventeenth-century house are still to be seen in the logs in the old stone kitchen, now the pantry. The stonework of the middle portion, to which classic columns were added in the Federal period, antedates 1730, and the rear section with gabled roof was built prior to the Revolution. The addition at the front (left in this view) was built by Joshua Humphreys in 1813. It is of stuccoed fieldstone and retains its original surface. Dormers were added to the center section later in the nineteenth century. *Photographs by Charles P. Mills and Son.*

All the pieces in the library are family heirlooms with the exception of a Philadelphia Marlborough sofa showing particularly fine workmanship in its block foot. The mahogany gaming table with claw-and-ball feet is a Humphreys piece, originally at Pont Reading. Edward Shippen of Lancaster, Pennsylvania, an ancestor of Mrs. Robb's, once owned the straight-legged card table with pierced brackets and the girandole mirror above it. A portrait of Sarah Plumley (Mrs. Edward Shippen) by Gustavus Hesselius hangs opposite. The China Trade porcelain punch bowl standing on the table, decorated with the spread eagle and *In God We Hope,* belonged to James Bruen, whose brother imported Chinese porcelain; Mrs. Robb has inherited many pieces from this source. The miniature walnut chest belonged to Jonah Woolman (1733-1799) of Rancocas, New Jersey, Mr. Robb's great-great-great-grandfather, and may have been made for him in Philadelphia at the same time as the desk and bookcase seen in the other view of this room. Mr. Robb's family home at Burlington, New Jersey, was the source of the Queen Anne walnut armchair with needlework seat at the right of the gaming table.

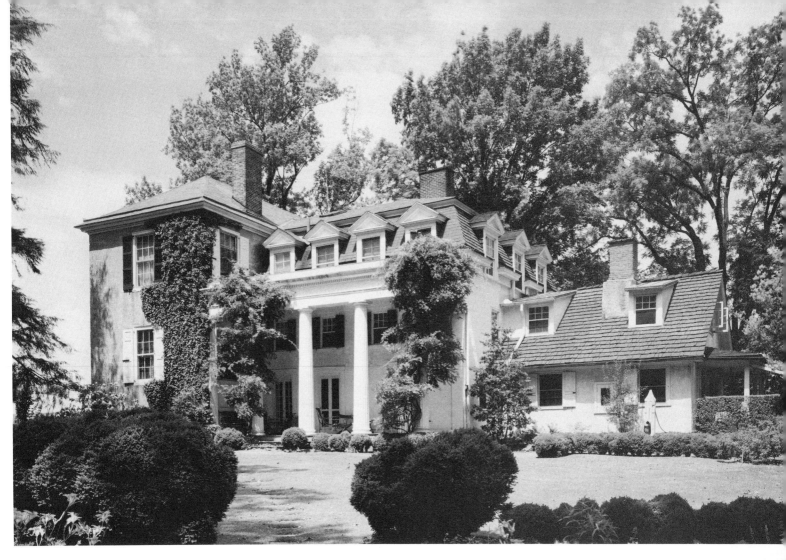
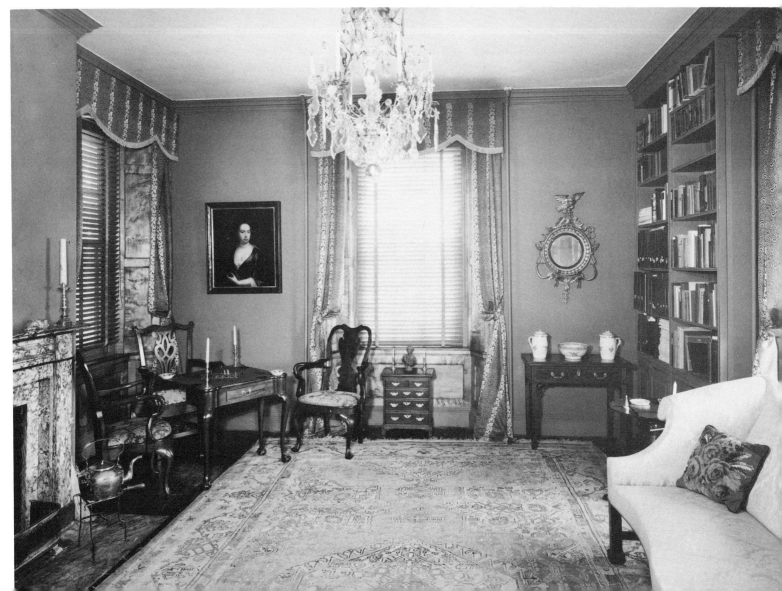

Another view of the library shows the mantel of Chester County marble and a Chippendale mahogany and gilt looking glass with eagle finial, possibly made in Philadelphia, originally owned by Mr. Robb's family; the Philadelphia armchair with trifid foot and Chippendale back, of about 1750, also came from this family. The original owner of the handsome Philadelphia desk and bookcase with flame finial and shaped paneled doors was Jonah Woolman. Bristol vases on the card table were made for the American market and are decorated with views of the Race Street Bridge and the Upper Ferry Bridge over the Schuylkill River. The portrait of Washington, a Chinese painting on glass, was brought over in the early nineteenth century. The present owners placed the Baccarat chandelier, one of a pair, here because it accords in date with the Federal addition to the house.

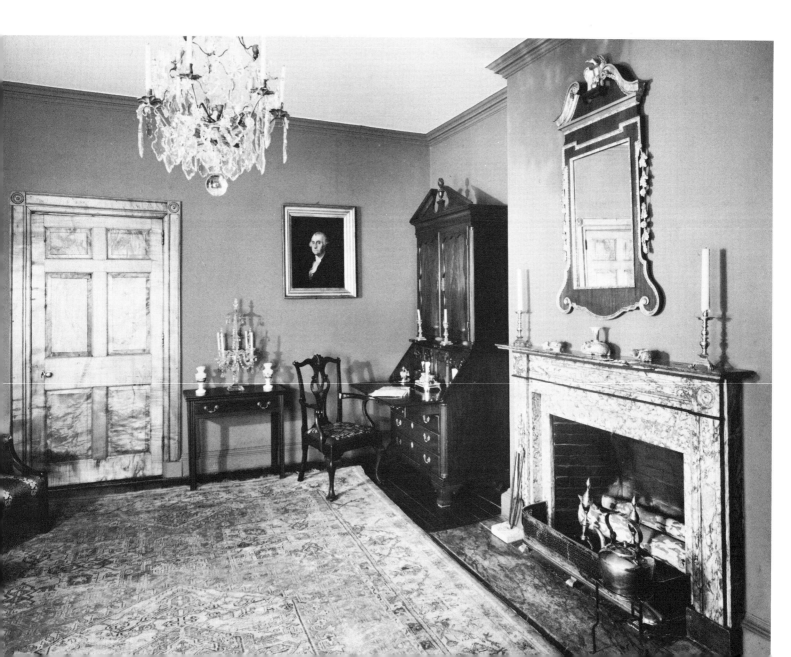

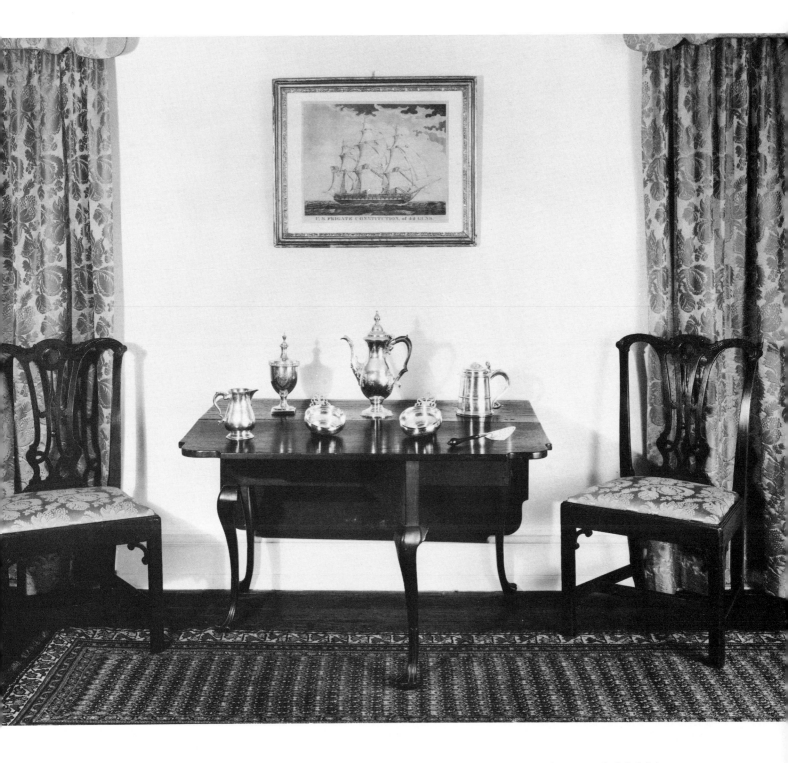

The finest known portrait of the frigate *Constitution*, engraved by Abel Bowen after William Lynn, hangs appropriately in the home of the *Constitution's* designer, where it is part of a collection of naval views. The pair of Chippendale chairs belonged to this great naval designer, Joshua Humphreys. A collection of inherited silver chiefly from the Hudson, Burr, and Yeates families stands on a handsome drop-leaf walnut table with well-designed trifid foot. The coffeepot by Joseph Richardson Sr. is unusual in having baroque leafage around the spout. William Hud-

son (1644-1742), mayor of Philadelphia in 1725, once owned the domed tankard by Peter David. Mr. Robb is of the eighth generation to own this and two porringers, the work of the Francis Richardson who founded a distinguished family of silversmiths in Philadelphia. The creamer is by Nathaniel Coleman of Burlington. Myer Myers of New York and Philadelphia made the unusual pierced pie knife originally owned by Jasper Yeates (1745-1814) of Lancaster, justice of the Pennsylvania Supreme Court; it was inherited by Mrs. Robb in descent through seven generations.

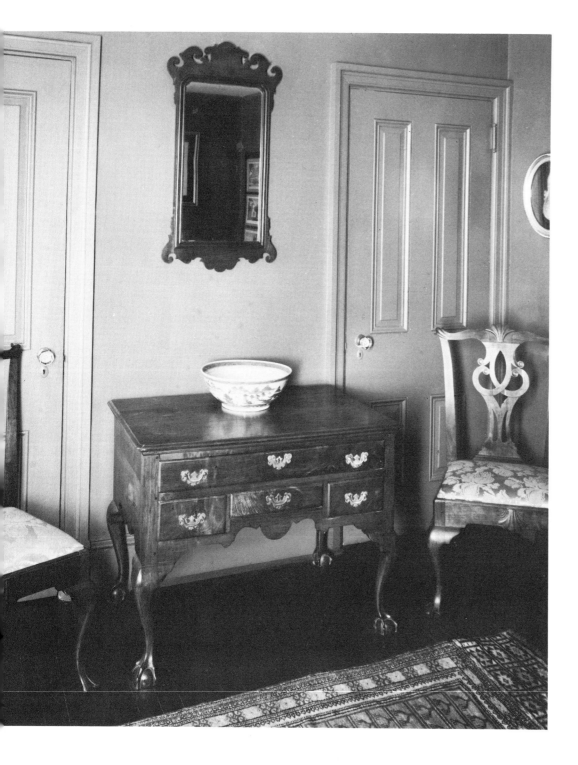

In the side hall, leading from the eighteenth-century entrance door into the dining room, a mirror by John Elliott hangs over a fine walnut lowboy which shows good detail in the four carved claw-and-ball feet and incurved corners of the top. Elliott's third type of label, used by him between 1768 and 1776, is on the looking glass. The walnut shell-carved side chairs are part of a set of six originally owned by Sarah Burr of Burlington.

Facing page.

The stair from basement to attic, in Joshua Humphreys' addition, is of curly maple, as are all the doors. The delicately turned spindles are especially graceful. Maple trees are said to have been cut on the place and taken for seasoning and millwork to Humphreys' shipyard on Almond Street, Southwark, near the Old Swedes' Church. Details of the mortising of the doors substantiate the tradition that the work was done at the shipyard. The pair of ribbon-back side chairs, made in Pennsylvania or possibly New Jersey, descended to Mr. Robb from the Haines family of New Jersey. The Sheraton mirror, inherited by Mrs. Robb, belonged originally to James Bruen (1780-1860) of Newark and Philadelphia.

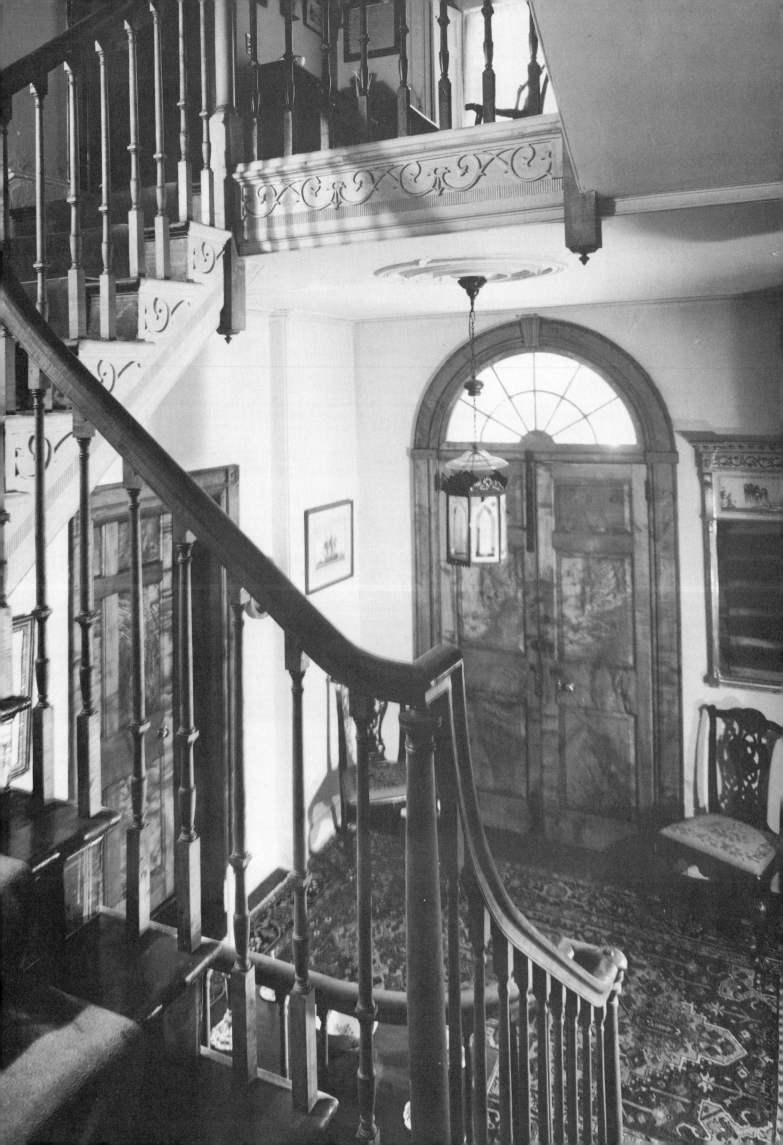

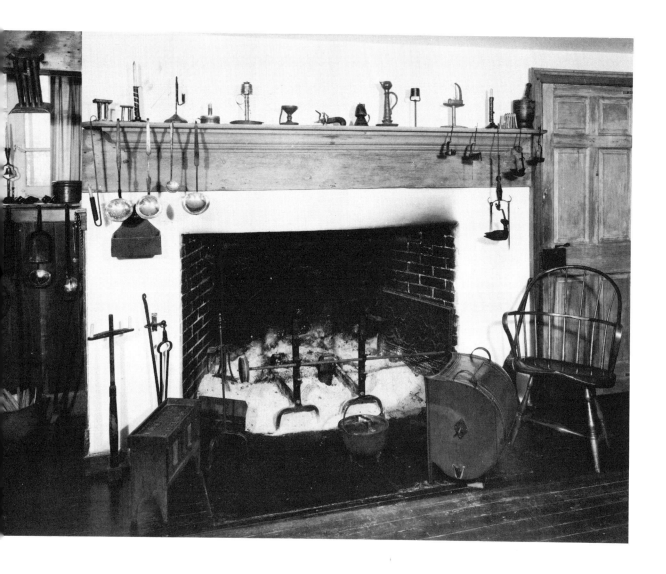

The winter kitchen is now used as a den where Mr. and Mrs. Robb display part of their extensive collection of lighting devices and early candle molds of every type. On the shelf over the fireplace are two rare Pennsylvania grease lamps made of pottery, a flintlock pistol-type tinder lighter, and, at the extreme left, two very scarce small tin molds for making little taper candles. Mrs. Robb makes candles in her molds, which are of many sizes beginning, chronologically, with a ¾-inch suitable for early brass candle sockets. Some of the molds have wooden frames with hand-wrought nails of eighteenth-century type which may be taken as evidence of date. These pewter, tin, and ceramic molds include an eight-tube tin one stamped G. H. SWINK, a rare instance of a marked example. The brass ladles are marked I. WHITMAN. Whitman made cooking utensils for the Pennsylvania Hospital in the eighteenth century.

Luxury of eighteenth-century France

General and Mrs. Ralph K. Robertson, New York City

THE COURTS OF LOUIS XV and Louis XVI set the fashion for the whole Western world, and commanded the talents of the most highly skilled craftsmen of their time. No wonder, then, that to many collectors the decorative arts of France represent the ultimate in quality and refinement. Court styles were imitated and adapted in the French provinces, as well as in other countries of the Continent and in England and its colonies, and the craftsmanship of each region has its devotees — happily. At their regal best the court styles impose a standard of dignity that does not accord with the general informality of today's living, and as antiques to live with many collectors prefer something more amenable. But for sheer elegance and exquisite workmanship most connoisseurs agree that the finest of the French is the finest of the fine.

Such are the pieces that give distinction to the New York apartment of General and Mrs. Ralph K. Robertson.

Besides furniture by Othon, Brizard, Tilliard, and their peers, there are tapestries designed by Boucher and woven at the royal manufactory of Beauvais, and porcelain from the royal manufactory of Sèvres; there are sculptures by Falconet and Houdon, drawings by Fragonard and David, and objects of art believed to have belonged to Marie Antoinette herself. In such pieces the rococo and neo-classic moods of the eighteenth century meet and mingle in this twentieth-century apartment.

The spacious entrance hall with its dramatically patterned marble floor is virtually a painting and sculpture gallery. Here are portraits by Dietz Edzard and sculpture by Henry Clews, of our own era, with sketches by Francesco Guardi and sculpture by Falconet, of the eighteenth century. The gilt-bronze candelabra as well are after Falconet's designs, and they stand on impressive Louis XVI marble-topped consoles, richly carved and gilded. The Louis XV chairs, upholstered in tapestry, are signed *Tilliard,* the stamp used by Jean Baptiste Tilliard (M–E, c. 1738) and his son, Jacques Jean Baptiste (M–E, c. 1752). *Photographs by Taylor and Dull.*

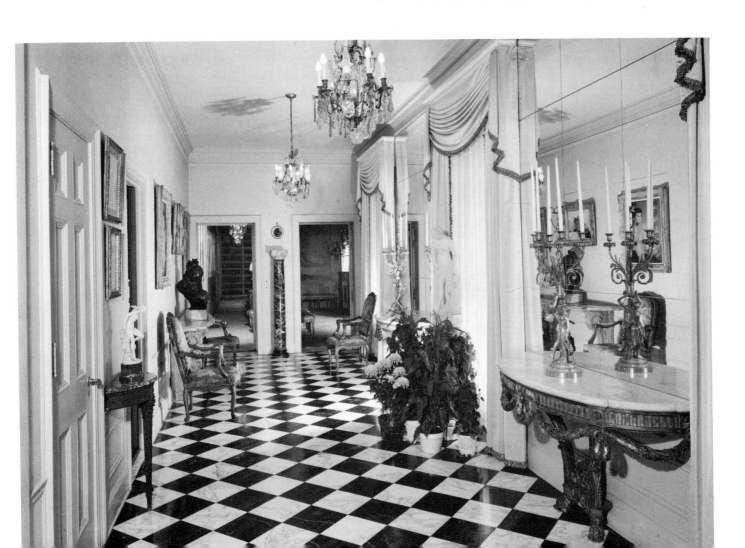

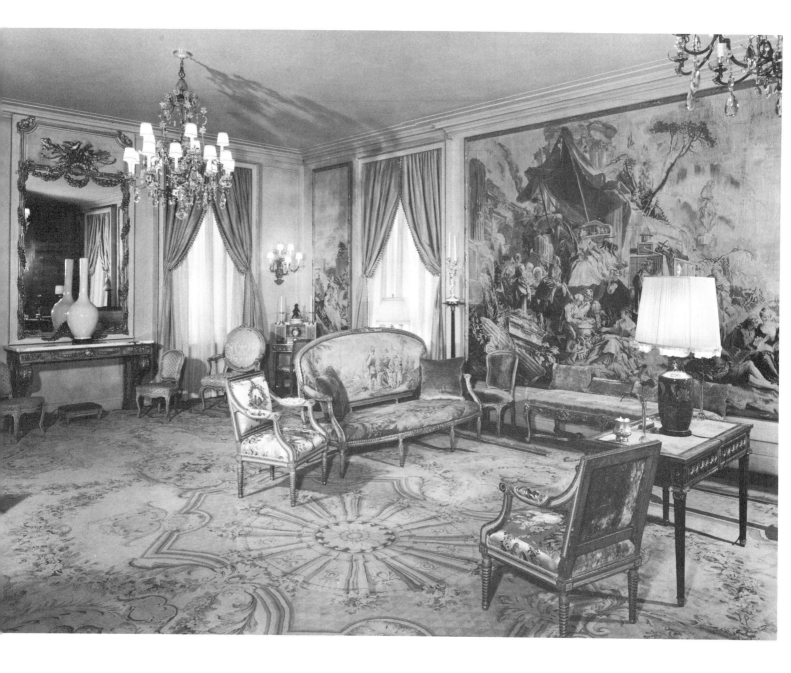

The music room is hung with Beauvais tapestries from a set, *Les Fêtes Italiennes,* designed by François Boucher; one is signed and dated 1736. Boucher tapestries also cover the Louis XVI sofa and a matching set of armchairs, which are signed by Pierre Othon (M–E, 1760). The square-backed Louis XVI armchairs with spirally carved legs are from a set by Pierre Brizard (M–E, 1772); the complete set consists of six armchairs, or *fauteuils,* two small settees, or *marquises,* and two high-backed chairs called *chaises fumeuses.* A tall vase of yellow Chinese porcelain is reflected in the Louis XVI mirror, whose garlanded and gilded frame has the classic character of the marble-topped console below it. The French eighteenth-century chandeliers here belong to a set of five in the apartment, and the gilt-bronze candelabra are after designs by Etienne Maurice Falconet. The figured carpet is a nineteenth-century Savonnerie.

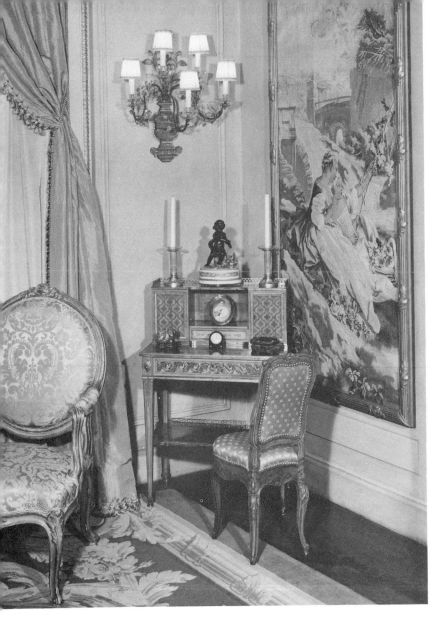

Shown in detail is the small marquetry lady's desk in the far corner of the music room, an exquisite *bonheur du jour* embellished with gilt bronze, which belonged to Marie Antoinette. The Louis XV side chair with carved seat frame and cabriole legs is unusually dainty in size, particularly in contrast to the imposing medallion-back armchair of the same period.

This view of the music room shows, at either side of the door, two of the gilded armchairs from the Othon set, upholstered in Boucher tapestry. The small Louis XVI writing table with two drawers, beside the chair at the right, is decorated with marquetry in the Chinese taste. On this and on the small Louis XV table at the left are terra-cotta busts by Joseph Charles Marin, a pupil of Clodion. The Louis XVI commodes in front of the tapestries at left and right are a superb pair with marble tops, marquetry panels and floral medallions, and rich ormolu mounts. In the *salon* beyond may be glimpsed the Louis XVI marble mantel, surrounded by Chinese porcelains, French marbles, and, on the low Chinese lacquer table, a sixteenth-century bronze figure of Apollo by Giovanni di Bologna.

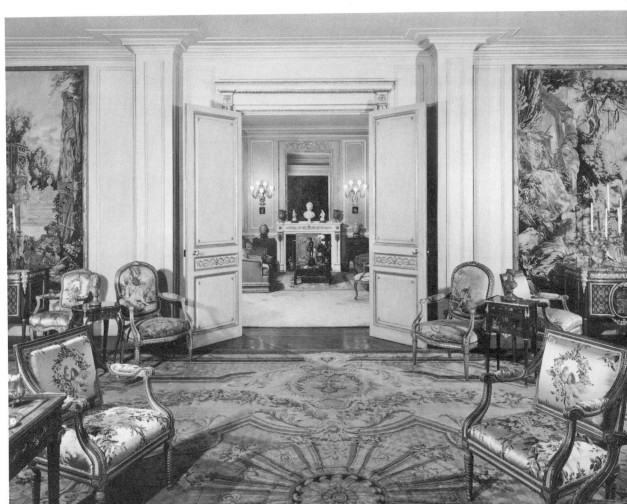

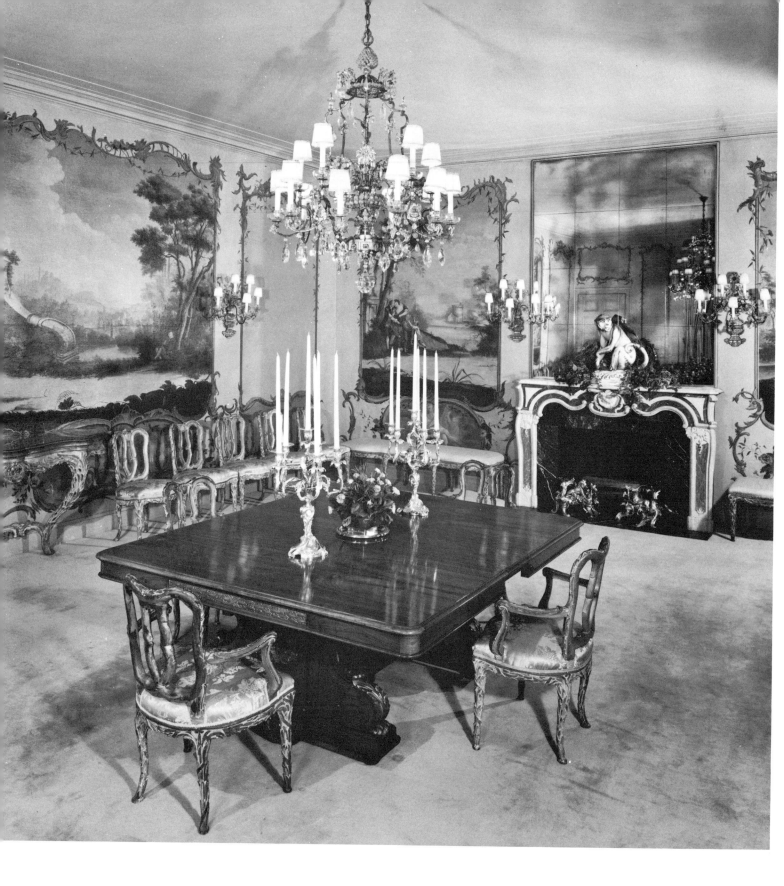

The walls of the dining room are covered with landscape paintings on canvas which are attributed to one of the several Dutch painters by the name of De Witte. The mantelpiece, though apparently of marble, is actually carved of wood and painted — a striking example of eighteenth-century *trompe l'oeil*. On it crouches a life-size monkey in Meissen porcelain. The Louis XV andirons of gilt bronze are in rococo design, and rococo too are the eighteenth-century Venetian chairs, carved and painted to simulate leafage. The great mahogany table is French, of the Second Empire, and the Louis XV silver candelabra on it are from a set of four, of which two are in the Louvre.

At one end of the drawing room are two Louis XVI pieces simple in form but exquisite in workmanship — a marquetry bureau-table and a *cartonnier,* or cabinet, with drawers above and cupboard below; both bear the stamp of Mathieu Guillaume Cramer (M–E, 1771). The marble bust portrait of a child, on the cabinet, is by Houdon, and the miniature Louis XVI armchair in front of the desk looks as though it might have belonged to that very child. Paintings at the left, above the Louis XV marquetry *encoignure* with its handsome gilt-bronze mounts, are a theater scene by Gabriel Jacques de Saint-Aubin and a small landscape by Jean Baptiste Le Prince.

On a magnificent Louis XV marquetry commode, one of a pair, stands a life-size marble portrait bust of a magistrate by Houdon; the vases on either side of it are Sèvres porcelain, mounted in ormolu. Reflected in the mirror are drawings by Boucher, Fragonard, and David, and an early Chinese painted screen. The Louis XVI armchair upholstered in tapestry belongs to the Othon set of which other pieces are in the music room.

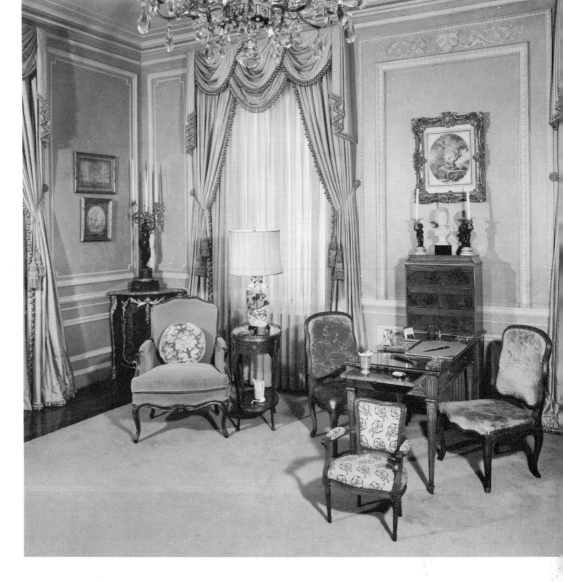

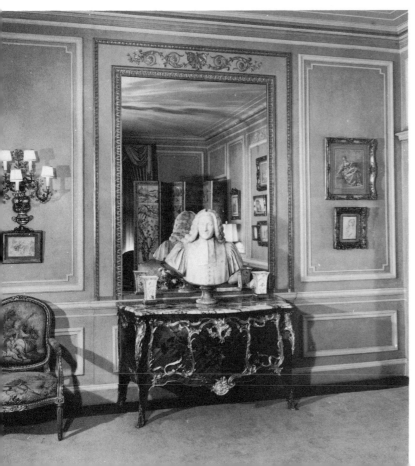

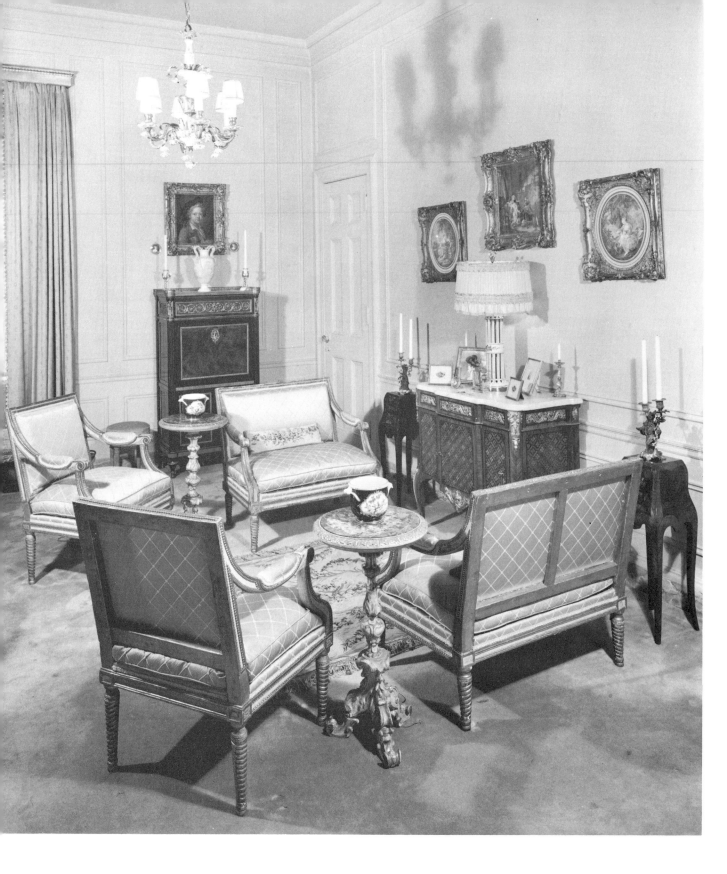

A small *salon* is called the Marie Antoinette room because the principal
pieces of furniture, several needlework pillows, and a small tapestry rug
are believed to have belonged to the French queen at Versailles. The arm-
chairs and the small settees, or *marquises*, are from the set by P. Brizard
of which matching chairs are in the music room. Two round water colors
by Boucher on the right wall flank a gouache by J. B. Baudouin, his pupil
and son-in-law. A marble vase by Clodion stands on the Louis XVI desk,
below a portrait by Pierre Adolphe Hall. On the lapis-lazuli tops of the
carved and painted candlestands are Sèvres *cachepots* with polychrome
decoration and *gros bleu* ground.

The library offers a contrast to the other rooms, whose choice *objets d' art* and delicate hues recall the gilded elegance of the eighteenth century in France. Here, against a strong green background, are mingled furnishings of varying age and source. An English Queen Anne settee is upholstered in deep green velvet with colorful embroidery worked by Mrs. Robertson. French walnut armchairs have the spiral turnings of the seventeenth century, while a Louis XVI table stands beneath a brilliant Chinese screen. The lamp table on the left is English Chippendale, that on the right Chinese.

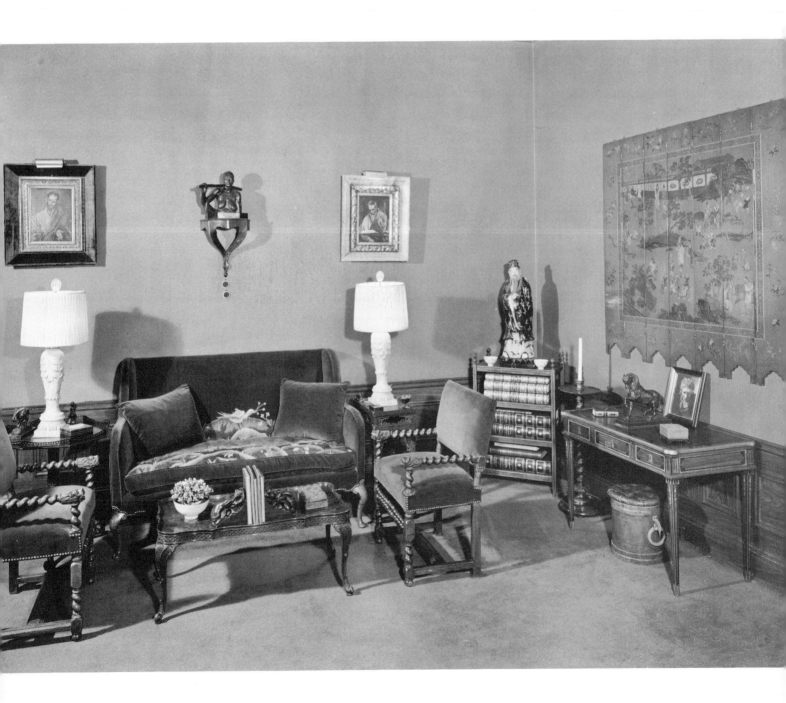

Transplanted colonial mansion

Mrs. George Maurice Morris, Washington, D.C.

THE LINDENS, home of Mrs. George Maurice Morris in Washington, D.C., was one of the most splendid houses of mid-eighteenth-century New England. It was built at Danvers, Massachusetts, in 1754 by "King" Hooper of Marblehead. After a long and not unscathed existence on its original site, it was acquired by Mr. and Mrs. Morris and moved to Washington in 1935. There they undertook to recapture, inside and out, the mansion's original dignity and distinction, furnishing it with American antiques that were historically appropriate and of a quality to do justice to their architectural setting. This could not be achieved overnight, though indeed The Lindens was well and fully furnished within a year or two after the Morrises moved in. Since then, however, a constant if gradual process of improvement and enrichment has been going on. It is often observed of collectors that their taste keeps reaching

back in time; that was the case here, and Mrs. Morris has continued the trend since her husband's death. While at first the majority of its furnishings were in the style of the mid-1700's, there were also a number from the end of the century and few that were appreciably earlier. Now Chippendale has replaced Hepplewhite, and Queen Anne and William and Mary have partially replaced Chippendale. Besides such basic changes, innumerable minor accents and individualizing touches have been added — all with strict concern for historic and stylistic correctness.

Today The Lindens is widely known as one of the most nearly perfect American eighteenth-century houses in private ownership. The antiques that furnish it are as distinguished as its architecture, and it has grown and mellowed as an old house does only when it is lived in and cherished.

The Lindens, built in 1754. Of wood, painted gray, the pilastered front simulates masonry; the other three walls are clapboarded. This façade and that of Mount Vernon are the only two surviving eighteenth-century examples in this country of sanded rustication, achieved by a process that goes back to pre-Christian Greece. *Photographs by Cortlandt V. D. Hubbard.*

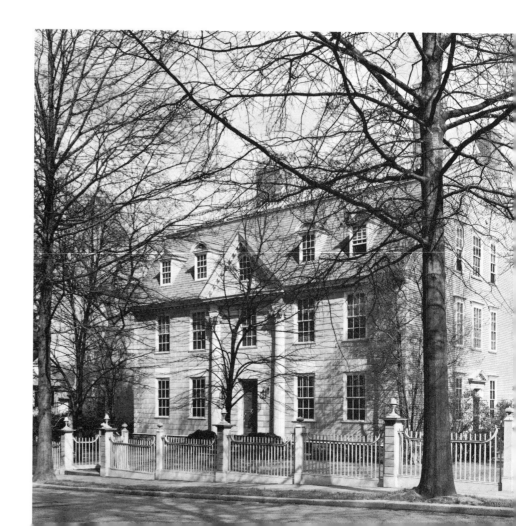

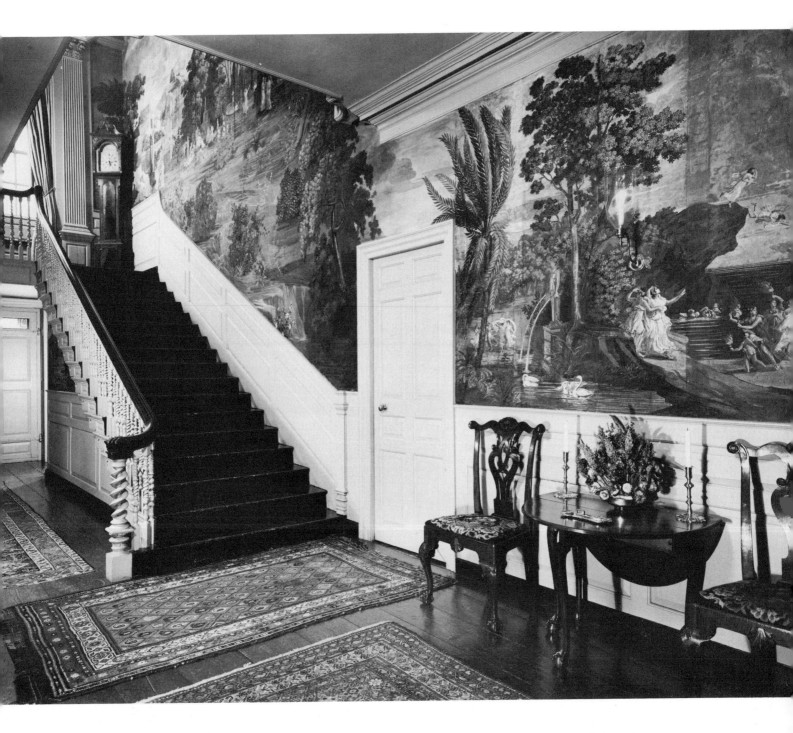

In the wide central hall, light from an arched window on the stair landing brings out the excellence of architectural detail and the rich coloring of Dufour wallpapers. These rare papers, making up three complete sets of designs, were hung probably in the 1830's. Against the high paneled dado a Chippendale oval dropleaf table is flanked by Philadelphia chairs of the same period, two of a set of six made for the Billmyer family of Germantown about 1760.

275

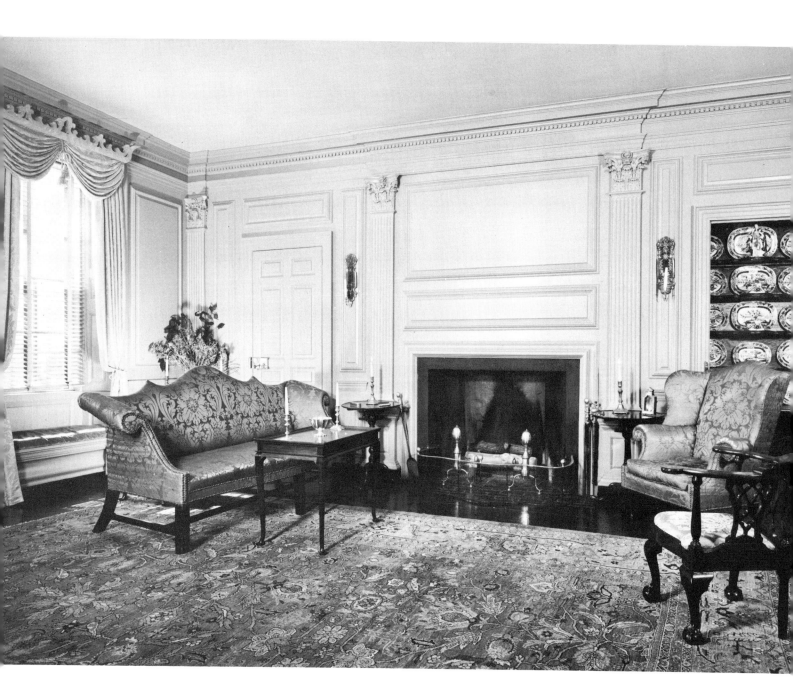

All four walls of the drawing room are handsomely paneled; they
are painted a delicate gray green. The noble Philadelphia sofa
here, and the graceful Townsend tea table with its collared legs,
were among the Morrises' earliest acquisitions for The Lindens.
The Philadelphia Chippendale wing chair and corner chair, how-
ever, replace less distinguished pieces. The dish-top tripod tables
have also been added more or less recently, as have the candle-
sticks and small decorations and the fine antique Sultanabad rug.
Crown Derby porcelain in red, blue, and gold is displayed against
the original marbleizing of the cupboard.

A pedimented secretary in cherry wood with finely carved detail, dominating the opposite end of the drawing room, is of Maryland origin, and the straight-legged Chippendale chair beside it is one of the relatively rare Baltimore pieces in this style. Philadelphia craftsmen fashioned the Chippendale tripod table and the Marlborough-foot wing chair; the Queen Anne chair is from Rhode Island. The gold brocatelle curtains, hung from Chippendale cornices covered with the same material, are draped in an eighteenth-century style.

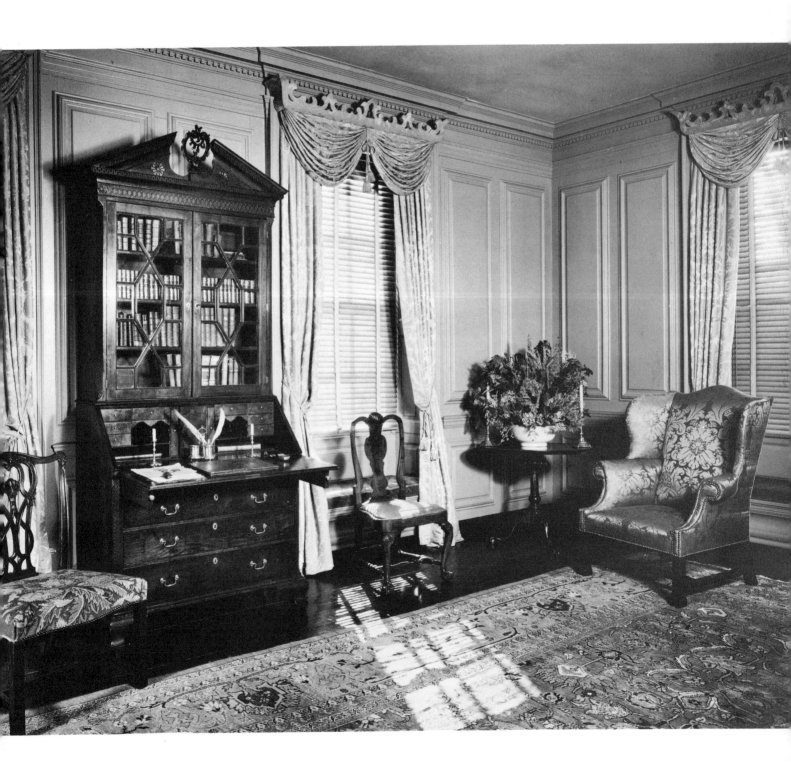

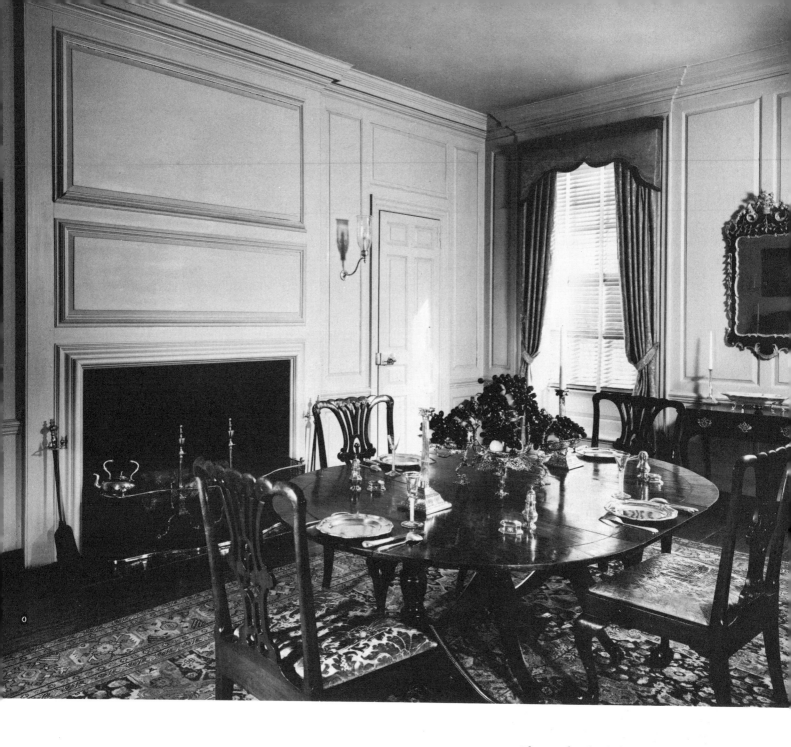

The woodwork of the paneled dining room is painted a delicate yellow that varies fascinatingly with changes of light. The handsome New York Chippendale chairs here are a rare set of twelve, at one time owned by General Matthew Clarkson, first president of the Bank of New York. The table is set with Georgian silver — gadrooned plates, flatware, trencher salts, pepper casters, columnar candlesticks, rococo épergne — and air-twist-stem glasses.

In the dining room, matching American mirrors in mahogany and gilt hang above two Georgian mahogany serving tables that are so like as to be virtually a pair. On this one is displayed a group of octagonal silver pieces that Mrs. Morris has collected over the years, each a worthy item and together forming a most unusual assembled service. Greatest rarity is the teakettle and stand, 1728, by Paul Lamerie. The Irish teapot is by Matthew Walker, Dublin, 1717. The tea caddy was made by Joseph Farwell in 1717, the cream jug by Glover Johnson in 1716; both smiths worked in London.

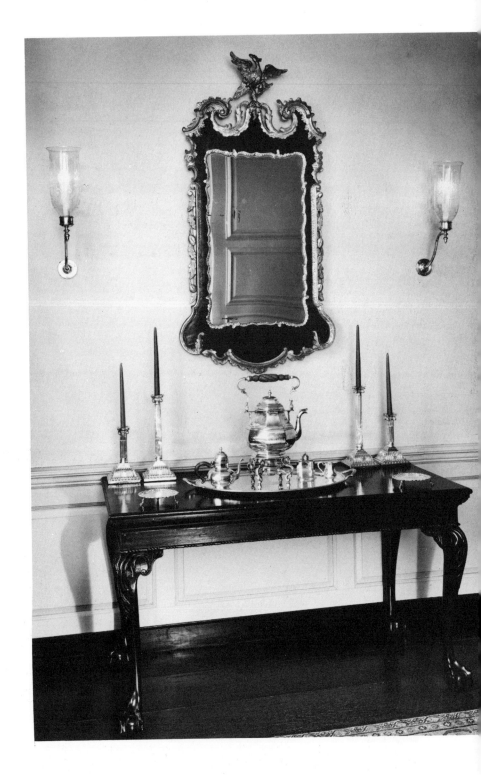

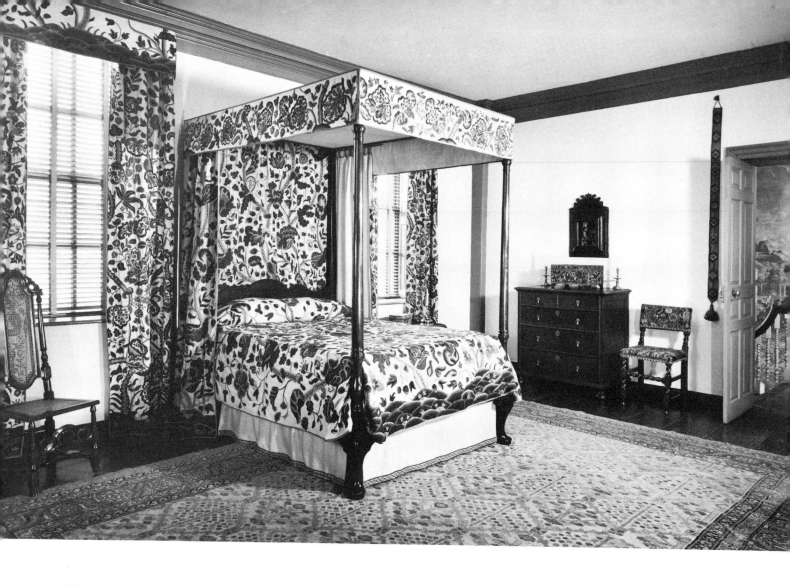

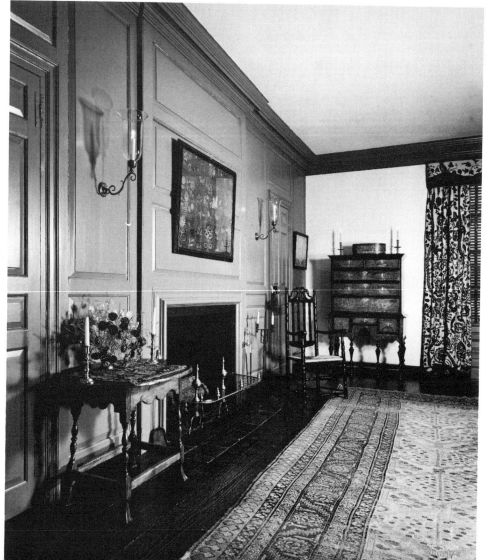

This bedroom is a treasury of late seventeenth- and early eighteenth-century American furniture and English needlework. The windows and the rare Queen Anne bed are draped in splendid crewelwork of the Charles II period. On the Pennsylvania ball-foot chest, c. 1700, a stump-work box stands between a pair of seventeenth-century brass candlesticks. The Cromwellian chair, c. 1660, beside the chest is upholstered in its original Turkey work. At the left of the bed stands an American caned chair, c. 1700, similar to earlier English and Flemish examples. The woodwork here is blue.

Another view of the blue bedroom shows the paneled fireplace wall. Here stands a rare little oval stretcher table of maple and fruit wood with finely turned legs and Spanish feet. The William and Mary highboy with trumpet legs was made in New England soon after 1700. Framed pieces of Charles II needlework hang on the wall.

An important example of Philadelphia Chippendale furniture is the mahogany chest-on-chest in the guest chamber; its treatment suggests the hand of Thomas Affleck. The paw-foot wing chair (right) was long thought to be of English origin though it was acquired in South Carolina; eventually its secondary woods were examined and found to be cucumber magnolia and American pine, indicating American and most probably Southern origin. American too is the superb Chippendale mahogany bed with carved knees and claw-and-ball feet; its elaborate cornice is draped with crimson damask. The New England Chippendale desk with serpentine front has unusual gadrooning on the skirt and on the ogee bracket feet. The gilded Chippendale mirror above was probably made in Philadelphia. There is unusual painted decoration on the floor of this room, partially visible here, and also on the floors of both lower and upper halls.

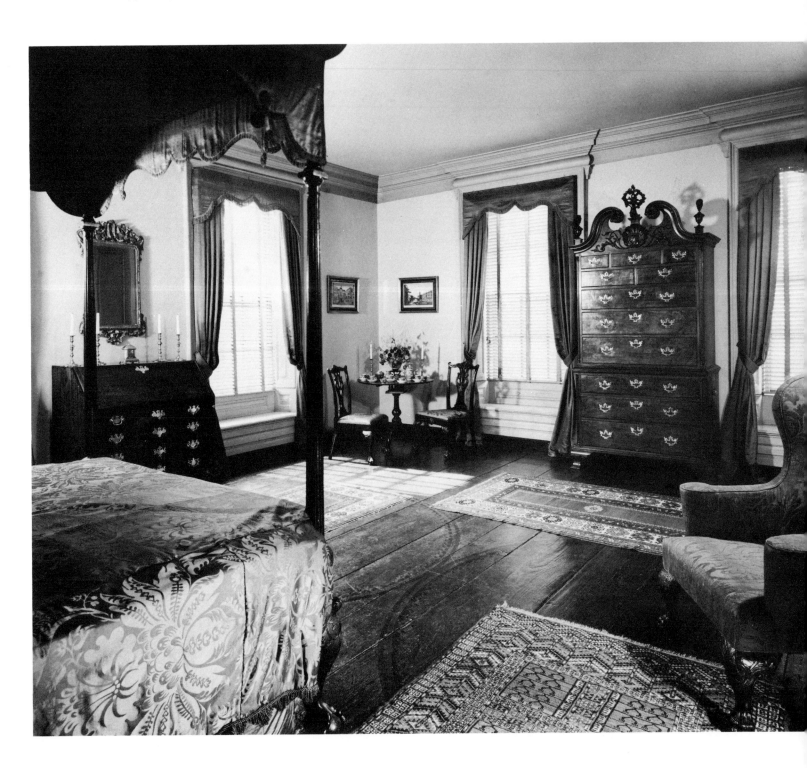

England's age of mahogany

Mr. and Mrs. Jerome C. Neuhoff, King's Point, New York

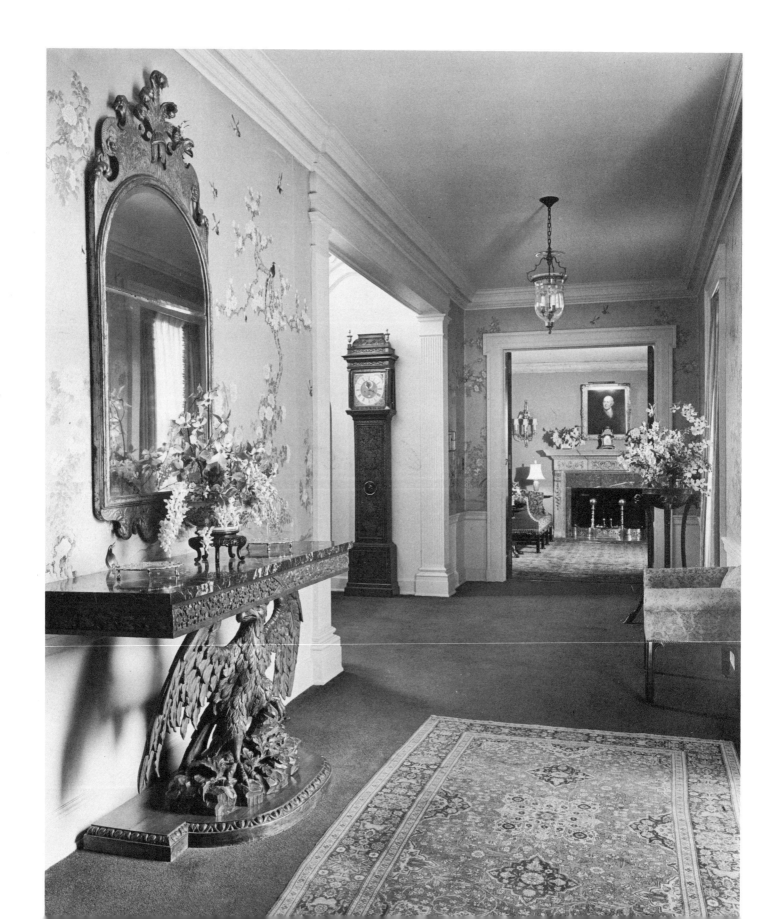

When Mr. and Mrs. Jerome C. Neuhoff built their house on Long Island they had never given antiques more than a passing thought. The house was, to be sure, in modified Georgian style, but they chose to install in it, along with a few family heirlooms, an imposing array of new furniture — refectory tables, walnut credenzas, and similar pieces in the Italian taste. Not long afterward, they happened to visit an exhibition in New York where early English furniture figured largely among the antiques and art displayed. "That furniture talked to me," says Mr. Neuhoff. "I realized that we had been missing something." Here was furniture that was beautiful, distinctive, substantial yet graceful, and eloquent of an age of good living.

From then on the Neuhoffs began looking at and for antiques, visiting shops and museums, reading the books about antiques, and gradually acquiring them. Their first purchase was a walnut candlestand in Charles II style, which they have since concluded is not of the period but an early "reproduction" made about 1800. Little by little they bought other pieces, in England and America, replacing what they had with antiques, and replacing those antiques with finer ones. Now their home is furnished exclusively with English pieces which constitute one of the outstanding collections of its kind in this country.

Their period is "the age of mahogany," from about the 1730's to the 1780's. While there are a few examples of earlier and later work, it is the fine design, rich ornament, and sound craftsmanship of that era which the Neuhoffs find most satisfying. Through living with these choice pieces, they have learned to understand even more fully the language of antiques, which speak of the men and women of other times who made them, lived with them, and loved them.

A pier table of dark mahogany in the drawing room has the deep, heavily carved frieze associated with Irish work of the Georgian period; the large lion's mask, C scrolls, and floral motifs are characteristic. The gilded pier glass above it, an English expression of the rococo, is carved with a delicacy and a sense of proportion that offset its large size. It reflects a portrait of a child by Mme. Vigée-Lebrun and the ribbon back of a Chippendale chair. *Except as noted, photographs by Taylor and Dull.*

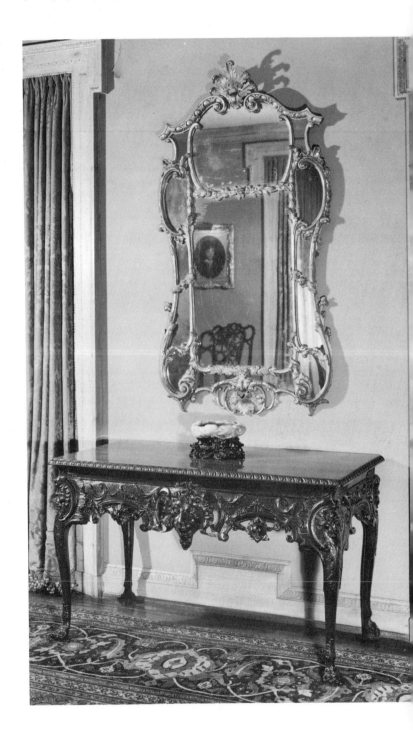

Facing page.

Entering the long hall, one faces a marble-topped console table of about 1730, whose boldly carved eagle base and oak-leaf frieze, never gilded, are in the mellowed color of natural old pine. Above it hangs a Queen Anne mirror (c. 1710-1720) with gilt frame carved in Prince of Wales plumes and eagle heads. The tall clock with marquetry case was made about 1710 by Daniel Quare of London. Such typical Adam motifs as ram's heads and hoof feet ornament the mahogany stand at the right. The rug here is a Kashan; the wallpaper, though modern, was hand-painted in China in the eighteenth-century manner. *Photograph by Gottscho-Schleisner, Inc.*

283

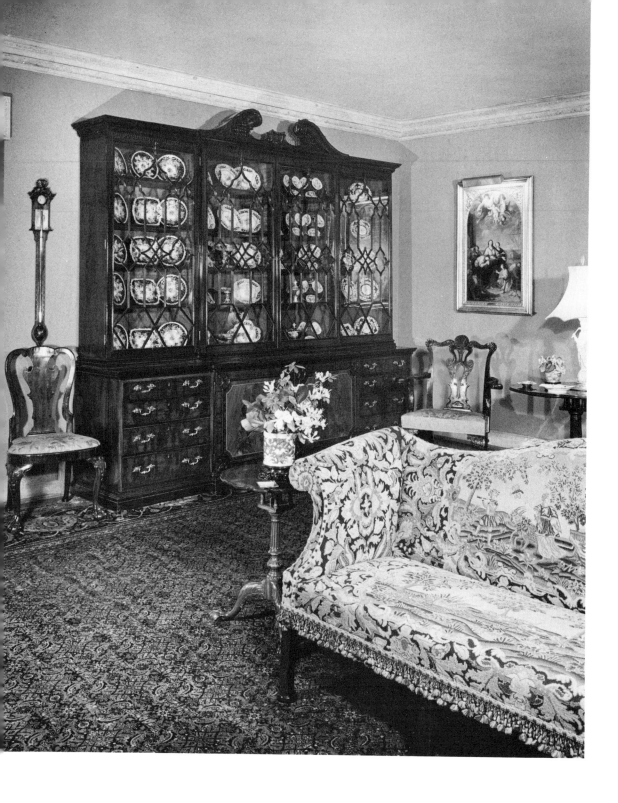

Outstanding in the drawing room is the Chippendale breakfront bookcase (c. 1770), a truly monumental piece. To the right of it a skillful balance of scrolls and angles is seen in the early Georgian side chair. The sweeping curves of the Chippendale sofa are covered in contemporary needlepoint worked in mythological scenes. Beside the sofa a Ming bowl rests on a small and elegantly carved tripod table, one of several fine examples of the type here. *Photograph by Gottscho-Schleisner, Inc.*

Color plate, facing page.

Of all the choice furniture in the house, the Neuhoffs' particular pride is the walnut secretary in the drawing room. Its richly figured wood and commanding proportions, and the extraordinary feature of glass finials, combine to make it a supreme example of early eighteenth-century cabinetmaking; the interior is elaborately fitted with compartments, drawers, and secret drawers, and carved pilasters with gilded capitals and figurines. The portrait over the mantel is of Lord William Bentinck, governor general of India, painted by Sir Thomas Lawrence, and the musical clock in its tortoise-shell and ormolu case was made about 1750 by Francis Perigal of London. The Tabriz rug is exceptionally large and finely knotted.

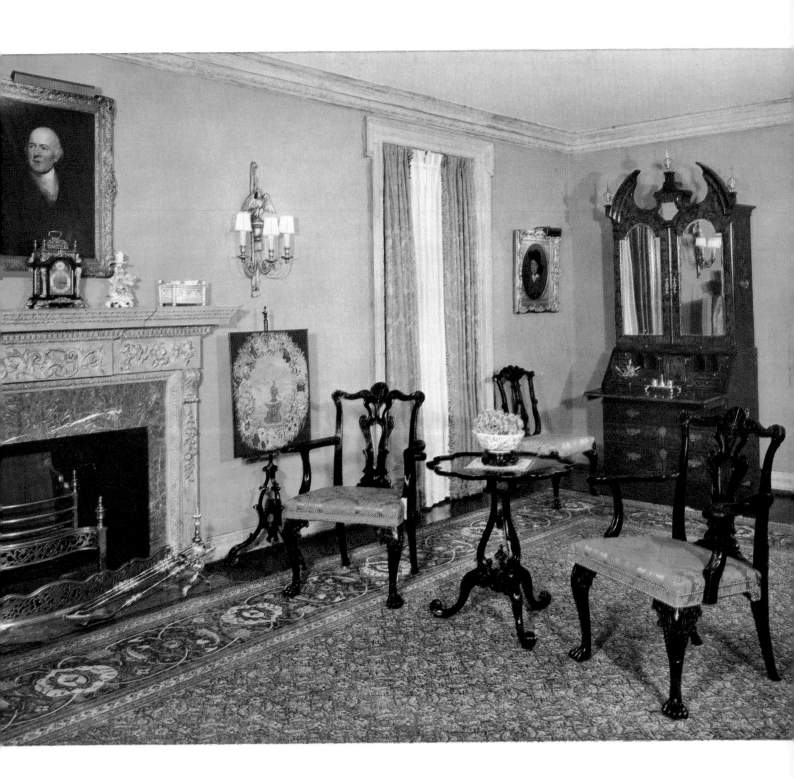

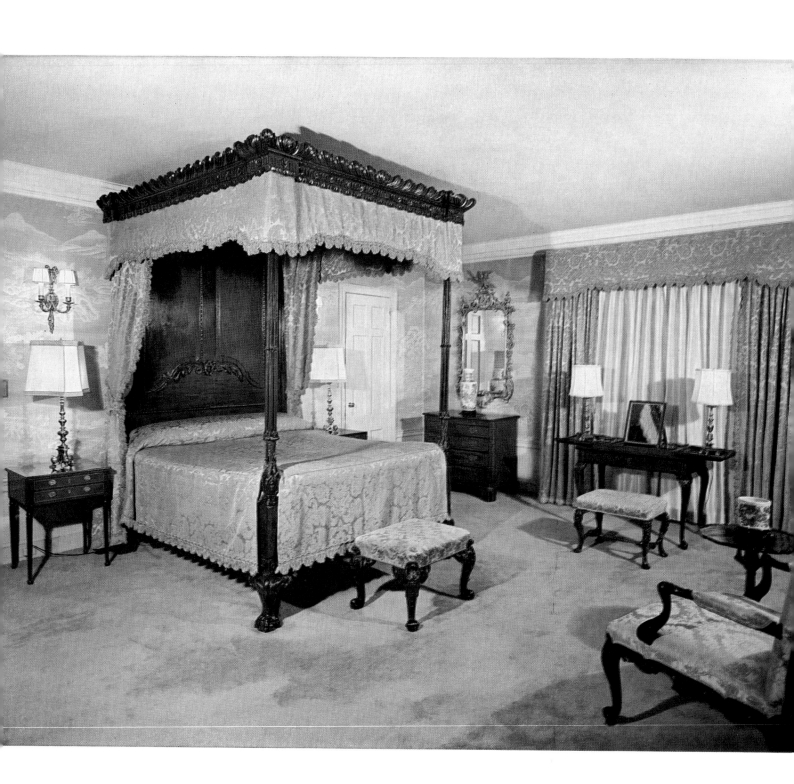

The soft gold background of this room, modulated by pattern and texture in the wallpaper, damask hangings, and carpet, and accented by green in porcelain and upholstery, enhances the rich color of the mahogany furniture. The two carved stools are noteworthy, and so is the fitted dressing table with its folding top and cabriole legs — a mid-eighteenth-century example of a form that became more frequent in the late 1700's. Complex gadrooning edges the carved cornice of the great Chippendale mahogany bed (c. 1750), which has a paneled head elaborated with carving, and cluster-column posts on vase-shape plinths.

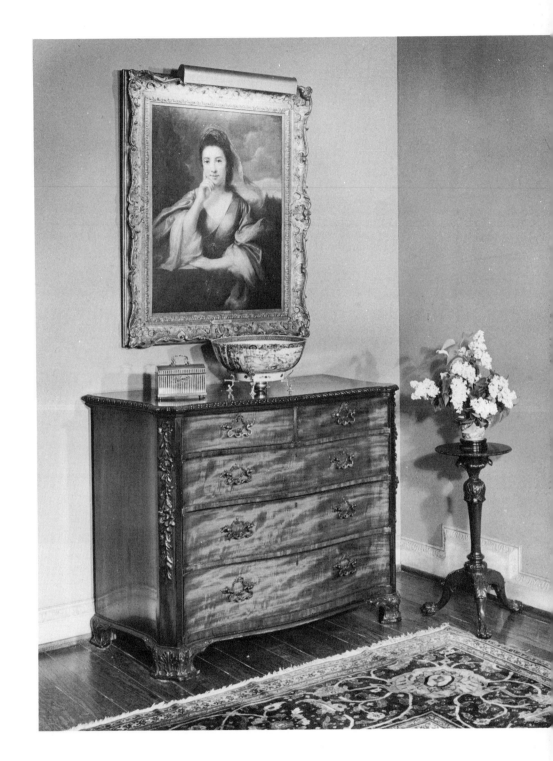

This well-proportioned chest of drawers in the drawing room, a Chippendale piece of about 1760, has its original rococo hardware. Such a piece might have stood in the home of the *Lady in Blue,* whose portrait by Sir Joshua Reynolds hangs above it. A George II silver dish cross supports the China Trade porcelain punch bowl. The George II mahogany candlestand has acanthus carving and paw feet. *Photograph by Gottscho-Schleisner, Inc.*

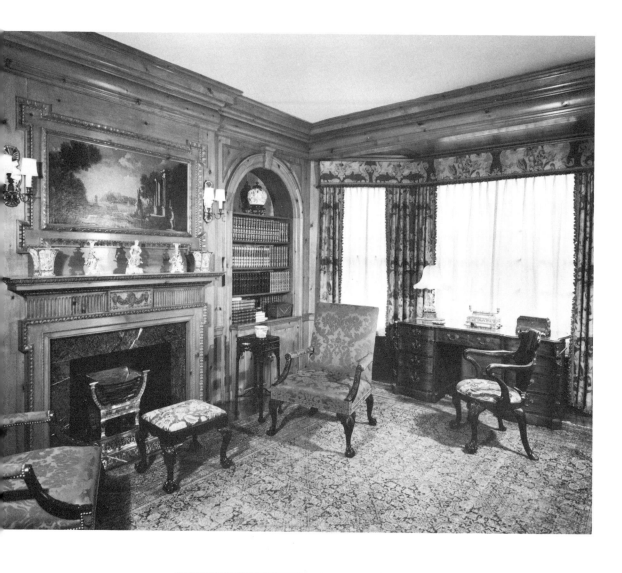

A painting of Roman ruins by Pannini fills the overmantel of the pine-paneled library, above mantel figures and vases in Derby, Bow, and Chinese porcelain. Between the matched pair of Chippendale open armchairs is a needlework-covered stool with unusually bold carving on knees and feet. At the right of the fireplace is a fine bit of Chinese Chippendale, an urn stand with bamboo-carved legs and delicate fretwork. The desk closely follows a design for a "Library Table" in Chippendale's *Director* of 1762, the pedestals serpentine on front and sides, with projecting corners handsomely carved. The "Hogarth" writing chair is an early example in mahogany of a George I type generally found in walnut.

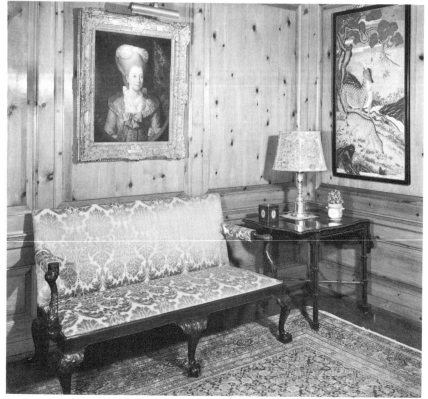

Chinoiserie appears again in the bamboo-carved legs and scrolled frieze of a pembroke table in the library. The straight lines of the back of the open-arm settee contrast with its curved and carved arm supports and legs. The portrait, by Zoffany, shows Queen Charlotte in a gray taffeta dress. The picture at right is one of a pair of early Chinese cloisonné panels.

A set of Chippendale chairs with interlaced splats is used with the long three-pedestal Sheraton table in the dining room, and above hangs a Waterford chandelier with richly jeweled corona. Beyond stands a Chippendale cabinet with rococo and "Chinese" carving, one of a rare pair. On the marble-topped serving table is a pair of mahogany knife boxes with silver mounts. The gilt convex mirror with spread eagle is a type popular in this country about 1800. The classic tureen on the dining table, made in 1792, and the 1767 tea urn on the serving table are both London silver; the candelabra are Sheffield plate.

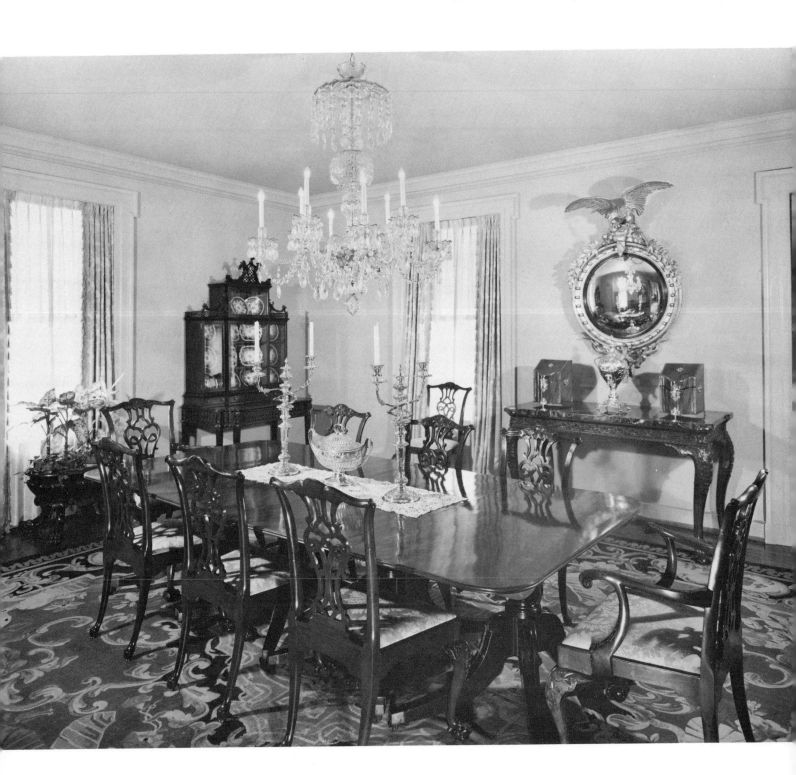

Another serving table in the dining room shows the influence of Robert Adam not only in its form but also in the husks, rosettes, leafage, and fluting of its carving. This purely neoclassic piece is in strong contrast with the baroque decanter stand below it, whose curves and scrolls and naturalistic carving place it before the mid-1700's. An early eighteenth-century Dutch flower painting by the younger Verbruggen provides a colorful background for sparkling Anglo-Irish cut glass and gleaming English silver. The boldly patterned rug is an Aubusson.